COLONIALIST PHOTOGRAPHY

DOCUMENTING THE IMAGE
A series edited by
Hélène E. Roberts, *Visual Resources, Dartmouth College, Hanover, New Hampshire*, and Christine L. Sundt, *Visual Resources, University of Oregon, Eugene*

Documenting the Image describes the history, influences, and implications of visual artifacts. Its goals include publishing monographs and reference books that promote visual collections around the world.

COLONIALIST PHOTOGRAPHY

Imag(in)ing race and place

Edited by
Eleanor M. Hight and Gary D. Sampson

London and New York

First published 2002
by Routledge
11 New Fetter Lane, London EC4P 4EE

Simultaneously published in the USA and Canada
by Routledge
29 West 35th Street, New York, NY 10001

Routledge is an imprint of the Taylor & Francis Group

© 2002 Eleanor M. Hight and Gary D. Sampson

Typeset in Sabon by M Rules, London
Printed and bound in Great Britain by
TJ International Ltd, Padstow, Cornwall

British Library Cataloguing-in-Publication Data
A catalogue record for this book is available from the British Library

Library of Congress Cataloging-in-Publication Data
A catalog record for this book has been applied for

ISBN 0–415–27495–8

CONTENTS

CONTENTS

FIGURES

ACKNOWLEDGMENTS

The concept for this book began with a session we organized for the annual meeting of the College Art Association held in Toronto in February 1998. We especially would like to thank Hélène Roberts, editor of *Visual Resources* and the *Documenting the Image* series, for suggesting that we develop a book from that session and for offering her continued guidance and support over the past four years. We would also like to express our gratitude to the speakers of the session: Ayshe Erdogdu, Andrew Evans, David Harris, Patricia Johnston, and Kim Sichel. Working with these scholars, as well as with our additional authors Julia Ballerini, Brenda Croft, Rebecca DeRoo, John Falconer, Michael Hayes, and Oscar Vázquez, has been an intellectually enriching experience for both of us. We thank them all for their patience. Our thanks go as well to Mark Simon of Harwood Academic Publishers for his enthusiasm for our project, for his advice in shaping the book, and for selecting a knowledgeable reader, whose insightful commentaries strengthened the essays. We are thankful to Helen Brocklehurst, Ruth Jeavons and Victoria Peters of Routledge for smoothing the transition of publishers and the editorial process, and for our astute copy editor John Woods. Many museum curators and archivists have been of tremendous help to us and to the other authors; we only apologize that we are unable to list them all here due to number of scholars who contributed to the book. We would also like to thank Marilyn Hoskin, Dean of Liberal Arts, and Thomas Trout, Associate Dean of Liberal Arts, of the University of New Hampshire for providing financial support for the book through the Richardson Fund.

Lastly, and most importantly, we would like to express our deepest appreciation to our families. Without the love, advice, and good humor of Anne, Tom, Maja, Nick, and Lucy we would never have been able to negotiate the uneven terrain of our scholarly pursuits and the editorial process.

Eleanor M. Hight

Gary D. Sampson

NOTES ON CONTRIBUTORS

Julia Ballerini is an independent scholar and lecturer whose most recent essay, "Passages: Studio to Archive to Exhibition," is in *Sevruguin and the Persian Image* (Washington, DC: Arthur M. Sackler Gallery, 1999). She is completing a book on Maxime Du Camp in Egypt entitled *The Stillness of Hajj Ishmael: Reflections on an 1850 Photographic Encounter*.

Brenda L. Croft, artist, curator, writer, lecturer, and consultant, is a member of the Gurindji Nation of the Northern Territory, Australia. She is Curator of Indigenous Art at the Art Gallery of Western Australia in Perth, Australia. Her recent curatorial activities include Australia's representative exhibition at the 47th Venice Biennale (1997). Her own work has been shown internationally, including the 48th Venice Biennale (1999). Croft also curated *Beyond the Pale: The Adelaide Biennial of Australian Art 2000* at the Art Gallery of South Australia; this exhibition was the first time the Biennial was dedicated to the work of Indigenous artists.

Rebecca J. DeRoo received her doctorate in art history from the University of Chicago. Her dissertation is titled *Private Objects/Public Institutions: French Art and the Reinvention of the Museum 1968–1978*. She is currently assistant professor of art history at Washington University, St Louis.

Ayshe Erdogdu is an independent historian of photography with special interest in issues of gender, race, and class in visual culture. Her essay for this volume is based on research for a book to be titled *Framing Alterity*. She lives in Houston and Ankara.

Andrew D. Evans recently completed a dissertation in history at Indiana University entitled *Anthropology at War: World War I and Racial Thought in Germany*. He currently teaches at the State University of New York, New Paltz.

John Falconer, currently in the Oriental and India Office Collections, The British Library, London, is author of *A Vision of the Past: A History of Early Photography in Singapore and Malaya – The Photographs of G. R. Lambert and Co., 1880–1910* (Singapore, 1987) and various articles on British colonialist photography.

Michael Hayes earned his doctorate from the University of Wollongong, Australia, and is currently Lecturer in Communications at RMIT University, Melbourne. He has written extensively on colonialism in the South Pacific.

Eleanor M. Hight is Associate Professor of Art History at the University of New Hampshire, Durham. Her book *Picturing Modernism: Moholy-Nagy and Photography in Weimar Germany* was published by The MIT Press in 1995. Her current research focuses on nineteenth-century photographs of Japan and Japonism in Boston in the late nineteenth century, as well as on the relationship of the archive to modernist photography in the photographs Lotte Jacobi made in Soviet Turkestan in the early 1930s.

Patricia Johnston is Professor of Art History at Salem State College. She has received wide acclaim for her book *Real Fantasies: Edward Steichen's Advertising Photography* (University of California Press, 1997). Her articles and reviews of photography and contemporary art have appeared in *Afterimage, Art New England, Views, Exposure, Technology and Culture*, the *American Historical Review*, the *Journal of American History*, and others. She is currently working on a book on nineteenth-century American painting and print media.

Gary D. Sampson is currently chair of Liberal Arts and an associate professor of art history at the Cleveland Institute of Art, Ohio. His recent publications include chapters on the photography of Samuel Bourne and Lala Deen Dayal in *India Through the Lens* (2000), published in conjunction with an exhibition at the Smithsonian Institution's Arthur M. Sackler Gallery. Among his curatorial projects was a comprehensive exhibition of photographs in the Richard F. Brush Permanent Collection at St Lawrence University, for which he also co-edited a book of essays and catalogue of the collection (2000).

Kim Sichel is associate professor of art history and the history of photography at Boston University, where she also directed the Boston University Art Gallery from 1992 to 1998. Her publications include *Germaine Krull: Photographer of Modernity* (1999), *From Icon to Irony: German and American Industrial Photography* (1994), *Black Boston: Documentary Photography and the African American Experience* (1994), *Mapping the West: Nineteenth Century American Landscape Photographs from the Boston Public Library* (1992), and *Brassai: Paris le Jour, Paris la nuit* (1988).

Oscar E. Vázquez is Associate Professor in the program in Art History at the University of Illinois, Urbana-Champaign. He has published on aspects of the academies, pedagogy, collections, and cultural identities of Spain and Latin America. His book *Inventing the Art Collection* was published last year by Pennsylvania State University Press and his current book project is *The End Again: Degeneration, Desire and the Spaces of Modernity*.

1

INTRODUCTION

Photography, "Race", and Post-Colonial Theory

Eleanor M. Hight and Gary D. Sampson

The theme of the Annual College Art Association Conference held in Toronto in February 1998 was "The History of Art in a Post-colonial Environment." In response to the call for sessions, we proposed a topic we thought essential to the conference theme: the relationship between photography and Western colonialism. Our hope was to gather a core of papers that would demonstrate, through a variety of subjects and critical methods, how photography functioned as a cultural and political medium intricately tied to the establishment and support of colonialist power. We were particularly concerned with the period from the 1840s to the 1940s, from photography's first experimental "documentary" uses to World War II, after which time many regions under the colonial authority of European nations and the United States struggled for independence. This collection of essays grew out of our CAA session,"Imag(in)ing 'Race' and Place in Colonialist Photography." It includes the expanded session papers of Ayshe Erdogdu, Andrew Evans, Patricia Johnston, and Kim Sichel, as well as additional contributions by Julia Ballerini, Brenda L. Croft, Rebecca DeRoo, John Falconer, Michael Hayes, Oscar E. Vázquez, and the editors. These writers examine a diverse range of photographs produced by Europeans and Americans of peoples and places in Asia, Africa, the Middle East, the Americas, Hawai'i, Oceania, and Australia. Building upon current ideas about the relationship between colonialism and visual representation, the chapters analyze the ways in which photographs operate as complex discursive objects of colonial power and culture.

Through a variety of case studies and interdisciplinary methods, the chapters underscore the problematic intersection of cultural, political, and economic institutions that constitute the project of Western imperialism. Yet, by no means do we wish to suggest that the authors present a unified argument that all colonial photographs act in a precise way to establish specific racial stereotypes and markers of inferiority in the depictions by Europeans and Americans of colonized peoples and their homelands. Nonetheless, the overwhelming evidence of the photographs seen within the contexts of specific episodes of colonial history indicates that the images produced a dynamic rhetoric of racial and ethnographic difference between white Europeans and Americans and non-European "races" and "places." The photographers expressed distinctions between colonized peoples and themselves ambivalently; as agents of colonial culture, they most often envisioned their subjects as objects of both racial inferiority and fascination. The photographers' perceptions of their subjects were influenced and

reinforced by a diverse array of familiar administrative practices, commercial enterprises, artistic and literary traditions, as well as the ongoing scientific investigation and classification of racial types. That the photographers shared attitudes with other colonial structures made these images readily accessible to the imaginative conceits of a broad range of Western viewers.

The colonial constructions of racial, cultural, and geographic difference found in the photographs under discussion are examined in the present volume through the channels of photographic production and consumption. These vary widely from the "scientific" recording methods of physical anthropology, especially the hierarchical categorizing of human specimens, to the popular commercial formats of collection and display: cartes-de-visite, tourist postcards, photograph albums, photographically illustrated books, and magazine advertisements. By using a combination of historical method and recent forms of interpretative analysis, the authors offer new insights into what we believe is still a little-understood aspect of modern cultural and social history – the pervasiveness of the symbolic and scientific uses of photography for the verification and justification of colonial rule. Not only do the chapters study photography's contribution to the creation of colonial authority and the writing of colonial history. They also address the complex ways in which photographs assist in the construction of a colonial *culture*, in the sense elaborated in Nicholas Thomas's critical analysis of anti-colonialist theories.[1]

In their respective approaches to the interpretation of colonial photographs, the authors of this volume have looked to the various disciplines contributing to the field of postcolonial studies today, especially anthropology, literary criticism, geography, imperial history, art history, and photo-history. Such a complex theoretical base makes the task of setting the foundation for the case studies all the more challenging. However, it also immediately imposes a positive form of resistance to settling into a fixed line of argumentation that colonialism's objects must be construed solely as essentializing texts of racial oppression and imperial governance, an approach we wished to avoid from the start. To do so would be simply to rehearse the same tendencies that one finds in the stereotyping and hierarchical ordering of humanity found, for instance, in early ethnographies. Yet, to examine the conceptions of race in photographs of colonized peoples is to recognize that the images played a certain role in the development of racial theories and prejudices by Americans and Europeans. Hence the photographs could be used in the dehumanizing practices of isolating allegedly degenerate groups, while they could also serve to identify others for their suitability for service or for their receptiveness to reculturation in accord with colonial authority.

The most straightforward use of photography to define racial types can be found in the field of physical anthropology. Before photography was available, Johann Friedrich Blumenbach (1752–1840), a German physiologist who is often considered the father of physical anthropology, used comparative anatomy, including measurements and drawings of crania, to study prehistoric human development and to compare racial types.[2] This, and later cranial studies such as those by the Philadelphia physician Samuel Morton, helped establish the anti-Darwinian theory that there were separate races, each of which was a separate species.[3] According to this theory, some of these species were more evolved than others; people with darker skin were deemed less evolved, more primitive, and white Nordic types were at the top. Such theories fed into the justification

for slavery in the South in the United States and for more widespread colonial rule in the nineteenth century. Even in the twentieth century, anthropologists and scientists continued to produce "documentary" evidence to prove that there was a correspondence between physical type and intelligence and even a propensity toward criminal behavior. The Harvard anthropologist Earnest A. Hooten built upon Morton's views in publications with such blatantly prejudiced titles as *Apes, Men, and Morons* (1937).[4]

Once available in the mid-nineteenth century, photography was used extensively to create "type" or specimen photographs in the newly developing science of biological or physical anthropology.[5] In these photographs, a non-European person under colonial scrutiny was posed partially or even totally unclothed against a plain or calibrated backdrop to create a profile, frontal, or posterior view. Or scientists measured and photographed the skeletons and skulls of people from far-flung colonized areas of the world. From these photographs physical traits were gleaned and ordered so that different ethnic groups could be classified according to common characteristics. Under the influence of Morton, Louis Agassiz, the Swiss natural historian at Harvard University, had daguerreotypes made of African slaves in South Carolina, and later albumen prints of slaves in Brazil, to document further the theory of polygenesis.[6] In Europe, anthropologists and ethnographers made similar studies under the auspices of government-sponsored institutes of anthropology and ethnology, such as the Société d'Anthropologie de Paris.

Based on the published studies in physical anthropology, in which races were defined and placed in a social hierarchy, racist or racialized theories developed. The French ethnologist Joseph-Arthur comte de Gobineau published his four-volume *Essai sur l'inégalité des races humaines* (Essay on the inequality of the human races, 1853–55).[7] His work, which was extremely influential, declared the superiority of the white "Aryan," that is, Germanic race. Only by keeping a population pure, by avoiding hybridity or miscegenation, could an Aryan society survive and prosper. His *Essay* influenced the British Germanophile Houston Stewart Chamberlain, who expounded upon the Frenchman's theme in his history of the nineteenth century.[8] Chamberlain was a great fan of Wagner who wrote on the composer's work and married his only daughter, and his promotion of Aryan superiority would influence Hitler and the National Socialist movement. Echoes of such ideas can be found also in the British notion of "the white man's burden," that imperialism could save or civilize non-whites who were perceived to be more primitive and in need of education.[9]

While today physical anthropologists and other scientists have discredited the notion that racial distinction is biological, ironically it is physical evidence that has been used to disprove such suspect theories through scientific advances in genetics and DNA analysis.[10] Recent criticism of literature and other forms of writing has also brought new light to the study of "race" as a cultural, social, and political fabrication.[11] The authors here focus on the ways in which photographers contributed to such fabrications by creating visible markers of racial distinction in their photographs, which then assisted in establishing a consensus of both professional and popular belief about the various people who fell under Western control. The racial stereotypes established in ethnographic photographs, and their presentation as titillating spectacle, eventually spilled over into ethnographic films and into the broader realm of popular films, as rigorously analyzed in Fatimah Tobing Rony's book *The Third Eye: Race, Cinema, and Ethnographic Spectacle* (1996).[12]

As will be seen in the analyses of specific photographic practices, the complexity of the colonial encounters between Europeans, Americans of European descent, and indigenous peoples would be slighted if these images were read only as embodiments of racial prejudices that could be used to suppress colonized people through surveillance and discipline. A subtle argument in discussions of race and colonialist culture is to what extent such prejudices can actually be attributed specifically to racial repugnance, on the one hand, and to colonialist righteous indignation over the customs and beliefs of people of other cultures, on the other. In other words, if the historical evidence is any measure, the latter does not necessary imply the former. Christian colonialists, for instance, made distinctions between their religious beliefs and social mores and those of the colonized, which were clearly viewed as inferior, but not always assuming an inferiority of race.[13] Furthermore, the Western visualization of native people and their environments as primitive or exotic was more often an attempt to make the unfamiliar or strange seem desirable in a traditionally legible way, than it was a deliberate racial or ethnographic denigration.

As objects of fascination, colonized people were often assigned positions formerly occupied by a colorful cast of conventional characters – shepherds, pagans, banditti, gypsies, loose-living women, and other roughcast types – who, when not appearing as subjects themselves, became little more than stock figures in a colonized landscape.[14] Their placement in these preconceived roles helped Westerners negotiate the personally threatening experience of the unknown by selectively transforming uneasy or awkward, even hostile, cultural confrontations into a more palatable form. As Thomas has pointed out, this is a less obvious form of "legislating" the colonized that differs from their more specific identification as racial inferiors by Orientalists.[15] Other writers have recently examined the transformation of North Africa, the Middle East, India, Southeast Asia, the South Pacific, and Latin America into a kind of exhibition space of natives, species, and habitats for the consumption of a Euro/American public that perceives them as radically different, or exotic. These writers have focused on literature, travel narratives, art, and anthropological method, but only rarely on photographic production and consumption.[16]

Aboriginal peoples were frequently depicted in their native environments, which served to differentiate them further from those of Americans and Europeans. While none of the chapters here focuses on photographs of sites completely devoid of human presence, the visualization of place was nevertheless important for the development of colonialist ideology. The seeds of empire grew in part out of colonialist efforts to control the earth's natural resources, and to do so the native inhabitants of a region rich in resources had to be dominated: both the geographic location and the people who lived there had to eventually be overcome, to be civilized for the control and comfort of foreign government officials, military personnel, civil servants, entrepreneurs, land developers, and agriculturists. Perceptions of ethnic groups as well as their homelands were shaped by notions of social evolution, which by the late nineteenth century were further defined by Darwinian concepts.[17] The people of unindustrialized cultures were seen as less evolved, and thus inferior, and like their native lands needed to be assisted (most often coerced) into changing according to European standards of economic, political, social, and cultural development. Thus, in photographs native people and their physical environments, even if fabricated in the studio, complemented each other; they helped define each other as an untamed spectacle for the fascinated, if anxious, Euro/American viewer.

Yet, since the foreign viewer did not want to observe, much less live in, a place that appeared either too raw or too frightening, the aesthetic concept of the picturesque had an important impact on the imaginative reconfiguration of colonial space for the benefit of the Western public. Its use in reframing locales biologically (in terms of flora and fauna) and geographically remote from Europe and the United States is abundantly evident in the illustrations found in travel narratives, expeditionary reports and journals, published folios, and later travel advertising, all of which were clearly designed to entice prospective colonialists to the foreign lands in question. For the British, and eventually for other Europeans and Americans, such written and pictorial representations reconfigured and ordered the unfamiliar and often raw terrain according to the pictorial conventions of the picturesque view. This restructuring enabled the Western observer and potential traveler to enter a scene safely and to be charmed by its novelty or its awe-inspiring grandeur. At the same time, these aesthetic interpretations of colonial space could also circumscribe both natural and built environments with an invasive colonial presence that could scarcely be counted as politically neutral and benign toward the inhabitants.

A particular case of this desire to rei(g)n in terrain deemed uncivilized was "La rue du Caire," an exhibit at the Paris Exposition Universelle of 1889, which was created to replicate the experience of a medieval Egyptian street. As Timothy Mitchell has recently observed, it was designed "in the haphazard manner of the bazaar," a confusing array of shops and streets with live animals and Egyptian personnel – all of which was a sure metaphor for the disorderly, decadent (but enchanting) world of the natives.[18] Yet, Mitchell contends, travelers to Cairo and elsewhere in Egypt tended to anticipate key points of interest and to visualize them as so many pictures. The problem "was not just to make a picture of the East but to set up the East as a picture." This is important for understanding the marketing and social impact of photographic views, which created "a distance between oneself and the world," as did "La rue du Caire," while it could also "constitute it as something picturelike – as an object on exhibit."[19] All of these ways for viewers/colonizers either to control or to distance themselves from peoples and places outside of Europe and the United States demonstrate the anxieties, even fears, Westerners had when confronting the unknown. While the photographs examined in this volume were produced to satisfy the desire for new experiences, they could also render a new location safe to explore when away from home.

Any study of photographic production and meaning in colonial contexts would be remiss to ignore the constantly metamorphosing field of "Orientalism" and its critique in recent post-colonial theory. From the point when the Eurocentric idea of an "Orient" arose in the second half of the eighteenth century, its geographic scope changed over the next two centuries to produce a number of "Orients" according to each current nationalistic point of view. British interest in India was not only economic at the time, but also scholarly. The notion of the Orient would not be limited to India, but broadened along with the imperialist expansion of Britain, France, and other European nations, as well as the United States, to include North Africa, Ottoman Turkey, the Middle East (Egypt and the Holy Lands), and Asia. Interest in China began to wane with the First China War in 1840 and was virtually supplanted in the 1860s by Japan, after the latter was re-"opened" to the Western world by the United

States in 1854. As is often forgotten in recent critical discourse, Orientalism as a field of study attempted to establish a positive cross-cultural understanding with the peoples of the subcontinent. At first Orientalism was a field devoted to the study of Oriental culture – literature, music, architecture, crafts, daily life – but the two spheres of East and West could not remain separate. Just as European influence spread eastward, the culture of the Orient impacted the West as well. Orientalism then pertained not only to the study and experience of the Orient, but also to its manifestations in Western culture.

Orientalism's study of the cultural and historical dimensions of lands and peoples undergoing colonization has been eclipsed by the more recent critique of the bifurcated worldview of East and West. This approach centers on a body of theoretical writings on the relationship of knowledge and power, especially those by the French scholar Michel Foucault. The Orient is considered as imaginatively constituted by a broad field of "discursive" elements, including the administrative, literary, religious, linguistic, philosophical, and social. Critical texts devoted to the post-structuralist, feminist, Marxist, and psychoanalytic readings of culture and politics are related to such an inquiry; together they address what is seen as the traumatic relationship of the industrialized West to the regions under its colonial surveillance, domination, and exploitation. Edward Said opened the door to the discourse of difference between Orient and Occident with his groundbreaking book *Orientalism* (1978), its polemic having been assisted by Foucault's ideas. Said, a Palestinian who is a professor of literature at Columbia University, postulated "Orientalism" as:

> a distribution of geopolitical awareness into aesthetic, scholarly, economic, sociological, historical, and philological texts; it is an elaboration not only of a basic geographical distinction (the world is made up of two unequal halves, Orient and Occident) but also of a whole series of "interests" which, by such means as scholarly discovery, philological reconstruction, psychological analysis, landscape and sociological description, it not only creates but also maintains; . . . it is, above all, a discourse that is by no means in direct, corresponding relationship with political power in the raw, but rather is produced and exists in an uneven exchange with various kinds of power.[20]

According to Said, then, Orientalism is not defined by actual topographical or political boundaries, but exists as a construction of the Western imagination.

The multiple discursive "interests" that constitute Orientalism as defined by Said formed the basis of the subsequent growing field of cultural criticism called "post-colonial" studies. His characterization of racial attitudes in terms of binary oppositions of Occident/Orient, self/Other, we/they, civilized/uncivilized, however, has come under scrutiny by post-colonial scholars for failing to take into account the nuances of the relationship between colonizer and colonized and the systems responsible for its reinforcement. Building specifically on the psychoanalytic views of Jacques Lacan and the radical politics of Frantz Fanon, Homi Bhabha stated that the object of colonial discourse "is to construe the colonized as a population of degenerate types on the basis of racial origin, in order to justify conquest and to establish systems of administration and instruction . . . I am referring to a form of governmentality that in marking out a 'subject nation', appropriates, directs and dominates its various spheres of activities."[21] In

this discourse of power, the colonized is "a fixed reality which is at once an 'other' and yet entirely knowable and visible."[22] Bhabha sees colonial discourse as dependent on a complex exchange of "official knowledge" production, again following Foucault, with the fixing of the colonial subject as a racially and culturally inferior type. Representations of the subject in a photograph can then function as a fetish of the imagined stereotype. At the same time, the image of the colonial Other becomes a trope of desire for the Western viewer, who subconsciously wishes to realize a "pure, undifferentiated origin."[23] Through the repetitive, fetishistic dissemination of stereotypes, the colonized subject becomes "mummified," to use Fanon's evocative term.[24] The imagined/imaged stereotypes perpetuate racial myths, and, in the process, particular ethnic groups and individuals are consigned to a condition of relative invisibility, of never being present in any vital human sense.

Despite the best intentions of Said, Bhabha, and others to advocate that indigenous voices representing the other side of these cultural exchanges be heard, certain anthropologists and historians who have studied the interrelationship of racial theories, imperialism, and cultural production have observed in the Said camp a general disregard for historical complexity.[25] The cultural anthropologist and historian James Clifford, for one, has critically reviewed Said's underlying approach in *Orientalism*.[26] While acknowledging the importance of Said's view that Western ideology is constructed through its relation to its Others, Clifford observes a philosophical conflict between his application of Foucault's notion of discursive formations and his analysis of authors and "traditions." This conflict, according to Clifford, betrays a humanism out of step with the impersonal theorizing of Foucault.[27] Nicholas Thomas, on the other hand, finds Bhabha tending to neglect the subtleties of specific colonialist texts by overemphasizing the sameness of cultural groups (e.g., the Arab world) and by dwelling on stereotyping and the general interpretation of all cultural objects as instruments of "governmentality."[28]

Thus, according to post-colonial thinking, as agents of colonialism and imperial rhetoric, various "texts," including literature and the visual arts, have much to tell the astute reader about the process of differentiating, ordering, and controlling the various peoples and landscapes under Western occupation. As Patrick Brantlinger has contended, "Imperialism, understood as an evolving but pervasive set of attitudes and ideas towards the rest of the world, influenced all aspects of Victorian and Edwardian culture." The impact of British imperialist rhetoric, with its aim to spread and conquer, can be seen, he explains, in the writings of Thackeray, Kipling, Conrad, and other authors, as well as in general narratives such as the myth of Africa as the "Dark Continent."[29] The authors of the present volume similarly take the position that under European and American colonialism, cultural exchanges, which were informed by fine shades of political ideology and policies of authority, were more complex and varied than the Foucauldian theorizing of the colonialist/colonized relationship would allow. At the same time, however, the writers here by no means reject the value of post-colonial studies in opening up an understanding of colonialism as a form of aggression, in which the inhabitants of designated locales were subjected to a concerted disruption, suppression, and reshaping of their cultural and social patterns to the benefit of European and American economic and political systems.

As a form of representation, photographs can be seen as substantiating imperialist rhetoric that essentialized both peoples and places; while they perpetrated the myths of

other races and their native environments. Photographs have been used in mapping the spread of imperialism, whether to designate actual geographical markers or to give validity to what Said referred to as "imagined geographies," an idea further explored by Joan Schwartz in 1996.[30] This role becomes clearer when photographs are scrutinized as agents of knowledge and power, as in the case of John Tagg's seminal book, *The Burden of Representation* (first published 1988). Tagg has investigated the hierarchical relationships between the subject and the photographer and/or the intended audience. His studies of the organized photography of criminals, the poor, vagrants, and workers (his key subjects) have emphasized the epistemological dependency of the modern state on the technology of photography. On the basis of his readings of Louis Althusser and Foucault, Tagg has argued that the uses of photography for disciplined record-keeping figures prominently in a production of knowledge that in turn functioned as a mode of power in the name of general social welfare.[31] Photography, Tagg writes, "has no identity itself," but yields to the power of the "apparatuses of the local state which deploy it and guarantee the authority of the images it constructs to stand as evidence or register truth."[32] In his seminal article "The Body and the Archive" (1986), Allan Sekula explored this idea in relation to the building of the archive, which he defines as both a collection of things and a closed system in which objects (in this case photographs) are acquired on the basis of their relation to the other contents of the archive.[33] The people under photographic surveillance could also include, by way of extension, the "colonized races" who were "forced to yield to the minutest scrutiny of gestures and features,"[34] as can be seen in the discussions of the "type" photograph in several chapters in this volume.

Tagg's thinking has influenced a significant body of literature that seeks to revise the discipline of art history in order to focus on the political aspects of representation. Prior to the impact of Marxist methodology and literary criticism on art historical scholarship in the 1970s, the tendency among art historians assessing European and American representations of people under colonial authority was to minimize art's connections to historical moments and to associated colonialist ideologies. Instead, Orientalist art, for example, was most often placed in a larger sequence of nineteenth- and early twentieth-century art movements or stylistic classifications – in particular picturesque romanticism, realism, academic art, and symbolism. This ahistorical, depoliticized approach to art history was attacked by the art historian Linda Nochlin in her article "The Imaginary Orient," which she wrote in response to David A. Rosenthal's 1982 exhibition and catalogue entitled *Orientalism: The Near East in French Painting, 1800–1880*.[35] Acknowledging her debt to Said, whose book *Orientalism* had appeared four years earlier, Nochlin analyzed a selection of French paintings from Rosenthal's exhibition. Nochlin deemed that Orientalist paintings such as *Snake Charmer* (The Sterling and Francine Clark Art Institute, Williamstown), which was painted in the late 1860s by the wildly popular Jean-Léon Gérôme (1824–1904), could "most profitably be considered a visual document of 19th-century colonialist ideology, an iconic distillation of the Westerner's notion of an Oriental couched in the language of a would-be transparent naturalism."[36] Though it was not central to her discussion, Nochlin recognized that photography had a special relevance to the issue of transparency as a possible mask for contradictory layers of cultural and political meaning. "Photography itself," she wrote, "is hardly immune to the blandishments of Orientalism, and even a presumably innocent or neutral view of

architecture can be ideologized."[37] In other words, the "photographic" precision of sumptuous detail in Gérôme's transcription of an Islamic edifice in Ottoman Turkey, the setting for a naked boy with a snake surrounded by assorted Middle Eastern onlookers, lures the viewer into casually ignoring the underlying motives of the spectacle. Convinced by the seeming objectivity of Gérôme's realist style, the viewer believes this is the "true" Orient rather than a scene envisioned from a position of cultural and political hegemony.

In the wake of Nochlin's powerful argument, historians of art and photography began to use similar tactics on other subjects. Krauss's student Abigail Solomon-Godeau offered a feminist critique of Paul Gauguin's Tahitian paradise in her article "Going Native: Paul Gauguin and the Invention of Primitivist Modernism" (1889).[38] Her analysis of Gauguin's pictorial stereotype of the Tahitian girl in relation to her representations in travel fiction written by Gauguin and others, such as Pierre Loti, and in other historical evidence, including photographs, proves that Gauguin's vision was imagined, constructed to recapture an earlier primitive state that presumably existed before contamination by European colonialism. Malek Alloula's *The Colonial Harem* (first published 1981) more specifically addressed Orientalism in photography by examining the ways in which turn-of-the-century Algerian postcards of partially undressed girls and women in harem-like settings reflect the empowered male colonialist view of the eroticized, feminized Other in the Middle East.[39] Despite the historical importance of Alloula's post-colonial study, however, his viewpoint lacks attention to "audience." W. J. T. Mitchell and, in this volume, Rebecca DeRoo have recently examined the problem.[40]

Alloula's study appeared in the early 1980s as part of an initial phase of scholarship with specific regard to photographs of empire. At first, few of these ventured beyond British dominions nor were rigorous theoretical exegeses of images a high priority, but they nevertheless served as important introductions to the field. Clark Worswick should be credited with having compiled in the late 1970s several volumes of photographs reflecting his interest in the depiction of empire, particularly in India, China, and Japan.[41] Ray Desmond, formerly of the India Office Library and Records (now the Oriental Library and Records Office in the British Library, London), published a seminal narrative with carefully researched documentation for the early history of photography in India (1976).[42] And in a critical analysis of Imperial architecture, Thomas R. Metcalf, professor of history at the University of California, Berkeley, began to articulate the ideological connections between photography and the British presence in India (1986).[43] One of our own authors, John Falconer, also unearthed important new material on the photography of the "Commonwealth of Nations" during his tenure at the Royal Commonwealth Society in the 1980s that resulted in an exhibition and accompanying catalogue (1982), which is a virtual historical compendium of photographers, background information, and images of the British Empire at its zenith.[44]

Many of the photographs taken and acquired by the colonial governments of Britain and other countries were gathered together in official archives. In the "scientific" documentation of the indigenous populations of Africa, Asia, Oceania, the Americas, and the Middle East, entire archives of photographs were assembled for the study and subsequent ordering of the world's populations. At first glance these photographs might appear to have been conceived with an apparent artlessness or scientific candor

to bring familiarity and classification to a great variety of ethnic groups and cultures. Only within the past two decades, however, have scholars begun to shatter this façade of objectivity. The reassessment of historical anthropology and ethnography, including the associated fieldwork, has brought about the recognition of photography's role in the collusion of these fields with the colonialist project and its constructions of racial stereotypes and prejudices. Two publications by curators of museum archives of ethnographic photographs are noteworthy in this respect: Melissa Banta and Curtis Hinsley's *From Site to Sight: Anthropology, Photography, and the Power of Imagery* (1986), and Elizabeth Edwards's *Anthropology and Photography, 1860–1920* (1992).[45]

In her introductory analysis of the medium as a technological asset in the developing science of "mankind," Edwards discusses the applicability of a semiotic reading of photographs in order to penetrate the factual exterior, so to speak, that veils the interior, ideological significance attached to photographs of people as human specimens. The photograph of an indigene pulled from a given archive can signify any number of meanings, depending upon the conditions surrounding the production of the image and its continued existence within a field of display mechanisms that would invariably include the accompaniment of written texts. As Edwards states, "photographs suggest meaning through the way in which they are structured, for representational form makes an image accessible and comprehensible to the mind, informing and informed by a whole hidden corpus of knowledge that is called on through the signifiers of the image."[46] This has profound implications for understanding how and why the native body has been repeatedly partitioned from its own culture, history, and geography as it is inscribed with typifying marks of difference in photographs.

The insights of Edwards, who explored the discursive relationship of photography to anthropology, owes much to the ideas of the French social theorist Roland Barthes. In his exploration of the relationship between a photograph and its object in the early 1960s, Barthes argued that a photograph was a "message without a code"; its message is connotative, rather than denotative, and is determined by the text that surrounds it.[47] This theoretical stance was expanded upon by other critics of contemporary society and culture, including Rosalind Krauss in her seminal essay "Notes on the Index."[48] She argued that a photograph operates as a system of signs, as in French semiotics, but her notion of the sign as "index" as having an actual "existential" connection to its referent was also derived from the work of the American philosopher and scientist Charles Sanders Peirce.

Using a semiotic approach tempered by careful historical scholarship, Christopher Pinney has reexamined ethnographic photography and colonialism in a number of illuminating studies, including an essay in Edwards's anthology and his recent book *Camera Indica: The Social Life of Indian Photographs* (1997; the title is a play, of course, on Barthes's book *Camera Lucida*).[49] Central to an understanding of the organized imaging, classification, and display of non-European peoples is what Pinney has called the "salvage paradigm," an idea derived from salvage anthropology. In colonial photographs of India, specific castes and tribes were framed as near-extinct specimens soon to disappear in the modern industrial world.[50] Such an attitude finds its parallel in the transcultural encounters recorded in European and American travel writing since the eighteenth century. Mary Louise Pratt has keenly observed that in their texts colonial travelers frequently split "contemporary non-European peoples off from their pre-colonial, and even colonial, pasts."[51] This she characterizes as a form of

10

"archaeology," where an attempt is made to revive indigenous history and culture; actual living people are recognized as of another era, not of the present. Thus, photographs of colonized operate in a manner similar to written "salvage" narratives as agents in the rendering of people that are not of European descent in a kind of preserved state for scrutiny and/or delectation by the Western beholder/reader. The salvage subtext of a photographic project can be unveiled through a combination of decoding strategies and contextual information.

Pinney also articulated a second paradigm as a primary function of anthropological photographs: the "detective" or "identificatory," whereby markers of difference are pursued with scientific rigor, albeit with often frightening ideological objectives.[52] The colonized subject is treated as having a possible impact on the dynamics of political power and control. As a result, he or she is subjugated to the dehumanizing project of the anthropologist who wishes to correlate the person's external physical features with some aspect of racial degeneracy or proclivity to behave in a predictable way. Some of this is viewed in the following discussions as having been informed by an insidious form of social Darwinism, which manifests itself in specific ways, depending upon the perception of the subject as ally or enemy. Thus, in accordance with the varied cultural attitudes and political motives of the photographers, clients, and viewers, type photographs can portray the colonial subject as in the guise of Jean-Jacques Rousseau's "noble savage," ferociously brave or exotically appealing, or in contrast, as indolent or cunning. James R. Ryan has followed a similar method, albeit with a broader investigation of British authority as reified in photographs, in his *Picturing Empire: Photography and the Visualization of the British Empire* (1997).[53] According to Ryan, a historian of geography, no matter how seemingly devoid of ideological reference, pictures of the topography and peoples encountered by the colonialist eye still collude with the imperialist project. Despite his scant discussion of the photographs themselves, Ryan nonetheless makes a valuable contribution in his extensive research on a wide range of official and amateur uses of the camera as forms of human and geographic surveillance across the British Empire.

Though the authors in this volume, we feel, are not overburdened by theory or jargon, their basic strategies for analyzing photographs – their relation to the world, the way they can be read – derive from the interpretative methods developed by Barthes, Krauss, Tagg, Pinney, Sekula, and others. The authors reconstruct the manner in which cultural attitudes, including racial and ethnic prejudices, were imbedded in selected photographs through the photographer's subjective strategies of imaging – the choice of subject, framing, focus, viewpoint, and the like. In this way the colonial photograph's "message" (to use Barthes's word), including its ideological emphasis, can be assessed in relation to the contexts of its creation and reception, both then and now.

Each of the authors here concentrates on a group of photographs of specific people, locales, and episodes in colonial history as a means of examining photography's discursive role in the production of colonialist ideology and culture. Despite their different subjects and approaches, however, the chapters are bound together by recognition of the uneasy encounters between the photographers and their subjects, and of the complex and varied circumstances under which the resulting photographs were and continue to be received and interpreted. In Chapter 2, Brenda Croft, an Australian Aboriginal artist and writer, counters the perpetuation of the one-sided Western view

of the colonial subject through her deeply personal analysis of photographs of her ancestors. She echoes the approach of subaltern studies scholars, who seek to rectify the biases of Western academe by stressing the resistance indigenous people in India displayed in the face of colonial authority and the resulting need to let their voices be heard.[54] Croft urges the reader to confront the trauma, and humiliation, of colonial assimilation. As one who locates part of her past in such images, she calls attention to the empowering factor of agency in the act of remembrance; even though many Aborigines were rendered nameless, they may yet resonate as individuals. Speaking for Aboriginal peoples in Australia and elsewhere, Croft emphasizes the importance of building a polyphony of voices in cultural studies, for, as bell hooks has observed, this tactic may help to disrupt "a continuation of a hierarchical idea of knowledge that falsifies and maintains structures of domination."[55] This approach is also taken, for instance, by the African American artist Carrie Mae Weems, who has turned Louis Agassiz's daguerreotypes of slaves into ancestors in her recent installations.[56] The "structures of domination," which hooks and Weems have poignantly addressed in the United States, developed in part in the colonized world because of the psychosocial trauma of cross-cultural encounter felt by the Western traveler. In Chapter 3, Julia Ballerini explores this issue in relation to the multiple characters of Ishmael, the Nubian sailor who figures prominently in Maxime Du Camp's photographs and writings on Egypt. For Ballerini, Ishmael engenders both impersonal and intimate projections of Du Camp's transcultural experiences in Egypt while traveling with the author Gustave Flaubert in the 1850s. She identifies a kind of "cultural hypochondria" in which she finds Du Camp's unstable manifestations of Ishmael emblematic of Western man's anxiety that his own culture might eventually fall into decline. This anxiety becomes sublimated in the process of controlling and situating the non-European as both subject and deferred Self.

While Du Camp's depictions of Egypt were clearly subjective, based as they were on his personal experiences, large-scale ethnographic projects, despite their aura of scientific objectivity, likewise show a similar source of unease and urge to control indigenous populations. The history of ethnographic uses of photography is ideologically linked to imperialism, but the precise outcomes of this connection are intricate and frequently ambiguous as John Falconer examines in his Chapter 4 on the publication of *The People of India* (1868–75). This eight-volume compendium of nearly five hundred type photographs with accompanying text was ostensibly authorized by the British government. In this massive undertaking, the new enthusiasm for using photography in anthropological exploration coincided with the British desire to organize and control the seemingly unruly melee of peoples in India. The association of certain groups with criminal or suspect behavior, or the elevation of others to a higher level in the social order because of physical attributes suggesting a noble demeanor, provided the British Raj with a further rationalization for its militarist and administrative grip on empire.[57] Falconer demonstrates that *The People of India* actually came about out of rather vague intentions and difficult circumstances of production, so the cause and effect between intentionality and the subsequent usage of colonial photographs is by no means a linear progression.

Outside of service to scientific and administrative authority, professional photographers played no small role in imaginatively engaging the European public, including an ever-increasing number of travelers, with the colonized and their land. They depicted

tribes and castes as exotic or primitive curiosities; jungle growth, mountain wilderness, and native villages as emblems of "the mysterious East" (Asia) or "the dark continent" (Africa). However, it was neither aesthetically appealing nor economically or politically prudent for a place to look too strange. As Gary Sampson points out in Chapter 5, selected native locales could be made to conform to European standards of taste, with appropriate accommodations, by creating and depicting such comforting markers as grand civic architecture, lavishly cultivated parklands, or picturesque vistas. He shows how Samuel Bourne's photographs of Barrackpore Park, the governor-general's country retreat near Calcutta and the location of incidents of native insurgency, reinscribed the hybridized aesthetics of the site through framing and inserting both native and European figures. In doing so, Sampson suggests, Bourne symbolically catered to the desire for exotic encounter on one hand, and for distancing the viewer from the threat of indigenous violence on the other by creating a safe space for the British colonialist.

Many European tourists and stay-at-home recipients sensed that the same peoples and places they found exotic and charming might soon disappear under Westernization. Thus, studio photographs for popular circulation often reflect the salvage approach as defined by Pinney. Moreover, collecting patterns reveal ambiguous inflections of rejection and desire of the exoticized/eroticized subject on the part of the collector. Nineteenth-century photographs of male Turks, as Ayshe Erdogdu observes in Chapter 6, tend to foreground their primitive, pre-industrial "nature." Their apparent indolence mimics picturesque conventions in the visual arts in general for depicting peripheral peoples, especially from Islamic cultures, as unproductive and backward. Such images of Middle Eastern men, which have not received much attention in postcolonialist studies, display their subjects as picturesque and exotic, while at the same time as degenerate and in need of improvement. While foreign women were picturesquely photographed as well, they were also portrayed, as elsewhere in the visual arts, as submissive objects of male fantasy. The evidence encoded in the photographs, however, continually points to a biased treatment of indigenous women by both foreigners and their own people that affirms the need for a more nuanced assessment of this supposition. In her analysis of nineteenth-century European photographs of Japanese women (Chapter 7), Eleanor Hight shows that commercial photographers, including the peripatetic Felice Beato, astutely based their own businesses on the thriving foreign market for Japanese ukiyo-e prints of female courtesans and geishas. Yet, the oppressed prostitutes who served as their models hardly experienced the life of charm and beauty that made them objects of desire in the photographs. Intended to represent aesthetically pleasing, sexually alluring women for the market of the foreign male collector, the photographs nevertheless reflect the exploitation of Japanese women by their countrymen, who for their own economic gain forced them into brothels in the treaty ports of Japan.

Though the majority of foreigners who traveled abroad and procured photographs were men, this was not always the case; by the end of the nineteenth century, larger numbers of European and American women went to the distant corners of the globe. In a corrective to Malek Alloula's canonical study of postcards depicting Algerian girls and women in harem settings, Rebecca DeRoo points out in Chapter 8 that the postcards were also avidly collected by French women. Through her study of the recipients and their collections, and the messages written on the postcards, DeRoo has come to the conclusion that the *collectionneuses* saw the Algerian women as appealing, for they

appeared to possess the luxurious life and sexual freedoms denied women in French society at the time. Patricia Johnston in Chapter 10 likewise observes such a longing to change places with the eroticized colonial subject in her study on the tourist advertising of Hawai'i before statehood. Johnston traces the representation of the islands as an imaginary idyll through the portrayal of the native female body from early anthropological and artistic renderings to the later seductive photographs in popular American women's magazines. What was first meant as objective documentation established stereotypes that underwent a process of alteration when transformed to meet the expectations of the European and American art market. This tendency toward aesthetic license shaped the images created to entice American women to travel to Hawai'i. Johnston suggests that Western women who viewed the advertisements were able to fantasize freely about inserting the self into the geographical sphere of islander women, while they could remain at a safe distance from the historical social and political conditions of Hawai'i. For both DeRoo and Johnston, then, the consumption of erotic images reveals issues of gender identity and sexual freedom that concerned the Western female collector/consumer.

Like Johnston, Michael Hayes in Chapter 9 examines tourism and photography but in the context of the first commercial cruises in the South Pacific. Building on Jonathan Crary's ideas about pictorial representation and the modern observer, Hayes analyzes the emergence of the scenic cruise in light of the concurrent use of photography as an implement of power under the assertive gaze and technical mastery of the camera's operator. Historical accounts written by photographers and passengers show how they were entranced by the novelty of "discovering" exotic lands firsthand; the former recorded these experiences for the latter to take home as souvenirs. Tourists desired to see reenactments of primitivizing behavior, such as Fijian men climbing coconut palms or Samoan women displayed half-nude. Alfred Burton's account of a voyage in 1884 expresses a curious desire on the part of the tourists to drop momentarily the authority to which they have been privileged by mimicking the "natives," appropriating supposed behavioral practices of South Sea Islanders such as swimming naked. In the above cases, from Turkey and Algeria to Hawai'i, Japan, Fiji, and Samoa, photographs created and reinforced in the viewer feelings of exotic or erotic longing. By offering a temporary withdrawal from the familiar decadence of the metropolis, the images allowed the viewers to fantasize a position of control or to project a displacement of the Other with the substitution of oneself.

Despite metaphors of military invasion and conquest found in the narratives discussed in Hayes's chapter, these instances of cultural confrontation seem relatively lacking in aggression compared to the ciphers of fear and loathing associated with photographs taken by anthropologists of prisoners of war in German camps during World War I. Andrew Evans in Chapter 11 examines the manner in which the prisoners in the camps – many of whom were non-Europeans fighting for the Allies – were subjected to humiliating scientific probing with the camera. The results were used to correlate physiognomic details with racial and ethnic degeneracy, and even criminality. For Evans, the image of the racialized colonial subject as enemy becomes an extreme trope of desire for the Western observers, who subconsciously wish to realize a "pure, undifferentiated origin," to use Bhabha's phrase discussed above. Photography was systematically employed as a means of marking difference from Germanic peoples to foster a nationalism that would eventually lead to the ideology of the Third Reich.

The very notion of "documentary photography" as an ideal balance of aesthetic representation and the insightful comprehension of a given situation has come under critical scrutiny for its contribution to a biased discourse of "official" knowledge. This is witnessed in another case of wartime documentation, where, in a contextual twist, propaganda photographs and films made during World War II to promote African service, agrarianism, and general mythos for French viewers also assisted in the suppression of the political plight of Equatorial Africa. Kim Sichel (Chapter 12) sees Germaine Krull's work for the Free French Photographic Service in Brazzaville, French Equatorial Africa, as promoting a mixed view of Africans as simultaneously valuable allies and ethnographic exotica. Krull's photographs and the film *L'Amitié noire*, on which she consulted, idealized tribal groups and physical bodies. In their artful presentation, the photographs minimalize the hardships and sacrifices these Africans endured while serving General Charles de Gaulle's Free French Army as soldiers and laborers, in the latter capacity of which they worked to supply the native resources of their own native lands for the European cause. The problematizing of the documentary ethos is further taken to task in Oscar Vázquez's rigorous analysis in Chapter 13 of the localized and international appropriations of the Puerto Rican *jíbaro*, or rural laborer. Images of the *jíbaro* were reconfigured in a manner advantageous to the political and economic interests of the United States. In the late 1940s, on the eve of Puerto Rico's first gubernatorial elections, the interests of US companies shaped political events in their own favor. Photographers, some of whom had worked for the Farm Security Administration in the United States, transformed the *jíbaro* from a machete-carrying *campesino* into a less threatening domesticated farmer working his modest garden plot. Vázquez carefully negotiates a path amid the various discursive arenas in which the *jíbaro* was manipulated as an emblem of insurgency, poverty, and then progress.

Through means often complex and subtle, colonial photographs engage viewers to look at the colonized through a pictorial dynamic of realist exoticism with varied results. They might highlight ethnographic details to produce a spectacle of difference or to aid in the alleged scientific measurement and classification of subgroups of indigenous peoples. In all such projects, the photographs function as semiotic indices abetting the affairs of the privileged state over its possessions. Colonial photographs nonetheless often engender ambiguous and fluctuating relationships between the photographer/observer and the subject peoples and terrains. In doing so, they serve the former to gain psychological and administrative order over the unfamiliar and sometimes threatening geopolitical disarray of the colonized. One cannot pretend to impartiality in attempting to discern with a post-colonial eye these interrelated structures of imagining and imaging the peoples and places under colonial control. In the course of such efforts, however, can one effect a critical consciousness – "a state of emergency," to use Walter Benjamin's term – for a radical awareness of the traditions of human oppression? Can one bring about a condition that will obviate the binary construction of self and Other, Bhabha's "state of *emergence*,"[58] that is neither deprecating nor condescending to either party? Rather than becoming a mere reification of authority concealed in a humanistic voice of concern, perhaps we are striving to acquire a critical understanding, gleaned from the historical and discursive characterizations of the colonial project, that can connect with displaced individuals and social groups in today's world, dominated as it is by a handful of post-industrialized, media-obsessed superpowers. Though we can draw no conclusions now, we can at least

hope that the following chapters might assist in a more humble endeavor: to see how photography has functioned to lend powerful support to the ideologies of cultural and racial dominance in the modern age.

Notes

1 Nicholas Thomas, *Colonialism's Culture: Anthropology, Travel and Government* (Princeton: Princeton University Press, 1994). Thomas's complex discussion seeks to bring careful historical understanding to what he sees as an over-reliance on theories of discourse that assert the colonialist project as ultimately "justified through ideologies of racism and oppression." While not denying the radical significance of such conclusions, he views as equally important colonialism as a "cultural process; its discoveries and trespasses are imagined and energized through signs, metaphors and narratives", 2–3.

2 Johann Friedrich Blumenbach, *Decas prima[-sexta] collectionis suae craniorum diversarum gentium illustrata / Nova pentas collectionis suae craniorum . . . tamquam complementum priorum decadum* (Göttingen: J. C. Dieterich, 1790–1828); illustrated parts of his collections of crania of various races.

3 Samuel George Morton, *Crania Americana; or, A Comparative View of the Skulls of Various Aboriginal Nations of North and South America: To which is prefixed an essay on the varieties of the human species* (London: Simpkin, Marshall, 1839); *Crania Aegyptiaca; or, Observations on Egyptian ethnography, derived from anatomy, history and the monuments* (Philadelphia: J. Penington, 1844); and his numerous articles. On Morton, see William Stanton, *The Leopard's Spots: Scientific Attitudes Toward Race in America, 1815–59* (Chicago: University of Chicago, 1960), 27–44.

4 Earnest A. Hooten, *Apes, Men, and Morons* (New York: G. P. Putnam, 1937). For a discussion of photography, Hooten's theories of biological anthropology, and primatology, see Melissa Banta and Curtis M. Hinsley, eds, *From Site to Sight: Anthropology, Photography, and the Power of Imagery* (Cambridge, MA: Peabody Museum Press, 1986), 64–71.

5 On the use of "type" photographs and anthropometry in anthropology and ethnography, see Elizabeth Edwards, "'Photographic Types': The Pursuit of Method," *Visual Anthropology* 3 (1990): 235–7; Frank Spencer, "Some Notes on the Attempt to Apply Photography in Anthropometry during the Second Half of the Nineteenth Century," in Elizabeth Edwards, ed., *Anthropology and Photography, 1860–1920* (New Haven and London: Yale University Press, 1992), 99–106.

6 Louis Agassiz, "The Diversity of Origin of the Human Races," *Christian Examiner* 49 (1850): 110–45. For a discussion of Agassiz's use of daguerreotypes made by the Philadelphia photographer Joseph T. Zealy for his study of African slaves in South Carolina, see Brian Wallis, "Black Bodies, White Science: Louis Agassiz's Slave Daguerreotypes," *American Art* 9 (Summer 1995): 39–61.

7 Joseph-Arthur comte de Gobineau, *Essai sur l'inégalité des races humaines* (Paris: Librairie de Firmin Didot, 1853–55).

8 Houston Stewart Chamberlain, *Die Grundlagen des neunzehnten Jahrhunderts* (The Foundation of the Nineteenth Century), 2 vols (Munich: F. Bruckmann A.-G., 1899).

9 The phrase, of course, is from the refrain of Rudyard Kipling's poem *The White Man's Burden* (1898):
 Take up the White Man's burden –
 Send forth the best ye breed –
 Go bind your sons to exile
 To serve your captives' need . . .
 What is perhaps not as widely known is that Kipling had the United States largely in mind when he wrote it. See Chris Brooks and Peter Faulkner, eds, *The White Man's Burden: An Anthology of British Poetry of the Empire* (Exeter: University of Exeter Press, 1996), 38–9; 307–8.

10 This knowledge has begun to enter the popular mainstream. See, for example, Natalie Angier, "Do Races Differ? Not Really, Genes Show," *The New York Times*, August 22, 2000.

11 See, for example, Henry Louis Gates, Jr, ed., *"Race," Writing, and Difference* (Chicago: University of Chicago Press, 1985), especially Gates's introduction. In his book *The Mismeasure of Man* (New York: W.W. Norton, 1981), 50–72, Stephen Jay Gould demonstrated that Morton's racial distinctions were fabricated and that there was little difference between the crania of different people.

12 Fatimah Tobing Rony, *The Third Eye: Race, Cinema, and Ethnographic Spectacle* (Durham and London: Duke University Press, 1996).

13 Thomas, *Colonialism's Culture*, 13–14.

14 The transference of conventional landscape devices to the representation of colonized space is seen, for instance, in J. A. Gilfillan's depiction of Maoris in their "native environment," which is arguably conceived in Claudean terms. See W. J. T. Mitchell, "Imperial Landscape," in W. J. T. Mitchell, ed., *Landscape and Power* (Chicago and London: University of Chicago Press, 1994), 21–27.

15 Thomas, *Colonialism's Culture*, 26.

16 A recent effort to explore intersections of art and colonialism, though without attention to photography, is Nicholas Thomas and Diane Losche, eds, *Double Vision: Art Histories and Colonial Histories in the Pacific* (Cambridge: Cambridge University Press, 1999).

17 For a lucid summary discussion of the shift in attitudes toward Darwinian notions of the colonized, see Andrew Porter, "Empires in the Mind," in *The Cambridge Illustrated History of the British Empire*, ed. P. J. Marshall (Cambridge: Cambridge University Press, 1996), 217–23.

18 Timothy Mitchell, "Orientalism and the Exhibitionary Order," in Donald Preziosi, ed., *The Art of Art History: A Critical Anthology* (Oxford and London: Oxford University Press, 1998), 456–57.

19 Mitchell, "Orientalism": 469. Consider, also London's South Kensington Museum, which would eventually become the Victoria and Albert Museum, where one could find by the 1870s plaster casts taken from the faces of living natives, full-scale casts of the "monuments" of empire, and a growing collection of photographs of the colonized world. See Tim Barringer, "The South Kensington Museum and the Colonial Project," in Tim Barringer and Tom Flynn, eds, *Colonialism and the Object: Empire, Material Culture and the Museum* (London and New York: Routledge, 1998), 11–27.

20 Edward W. Said, *Orientalism* (New York: Random House, 1978, Vintage Books edition, 1979), 12. Gérôme's painting was used for the cover of Said's book, as Nochlin pointed out in her review.

21 Homi K. Bhabha, "The Other Question: Stereotype, Discrimination and the Discourse of Colonialism," in Homi K. Bhabha, *The Location of Culture* (London and New York: Routledge, 1994), 70; this essay was originally published in *Screen* 24, 6 (1983): 18–36.

22 Ibid., 70–1.

23 Ibid., 81. The idea of racial purity, of course, goes back to the earlier racial theories of the likes of Gobineau and Chamberlain.

24 Bhabha, in "The Other Question": 78, quotes from Frantz Fanon, "Racism and Culture," in his *Toward the African Revolution: Political Essays* (New York: Grove Press, 1967; translation of *Pour la Révolution Africaine* (François Maspero, 1964)). The following is from the translation by Haakon Chevalier (New York and London: Monthly Review Press, 1967), 34: "This culture, once living and open to the future, becomes closed, fixed in the colonial status, caught in the yoke of oppression. Both present and mummified, it testifies against its members. It defines them in fact without appeal. The cultural mummification leads to a mummification of individual thinking. . . ."

25 Especially helpful in this regard is John M. MacKenzie, *Orientalism: History, Theory, and the Arts* (Manchester and New York: Manchester University Press,1995), intro.

26 James Clifford, *The Predicament of Culture: Twentieth-century Ethnography, Literature, and Art* (Cambridge, MA: Harvard University Press, 1988), 255–76. Others have found factual errors and inconsistencies in Said's work, but here the focus is on *Orientalism*'s importance for the development of post-colonial criticism.

27 Ibid., 261–71.

28 Thomas, *Colonialism's Culture*, 24, 37–51.

29 Patrick Brantlinger, *Rule of Darkness: British Literature and Imperialism, 1830–1914* (Ithaca, NY: Cornell University Press, 1988), 8–9.

30 Joan M. Schwartz, "The Geography Lesson: Photographs and the Construction of Imaginative Geographies," *Journal of Historical Geography* 22 (1996): 16–45.

31 See Michel Foucault, "The Subject and Power," *Critical Inquiry* 8 (Summer 1982): 777–95. Foucault has examined the way in which photographs can be understood as agents in the construction of Western historical narratives and culture, while they have also played a significant role as instruments of surveillance and oppression.

32 John Tagg, *The Burden of Representation: Essays on Photographies and Histories* (Minneapolis: University of Minnesota Press, 1993), 63–4.

33 Alan Sekula, "The Body and the Archive," *October* 39 (Winter 1986): 3–64.

34 Tagg, *Burden*, 64.

35 Linda Nochlin, "The Imaginary Orient," *Art in America* 71, 5 (May 1983): 118–31, 187–91. Donald A. Rosenthal, *Orientalism: The Near East in French Painting, 1800–1880* (Rochester, NY 1982), exhibition at the Memorial Art Gallery, University of Rochester and the Neuberger Museum, State University of New York.

36 Nochlin, "The Imaginary Orient": 119.

37 Nochlin, "The Imaginary Orient": 123.

38 Abigail Solomon-Godeau, "Going Native: Paul Gauguin and the Invention of Primitivist Modernism," *Art in America* 77 (July 1989): 118–29.

39 Malek Alloula, *The Colonial Harem*, trans. Myrna and Wlad Godzich (French ed., 1981; English ed., Minneapolis: University of Minnesota Press, 1986).

40 W. J. T. Mitchell, "The Photographic Essay: Four Case Studies," in *Picture Theory* (Chicago: University of Chicago Press, 1994), 281–322; and DeRoo's Chapter 8 below.

41 Clark Worswick, *Japan: Photographs, 1854–1905* (New York: Penwick/Knopf, 1979); *Princely India: Photographs by Raja Deen Dayal 1884–1910* (New York: Pennwick, and Alfred A. Knopf, 1980); Worswick and Ainslie Embree, *The Last Empire: Photography in British India, 1855–1911* (Millerton: Aperture, 1976); Worswick and Jonathan Spence, *Imperial China: Photographs, 1850–1912* (New York: Pennwick/Crown, 1978).

42 Ray Desmond, "Photography in India during the Nineteenth Century," in *India Office and Records Library: Report for the Year 1974* (London, 1976): 5–36.

43 Thomas R. Metcalf, *An Imperial Vision: Indian Architecture and Britain's Raj* (Berkeley and Los Angeles: University of California Press, 1986).

44 *Commonwealth in Focus: 130 Years of Photographic History, for Festival '82, Australia* (Victoria, Sydney, and Melbourne: Australia Council, arranged by the International Cultural Corporation of Australia Ltd, with assistance from the Royal Commonwealth Society, London; the Australia High Commission, London, the Department of Foreign Affairs; Department of Home Affairs and Environment and the Queensland Art Gallery, 1982).

45 Banta and Hinsley, eds, *From Site to Sight*; and Edwards, ed., *Anthropology and Photography*. In *From Site to Sight*, Banta and the social historian Curtis Hinsley explored the various uses of photography in biological, social, and cultural anthropology for expeditions, archaeology, and museum interpretation in regard to the vast holdings of the Peabody Museum of Archaeology and Ethnology at Harvard University. Edwards, archives curator at the Pitt Rivers Museum at the University of Oxford, gathered the writings of scores of scholars on the historical and theoretical perspectives embodied in photographs in the Royal Anthropological Institute in London. Together the books addressed a plethora of issues directly related, even if not discussed as such, to the relationship between photography, anthropology, and colonialism.

46 Edwards, "Introduction," *Anthropology and Photography*, 8.

47 See especially Roland Barthes, "Le Message photographique," *Communications* 1 (1961): 127–38; "Rhétorique de l'image," *Communications* 4 (1964): 40–51; and *Camera Lucida*, trans. Richard Howard (New York: Hill and Wang, 1981), originally published in French as *La Chambre claire: note sur photographie* (Paris: Gallimard Seuil, 1980).

48 Rosalind Krauss, "Notes on the Index," Parts I and II. In Krauss, *The Originality of the Avant-garde and Other Modernist Myths* (London: The MIT Press, 1985), 196–219.

49 Christopher Pinney, "The Parallel Histories of Anthropology and Photography," in Edwards,

ed., *Anthropology and Photography*, 74-95; and *Camera Indica: The Social Life of Indian Photographs* (Chicago: University of Chicago Press, 1997).

50 Pinney, *Camera Indica*, 45–56.

51 Mary Louise Pratt, *Imperial Eyes: Travel Writing and Transculturation* (London: Routledge, 1992), 135.

52 Pinney, *Camera Indica*, 45–6.

53 James R. Ryan, *Picturing Empire: Photography and the Visualization of the British Empire* (Chicago: University of Chicago Press, 1997).

54 The first of five volumes attempting to break out of what was conceived as an "elitist bias" in South Asian studies appeared in Ranajit Guha, ed., *Subaltern Studies: Writings on South Asian History and Society* (New Delhi: Oxford University Press, 1982); see also Ranajit Guha and Gayatri Chakravorty Spivak, eds, *Selected Subaltern Studies* (New York: Oxford University Press, 1988), a compilation of essays from the five published collections 1982–87. For an introduction to the Subaltern in the context of the developing field of post-colonial studies, see in particular Padmini Mongia, ed., *Contemporary Postcolonial Theory: A Reader* (London and New York: Arnold, 1996).

55 bell hooks, *Yearning: Race, Gender, and Cultural Politics* (Boston, MA: South End Press, 1989), 128. hooks is particularly writing in critical response to James Clifford and George Marcus, eds, *Writing Culture: The Poetics and Politics of Ethnography* (Berkeley: University of California Press, 1986).

56 On Weems's use of historic photographs in her work, see Ernest Larsen, "Between Worlds," *Art in America* (May 1999): 122–9.

57 On this interpretation of *The People of India*, see Pinney, *Camera Indica*, 33–45.

58 Homi K. Bhabha, "Interrogating Identity: Frantz Fanon and the Postcolonial Prerogative," in his *The Location of Culture*, 41. Bhabha here refers to Benjamin in asking, "What is the distinctive force of Fanon's vision? It comes, I believe, from the tradition of the oppressed, the language of a revolutionary awareness that, as Walter Benjamin suggests, 'the state of emergency in which we live is not the exception but the rule. We must attain to a concept of history that is in keeping with this insight.' And the state of emergency is also the state of *emergence*." Benjamin is quoted from his "Thesis on the Philosophy of History" in his *Illuminations* (New York: Schocken Books, 1968), 257.

2

LAYING GHOSTS TO REST

Brenda L. Croft

If context is all-important, it is usually out of reach. Place is an integral part of these images even when there is no landscape evident, even when there is "no there there," since many of the locations are unrecorded, lost to us. So understanding nineteenth-century photographic portraits of Indigenous peoples of Oceania is a process of reaching out for what finally is absent, rather than grasping the presence of new "truths" and disseminating new "information."[1]

In one of the earliest photographs of my father he is barefoot, and somewhat incongruously attired in the vestments of an altar boy, head shyly tilted down, standing to the extreme left of a large group of Aboriginal children, mostly young boys, I think (figure 2.1). The black and white gelatin silver print is late 1930s, when he was about twelve years old. Mirroring him to the right of the scene is a boy in similar garb, his friend

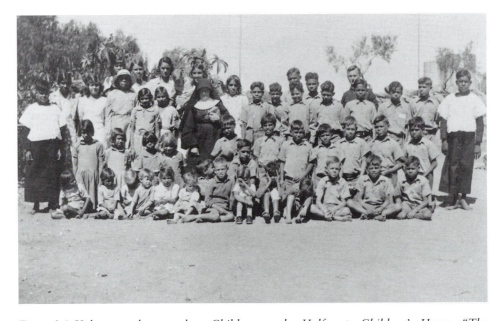

Figure 2.1 Unknown photographer, *Children at the Half-caste Children's Home, "The Bungalow," Alice Springs, Northern Territory, Australia,* c. 1938. Author's father, Joseph Croft, is the altar boy at extreme left.

Alec Kruger, older by a couple of years. The only non-Aboriginal people in the group are Father Percy Smith and a nun, both cloaked in the clerical black of their office.

This photograph did not sit alongside other images in the family photo album of my childhood. I only recently received a copy of it when Father Smith's son, John, sent it to me. Father Smith, an Anglican minister, oversaw "The Bungalow," a "half-caste" children's home outside Alice Springs. Father Smith was fondly remembered by many of the children, who included activist Charles Perkins, in whose book *A Bastard Like Me*, published in 1975, my mother first recognized my father in the little altar boy.[2] "Oh yes," he said at the time, "I remember that now."

Memory as history

It is a curious experience to go through the photographic archives – files and dusty files of pictures of people, most of them dead now. So few of the subjects are identified – not by Indian name, colonial name, or even by tribal affiliation. They are like ghosts deprived of rest. The photographers (they too are often anonymous) have put the subjects on the historical map, often falsifying forever a person's place in the world. There are many reasons for this – from the subjects' justified fears and resentments, to some photographers' ignorance and indifference to scholarship. Many of these images were also propaganda – taken not only to record "vanishing" Indigenous cultures, but also to grease the wheels of assimilation.[3]

Photography is about memories, both personal and collective, about "capturing," and dislocating, a particular moment in time. Early photographs purported to be creating an historical record, though many were often falsely staged. As Gerard Vizenor has noted, "The camera creates an instance that never existed in tribal stories; the last and lost was not in tribal poses but in the remembrance of the witness who dies behind the camera."[4] What is offered to the viewer is only one perspective – that of the "witness" – of individual, family, or collective/communal histories.

There are always gaps, as with any photo album. Empty spaces in a grandparent's album, photo corners acting as silent, crumbling grave posts, from which some unknown relative secretly extracted treasured mementoes, thereby removing them from the "bigger picture." Owing to their ephemeral nature, memories eventually fade and pass away with people, leaving later generations with little or no recollection to identify solemn faces gazing back from fragile pages. What connection could be made with these silent, anonymous sentinels of the past?

Whenever considering colonialist images of nineteenth-century Aboriginal peoples, I find strong comparisons with similar images of other Indigenous people. The individuals on display in the photography exhibition *Portraits of Oceania*, held at The Art Gallery of New South Wales in 1997, gazed at us from fragile "mirrors," reflecting every Indigenous person who viewed them. Little information is available to locate these people specifically, or to acknowledge their resistance to the onslaught of colonialism, the effects of which still reverberate through contemporary Indigenous nations. Images such as these have haunted me since I was a small child, and, along with a desire to remap my father's familial history (and my own), they were instrumental in guiding me to utilize the tools of photography in my work. Images such as those in *Portraits of Oceania* are inherently concerned by, and with, "place" and "time."

Viewing these and similar photographs of Indigenous people/people of color taken during the nascent days of photography, memories of my father projected themselves, shadow-like, behind each of the portraits. Time(less) capsules, imag(in)ing the same, yet somehow different.

A century's distance

measurement and classification of the body were central to the emerging discipline of anthropology in the nineteenth century within the context of race and evolution . . . "race" encompassed more than physical characteristics. It connoted moral character, intellectual capacity, even the capacity for "civilised" behaviour. Because races could be arranged in a hierarchy of superiority, it was thought that photographic documents would help slot each racial group into the grand scheme. One such project called for study of the "Typical Races of the British Empire." An even more ambitious undertaking for an "Ethnological Photographic Gallery of the Various Races of Man" was begun in the late 1870s . . . for the Berliner Gesellschaft für Anthropologie. This map . . . started at the top with the "Germanic and Teutonic" types and worked downwards, arriving eventually at the Australian aborigines.[5]

Cultural genocide was condoned by the prejudicial opinion of the period that Aboriginal nations were on the verge of extinction. Such beliefs, either supported or acted upon, were the impetus behind photographing Indigenous people to ensure that an "historical" record remained. Aboriginal people were considered museum specimens "in the field." If they were not considered to be living an "authentic"' lifestyle, then it was a simple enough task for the photographer to recreate the "field" to one's liking in the studio. Find a freshly killed 'roo, add a scattering of weapons or tools, a few leafy branches from a gum tree outside, a mia-mia, throw in some beads, plenty of bare flesh, and presto, "picture-perfect."

Aboriginal people were considered subhuman, so little time was expended on the gathering of identifying data beyond the most basic of notations. This presents the contemporary observer with little immediate sense of whose gaze we are returning, unless we are willing to take the time that those behind the camera did not. The act of "taking" a photograph becomes a metaphor for the dislocation experienced by Indigenous peoples throughout the history of the world, carried out in a particularly brutal and "effective" manner in Australia. "Taken," abducted – figuratively and literally – and locked into some fancy man's idea of exotica.

Some of the photographs exhibited in *Portraits of Oceania* were purchased in 1986 for $650 – as an album – by The Art Gallery of New South Wales from an elderly pastoralist living in Hazelbrook, New South Wales. Discarded historical artifacts with unknown or forgotten provenance. Few details existed other than those provided in the frontispiece to the original album that listed its contents. Reading the original list, it is evident that many will never be publicly exhibited because of their culturally sensitive nature and will remain in the collection's storage facilities.

Why is it that the names of those who collected these photographic "specimens," who made photographs of them, are so familiar, whilst we are left with an irrevocable

sense of loss over the identities of those portrayed? Douglas T. Kilburn. Kerry & Co. John William Lindt. Paul Foelsche. Baldwin Spencer and F. J. Gillen. Fred Kruger. The authors of these images are all recorded with few exceptions. We know their names, like some mantra reverberating from the Book of the Dead. Possibly these white men were trusted by the people they photographed, perhaps some even considered as friends. I do not sense this as I refer to "their" images over and over, searching for something not already observed: "As we peruse old photographs from a century's distance, we are all looking not only at but for something."[6]

Re-reading the sparse details relating to the portraits, a heady combination of anger and grief almost overwhelms me. I want to know who they were, where they were from, what became of them. Their names should be invoked, although this acts against traditional cultural practice. These people deserve to be commemorated as the individuals, community members, and elders they were; not as disembodied, cut off from their traditions, their spirits never to rest. By speaking their names aloud the viewer invokes a roll call:

Bob Murray wife, Bunitj, aged 40 – was she some station owner's trophy wife? Stoic and uncomfortable, her shoulders pressed back, at Foelsche's direction?[7] *"Amie," Larrakia, aged 22* – hands crossed and resting on her lap, her gaze sullen, who can blame her? *Davy, Woolna, aged 47* – a strong, wiry man with fingers missing from both hands – lost in battle or the result of leprosy (prevalent in the region until the mid-twentieth century)? *"Nellie" Davy wife, Woolna, aged 17, January 1889* – why record a more precise date when the other plates are notated only by calendar year or decade? *"Mary" Davy wife, aged 19* – her gaze is inexplicably sad and immediate over one hundred years later. *A Woman, Minnegie, Limilngan, aged 20. A Woman, Alligator River, Bunitj NT, aged 30. A Woman, Minnegie or Mary River, Limilngan NT, aged 18.* These last three young women "take my eye" with their belligerence, their determined individuality, their anger resonating from their portraits. They are pissed off and I like them for it, these young warrior women.

Details become scarcer: *a girl, Limilngan NT, aged 14. "Ballinger," Bunitj NT, aged 28.* A palpable fear exudes from a two-dimensional plane, possibly in response to Foelsche's presence.

An ominous feeling settles upon me as I realize that some of those portrayed were possibly my countrymen and women, since policeman-cum-photographer Paul Foelsche worked in communities in the Northern Territory near my father's/my nation, the Gurindji. The collective gaze of the young women register volumes in anger and fear – were they molested or raped by the policeman/photographer, often standard procedural practice in dealing with "savages?" (My paternal grandfather was either a white policeman or stockman.) Was a purpose other than "photometric" documentation performed by these photographs? Did Foelsche follow departmental directives, or were they taken for his private use? Why were he and the others not bothered to note basic details – name (tribal and/or "given" European), full date, nation – after expending the time and energy in bringing these people to some generic location, measured, for what imperial reason?

The intricate and diverse ceremonial cicatrix adorning the torsos and arms of the men and women and the elaborate traditional headdresses and ceremonial pouches around many of the men's and women's necks are intriguing. However, a sense of cultural protocol echoes down corridors over millennial generations, reminding me that

although I do not "know" why my gaze is averting itself, the intensity of many of the men creates discomfort, and a trace of cultural memory warns me to look away. The contradiction, then, of wanting to look whilst knowing that this may not be acceptable creates a quandary for many contemporary Indigenous people.

Returning the gaze

Kerry & Co.'s stylized photographs depict Aboriginal men in pseudo-traditional studio settings, posed with a diversity of tools and weaponry. In one image, a man in his thirties stands half-heartedly, projecting an air of resignation, boomerang raised in one hand, the other gripping a parrying shield. The sparse details state that the photographs were taken in New South Wales and North Queensland at some unknown date. Few names, no ages, no localized areas. A lone young woman stands alongside her countrymen. *"Tewitt," Chief Jervis Bay Tribe, NSW*, appears to smile, his eyes warm, possibly amused by the whole scenario.

John William Lindt loved the studio postcard setting that employs all the stereotypical, sentimental notions and props. Such contrived images were produced for a commercial market, and Lindt appeared to add European elements as he saw fit. It is difficult to determine the accuracy of his tableaux, as commercial photographers were known to construct an "authentic" scene if reality did not meet their aesthetic requirements. Two Lindt images intrigue me. First, *Untitled (Aboriginal man holding a club)*, c. 1873, from the collection of the National Gallery of Victoria, in that the man has a checked shirt tied around his waist, his upper torso heavily marked by cicatrix (figure 2.2). (Perhaps Lindt was fresh out of possum skin that particular day.)

More particularly, *Untitled (Aboriginal man holding a gun)*, c. 1873, from the same collection, holds my attention because he is holding a gun in a very resolute and confident manner (figure 2.3). Was Lindt audacious, or merely unaware, when handing the "superior" weapon of the colonizer to a "savage" as a prop? The subject's sturdy grip conveys an assured knowledge of the rifle's use, and I imagine his attitude is one of informing the white man to "watch out." I love this image for its projection of resistance, surely unintentional, which renders the kitsch backdrop immaterial. No hint of fear or resignation, this man projects pure resilience.

Fred Kruger's photographs of Aboriginal people in Victoria are fascinating as I consider he was closest to depicting honestly a rapidly changing lifestyle, and Aboriginal people's adaptation to those changes, whether in mastering the game of cricket (was there ever a more colonial recreation?) or working in the hop gardens at Coranderrk, which operated successfully until local farmers shut them out of business. I am frustrated that he rarely recorded details of the people he documented, and that the time frame is so fluid. Yet, in Kruger's images of groups at Coranderrk – at work, playing cricket, fishing, or resting by the river – one senses a true representation of community, of people determined, by their very numbers, irrespective of their colonial attire or their status as fieldworkers, to signal their intent to incorporate and withstand whatever changes the coming decades herald.

The fascination with "capturing" Indigenous people in an "authentic" environment – coupled with a (false) sense of urgency that each moment's passing meant missed opportunities to document a race or races on the verge of extinction – must have obsessed photographers such as Lindt, and to a lesser extent, Kruger, working in the southeastern

regions. The invention of photography occurred almost too late, with so much chang-ing in such a short space of time, that, to recreate their pristine scenario, settings had to be falsified in order to meet the needs of their respective clienteles.

One of the most important images in *Portraits of Oceania* is the oldest known photograph of Aboriginal people, a daguerreotype of three Victorian Kooris taken by Douglas T. Kilburn in 1847 now held in the collection of the National Gallery of

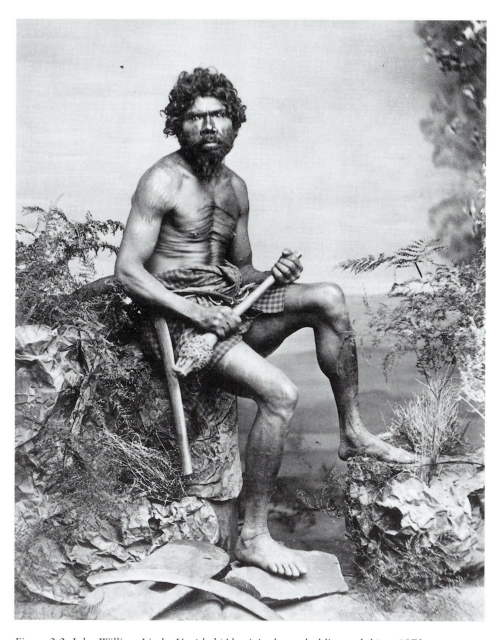

Figure 2.2 John William Lindt, *Untitled* (Aboriginal man holding a club), c. 1873.

Victoria (figure 2.4). In some ways it is perhaps the one image most contemporary in appearance. The three are a child, a man in his twenties, and a fierce-looking older man of forty or fifty years. The proud bearing of the elder man is reminiscent of Geronimo, renowned Chiricahua Apache leader, whose pose has been described by the contemporary Native American artist and activist Jimmie Durham (Wolf Clan Cherokee):

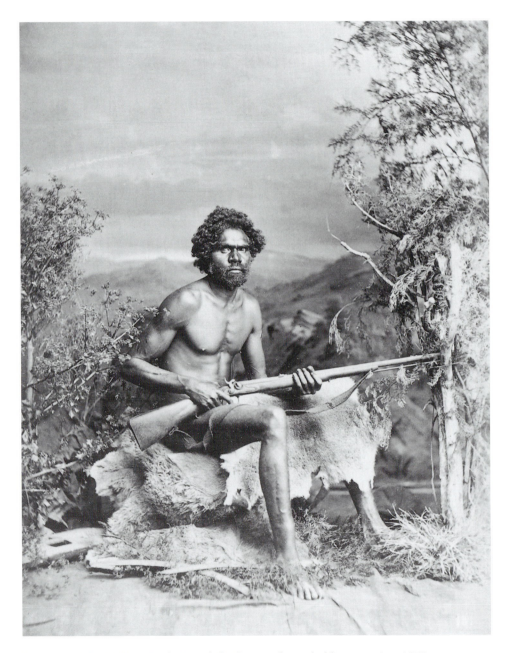

Figure 2.3 John William Lindt, *Untitled* (Aboriginal man holding a gun), c. 1873.

Yet even when he was "posed" by the man behind the camera, he seems to have destroyed the pose and created his own stance. In every image he looks through the camera at the viewer, seriously, intently, with a specific message. Geronimo uses the photograph to "get at" those people who imagine themselves as the "audience" of his struggles. He seems to be trying to see us. He is demanding to be seen, on his own terms.[8]

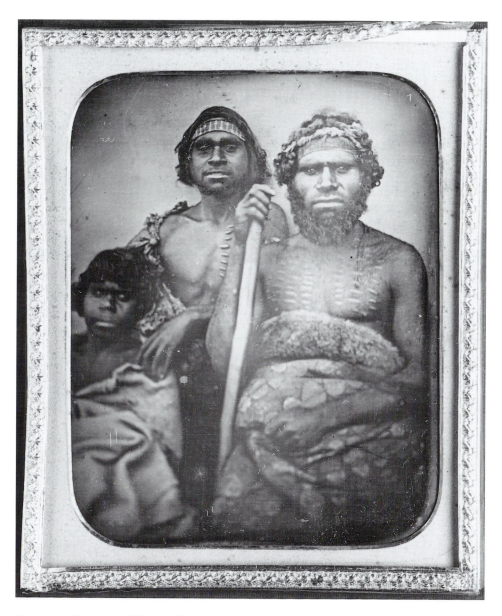

Figure 2.4 Douglas T. Kilburn, *Untitled* (Group of Victorian Aborigines), c. 1847.

The younger man, with his equally direct gaze at the viewer and the photographer, appears greatly amused by the whole scenario, exuding a confidence that belies the impending fate of thousands of his compatriots. Their gaze subverts the officially sanctioned opinion that these people were members of a race, of many nations, on the verge of extinction. The joke is on whom? This same gaze, the same stance, the same resistance is echoed in images of Indigenous people from every place and of every time. The collective pain, anger, resignation, tired patience, sense of loss and displacement is reflected in contemporary "shots" of angry, urban Indigenous people and people of color in their determination to continue resisting.

Indigenous people are bonded/banded together by our shared experiences of displacement; once reduced (literally) to the picture postcard, now coming into focus through the print, electronic, and digital media. One cannot avoid reflecting on the impact of specific images, stored in a dimly lit archive in the mind's eye, and I assess my own role as a purveyor of contemporary images of Indigenous people. Indigenous photographers work to overcome memories of generations and centuries of indelible mistreatment, and the mistrust and hatred held by Indigenous people, and people of color, towards that most abusive of colonial weapons – a camera. It will be an ongoing process for both Indigenous and non-Indigenous people to analyze and assess these documents that project inextricable links to the past and present. The haunted faces of our ancestors challenge and remind us to commemorate them and acknowledge their existence, to help lay them, finally, to rest.

It is said that one picture can be worth a thousand words. These images cannot provide us with the full identities of those portrayed, flesh out the how and whereabouts of their lives. However, if you look closely, these pictures could tell you a thousand generations' stories, if only you are willing to use your imagination: look and truly listen:

> Such is the power of the photograph, of the image, that it can give back and take away, that it can bind.[9]

Notes

This chapter originally appeared in the exhibition catalogue *Portraits of Oceania* (Sydney: The Art Gallery of New South Wales, 1997) and is reprinted here with the kind permission of The Art Gallery of New South Wales.

1 Lucy R. Lippard, "Introduction," in Lucy Lippard, ed., *Partial Recall: Photographs of Native North Americans* (New York: New Press, 1992), 20.
2 Charles Perkins, *A Bastard Like Me* (Sydney: Ure Smith, 1975).
3 Ibid., 15. "wheels of assimilation" quoted in Paula Richardson Fleming and Judith Luskey, *The North American Indians in Early Photographs* (New York: Dorset Press, 1988), 142.
4 Gerard Vizenor, "Ishi Bares His Chest: Tribal Simulations and Survivance," in Lippard, *Partial Recall*, 66. At the time of writing, Vizenor (Minnesota Chippewa) was Professor of Native American Indian literature in the Ethnic Studies Department at the University of California, Berkeley.
5 William A. Ewing, *The Body: Photographs of the Human Form* (San Francisco: Chronicle Books and London: Thames and Hudson, 1994), 112. See also Roslyn Poignant, "Surveying the Field of View: The Making of the RAI Photographic Collection," in Elizabeth Edwards,

ed., *Anthropology and Photography, 1860–1920* (New Haven and London: Yale University Press, 1992), 58.

6 Lippard, "Introduction", 19.

7 These and the other photographs discussed in this essay are illustrated and documented, as far as possible, in the exhibition catalogue *Portraits of Oceania*.

8 Jimmie Durham, "Geronimo!" in Lippard, *Partial Recall*, 56.

9 bell hooks, "'In Our Glory': Photography and Black Life," in *Art on My Mind: Visual Politics* (New York: The New Press, 1995), 56.

REWRITING THE NUBIAN FIGURE IN THE PHOTOGRAPH

Maxime Du Camp's "cultural hypochondria"

Julia Ballerini

When the writer Maxime Du Camp (1822–94) went to Egypt in November 1849, accompanied by his friend Gustave Flaubert (1821–80), the two sailed up and down the Nile for six of the eight months of their stay before going on to travel another ten months in Palestine, Syria, Turkey, Greece, and Italy. Du Camp acquired a camera for this trip, and most of his 216 negatives were made during the Nile part of his journey, 125 of which were published in what became the first major photographic album of its kind.[1] Not only was Du Camp hyperactively engaged in photographing (Flaubert wrote in a letter home, "I don't know why Maxime hasn't killed himself with this raging mania for photography"[2]), he was also making papier-mâché impressions of reliefs and taking copious notes which served as raw material for three books and numerous short stories. Flaubert, to the contrary (and much to Du Camp's annoyance), spent a good deal of his time lounging on the boat's deck or in the shade of a palm tree, a lassitude that turned out to be the gestation period for his extraordinary novel *Madame Bovary*, which he began writing upon his return to France. The results of Du Camp's frenetic efforts, by comparison, are the epitome of the ordinary. His observations are commonplace, his writing a series of banal clichés, and his photographs mostly unimaginative frontal compositions. What does distinguish Du Camp is his maniac determination to leave no stone unturned, a persistence that exaggerates the ordinary by its sheer force. While Flaubert has provided posterity with incisive insights into the daily lives of the bourgeoisie of his time, Du Camp has unwittingly provided an intensified example *of* the bourgeoisie itself.

As such, he is a manifestation of what Oscar Ortiz, in describing the explorer Alexander von Humboldt, has called "cultural hypochondria," a term I take to mean an excessive anxiety over the possibility of the disintegration and death of a culture.[3] This form of hypochondria was particularly acute at mid-century in France as the prevailing and widespread uncertainties that had been gaining momentum since the turn of the century over the direction – or even the continuation – of French civilization as it had been known were accentuated, even confirmed, by the 1848 revolution, in which Du Camp took part. Moreover, as an only child, orphaned at an early age, Du Camp was especially prey to the pervasive anxiety over what seemed an inability to control and order not only the present, but also the past. The many changes in the

social, political, and productive structures of modern life appeared so extreme as to preclude the formation of a continuous chain of logical development from the past to the present, especially for the gradually disenfranchised upper bourgeoisie, of which Du Camp was a member.

Such anxieties about the continuity of a civilization were played out in many forms. In regard to Egypt, these took on the two main manifestations of such paranoia, one, that of seeing symptomatic similarities at every turn and, two, a fear of contagion. Comparisons were made between the remains of Egypt's past, its colossal ancient monuments in ruins, many of their inscriptions indecipherable, and the perilous state of contemporary French culture that appeared to be showing symptoms of a similar disintegration. The living indigenous inhabitants of Egypt, in their ignorance of their past, also provided symptomatic parallels that fed the pervasive anxiety about the past in relation to the future. On the other hand, the eroticization of the exotic, uncultured "primitive" prompted a fear of contagion through the very desire for such a supposed regression into forgetfulness.

Only twenty-eight years old when he set off for the Near East, Du Camp had already prepared extensively for this journey since his early youth, reading from Greek and Roman texts to nineteenth-century ones, from the scholarly to the travelogue, and copying long extracts in his even, cramped script. He had also kept abreast of recent archaeological discoveries and had made a name for himself as a travel writer with his *Souvenirs and Landscapes of the Orient* resulting from a ten-month trip to Turkey, Greece, and Asia Minor in 1844–45.[4] He had also managed to become a full member of the Société Orientale just before leaving for Egypt with the promise that he would bring back abundant documentation of the remains of its ancient civilization.[5] While his self-education was not as programmatic or extensive as that of his colleagues at the Société, it was nonetheless that of a highly educated traveler. Moreover, like Humboldt, Du Camp manifests an incredible addiction to registers and annotations, paying great attention to classification and method, even making alphabetical indexes to his own handwritten notes.[6]

Another manifestation of Du Camp's addiction to the indexical is the presence throughout his Nile photographs of a small, dark figure, a Nubian named Ishmael who also served as one of the sailors on his boat. Du Camp clearly states that he used him merely as a measure of scale. Certainly the human figure was a common indicator of architectural scale throughout nineteenth-century European travel illustration in all media. But such living yardsticks often serve more than their declared purpose, operating within a variety of staged scenarios according to many variables: the identity of the figure that is pictured, the ways it is situated in relation to the monuments, its relation to the person who has placed it there and to the eventual viewer.

What is striking about Ishmael's presence in Du Camp's photographs is that, with rare exceptions, he is alone and deliberately "framed" by Du Camp, in both the pictorial and testimonial connotations of the word. What is an occasional construction in the work of other photographers abroad at the time, for Du Camp becomes an obsessive, insistent trope. Ishmael is repeatedly a picture within a picture, his presence re-constructed according to differing scenarios (figures 3.1 and 3.8). In some photographs he is assimilated within the architecture, posed sideways, one foot in front of the other, becoming the carved relief of a column (figure 3.2). Elsewhere he is atop a monument, cast against the skyline like a figure strayed from a frieze (figure 3.3).

At times he becomes an almost invisible architectural detail (figures 3.4 and 3.5). In one image he stands, contrapposto, atop a makeshift pedestal, in the pose of a classical Greek statue (figure 3.6), while in another, he is firmly planted, kouros-style (figure 3.7).

I have written elsewhere about the implications of Ishmael's configurations within these photographs and about his quasi-nudity, another significant departure from the

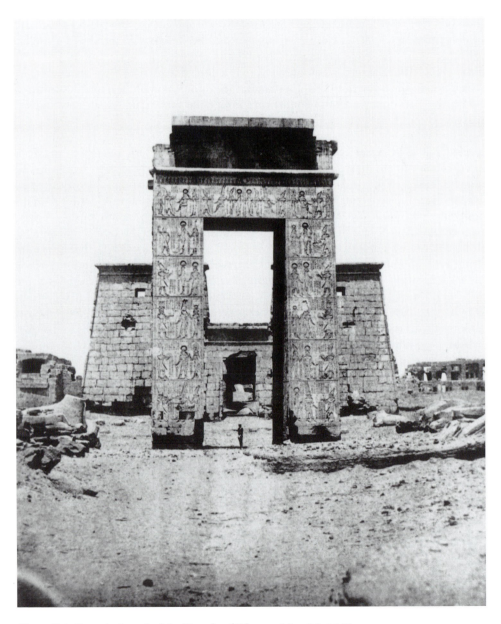

Figure 3.1 Karnak, Portal of the Temple of Khonsu, May 25, 1850.

Figure 3.2 Temple at Kertessi, April 9, 1850.

Figure 3.3 Thebes, Temple of Khonsu at Karnak, May 6, 1850.

Figure 3.4 Kom Ombo, Temple of Ombos, April 20, 1850.

Figure 3.5 Detail of Fig. 3.4.

norm.[7] My attention here is instead on Ishmael's presence in Du Camp's related writings. Not that there are clear parallels to be drawn between Du Camp's visual and verbal presentations of Ishmael; rather than illustrate one another they illuminate one another tangentially. At times it almost seems as if the rectangular voids in so many of Du Camp's photographs are blank pages awaiting verbal inscription, a fancy that has

Figure 3.6 Thebes, Medinet Habu, Harem of Ramesses III, May 8, 1850.

Figure 3.7 Dendera, Sanctuary on Top of the Temple of Hathor, May 25, 1850.

Figure 3.8 Thebes, Temple of Khonsu, Karnak, May 6, 1850.

some basis in the fact that Du Camp was exclusively a writer, save for this single photographic venture (figures 3.1, 3.6, and 3.8).

The three texts specifically connected to Du Camp's trip are significantly different in style and focus: the lengthy introduction to the photographic album is a pastiche of scholarly quotations, *The Posthumous Book: Memoires of a Suicide* a thinly disguised autobiography, and *The Nile* a travel narrative.[8] Ishmael's enigmatic figure flickers throughout the three like a character in a film, related to the plot, but never fully developed and seen only in disconnected glimpses. Yet it is among the divergences, convergencies, and interstices of the representations of the Oriental within this trilogy that Ishmael's metamorphoses and invisibilities in Du Camp's photographs are fleshed out. His visually ambivalent positionings as both embedded in the past and existing in the present become more specifically inscribed as he assumes different characters alongside the three different personas adopted by Du Camp in these publications.

The three books are representative of the three major genres of travel writing that were flourishing in the 1850s. The lengthy introduction to the photographic album closely adheres to a scientific model while *The Posthumous Book*, published the following year, 1853, is an example of late romanticism. The more informal travel account, *The Nile*, follows the popular journalistic format of letters to a friend at home. Ishmael is thrice reinvented according to the demands of each genre, as is his author, Du Camp, their two metamorphoses reflecting the unstable nature of personal and cultural mirrorings through an encounter with an Other.

Ishmael is figured in approximately one-third of the 122 photographs of Egypt in Du Camp's large, leather-bound photographic album, but his name is not given in the lengthy text that precedes the images, nor is his presence at the various sites ever mentioned. Du Camp's presence *in situ* is also absent from this introduction which consists of quotations from the two most eminent archaeologists of his era: Champollion the Younger and Richard Lepsius, whose books on Egypt were hot off the press, published, in fact, while Du Camp was traveling in Egypt. The quoted passages, all meticulous descriptions of monuments, are usually several pages long, joined to one another by a sentence or two in Du Camp's own words. Du Camp avoids the first person singular "I" in these transitional paragraphs, using instead the more distancing "one" or "we." ("One recognizes that," "we prefer to," etc.) He is careful to qualify most opinions as being those of others, building up the credibility of his introduction on the basis of his detachment – visual, sensorial, and emotive.

The album shows all the signs of an attempt to produce a "safe" book, its introduction intended for a French governmental elite under whose official aegis Du Camp was traveling (although at his own expense).[9] Yet, however hastily put together with an aim to please, the album's sensory detachment is exemplary of a commonplace goal of impartiality for works of its kind.

As in other such works, active verbal constructions are used in describing monuments and objects, giving the effect that inert matter has acted entirely of its own volition without human, or even natural, intervention. For example, the pyramids have not *been* opened, they *are* open, implying that this phenomenon of openness has occurred on its own. Stative verbs and intransitive constructions are also frequently used to the same effect: "The lighthouse, one of the seven wonders of the world, has fallen away, stone by stone."[10]

Not that there is an absence of references to people. By the first two pages Du Camp has already cited such wide-ranging sources as Strabo, Abdallatif, Davidson, Seneca, Pindar, and Champollion. But seldom is there any sign of human activity; rather these travelers and scholars, past and present, bear immobile testimony to the facts that are presented. Even in this passive role their testimony is usually not based on active visual observation but relies instead on the authority of mathematical measurement and on a relay of previous textual evidence.[11]

Much as Du Camp's presents himself as a detached, unfeeling chronicler, he also eradicates or relocates the sensorial and emotive qualities of those whom he has called upon to testify. Adjectives that might express a mental state or temperament are rare. When they occur, as in "the proud cartouche of Dr. Lepsius," they modify an inert material thing, an inscription in stone, and not the living Lepsius who (proudly) produced the inscription.[12]

The picturing of Ishmael as inert matter, a mere bit of architectural detail (figures 3.4 and 3.5), or mimicking postures from different phases of ancient Egyptian and Greek culture (figures 3.2 and 3.6), is in keeping with the tone of the album's introduction. Embedded within the pharaonic monuments, Ishmael's disturbingly ignorant living presence can be overlooked, if not denied, especially as it existed within the temporal and spatial mapping of mid-nineteenth-century anthropology which transformed living peoples of the world into a living museum of time epochs.[13] In fact, Ishmael's presence in Du Camp's photographs has gone unremarked by all viewers until well into the twentieth century. At the same time, Ishmael is clearly a living being, immobilized by the immediacy of nineteenth-century photographic time, not by epochal historical time.

Du Camp's living, emotive presence is also denied through his presence on the other side of the camera, photography being his ultimate trump card in the fabrication of himself as a neutral observer. Discursively constructed to exclude any creative participation on the part of the operator behind the camera, photography seemed the answer to the quest for impartial veracity that is reiterated in every major narrative of discovery published between the mid eighteenth and mid nineteenth century, alongside laments over art's insufficiency and unreliability.[14] True to form, the first lines of the prospectus to Du Camp's album compare the "scrupulous detachment" of photography to the unreliability of other media whereby "the artist's observations can go astray and disturb the truth by substituting his wishes or his technique: substitutions which run the serious danger of altering the texts and leading astray the discussions."[15] Such a comparison between media was reiterated again and again at mid nineteenth century by a broad range of people throughout Europe and the Americas. According to the art critic Francis Wey (one of the reviewers of Du Camp's album), photography was incapable of expressing "fantasy, sentiment, style," or any kind of "originality of spirit."[16] An English physician described photography as a representation made "without the aid of man,"[17] and Edgar Allan Poe wrote that close scrutiny of a photograph disclosed "only a more absolute truth."[18]

Of course, while certain literary and visual practices were constructed as detached and therefore objective in popular nineteenth-century scientific and technological discourse, the two terms can never be equated. As I argue, Du Camp's apparent impartiality is but one other manifestation of the highly subjective nature of his Egyptian enterprise. On a practical level alone, the distance between discourse and

actuality can be indeed great. Du Camp's photographs required considerable "aid" on his part: "If eventually I go to hell it will be as punishment for the anger, irritation, rage, and bother of all sorts brought on by photography . . ."[19] But, even within a discourse that excluded the photographer from the act of representation, the photograph was testimony to the operator's *presence* on the scene. In Du Camp's case, such a mechanical testimony of presence fills the gap created by the absence of the author's "I" from the text. It is the photographs that speak the "I was there" and the "I saw" *for* Du Camp. It is the photographs that provide a link to the author's body in his bodiless text. They guarantee, through a single, indisputable gesture, a presence that language can only presume.

In this context Ishmael's figure in the photographs also testifies to Du Camp's presence. Ishmael is witness to the invisible "I" on the other side of the camera as well as being an elusive stand-in for him. In serving as an additional guarantor of Du Camp's presence, Ishmael's figure has a function similar to that of the other immobile, unfeeling witness upon whom Du Camp relies, including, of course, himself. They are all stationary devices, inert testimonials like the camera itself. By visually and textually abolishing a living present, the album also skirts the issue of a living future, deferring, if not assuaging, a pervasive cultural hypochondria. In this, the photographic flattening of Ishmael within a historical past is a key element.

The part Ishmael plays in *The Posthumous Book* is an entirely different one, one in which he is closely associated with an emotive Du Camp. The novel, Du Camp's first, is written in the form of a journal that has been entrusted to him to be read after the suicide of its protagonist, Jean-Marc. Du Camp positions himself as a detached witness who merely relays Jean-Marc's diary to the public, much as he presents the long quotations from outside texts in the introduction to his album of photographs, the difference being that the protagonist of *The Posthumous Book* is not a man of science but a sentimental hero whose biography corresponds to Du Camp's in almost every detail.[20]

Ishmael is cast in the role of Jean-Marc's servant. As the plot unwinds, Jean-Marc's Circassian slave and concubine, Zaynèb, is discarded by her master. In revenge she kills Jean-Marc's blonde French mistress. As punishment Zaynèb is given to Ishmael, who is consistently described as ugly, one-eyed, and very black. For Zaynèb, who identifies herself with the traits that constitute her worth within the system of exchange by which she is assessed – her (relatively) fair skin – this final exchange is highly demeaning. "I am a white woman and I was not made to belong to a one-eyed negro," she protests.[21] The exchange, while devaluing Zaynèb's "whiteness," will raise Ishmael's prestige in his community. She is a prized gift that he has long coveted, and he composes an impromptu celebratory song: "She will nurse my children . . . the black women will die of jealousy and the true believers upon seeing me will say: Ah! how happy he is! Ohé! ohé!"[22]

The theme of two men united erotically through the exchange of a woman is not an unusual one, then and now, in life as in literature. It acquires a greater complexity, however, when the three are a white Frenchman, a black Nubian man, and a fair-skinned Circassian woman, exemplifying the ever present convergence between the individual world of libidinal desires and the social world of politics and finance.[23] Probably unconsciously on Du Camp's part, his story reflects the increasing instability

at mid-century in Europe of economic and sociocultural positions as they had been defined by color and race. A light-colored person who is identified as belonging to a darker-toned race is an ambivalent figure to begin with. If the construction of "black-ness" as the negation of "whiteness" is a nineteenth-century trope fundamental to the positioning of the French race, the "mixed" ambivalence of Zaynèb's light skin undoes this constructed opposition, calling the stability of "whiteness" into question.[24] Existing in a gray area between the polar opposites of black and white, Zaynèb is an embodiment of the lack of fixity of both. As mistress of Jean-Marc and Ishmael's even-tual bride, she links the two. At the same time, she marks their difference. While Jean-Marc and Ishmael share her body (consecutively), it is Jean-Marc who eventually disgraces and discards it and Ishmael who prizes it.

Jean-Marc has the power to "give away" whiteness in the form of Zaynèb, an act Ishmael can never perform, even within his own country where the darker-skinned Nubians from Upper Egypt were usually slaves in Lower Egypt. In this Jean-Marc rep-resents the stereotypical colonist who bestows the traits of an en-lightened people on those in the dark, as it were. Ishmael, in turn, is the black native who joyously receives the gift of whiteness. However, as Du Camp tells the story, this simple bestowing of traits is complicated. For one, Zaynèb is not *truly* white as is, by contrast, the blonde Suzanne whom she kills. Suzanne, in the purity of her lightness, is not an exchangeable commodity but one doomed to extinction. Moreover, her doom is the indirect outcome of the white man's desire, however temporary, for the native woman, a desire that leads to a series of events that culminate in the suicide of Jean-Marc himself. Secondly, such a gift, which en-lightens Ishmael, only further contaminates Zaynèb's already imperfect whiteness. In addition, the assumption is that she will bear Ishmael children of as yet undertermined shades of light and dark skin, further undermining the polar-ities of black and white.[25]

Much as Ishmael's definition as an inert bit of matter in the album corresponds to that of Du Camp as an impartial conduit of information, so does Ishmael's role in the *The Posthumous Book* as a (literal) carrier of the instability of clear (racial) distinctions correspond to the unstable states of life and death of Du Camp's role as the suicide Jean-Marc. Jean-Marc is alive as he writes the text that we read *after* his death, but then his death is merely textual as he continues to live as Du Camp. As Ishmael is posi-tioned in the photographs as both in the past and in the present, inert matter and living sailor, so is Jean-Marc/Du Camp shifted among past, present, and future existences and extinctions.

Much as the fixed oppositions of life/death, black/white and all they represent are unsettled in *The Posthumous Book*, so is a sense of stable, identifiable space and time. While the photographic album is organized according to a series of geographi-cally consecutive sites, indicating a clear spatial organization, and consequently a temporal one as well, *The Posthumous Book* is constructed of flashbacks within flash-backs, entries that are specifically dated, and others that are headed "no date."

The attributes of photography as a clear marker of space and time also are under-mined, although indirectly. Photography itself is never referred to in *The Posthumous Book* but the figure of Ishmael readily lends itself as a stand-in for the camera. He is consistently and repeatedly described as *un nègre borgne*, a one-eyed negro. Ishmael's one blind eye is not an unusual condition, as Du Camp knew. Eye infections were ram-pant and frequently led to such a permanent condition. "In certain villages it is unusual

to see a man who enjoys the use of both eyes," Du Camp writes.[26] In addition, many men deliberately blinded themselves in one eye in order to avoid military service.

It is not Ishmael's individual condition of one-eyedness that Du Camp addresses but his status as a one-eyed, black object. As such he is a living embodiment of the monocular darkness of the camera obscura, and his one-eyed gaze like the eye of the camera, "the photographic lens that takes aim at everything."[27] Ishmael-as-camera makes Du Camp an object-to-be-photographed, as well as one who photographs. At the same time Ishmael is a "humble servant," a characterization of photography found in so many writings on the subject at mid-century, including those of Du Camp's friends Charles Baudelaire and Théophile Gautier. Ishmael-as-camera exists in the threatening ambivalence of the humble servant who looks back at his master and takes aim, another aspect of his threat to stable polarizations, a threat that other races readily came to signify for the European as distinctions between master/servant, white/black, and primitive/civilized were unsettled.[28]

Du Camp's two personas, the self-involved, suicidal Jean-Marc and the self-effacing, objective producer of information, can be polarized. In the photographic album Du Camp is associated with the public spaces of institutionalized knowledge and detached, panoptic forms of observation, while in *The Posthumous Book* he lives within the spaces of his troubled psyche, prey to debilitating emotions. Nonetheless the two share a fundamental characteristic: an exaggerated passivity. As a man of science, Du Camp admits to no interest other than pure scholarship, positioning himself off to the side of his text, detached if not invisible. As a Romantic protagonist, he is positioned at the center of his narrative rather than on the periphery; nonetheless, his overwhelming passivity makes him a character who does not intervene in the action. Things happen *to* him. Far from being a form of self-effacement – its rampant egotism is admitted – his is nonetheless a *display* of self-effacement. In *The Posthumous Book* Jean-Marc's suicide is the ultimate gesture of such a display.

In this the two Du Camps typify two main ploys in a nineteenth-century construction of a benevolent, non-interventionalist colonial stance. Du Camp's "pure" scholarship in the photographic album, unaffected by personal biases (it is not even his scholarship), and his spineless languor as Jean-Marc in *The Posthumous Book* both function to assure his harmlessness. The two books position him at the scientific and Romantic parameters of a bourgeois colonialism that disguises its power with two apparently irreconcilable façades that nonetheless complement and reinforce each other.

The two books also complement each other in a different way, one which has more to do with a tradition of the voyage as a means of proving one's manhood. The traveler overcomes difficulties and returns home (to his beloved) bearing the sacred object of his quest, tempered by a new understanding of the world and of the self. The photographic album, while it does not narrate such a successful return to the homeland, nonetheless indicates it. Champollion and Lepsius bring back the secrets of an ancient language and culture, and Du Camp returns with an unprecedented number of images registered by the new – and still somewhat magical – means of photography. By contrast, *The Posthumous Book* narrates the traveler's failure and impotence. Jean-Marc returns empty-handed, already a dead man before the fact. His narrative – a work in progress in which the last word has already been written – is without hope, his death already inscribed before his travels begin.[29] It is Ishmael who will have a future, death

being the fate of Jean-Marc and Suzanne in a symbolic displacement of the cultural hypochondriac's worst fears.

Ishmael's roles in the two books are also complementary in relation to photography. As the object registered *by* the camera in the photographic album, he is a part of that which the traveler brings home in triumph, one more token of the successful completion of the journey. On the other hand, as the *nègre borgne* in *The Posthumous Book* – a black, one-eyed *camera incarnata* – he is the one, not Jean-Marc, who returns to his native village with the prized foreign object: the fair-skinned Zaynèb. It is Ishmael whom the villagers will envy and admire. In *The Posthumous Book* Ishmael is not the object to be brought back home, but the mechanism by which that object is attained. As such, he undergoes a transformative slippage into the area of Western technology as a mechanism by which to "capture" the foreign body. His position in the album where he is literally embedded in the monuments from the Egyptian past is compromised.

There is, however, a crucial similarity. Whether Ishmael is sent scrambling among the ruins as an object of aim or whether he is a reference to the mechanism of aim itself, Du Camp always configures him as an object to be manipulated. As camera Ishmael does not act on his own but is triggered by Du Camp for Du Camp's own purposes. As a measure of scale he does not determine his own representation, at least not according to Du Camp's account – which is, unfortunately, the only one we have.

In Du Camp's travel narrative *The Nile* Ishmael is again reconfigured in accord with Du Camp's change of character as he positions himself within a different literary genre. Three major aspects of Ishmael's characterization complement, contrast, and expand upon his presence in the photographic album and in *The Posthumous Book*: one, the way he is named; two, his description as "a very handsome Nubian"; and, three, the character of Joseph Brichetti who, in actuality, took on the job of Du Camp's servant played by Ishmael in *The Posthumous Book*. Each of these three configurations further elaborate Ishmael's role as an indicator of Du Camp's cultural hypochondria.

The Nile was intended for a general public, first appearing in installations in the *Revue de Paris*.[30] Like Du Camp's introduction to his photographic album, *The Nile* has a patchwork quality, although the stitching and patterns differ significantly. Du Camp again relies on an established informational, encyclopaedic model, but abruptly interspersed among scholarly passages and quotations (some of which are lifted directly from the album introduction) are on-the-spot dialogues, tirades on contemporary politics (both Egyptian and French), and romantic descriptions of landscapes.[31]

In keeping with such literary permutations, Du Camp constructs himself as an innocent, somewhat bumbling and uninformed tourist, even going so far as to mock the scholarly, informative aspects of *The Nile* and of the introduction to his photographic album. For example, a long quote from Lepsius that he also cited in the album is preceded by the comment that "this should be left to those who are scholars, or pretend to be."[32] In another passage he imagines the reader being bored with "these long descriptions of architecture,"[33] the very descriptions that, in fact, constitute the entire content of his album introduction. By contrast, he constructs *The Nile* as a spontaneous, off-the-cuff product: "I copy my day by day notes . . . incomplete sentences, fragmented and full of repetitions, to better give . . . the immediacy of my varied impressions."[34]

Du Camp took further advantage of the right to amateurism enjoyed by the travel

narrative in his use of the popular literary device of casual letters to a friend. The disharmony of *The Nile*'s mix of geography lessons, legends, historical accounts, romantic scenes, ethnology, dialogue, and lyric description is highlighted by Du Camp's repeated invocations to the ostensible recipient of his "letters," Théophile Gautier. Interjections, such as "Help, dear Théophile . . . give me a transition to get back to my subject,"[35] serve as constant reminders of the author's presence and contribute to his characterization as an inept amateur.

Ishmael makes only one cameo appearance in *The Nile* but it is a significant one. Du Camp describes photographing him at the temple of Dendera, the clearest and closest image he ever made of him (figure 3.7): "Every time I visited a monument I had my photographic equipment carried along and took with me one of my sailors, Hajj Ishmael."[36] Despite the matter-of-fact casualness of this introductory sentence, one element immediately stands out: Ishmael is given a name. However much Du Camp's descriptions are framed by Western practices of travel literature, in naming Ishmael he departs from the norm. In most accounts – be they scientific, sentimental, or journalistic – the inhabitants of non-Western countries are merely indistinguishable bodies that transport baggage, fetch water, laze about, steal provisions. They are useful, annoying, or threatening appendages to the traveler's own body. Most references to them are preceded by the possessive pronoun specifically connecting them to the traveler: "my servant," "my camel driver," "my local guide." By naming Ishmael in *The Nile* Du Camp modifies his presence as merely an inert measure of scale, signaling an individual who actually existed at a specific time and place.

Moreover, Du Camp always refers to him as *Hajj* Ishmael, indicating that he is a Muslim who has made the holy journey to Mecca, and thus a man of a certain distinction. *Hajj* is also a title that was appropriated by many non-Muslim mid-nineteenth-century travelers. Baron Justin Isidore Taylor took on the pseudonym Laorty-Hadj (Laorty being an anagram of Taylor) for a book on Egypt, published not long after *The Nile*.[37] In keeping with such a fashion Du Camp describes himself as journeying "towards the unknown like a *hajj* in search of an ideal Mecca."[38] *Hajj* was yet another form of masquerade as Other, much like the donning of Oriental costume, at home and abroad. As a form of self-exoticism it was not without its ambivalences. The pilgrimage to the Holy Places – the *rihla* – was a time-honored voyage of faith in Islamic culture, hardly comparable to the voyages of exploration and emerging tourism that characterized Du Camp's trip. Making play of that which is sacred to another culture is a gesture of dis-regard, a looking away, and marks a power over the Other, a power that takes what it will on its own terms. At the same time such wrappings within the clothing and namings of the Other also mark a desire for a bodily incorporation, not merely with the Other, but within him.

Another element that distinguishes the presentation of Ishmael in *The Nile* is Du Camp's offhand remark that he was "a very handsome Nubian." Not only is this a contrast to the ugly negro in *The Posthumous Book* and to the quasi-invisibility of Ishmael's body in the photographic album, it is an observation that is irrelevant to Du Camp's declared purpose in photographing him, which, he goes on to say in the same sentence, was "to obtain a consistently uniform scale of proportions."[39] Moreover, in this and in most of Du Camp's photographs that include him, Ishmael is naked except for a loin cloth, a highly unusual state of undress for staffage figures, and for Nubians and Egyptians, at the time.

Such mild erotization of the indigene is due in part to the changing status of the Oriental travel narrative at mid nineteenth century. Popular in Western literature from the mid seventeenth century onward, the travel account was always a kind of grab-bag that might incorporate philosophic meditations, historical accounts, ethnographical and geological studies, memoirs, interior monologues, picturesque descriptions, discussions of contemporary politics, and more. With the increase of pleasure trips a new relation between the European traveler and the Orient was forming, one reconfigured by the more immediate and sensual interests of the tourist. From 1830 on, as European presence in Egypt became more sizable and varied, the discourse that develops around tourism is constructed around the allure of the Orient, that of its "primitive" exoticism, as well as that of its ancient civilizations. Images of Ishmael stripped down to a loin cloth and a description of him as a very handsome *hajj* fit easily within such a discourse.

Ishmael is named, his physical beauty admired, and he is recognized as a *hajj* by Du Camp who, through his own masquerade as *hajj*, associates himself with Ishmael. Nonetheless, Du Camp maintains a reserved distance from him and from all his experiences in *The Nile*, as in his other writings. As always, there is little trace of an organic human body, including his own. Often the actuality of the Orient is translated into a painting or a carving, as when a young girl is said to resemble the "granite sphinxes crouched immobile and serious in front of the temples,"[40] a description that echoes the Medusa effect of some of the poses Ishmael assumes in Du Camp's photographs. Despite their naming, Du Camp's stock characters are never individualized, even in his letters to friends. His physical detachment from his written account is especially evident when compared to Flaubert's intensely carnal and immediate travel notes and letters where the two are described as coping with such things as slippery bat dung, kittens on a prostitute's bed, or desert sand gritting between their teeth.[41]

Not that Du Camp was impervious to carnal arousal. According to Flaubert, "We had hardly landed [in Alexandria] when the infamous Du Camp got turned on by a black woman who was pumping water at a fountain. He is also turned on by little black boys. By whom is he *not* aroused! Or, rather, by *what*?"[42] Yet even in his unpublished notes Du Camp maintains a prissy distance, as when describing the sailor Hassin's "charming behind which we saw often when he jumped into the water with the other sailors . . . I'm sure that he served as wife to quite a few of the crew."[43] In these same notes he says of Ishmael, "Of all the sailors he was the one I liked best. He was very sweet natured, with an ugly face, one-eyed, superb muscles."[44]

Unlike Flaubert, however, even such relatively tame observations and admissions were banned from any writing Du Camp intended for other readers, be it a letter or a publication. In all cases, in notes intended for himself alone or for others, it is only under the cover of ethnographic discourse that Du Camp fully describes a living person. Ethnographic recording, along with medical documentation, were commonly used to authorize a detailed visual scanning of a body. Thus Du Camp is at liberty to describe a Muslim limb by limb as he performs ritual ablutions before prayer – face, mouth, nostrils, right and left arms, elbows, etc., but not otherwise.[45] An initiation performed upon Du Camp by a young snake charmer is described in detail as a matter of purely ethnographic interest although the eroticism of the passage is evident, and perhaps accounts for the fact that it has been muted in a later version of *The Nile*.[46] Much as Du Camp distances and often conceals the body of Ishmael among the monuments

that are the ostensible primary focus of his photographs, never allowing the viewer a close look at him, so does he distance and conceal the human bodies in his texts, tucked among their surrounding ethnographic details.

At times they also hide within botanical observations. The only outright description of any sexual encounter in *The Nile* is that of date trees artificially fecundated "the minute the long, white and perfumed cluster of the male palm begins to open its petals and release its pollen." Once the pollen has been distributed by hand, the trees "peacefully take pleasure in the sweetness of their love without being forced to wait for the fecundated molecules carried by the wind."[47]

Another significant component to Du Camp's retelling of this photographic shoot at Dendera is his ordering of Ishmael to climb up on a column that bore "a huge face of an idol" (figure 3.7).[48] It is a carving of Hathor, the Egyptian goddess of love and fertility. Ishmael is visually connected to it by his outstretched left arm, but any association of him with regeneration has been qualified by Du Camp's description of the carving in the preceding paragraph, according to which it is "from an inferior period, one already forgetful of the traditions of the grand style."[49] In the introduction to the photographic album, Du Camp goes further, describing this sculpture as an example of "an extreme degeneration,"[50] an opinion he supports by quoting the authoritative Champollion. Together the two texts, along with the photograph, flesh out an association of Ishmael with a diety of love and regeneration whose image is tainted by the degenerate style in which she is represented, a style forgetful of past traditions. Any desire for incorporation within this "very handsome Nubian" is tempered and made ambivalent by a reminder of the symptomatic, ongoing forgetfulness of which he is a part and a carrier thereof.

Chameleon-like, Du Camp's photographic and literary styles conceal such ambivalent fears and desires behind a screen of apparently detached observations and commonplaces. As Amit Chaudhuri has said of the traveler Richard Burton – a man who became a master of disguise – it is as if one kind of language were constantly hiding, or opening out on to, another.[51]

Du Camp's literary characters are also constantly hiding, or opening out on to, one another. In the case of Ishmael, the role of servant that he plays in *The Posthumous Book* is, in the actuality of *The Nile*, a guide from Geneva named Joseph Brichetti. Joseph is described as preceding Du Camp, carrying a lantern to illuminate his way, much as Ishmael is described as serving Jean-Marc.[52] An older man – he is fifty-five – Joseph was first lured to the Orient in his youth by the possibilities of commercial success, but he never made his fortune and never returned home. Unlike the French-born beys and pashas active in Egyptian government, Du Camp describes Joseph as an example of the flip side of a romanticized ideal of self-exoticism. Joseph's is an Orientalism defined by loss and lack. He no longer has the ability to speak a language comprehensible to a European, and is also illiterate. His awkward mixture of French, Italian, and Arabic is ridiculed by Du Camp, much as he and other travelers poke fun at the haphazard Esperanto spoken by indigenous peoples. Upon his arrival in Alexandria, Du Camp describes the natives as "all jabbering an impossible language, evidently borrowed from the ceremonial scenes in the *Bourgeois Gentilhomme*,"[53] and in his notes he writes that Ishmael also "jabbered a kind of gibberish that he had learned from a French businessman."[54]

Although Du Camp respects Joseph as someone who knows Egypt "down to its

smallest village and every palm tree,"[55] Joseph does not occupy the ideological position of colonialist authority that was an integral component of the tourist industry's packaging of the Orient into a commodity for Western consumption. Rather, Joseph's familiarity with Egypt is the result of his *failure* as a colonist. In other words, he has been fatally and terminally contaminated. Joseph's knowledge of the country is not a result of detached epistemological learning and panoptic observation from "above," but from his downward slide into the morass of native life itself. He is a living example of a white European infected with the native's cultural forgetfulness and loss, a contagion that is further accentuated as Ishmael takes on Joseph's role in *The Posthumous Book*. The European would-be profiteer and the ignorant indigene can all too easily become one and the same. Further shades of gray dissipate the polarities between black and white.

The substitution of Ishmael for Joseph in *The Posthumous Book* is yet another instance in which Ishmael serves Du Camp as a lightning rod to draw in a multitude of anxieties and desires having to do with Du Camp's simultaneous fear of *and* longing for the collapse of clear polarities, distinctions, and boundaries – what I have called his cultural hypochondria. Like many Europeans of his generation and, much as a hypochondriac's fears can also be said to be his or her subliminal desires, Du Camp was both attracted to and terrified by the collapse of clear demarcations between black and white, beautiful and ugly, male and female, life and death, primitive and civilized.

In a poem of 1851, Du Camp describes himself as a traveler whose "feet are curved and parched like a Bedouin's," and whose "hair is frizzy like that of a negro."[56] Contrarily, in *The Nile*, he constructs a "masterly" scenario in which he threatens a backward, credulous Ishmael with death. His chosen weapon is a product of Western technology: his camera, configured as a lethal cannon.

> The great difficulty was to get Hajj-Ishmael to stand perfectly motionless while I performed my operations; and I finally succeeded by means of a somewhat baroque trick, which, dear Théophile, will give you an idea of the naive gullibility of these poor Arabs. I told him that the brass tube of the lens jutting from the camera was a cannon, which would vomit a hail of shot if he had the misfortune to move – a story which immobilized him completely, as can be seen from my photographs.[57]

Yet, much as Du Camp may have consciously wished to immobilize Ishmael completely, in posing and framing him in different ways Du Camp has also reanimated him. Like figures in a film strip for a movie, awaiting the inevitable moment when they must begin to move, the immobile figurations that Ishmael assumed for Du Camp's lethal camera begin to stir and interpenetrate, agitating the viewer's mind and eye.

Ishmael's different characterizations in Du Camp's texts – measure of scale, ugly negro, one-eyed camera, and beautiful Nubian – also begin to interpenetrate, further animating the photographs. In turn, Ishmael's photographic and textual presences reflect on to the different characters Du Camp assumes in *Egypt, Nubia, Palestine and Syria*, *The Posthumous Book*, and *The Nile*, as detached scholar, impassioned romantic, and bumbling tourist. While radically different from one another, they too tend to interpenetrate rather than being in isolated opposition to one another. The shifting identities that coexist in the actuality of Du Camp's singular person are typical of the

ambivalent responses of so many European travelers faced with a civilization that appeared to have undergone a fatal rupture in continuity at some point in its history. It was a rupture that irreparably severed an entire culture from the present moment, leaving only inert, mute matter to testify to its absence. In the figure of Ishmael, repeatedly immobilized by the camera, yet very much alive and muscular, Du Camp revisited again and again this feared and desired breach.

Notes

1 *Egypte, Nubie, Palestine et Syrie: dessins photographiques récueillis pendant les années 1849, 1850 et 1851, accompagnés d'un texte éxplicatif* (Paris: Gide & Baudry, 1852). The album was a public success; even at a costly 500 gold francs its edition of approximately two hundred was out of print by 1869. All photographs are salt paper prints from waxed paper negatives. The actual number of the edition is not known. The estimate of two hundred is that of Isabelle Jammes, *Blanquart-Evrard et les origines de l'édition photographique française: catalogue raisonné des albums photographique édités, 1851–1855* (Geneva: Librarie Droz, 1981), 83. Du Camp also put together several albums on his own, some of which are extant.

2 "Je ne sais pas comment Maxime ne se fait pas crever avec la rage photographique qu'il déploie." Letter to his mother of April 15, 1850, Gustave Flaubert, *Lettres d'Orient* (Bordeaux: L'Horizon Chimérique, 1990), 140.

3 Oscar Rodríguez Ortiz, *Imágenes de Humboldt* (Caracas: Monte Avila, 1983), 10, as quoted by Marie Louise Pratt, *Imperial Eyes: Travel Writing and Transculturation* (London and New York: Routledge, 1992), 119. My discussion of the travel narrative is greatly indebted to Pratt's book.

4 *Souvenirs et paysages d'Orient: Smyrne, Ephese, Magnesil, Constantinople, Scio* (Paris: A. Bertrand, 1848).

5 The Société Orientale was founded in 1842; Du Camp was made a member in August, 1849.

6 These notes are in the Bibliothèque de L'Institut de France, Paris, M.S. no. 3720. A transcription has been published, edited by Giovanni Bonaccorso: *Maxime Du Camp: Voyage en Orient (1849–1851)* (Messina: Peloritana, 1972).

7 Julia Ballerini, "The In-visibility of Hadji-Ishmael: Du Camp's 1850 Photographs of Egypt," in *The Body Imaged*, ed. Kathleen Adler and Marcia Pointon (Cambridge and New York: Cambridge University Press, 1993), 147–60. See also Ballerini, "La Maison démolie: Photographs of Egypt by Maxime Du Camp, 1849–50," *Home and Its Dislocations in Nineteenth-century France*, ed. Suzanne Nash (Albany, NY: SUNY Press, 1993), 102–23.

8 *Le Livre posthume: mémoires d'un suicidé* was published in serial form in the *Revue de Paris* beginning December 1, 1852, before appearing as a book (Paris: V. Lecou, 1853). The edition used for this chapter is that annotated by Rodolphe Fouano (Paris: Editions de Septembre, 1991). *Le Nil* also first appeared in serial form in the *Revue de Paris* beginning on October 1, 1853, before appearing a a book (Paris: Imprimerie de Phillety Fils aîné, 1854). The edition used in this chapter is that edited and annotated by Michel Dewachter and Daniel Oster (Paris: Sand/Conti, 1987).

9 Du Camp had obtained a mission from the French Ministry of Public Education.

10 "la phare, une des sept merveilles du monde, s'est égrené pierre à pierre" *Egypte, Nubie, Palestine et Syrie*, 3. In French such constructions are even more self-referential than in their English translation.

11 See Pratt's discussion of John Barrow's travels, *Imperial Eyes*, 76.

12 "le cartouche orgueilleux du docteur Lepsius." *Egypte, Nubie, Palestine et* Syrie, 5.

13 See Johannes Fabian, *Time and the Other: How Anthropology Makes its Object* (New York: Columbia University Press, 1983).

14 See Barbara Maria Stafford, *Voyage into Substance: Art, Science, Nature, and the Illustrated Travel Account, 1760–1840* (Cambridge, MA: MIT Press, 1984), 28, and 245 in particular. On the other hand, Geoffrey Batchen's study of pre-photographic discourse, *Burning with*

Desire: The Conception of Photography (Cambridge, MA: MIT Press, 1997), presents a more complex construction that contradicts the idea of a quest for "truth" in representation. Convincing as Batchen's argument may be – and the prospectus does announce Du Camp's album somewhat contradictorily as "*pittoresque*" and "*savant*" – what is most stressed in this announcement is the pervasive idea of the mechanical neutrality of photographic imagery.

15 "Il [photography] saisit la nature morte avec une passivité scrupuleuse, tandis que l'artiste peut égarer son observation et déranger le vrai en y substituant sa volonté ou ses effects: substitution qui a le danger grave d'altérer les textes et d'égarer les discussions." Copies of the prospectus are together with the copies of *Egypte, Nubie, Palestine et Syrie* in the reserve collections of printed books at the Bibliothèque Nationale and at the Bibliothèque de l'Institut de France.

16 "L'invention, la fantaisie, le sentiment, le style, le rève de la pensée, le travail de l'exécution matérielle, où se glisse l'originalité de l'esprit, sont des qualités hors d'atteinte." "Du Naturalisme dans l'art: de son principe et de ses conséquences," *La Lumière* (March 30 and April 6, 1851, pp. 31 and 34): 34. Wey's review, "Album d'Egypte de M. Maxime Du Camp," also appeared in *La Lumière* (September 14, 1851): 126–7.

17 John P. Simon, M.D., *A Practical Description of the Process Called the Daguerreotype* (London, 1839). As quoted by Helmut and Alison Gernsheim, *L. J. M. Daguerre: The History of the Diorama and the Daguerreotype* (2nd ed., New York: Dover, 1968), 48.

18 Edgar Allan Poe, "The Daguerreotype," January 15, 1840, in *Edgar Allan Poe's Contributions to Alexander's Weekly Messenger*, ed. Clarence S. Brigham (Wooster, MA: Foxcroft Library Editions, 1973), 21.

19 "Si plus tard mon âme est damnée, ce sera en punition des colères, des irritations, des fureurs, des ennuis de toutes sortes qui m'a causes la photographie qui était loin, à cette époque, d'avoir des procédés aussi faciles, aussi commodes et aussi expéditifs que ceux qu'elle possède aujourd'hui." *Le Nil*, 114.

20 The transparency of Du Camp's disguise as Jean-Marc is a conventional literary device. The autobiography of Stendhal (Henri Beyle), titled *The Life of Henri Brulard* and written fifteen years earlier, is a notable precedent.

21 "Je suis une femme blanche et ne suis point faite pour appartenir à un nègre borgne." *Le Livre posthume*, 166.

22 "Les femmes noires en mourront de jalousie, et les vrais croyants diront en me voyant: Ah! Comme il est heureux! Ohé! Ohé!" *Le Livre posthume*, 167.

23 See Kaja Silverman, *Male Subjectivity at the Margins* (New York: Routledge, 1992).

24 See Lisa Lowe, *Critical Terrains: French and British Orientalisms* (Ithaca and London: Cornell University Press, 1994), 80–92, for a discussion of Flaubert's *Salammbô*, where a light-skinned woman is the site for such ambivalence. Lowe, in turn, refers to Christopher Miller, *Blank Darkness: Africanist Discourse in French* (Chicago: University of Chicago Press, 1985).

25 An important recent text is Robert J. C. Young, *Colonial Desire: Hybridity in Theory, Culture and Race* (London and New York: Routledge, 1995).

26 "dans certains villages il est rare de voir un homme jouissant de l'usage de ses deux yeux." *Le Nil*, 91.

27 Malek Alloula, *The Colonial Harem* (Minneapolis: University of Minnesota Press, 1986): 14. Trans. Myrna Godzich and Wlad Godzich. *Le Harem Colonial: Images d'un sous-érotisme* (Geneva and Paris: Editions Slatkine, 1981). Alloula is specifically referring to the gaze of the veiled Algerian woman: "the feminine gaze that filters through the veil is a gaze of a particular kind: concentrated by the tiny orifice for the eye, this womanly gaze is a little like the eye of a camera, like the photographic lens that takes aim at everything", 14.

28 The ambivalence of colonial discourse and the desire that underlies it have been discussed in a series of essays by Homi Bhabha written from the mid-1980s to the present. Several are collected in Homi K. Bhabha, *The Location of Culture* (London and New York: Routledge, 1994).

29 In this regard see Jean-Claude Berchet, "Préface," René Chateaubriand, *Mémoires d'outre tombe*, vol. I (Paris: Boradas, 1989), liv.

30 See note 1.

31 For Orientalists the primary model was the twenty-four-volume *Description de l'Egypte*, a compilation of the work of the full-scale troop of scholars and artists that Napoleon took with him to Egypt. *Description de l'Egypte, ou Recueil des observations et des recherches qui ont été faites en Egypte pendant l'expédition de l'armée française, publiée par les ordres de sa majesté l'empereur Napoléon le Grand* (Paris: Imprimerie Impériale, 1809–28).

32 "il faut laisser cela à ceux qui sont savants, *Ou font semblant*." *Le Nil*, 123.

33 "N'est tu pas las, cher Théophile, de ces longues descriptions architecturales toujours pareilles qui je suis forcé de te faire . . ." *Le Nil*, 163.

34 "Maintenant, cher Théophile, je copie textuellement mes notes au jour de jour . . . phrases incomplètes, morcelées et pleines de répétitions, tu saisiras mieux au vif mes impressions variées." *Le Nil*, 135.

35 "Au secours, cher Théophile! . . . indique-moi une transition pour rentrer dans mon sujet." *Le Nil*, 150.

36 "Toutes les fois que j'allais visiter des monuments, je faisais apporter avec moi mes appareils de photographie et j'emmenais un de mes matelots nommé Hadji-Ishmael." *Le Nil*, 227.

37 R. P. Laorty-Hadji, *Egypte* (Paris, 1856). Taylor's interest in Egypt can be directly related to his production of the well-known *Voyages pittoresques*, a survey of medieval monuments of the ancien régime throughout France, which appeared in twenty volumes from 1820 to 1874.

38 "je m'en suis allé dans l'inconnu comme un hadji à la recherche d'une Mecque idéale." Du Camp, *Souvenirs littéraires* (Paris: Hachette, 1882-83), 479.

39 "C'était un fort beau Nubien; je l'envoyais grimper sur les ruines que je voulais reproduire, et j'obtenais ainsi une échelle de proportion toujours exacte." *Le Nil*, 227.

40 "les sphinx de granit accroupis immobiles et sérieux devant les temples." *Le Nil*, 92.

41 It is Flaubert who notes that their manservant Sassetti is bored, occasionally gets drunk, and may be getting sick because he refuses to wear any head covering. (Letter to his mother, February 3, 1850, *Lettres d'Orient*: 103–4.) He describes a man buggered by a large monkey to entertain an impromptu audience (letter to Louis Bouilhet, December 1, 1849, *Lettres d'Orient*: 57), and two little girls in blue smocks making imitation fart sounds with their hands (travel notes, December 2, 1849, *Voyage en Egypte*, previously unpublished notes edited with an introduction by Pierre-Marc de Biasi (Paris: Bernard Grasset, 1991), 193). It is Flaubert who tells us that he and Du Camp slip on bat dung in the interior of the Great Pyramid (December 9 and 12, 1849, rewritten on June 27, 1851, *Voyage en Egypte*, 211), and that a litter of kittens has to be removed from the bed of one of the prostitutes they frequented (December 1 and 2, 1849, *Voyage en Egypte*, 197). It is Flaubert who provides the mundane details of the effects of the *khamsin* winds as sand grits between their teeth (February 7, 1850, *Voyage en Egypte*, 256).

42 "A peine avions-nous touché terre que déjà l'infâme Du Camp avait des excitations à propos d'une negresse qui pouisait de l'eau à une fontaine. Il est également excité par les négrillons. Par qui n'est-il pas excité? ou pour mieux dire, par quoi?" Flaubert, letter to Louis Bouilhet, December 1, 1849, *Lettres d'Orient*, 55.

43 This notebook, titled "Drogman, Equipages de la cange," is in the Bibliothèque de l'Institut de France (M.S. 37211, I). According to Du Camp, these notes were written at the end of his trip on October 2, 1851. Here as translated by Francis Steegmuller, *Flaubert in Egypt: A Sensibility on Tour* (Boston: Little Brown & Co., 1972), 225.

44 Ibid.

45 *Le Nil*, 93.

46 The version of this event in the 1855 edition of *Le Nil* published by the Librarie Nouvelle (pp. 55–6) is significantly more erotic than that in the Dewachter and Oster edition of *Le Nil* of 1987 (p. 86). I have yet to determine whose editing this is and when it occurred.

47 "Au moment où la longue grappe blanche et ordorante du palmier mâle va entr'ouvrir ses pétals et laisser échapper son pollen, un homme grimpe jusque sur sa tige, tranche la fleur et la divise précieusement en plusieurs fragments qu'il va suspendre ensuite au-dessus des palmiers femelles. Alors ils jouissent en paix des douceurs de leur amour sans être forcés d'attendre les molécules fécondantes apportées par le vent." *Le Nil*, 166.

48 "une grosse figure d'idole." *Le Nil*, 228.

49 "une époque inférieur et déjà oublieuse des traditions du grand style." *Le Nil*, 227.

50 "ces sculptures sont d'une dégénérescence extrême." *Egypte, Nubie, Palestine et Syrie*, 18.

51 Amit Chaudhuri, "In Oriental Guise," *Times Literary Supplement* (July 27, 1988): 10. (Review of Christopher Ondaaji, *Sindh Revisited: A Journey in the Footsteps of Captain Sir Richard Francis Burton, 1842–1849*.)

52 *Le Nil*, 85.

53 "baragouinant tous un langage impossible, évidemment emprunté aux cérémonies du *Bourgeois Gentilhomme*." *Le Nil*, 72.

54 "Drogman, Equipages de la cange," as translated by Steegmuller, *Flaubert in Egypt*, 225.

55 "Egypte qu'il connait maintenant jusque dans son plus petit village et son dernier palmier." *Le Nil*, 114.

56 "J'ai, comme un Bédouin, le pied sec et cambré; / Mes cheveux sont crèpus ainsi que ceux d'un nègre." Du Camp, "Avataras," (1851), *Les Chants modernes* (Paris: Levy Frères, 1855), 229.

57 "La grande difficulté avait été de le faire tenir parfaitement immobile pendant que j'opérais et j'y étais arrivé à l'aide d'une supercherie assez baroque qui te fera comprendre, cher Théophile, la näiveté crédule de ces pauvres Arabes. Ju lui avais dit que le tuyau en cuivre de mon objectif saillant hors de la chambre noire était un canon qui éclaterait en mitrailles s'il avait le malheur de remuer pendant que je le dirigeais de son côté; Hadji-Ishmaël persuadé ne bougeait pas plus qu'un terme; tu as pu t'en convaincre en feuillant mes épreuves." *Le Nil*, 227–8.

4

"A PURE LABOR OF LOVE"

A publishing history of *The People of India*

John Falconer

In the outgoing president's annual address to members of the Asiatic Society of Bengal in 1900, the civil servant and anthropologist H.H. Risley,[1] having dealt with the routine financial and administrative concerns of India's longest-established learned society, presented a conspectus of the current state of research into the history and culture of the subcontinent. Much of this talk was naturally taken up with his own specialty, outlining a broad account of the progress of ethnological research in India's vast and varied landmass, many of whose lesser-known tribes were "in danger of being swept away by our advancing civilization," as the reach of British administration spread outwards to many previously inaccessible parts of the country.[2] European control, whose relentless expansion was most potently symbolized by the railway, "that most powerful of all disintegrating social factors", threatened to obliterate all traces of peoples whose existence until a few years earlier had been barely known, let alone adequately recorded or studied. In discussing the measures which he felt should be adopted "to open up and render accessible to the world the great store of ethnographic facts which India still offers to those who are willing to seek them," he echoed the sentiments of the British Association for the Advancement of Science, which had recently memorialized the Secretary of State for India, suggesting that the forthcoming Indian Census offered a rare opportunity for a concurrent and more detailed collection of ethnological data.

The British Association saw such work as falling under three main headings: systematic descriptions of tribes and castes and their histories, the taking of anthropometric measurements "directed to the determination of types," and "photographs of typical members of particular castes and tribes and if possible of archaic industries." This last, "which might be accomplished by placing photographers at the service of the Census Officers, would be the accomplishment of an Ethnographical Survey of India similar to and certainly no less important than the Archaeological Survey of which the Government of India may so justly be proud." While applauding the aims of the British Association in putting forward this proposal Risley, who had been appointed Census Commissioner in 1899, did not believe that its recommendations could be carried out within the terms of the census, although, in common with most of his contemporaries, he saw the requirements of science and administration as inextricably intertwined, the former supplying the information necessary for the "task of governing a great congeries of races, tribes and castes among whom diversity is the

rule and uniformity the exception." More immediately realizable perhaps was the idea of producing a comprehensive photographic record of India's people, since

> an enormous number of admirable photographs of the various races of India are already in existence, and if we did nothing more than select from among these typical pictures of the characteristic people of each Province, and repro-duce them by one of the cheap modern processes, we should preserve and place on record a mass of very valuable material. The end in view would be to produce a revised and expanded edition of a book famous in its day, Watson and Kaye's *People of India,* the pictures of which have now faded almost out of recognition . . . And it is an object in which I believe we could count on the enthusiastic co-operation of both professional and amateur photographers throughout India.[3]

Indeed, within a decade Risley himself was to publish a work which borrowed the title of its predecessor, but which was doubtless seen by him as entirely superseding it.[4] But if Risley's reference to a work "famous in its day" is dismissive, his own book is entirely so, for here Watson and Kaye's publication is consigned to oblivion, meriting not a single mention. Risley's own far less lavishly illustrated book does not even make use of the "admirable photographs" which he had earlier praised, instead relying on the lithographs (produced from photographs, mainly by Benjamin Simpson) which had been used to illustrate Edward Tuite Dalton's *Descriptive Ethnology of Bengal* (Calcutta, 1875). His reasoning in relying on such a geographically unrepresentative selection of illustrations concentrating largely on the hill tribes of India's northeastern frontiers, rather than the much broader collection available in Watson and Kaye's work, confirms how completely the work, whatever its previous fame, had entirely fallen out of favour with the anthropological community.[5] It is noteworthy, however, that almost all the ideas propounded in Risley's talk echoed the same issues, discus-sions, and working methods which had, after numerous delays and false starts, finally resulted in a monumental project to record and illustrate the ethnological variety of a subcontinent.

Published in eight volumes between 1868 and 1875 under the editorship of Dr John Forbes Watson and John William Kaye, and containing 480 photographic por-traits of Indian races, castes, and tribes alongside descriptive and historical letterpress, *The People of India* is widely acknowledged to be among the most important nine-teenth-century attempts to harness photography to the service of ethnographic documentation. Whether viewed on its own terms as a straightforward contribution to ethnology, as an example of the nineteenth-century fascination with accumulating and classifying exhaustive archives of data and knowledge, or as a prime illustration of the use of an ostensibly scientific project for political ends in the colonial arena, the volumes stand as a landmark in the history of nineteenth-century photography. But for such an important publication, whose resonances interlink the histories of photogra-phy, ethnology, and colonial administration in nineteenth-century India, remarkably little attention has hitherto been paid to the circumstances of its background and troubled gestation. This was apparent from the beginning, for contemporaries greeted its publication with remarkable indifference, but for modern scholars the work is coming to be seen as a fascinating and fertile source for examining some of the ways

in which the Victorian mind attempted – both avowedly and implicitly – to accumulate, organize, and use ethnological information in ways which both justified and reinforced notions of dominance. The history of the publication, insofar as it can now be unearthed, further emphasizes its significance as a product of a specific period both of scientific method and of imperial preoccupations. While its "scientific" content

Figure 4.1 John Forbes Watson (1827–92), Reporter on the Products of India and Director of the India Museum, 1858–79, and editor of *The People of India*. (Reproduced from obituary notice in *The Journal of Indian Art*, vol. 3, 1890.)

is now largely a dead letter (and indeed its editors acknowledged its shortcomings in this area within a few years of publication), the magnitude of the work as a Herculean attempt to encapsulate and categorize a society has become clearer. The background of the books' principal editors also inevitably colored the motivations underlying its production. Dr John Forbes Watson (1827–92), the son of an Aberdeenshire farmer, had served in the Bombay Medical Service from 1850 to 1853, when ill-health forced his return to England. A compulsive collector of facts and data on a variety of Indian subjects, he was the natural choice for the appointment in 1858 as Reporter on the Products of India and Director of the India Museum, a post he retained until the dispersal of the Museum in 1879. From this position he pioneered the idea of trade and commercial museums and for the next three decades devoted himself – through lectures, publications, and exhibitions – to promoting "a picture of India in all its varied aspects – scientific, commercial, artistic and ethnological – to present an epitome of all the information required to enable the savant, the administrator, or the merchant to derive immediate and tangible benefit from the inspection, and to create a focus of Indian research, enquiry and popularization."[6] As this passage makes clear, the thrust of Watson's work was directed towards the tangible benefits which such knowledge could bestow on commercial development and administration, and this emphasis was to be clearly apparent in *The People of India*. His colleague Sir William Kaye (1814–76) had served briefly in the Bengal Army before pursuing a literary career in India until 1845. In 1856 he entered the East India Company's Home Civil Service, succeeding John Stuart Mill as Secretary in the Political and Secret Department two years later and remaining in the post until his retirement in 1874. Both men were thus intimately concerned with the collection and use of information for commercial and administrative aims. And, while ostensibly directed towards providing a comprehensive and scientific account of the subcontinent's racial composition, *The People of India* could never have been expected to escape the shattering impact of the mutiny of 1857–58, whose tensions reverberate throughout the work, nor the assumptions of the justness of British rule, which in part motivated its creators. For the historian of anthropology in particular, a discipline whose nineteenth-century evolution is fundamentally grounded in the antagonisms and contradictions between concepts of superiority, control, and scientific objectivity, *The People of India* offers a wealth of illustrative data which is now being examined in greater detail and which has in recent years been admirably analyzed by Christopher Pinney in particular.[7]

Some of the misunderstandings relating to the production of the work are due in part to the bald account of its background given in the preface. For such an elaborate and ambitious production, the introduction to the first volume offers an unsatisfyingly vague and in some respects positively misleading account of the genesis and progress of the project. Here the editors note the "interest which had been created in Europe by the remarkable development of the Photographic Art," and remark that this interest had in turn communicated itself to India, where it "originated the desire to turn it to account in the illustration of the topography, architecture, and ethnology of that country." Specific credit for the patronage and encouragement of photography is here given to the Governor-General Lord Canning and to Lady Canning, whose interest took concrete form in their wish "to carry home with them, at the end of their sojourn in India, a collection, obtained by private means, of photographic illustrations, which might recall to their memories the peculiarities of Indian life."[8] The upheavals of the

Indian Mutiny of 1857–8 "necessarily retarded for a time all scientific operations," but subsequently also "imparted a new interest to the country which had been the scene of, and to the people who had been the actors in, these remarkable events." Therefore, once imperial authority had been re-established,

> the officers of the Indian Services, who had made themselves acquainted with the principles and practice of photography, encouraged and patronized by the Governor-General, went forth and traversed the land in search of interesting subjects.[9]

The magnitude of this scheme, here described in almost biblical cadences, resulted in an accumulation of material which soon exceeded the dimensions of a private collection, and the Governor-General, feeling that its scientific importance warranted its elevation to official status, placed its administration in the hands of Clive Bayley, Home Secretary to the Government of India: and thus, "some of the more important results appear in the present work."

When it was felt that sufficient illustrative material had been received to give a fair representation of the variety of Indian races, the sanction of the Secretary of State for India was sought for the publication of the photographs, and, this being granted, the practical photographic work was undertaken, supervised by William Griggs of the India Museum in London, under the overall superintendence of Watson. The negatives of the photographs sent back to London remained in India, "but from the plates [i.e. prints] sent home it was easy to produce fresh negatives, the prints of which might be multiplied to any extent." This outline, presenting the creation of the work as a seamless development from a personal enthusiasm growing into an officially sanctioned project which was finally published, fails to place the work within a broader ethnological and photographic context, and also presents a distorting simplification of a much more haphazard process.

While the acquisition of knowledge for its own sake was the explicit motive for the surveys which had been instituted soon after the beginnings of British rule, they also came to form an integral part of an ideology to tabulate, systematize, and ultimately control the culture of a subcontinent, expanding their concerns to envelop not merely the physical and administrative complexities of India, but also the cultural and historical structure of the country. The growth of the whole administrative and conceptual structure of the surveys reflects the concerns of empire itself, from the first topographical surveys which, at the start of the nineteenth century, struggled to delineate the physical contours of a newly acquired dominion, through the revenue surveys, with their clear and pragmatic aim of structuring fiscal administration, to the Archaeological Survey of India, which in the last quarter of the century extended these concepts to more nebulous cultural fields.[10] And the Archaeological Survey, as the introduction to *The People of India* makes clear, had clear connections with concurrent ethnological researches. While seeking to record and conserve India's material heritage, it operated within a framework which incorporated a perceived decline in Indian civilisation from the purity of early Buddhist art to the "decadence" of modern Hindu architecture, with redeeming periods of artistic virility injected only by foreign conquerors. Such assumptions inevitably supplied ready justification for British rule: Thomas Biggs, for example, photographing architecture at Badami for the East India

Company in 1855, found the "indecent" sculptures he encountered there yet "another proof of the early date at which the morals of India assumed such a headlong and downward tendency,"[11] while the architectural historian James Fergusson, an impassioned proselytizer on behalf of photography as a documentary tool, saw the study of architecture as a means of elucidating the histories of races "whom we have undertaken to guide and govern."[12]

The explanatory introduction to *The People of India* naturally omits such deeply embedded preconceptions, but on a more factual level it also glosses over a number of conflicting accounts relating to the transition of a semi-private collection into a published work. While a number of these points remain unresolved, contemporary official records do make possible a clearer picture of how this remarkable work came about. An essential component of this picture is the growth of links between photography and ethnography and the way in which the medium came to be seen – for a period at least – as an indispensable and invaluable tool for ethnographic documentation.

Ethnography and photography in India

The foundations of research into India's history and cultures had been largely laid by men such as the oriental scholar and judge Sir William Jones, who was responsible for the establishment of the Asiatic Society of Bengal in 1784. Ethnological investigations in succeeding years largely followed the historical and literary methods employed by Jones and fellow scholars, the dominant method of research resting on comparative linguistic analysis. But by the 1840s and 1850s, a greater emphasis – fostered by increasing familiarity and interaction with the multiplicity of races inhabiting the subcontinent – was beginning to be placed on physical comparisons between racial and tribal groups, challenging the primacy of comparative linguistic analysis, to the extent that by the mid-1860s it was recognized as a commonplace that "the appearance, which can be so well preserved and conveyed by photographs", was, along with language, social customs, and osteology, one of the four main "divisions of enquiry."[13] This acceptance of illustrative material as an important source of information had become apparent before photography was technically in a position to be of significant use. Soon after its foundation in Paris in 1839, the Société Ethnologique made contact with the Asiatic Society of Bengal, sending a copy for publication of its *Instruction générale adressée aux voyageurs, etc.*, which stressed the importance of visual representations of races (preferably in full face and profile), without which the distinct types of humanity could not be distinguished, and also soliciting "any drawings of Indian races" which might be available.[14] In 1844, a similar but more detailed document, *Queries Respecting the Human Races, to be Addressed to Travellers and Others*, also found a place in the society's journal as a guide and inducement to study "the more savage races of India."[15] Stressing the imminent extinction of many tribes now coming into contact with European expansion, the author Richard King, one of the founders of the Ethnological Society, argued that not only science and humanity, but also Britain's reputation as a leader in such research, demanded that the details of these "threatened races" be recorded while there was yet time. Here also, particular attention was to be paid to producing records, tabular, descriptive and illustrative, of peoples encountered by travelers, and in this context, "the head is so important, that particular attention must be paid to it . . . A profile, and also a front view should be given." As well as the chauvinistic

appeal to Britain's national pride in the accumulation of such data from its overseas possessions, such knowledge would further serve the interests of science, philanthropy, and more practical commercial considerations, since, "when colonisation is contemplated", such information would "point out the mutual advantages which might be obtained by preserving, instead of annihilating, the aboriginal population."

By the mid-1840s French travelers had started to use the daguerreotype to record the features of races encountered on voyages of exploration,[16] and within a few years the shortcomings of the artist were being unfavorably compared to the supposed objectivity of the camera. Thus George Gliddon, bemoaning the lack of accurate illustrative material for the compilation of his "Ethnographic Tableau" pointed out that, while European artists and engravers might be successful in reproducing dress and locality, they habitually and unconsciously tended to "Europeanize" the most important point, the physical features. A solution to this, Gliddon argued, would be the disbursement of government funds to create an anthropological gallery along the lines of the photographs taken by Deveria, Rousseau, and Jacquart, housed in the Musée d'Histoire Naturelle in Paris. Such a collection could be systematically compiled, with instructions issued to explorers, colonial civil servants and other government employees to collect, "at national expense," portraits of racial types, "executed upon an uniform scale."[17] From its earliest days, photography as a tool of descriptive ethnology was linked to an era of colonial expansion and domination.

While photography was quick to travel from Europe to India after the public announcement of the daguerreotype process in Paris in 1839,[18] for several years activity appears to have been sporadic, with commercial studios beginning to be established in significant numbers only in the 1850s. The early years of that decade also saw a remarkable upsurge of amateur activity, largely instigated by civil or military employees of government, who saw in the medium an ideal tool to create a record of archaeological sites, landscapes, and portraits. This enthusiastic adoption of photography was clearly associated with official endorsement of the medium as a cheap and effective way of documenting the wealth of archaeological sites in the country. In 1854 the East India Company directed the Bombay Government's attention "to the use of photography on paper, to expedite and economise the labors of the Cave Committee,"[19] which had until then been employing an artist to produce archaeological paintings of the cave temples of western India, and further offering to supply photographic equipment for such work.[20] The architectural photography of Thomas Biggs in Bombay and Linnaeus Tripe in Madras were among the direct results of this official sanction, and Tripe at least felt that his remit should also include ethnographic photography. Financial retrenchments led to the abolition of both these posts within a few years, but by this time photography had become accepted as the most accurate and economical tool for such investigations, and its benefits were enthusiastically proclaimed by the photographic societies which by 1856 had been established in all three presidencies.[21] By this time the army surgeon John McCosh felt able to recommend photography "as a simple and instructive pursuit,"[22] and ethnographic portraits and studies, at least in their more picturesque manifestations, were considered amongst the most promising subjects for the amateur photographer. In addition to their picturesque and "exotic" qualities, such work could be made to serve useful political and philanthropic purposes. Thus the Reverend Joseph Mullins, in delivering a talk *On the Applications of Photography in India* to members of the Photographic Society of

Bengal in October 1856,[23] encouraged his audience to look beyond the standard hack-neyed subjects, towards a "more complete and systematic" documentation. Among the varied subjects to which photography could be applied, he too emphasized the importance of documenting the races of India, echoing Gliddon's complaint that this was an area where "our English artists are dreadfully at fault."

While the judges of the exhibition held by the Photographic Society of Bengal in 1856 echoed this view in lamenting the lack of portraits of "castes and costumes", several photographers were by now at work to remedy this situation. In Bombay, William Johnson and William Henderson, two founder members of the Bombay society, contributed a number of portraits of Indian races, castes, and occupations to a part-work issued under the aegis of the society entitled *The Indian Amateurs Photographic Album*.[24] This series, which ran for three years from 1856 to 1859, contained three original prints in each issue. A few years later Johnson reissued many of these portraits, with montaged backgrounds of appropriate scenes, in *The Oriental Races and Tribes, Residents and Visitors of Bombay* (2 vols, London, 1863-66), the earliest ethnological work published in India to make direct use of photography. By this time also, the use of photography was becoming more widespread in learned journals and from the mid-1850s papers published by the Asiatic Society of Bengal were from time to time illustrated with lithographs reproduced from photographs, and prints were commonly handed round at meetings.[25]

Collecting the photographs

It is against the background of an increasing use and acceptance of photography as the most efficient and accurate method of building a record of the diversity of Indian life that Lord Canning's decision to place the collecting of such material on an official footing should be viewed. In the introduction to *The People of India*, the editors write that the project was endorsed only after photographers in the services "had traversed the land in search of interesting subjects." This appears to be a reversal of the actual course of events, since such photography on a large scale appears to have begun in earnest only after the idea had become official policy. Lord Canning's enthusiasm was made known in a circular sent out by Sir Edward Clive Bayley, Officiating Foreign Secretary, in June 1861. This memorandum, addressed to all the provincial administrations, enclosed a substantial list "of the more remarkable tribes to be found in India", and requested that "Photographic likenesses" be made "of a few characteristic specimens of such of them as exist within your jurisdiction."[26] The enclosed list was not to be considered comprehensive and officers were encouraged to photograph and collect data on any additional groups encountered, "if others of interest are to be found." As to the photographers themselves, the Governor-General considered that "in most stations persons capable of practicing photography are to be found," and authority was given to pay the "usual charges" for such work. The scientific value of such photographs, the memorandum continues, would be greatly enhanced by additional descriptive information, and contributors were therefore asked to supply "a brief written description of the tribe represented, their origin, physical characteristics and general habits." Officers were warned, however, to approach their subjects with tact and to guard against "arousing any jealousy or suspicion on the part of the tribes to be portrayed." As to the form of such photographs, it was acknowledged that, while

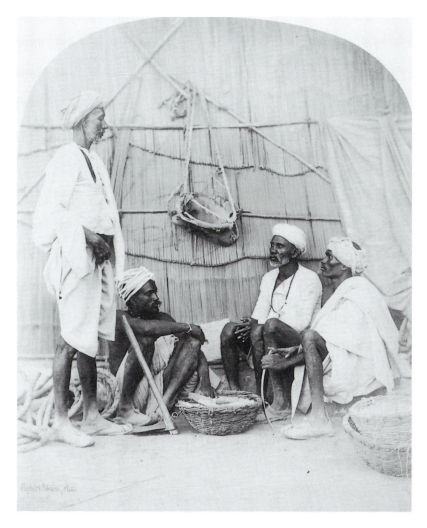

Figure 4.2 Shepherd and Robertson, *Golahs. Low Caste Hindoo tribe. Rajpootana, c. 1862.* Plate 351, vol. 7 of *The People of India.* The accompanying letterpress notes that "The Golahs are a low class caste or tribe of Hindoos, but by no means one of the outcast tribes . . . The Golahs are considered a gentle, honest class, and no habitual crime is attributed to them. As a rule they are very industrious, and are not migratory or unsettled."

the different working conditions and equipment of contributors could not be standardised, "the photographs should be large enough to exhibit the chief physical peculiarities and the distinctive costume of each race." Omitted from this document is any precise statement as to the intended use of the resulting collection, although it seems clear that by its official status it had become something more than merely a personal collection for the Governor-General's benefit. The circular does state however, that the request for this material came from "Her Majesty's Government" rather than the Indian authorities, and it therefore appears that from the start the photographs

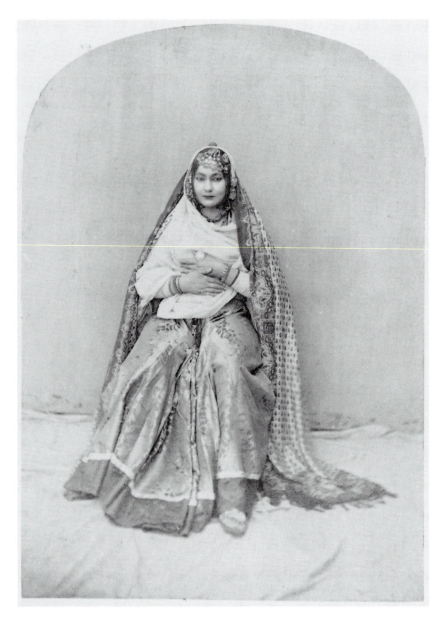

Figure 4.3 Unknown photographer, *Zahore Begum. Mahomedan. Allahabad, c. 1862*. Plate 104, vol. 2 of *The People of India*: "Zahore Begum is a Cashmere Mussulmani, and follows the profession of a courtezan. As may be supposed, her character is not very respectable."

were envisaged as forming a part of the forthcoming International Exhibition, due to be held in London in 1862, with additional sets for distribution to various learned bodies (twenty copies of each photograph were requested). Even if this had not been the original motivation behind the initiative, within a few months such had become generally accepted, as this destination is mentioned in several subsequent reports. But it was a poorly managed project, with insufficient time allowed to gather material from all parts of the subcontinent, and in the event only a small proportion of the photographs sent to London arrived in time to be put on public display.[27]

It is possible, although supportive documentation is wanting, that the idea of using the photographs for exhibition purposes came from A. M. Dowleans, a member of the Calcutta bar who was appointed to act as the Indian Government's agent for the 1862 exhibition, having performed a similar function for the Paris Exhibition of 1855. Although he was confirmed in this post only in early 1862, his interest in the photographs appears to have been aroused soon after the original memorandum was issued. In a letter written in 1862, he writes that after discussions with Lord Canning he had suggested that the value of the photographs would be substantially enhanced if accompanied by more detailed statistical information embracing such matters as the localities in which each tribe lived, their main occupations, whether they were settled or migratory, their religious practices, and their "general disposition and character." It would appear to be as a result of these discussions that a further circular, incorporating these additions and further requesting that "the height of figures in the photographs, and the colors of the dress with the exact tint of their complexion and eyes," was issued in December 1861.[28]

The photographers at work

The request for photographs was answered by a variety of political officers, military men, doctors, and others wishing to put their skills to use in the service of government and scientific inquiry. Some examples of the work undertaken by the photographers who responded to the circular, and whose work was eventually included in the published volumes, provide an insight both into the varied nature of photographic activity in the subcontinent at this period and also some of the difficulties – photographic and administrative – which such a project inevitably entailed.

One of the most obvious problems facing such volunteers was the fact that, in the nature of things, those racial groups about whom least was known – and about whom it was therefore most desirable to gain information – tended to be situated at the peripheries of British influence. Thus Lieutenant-Colonel Ramsay, the British Resident at the Court of Nepal, noted in his response that "there are no amateurs in the art of photography here, and the inducements to professionals to visit Khatmandoo are so very small, that none have ever come up here." In addition, he considered that photographers would find little trade from the inhabitants of the country, since "such persons would meet with no encouragement from the sirdars, who would prefer the rudest highly colored daub by one of the native artists of the valley to the best and most perfect specimen of photography that could be produced." Unless, therefore, the government was willing to go to the expense of commissioning a professional photographer to travel up to Nepal, there seemed little likelihood of obtaining a series of portraits.[29] In the event, the issue was resolved with the arrival of a new Assistant

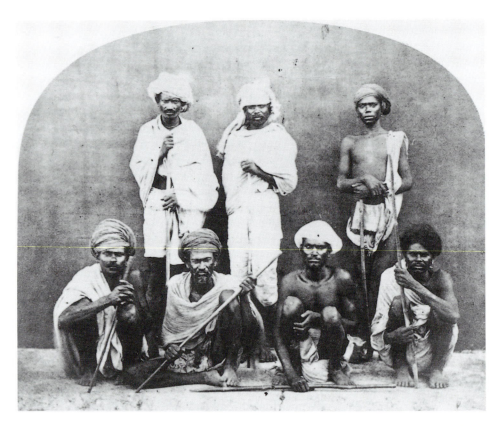

Figure 4.4a James Waterhouse, *Bheels, Satpoora Range. Aboriginal tribe. Saugor, 1862*. Plate 364, vol. 7 of *The People of India*. "The group . . . are of wild Bheels from Nimawur, Khandesh, and other parts of the wildest forest country, who were in prison at Mundhlaiser [Mandleshwar] for an attack upon a police post; and this accounts for their being decently clothed, and having a more civilized appearance than they would in their wild state . . ."

Resident, Clarence Comyn Taylor, a skilled amateur photographer who expressed himself willing to undertake such a commission; despite Ramsay's earlier misgivings, he found that Maharaja Jang Bahadur was taking an active interest in the matter, although even so, "of some of the tribes I do not expect that Captain Taylor will be able to include any of the women; and but few heads of tribes."[30] Maharaja Jang Bahadur's interest was no doubt partly at least motivated by the desire to obtain "portraits, Durbar [court] groups, and views of the principal temples of the valley" for himself and members of his court, and, in the interest of gaining their co-operation, this work was also included in the project.[31] By late September 1864 four sets of twenty subjects were dispatched to Calcutta together with a descriptive text, also contributed by Taylor. These photographs were later to appear as plates 58–77 of volume 2 of *The People of India*, although the accompanying letterpress was taken from the work of an earlier Resident in Nepal, Brian Houghton Hodgson, rather than from Taylor's notes.[32]

Ramsay's initial difficulties in finding a photographer in so relatively isolated a spot

Bheels of the Sathpooras.

No.	Name.	Residence.	Height.	Color.	Age.	Dress.	Remarks.
1	Jo Ram Naik ...	Khandeish ...	5-3	8	42	White puggree, dhotee, and sheet	The Bheels represented in this photograph are inhabitants of different parts of the jungly districts of Nimar, Burwanee, and Khandeish; they were prisoners in Mundlaisir jail, and had been confined there for being concerned in an attack on a post near Burwanee. They are wild Bheels.
2	Sakria ...		5-3	11	38	Ditto	
3	Raymon ...		5-2	9	18	Red puggree, white clothing, very scanty.	
4	Rutna ...		5-6	11	40	Same as No. 3.	
5	Kumaon, Naik ...		5-5	17	50	Ditto	
6	Tantia ...		5-5	5	35	Same as No. 1.	
7	Ram Lo ...		5-6	23 Brownish.	32	No puggree, dhotee and sheet of white calico.	

(Sd.) J. WATERHOUSE, *Lieut.,*

Royal Artillery.

Figure 4.4b Tabular description to accompany photograph of group of *Bheels, Satpoora Range*, from James Waterhouse's narrative.

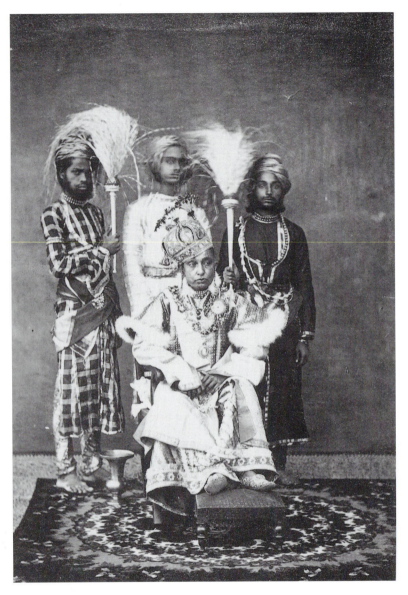

Figure 4.5 James Waterhouse, *Her Highness Nawab Sekunder Begum G.C.S.I. Bhopal, November 1862*. Plate 389, vol. 7 of *The People of India*.

were repeated even in more central locations. At Bharatpur in Rajasthan the political agent was unable to find an amateur to undertake the work, and was finally forced to hire the Agra firm of Shepherd and Robertson, who took a series of ten portraits of typical caste groups and occupations which were subsequently used in volume 7 of *The People of India*, plus an extra study of the Durbar of the young Maharaja of Bharatpur, taken simply because the opportunity presented itself during the photographers' visit.

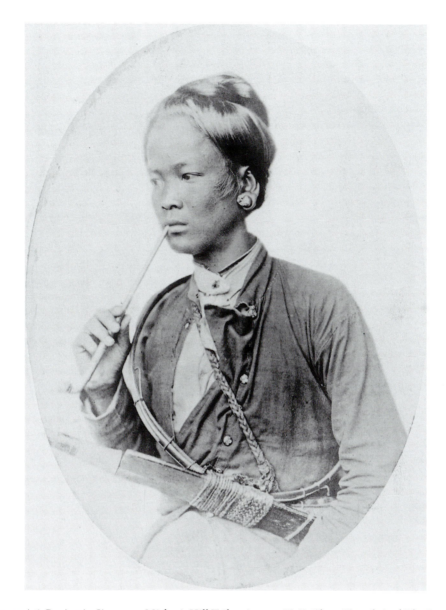

Figure 4.6 Benjamin Simpson, *Mishmi. Hill Tribe. Assam, 1862*. Plate 28, vol. 1 of *The People of India*.

Shepherd and Robertson's work appears to be the only occasion on which commercial photographers were commissioned to supply prints.[33] That cost was the deciding factor in this becomes clear in the case of C. S. Haygarth, Inspector of Mails on the Agra and Bombay Line, who proposed that he undertake the work in the Gwalior District "on the terms customary with professional photographers." The exorbitant charges he suggested were met with a swift response to halt all photography on such "preposterous" terms.[34]

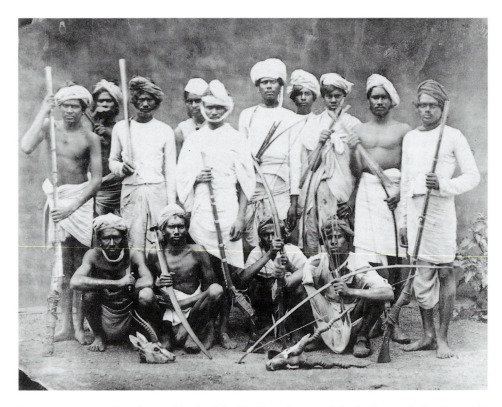

Figure 4.7a James Waterhouse, *Bheels of the Vindhyan Range, Malwah, Central India*. Plate 377, vol. 7 of *The People of India*. "The group of Bheels, or Bhils, is taken from members of the Malwah Bheel corps, and the men have a much more civilized look than in their native condition. They have been drilled, and are soldiers of government, which has improved them."

In addition to this reliance on the amateur and sometimes unsuccessful enthusiasms of photographers who offered to send in photographs from their stations, more positive steps were taken in a number of cases to secure the required portraits. In a few instances this involved the seconding of military officers to photographic duties for a short time, much as Biggs and Tripe had been employed in the preceding decade, although for a more limited period. Lieutenant Willoughby Wallace Hooper of the 7th Madras Light Cavalry, stationed at this period at Kamptee near Nagpur, was one such officer placed at the disposal of the Commissioner to take a series of studies of the "wild tribes" of the Raipur and Bilaspur districts for transmission to London.[35] Joining the Deputy Commissioner at Raipur in December 1861, he "marched with him through the northern portion of the district round to Ruttunpore, photographing, as I went along, specimens of such tribes as I was enabled, through his assistance, to procure. These consisted on Gonds, Chumars, and Cowers." A further tour with the Deputy Commissioner of Bilaspur brought him back to that town at the end of April 1862. The appearance of the photographer, in the company of the representative of British authority, was not unnaturally

BHEELS OF THE VINDHYAS.

No.	Name.	Residence.	Height.	Color.	Age.	Dress.	Remarks.
1	Deetia ...	Jhabooa ...	5 feet 5 inches.	Medium brown.		Red pugree, white dress.	
2	Beeja ...	Barreah ...	5 " 6 "	Vandyke brown.		White pugree, white dress.	
3	Buddeah ...	Jhabooa ...	5 " 6 "	Ditto ...		Ditto.	
4	Jalim ...	Ditto ...	5 " 6 "	Darker ...		Ditto.	
5	Gobriah ...	Mandoo ...	5 " 11 "	Very dark.		Ditto.	
6	Nur Singh ...	Jhabooa ...	5 " .5 "	Medium vandyke.	None of them knew their age. The youngest was about 14, the eldest 30.	Ditto.	
7	Beer Singh ...	Amjheera ...	5 " 7 "	Same as No. 5.		Ditto,	
8	Nimbah ...	Ditto ...	5 " 7 "	Ditto ...		Red pugree,	
9	Dulliah ...	Jhabooa ...	5 " 7 "	Very dark.		Ditto,	
10	Nantia ...	Ditto ...	5 " 8 "	Reddish vandyke.		Ditto,	
11	Wereeja ...	Dohud ...	5 " 5 "	Medium vandyke.		Ditto,	
12	Poonia ...	Barreah ...	5 " 7 "	Same as No. 2.		White pugree,	
13	Nain ...	Jhabooa ...	5 " 5 "	Same as No. 4.		Ditto,	
14	Ram Singh ...	Nalcha ...	5 " 6 "	Very rich dark brown.		

Remarks:

This photograph was taken at Sirdarpoor in June 1862; it was a very good plate, but the film broke while printing it in the rains. I tried to copy it, but failed to get a good copy; I have, therefore, printed some copies from the spoiled negative, and send them in along with a few prints taken before the film broke. If considered worth it, the best print might easily be copied by a Professional. The subjects are all Sepoys in the Malwa Bheel Corps, and therefore look more civilized than they do in their wild state.

(Sd.) J. WATERHOUSE, *Lieut.*, R. A.,

On Special Duty.

Figure 4.7b Tabular description to accompany photograph of group of *Bheels of the Vindhyan Range,* from James Waterhouse's narrative.

Photographic Memoranda.

Name of subject.	Date when photograph was taken.	Time.	State of the weather.	General colour.	Lens used.	Diameter of the diaphragm.	Exposure.	Collodion used.	Developer.	Size of Plate.	Temperature of dark room.
Brinjarahs ...	Sirdarpore, 19th June 1862.	10·45 A. M.	Cloudy, but tolerably bright, high wind blowing.	Dark-brown, red, and white.	Ross's Portrait.	1¼ inch.	17 sec.	Thomas'thick Cadmium mixed with bromo-iodized.	30 grains Proto-sulphate iron, afterwards intensified with Pyrogallic acid and nitrate of silver.	8¼ × 6¼	80° F.
Naiks ...	19th June.	11·15 A. M.	Cloudy.	Dark-brown, blue, red, and white.	Ditto.	Ditto.	18 sec.	Ditto.	Ditto.	Ditto.	Ditto.
Bheels of Jhabooah ...	19th June.	12 noon.	Raining.	Dark.	Ditto.	Ditto.	19 sec.	Ditto.	Ditto.	Ditto.	Ditto.
Bheels of Dhoonghur...	19th June.	1 P. M.	Cloudy, but bright, white clouds.	Dark.	Ditto.	Ditto.	18 sec.	Ditto.	Ditto.	Ditto.	Ditto.
Bheelalahs ...	20th June.	11 A. M.	Cloudy and dull.	Dark.	Ditto.	Ditto.	20 sec.	Ditto.	Ditto.	Ditto.	81° F.
Bheels of Mundlaisir	Mundlaisir, 28th May 1862.	8·20 A. M.	Bright sun and very hot and windy.	Dark-brown and white.	Ditto.	Ditto.	30 sec.	Thomas's Cadmium 3 months old.	Proto-sulp. iron, 20 gra., Glac. Acet acid 3sm.Alcohol 1sm. Water, 1 oz., afterwards intensified with Pyrogallic acid and nitrate of silver.	9 × 7	92° F.
Bheels of the Sathpoorus	28th May 1862.	7·40 A. M.	Bright sun and very high wind.	Dark-brown and dirty white.	Ditto.	Ditto.	30 sec.	Ditto.	Ditto.	Ditto.	Ditto.

(Sd.) J. WATERHOUSE, *Lieut.*
Royal Artillery.

Figure 4.8 Photographic memoranda from James Waterhouse's narrative of his tour of Central India.

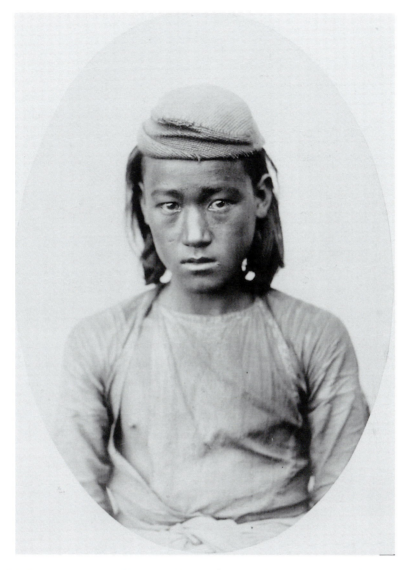

Figure 4.9 Benjamin Simpson, *Newar or Niwar, Slave Population, Supposed Aboriginal, Nipal,*
 1862. Plate 72, volume 2 of *The People of India*.

an uncomfortable experience for some of his potential sitters, and Hooper echoes a
common complaint regarding the difficulties of convincing his subjects that no harm
would come to them:

> The photographs which I took of them, I had the greatest difficulty in procur-
> ing, as never having seen an European before, they were naturally very much
> alarmed, more specially as it was very difficult to make them understand
> what I was doing with them.[36]

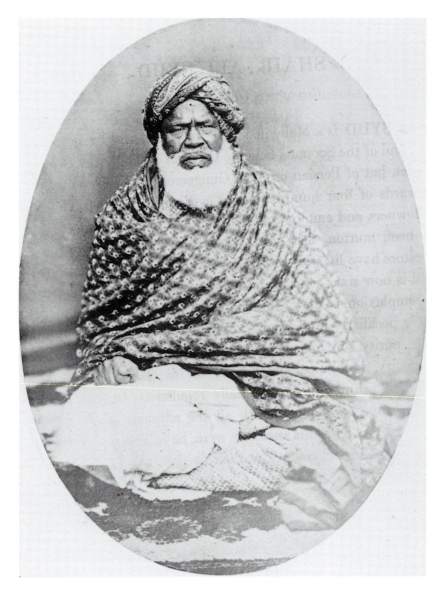

Figure 4.10 Unknown photographer, *Shair Ullee Syud, Shiah Mahomedan: Descendant of Mahomed, Allyghur.* Plate 139, volume 3 of *The People of India.*

The fullest and most informative documentation of government employees seconded to photographic work for the purpose of the London Exhibition was provided by James Waterhouse, one of the most prolific contributors to *The People of India.* Waterhouse holds an important place in the history of photography beyond the confines of the Indian subcontinent, mainly for his work relating to the technical development of various photomechanical processes, particularly in their application to

cartography. Waterhouse arrived in India in 1859 as a young lieutenant in the Royal (Bengal) Engineers and was already a skilled photographer by the time of his secondment to the Foreign Department in November 1861.[37] He was dispatched to Central India and in early 1862 he left Sagar on a circular tour, undertaken in three stages, which was to occupy most of the year. His own account of this commission offers a vivid insight into the frustrations and rewards of early photographers in India, as well as illustrating Waterhouse's own dedication to securing a detailed photographic record in the face of technical problems, extreme weather, and recalcitrant sitters. His narrative supplies a full and fascinating description of his movements and working methods which adds immeasurably to the value of the photographs themselves.[38]

At the time of his official secondment Waterhouse was already engaged in ethnographic photography, presumably in response to the original circular, and was busy printing up negatives of the tribes in the Sagar district. It was not until January 15 1862, when his exhausted chemicals were replenished with fresh supplies from Calcutta, that he set out from Sagar for Sehore, where he arrived on the 24th. One of the main reasons for the tour was to photograph the Begum of Bhopal, a female Muslim ruler in Central India who was soon to be invested with the Star of India in recognition of her loyalty to the government during the Mutiny. Since she was absent from Bhopal in January, Waterhouse was instructed to travel first to Indore and to postpone his visit to Bhopal until the end of the tour. On learning that the Muslim ruler, the Nawab of Jaora, was planning a large entertainment to celebrate the wedding of his son, he decided that such a gathering offered a rare opportunity "of getting some photographs illustrating some of the ceremonies, etc., of Mussulman marriage, and also of getting portraits of the chiefs who had been invited." He arrived at Jaora on February 16, but here met with the first of many delays: the Nawab's son had been struck down with smallpox and the celebrations were naturally canceled, the visiting chiefs immediately dispersing to escape infection. To compensate for this disappointment, the Nawab arranged a week-long entertainment for the 24 British officers attending, but such festivities left Waterhouse little time or opportunity for photographing either the Nawab or his retinue.

His problems did not cease with the resumption of photographic activities, for at the end of the entertainment the weather became uncomfortably hot and it proved impossible to persuade potential sitters to turn up in the cooler hours of the early morning. Despite being ready for work at 6 a.m. each day, his subjects seldom arrived before 9, by which time the temperature in his tent-cum-studio was approaching 100°F and photography was out of the question. Frequently his subjects simply failed to appear at all, and all these frustrations were compounded by the Nawab's own interest in photography, which led to the depletion of his chemicals supplies and the loss of some of his best negatives, which broke under the stresses of being printed for the Nawab in such great heat.

On 14 March Waterhouse left Jaora to visit the Rajas of Ratlam and Sailana. At Ratlam, where he stayed for six days, he was received with "tolerable civility," but again adverse conditions of heat and dust largely defeated his photographic activities, and such was the speed with which his collodion dried that he was able to use only small plates. Both at Ratlam and Sailana his portraits of the rulers were failures, in the latter case owing to the Raja's inability to remain still for the duration of the exposure, leading to repeated attempts which exhausted his supply of collodion without having

achieved any satisfactory image. The situation was a little better at Sitamau, the capital of a small princely state of the same name to the south of Indore, where he arrived on March 30 and was met with "every civility and assistance, which was not the case at most of the places I stayed at, and the consequence was, I had not so much difficulty about getting pictures." Having been furnished with letters from the Raja of Sitamau which arranged for various tribal groups to be assembled at Ganghar, he arrived there on April 11, only to find that his promised subjects had not turned up: "I . . . was informed that there were none in the neighborhood: the fact was they were suspicious and ignorant, and thought their pictures might be used against them, and therefore refused to sit." With his chemicals exhausted, Waterhouse decided to return to Indore to recuperate and repair his equipment, which had been damaged by the "heat and continual knocking about," before setting out on the second leg of a tour which was proving more draining than he had anticipated.

Waterhouse remained at Indore for a month, before setting out on the four-day journey to Mandleshwar on May 20. Here also he was plagued by the heat, the temperature in his dark-tent reaching the nineties even early in the morning, but he at least succeeded in obtaining some successful portraits of the Bhil people of the Vindya Mountains. At Maheshwar a "not altogether good" negative was obtained, after several attempts, of the Maharaja Holkar, but further sittings were prevented by the latter's abrupt and unannounced departure for Indore. With the onset of the rains in late June, Waterhouse himself returned once more to Indore, where he remained until early October, printing up his negatives when the weather allowed and, after recovering from a bout of fever, attempting some photographs of the "agricultural and mercantile classes," whose shyness once more largely negated his efforts. But if on the one hand the aboriginal tribes avoided the photographer through fear, other motives thwarted Waterhouse's attempts to portray the more elevated sections of Indore society:

> The Sirdars [chief officers] of the Court refused to come to me, so I went to the Palace one day, on the understanding that all the Sirdars were to be there and some Mahrattas [descendants of the dominant dynasty of the Deccan in the sixteenth to eighteenth centuries] and agricultural classes, but jealousy and prejudice prevented the higher nobles from sitting with the lower, and they wanted me to go to each of their palaces; I had neither time nor inclination to do this, it being very unpleasant to mix with such independent, impertinent people as the Mahrattas, who are always on the look-out for an opportunity of saying or doing something unpleasant to an European's feelings, and never think of offering any assistance whatever.

The passage admirably exposes the ambivalent relationship between photographer and subject in nineteenth-century India. The European photographer's dominant role as representative of a colonial elite – a reversal of the more common position of the photographer as employee and social inferior – is here further complicated by Waterhouse's presence in an independent princely state, where British authority was limited. His inability to exert authority in the face of such "impertinent" autonomous behavior was clearly frustrating.

The third section of his tour proved to be the most fruitful. Waterhouse arrived at Bhopal on October 30, 1862, in time to attend the celebrations of the Begum's

investment with the Order of the Star of India. His attempts to photograph the cele-
brations themselves were unsuccessful, but, after the guests had departed, the Begum
granted him many sittings at the palace, fully entering into the spirit of the work:

> I used to go up every morning at 6 a.m. and return at 11 or 12, and was
> taking pictures all the time. I was very successful, indeed, and took nearly 40
> negatives without a failure. The Begum dressed herself, her daughter, and
> Madame Doolan [a member of the Bhopal royal household] in all the fashions
> of native costume in order that I might get photographs of the dress of native
> ladies. At Bhopal I was received with more civility than at any other place I
> visited, except, perhaps, Seetamhow. I printed a great many prints during my
> stay at Bhopal, as I was in perfect quiet, alone, and uninterrupted.

Leaving Bhopal on November 22, Waterhouse returned to Sagar via Sanchi (where
he spent ten days photographing the great Buddhist stupa), arriving back at the can-
tonment on December 21, 1862. After attending to military duties for some time, he
was able to devote himself to the printing of the negatives obtained over the course of
the preceding year: his own statistics reveal the scope of the project and the labor
involved, a task exacerbated by difficulties peculiar to India:

> I have had to print at least 30 copies of each negative, and frequently 40 or 50
> owing to the doubtful quality of the paper. The labor entailed by this is enor-
> mous; I calculate that I have printed upwards of 3,000 prints in order to get
> the 1,252 prints sent in.

In addition to the technical problems which accounted for the inferior quality of some
of the prints, Waterhouse was also aware that circumstances had hindered any artis-
tic element in a number of the photographs, the combination of hurry, environment,
and lack of co-operation from many of his sitters militating against sensitive or expres-
sive portraiture:

> I am but too well aware that there is a great want of artistic arrangement in
> my pictures, but, under the circumstances, I found it almost impossible to suc-
> ceed in arranging the subjects in a telling way. I always arranged them
> properly for the first attempt, but the sitters almost always moved more or
> less, and after three or four failures they became tired and forgot their origi-
> nal position; and in the hot weather I hardly had time even to look at the
> sitters, the plates dried so quickly; so I generally told them to make themselves
> perfectly comfortable, and just looked to see that there was nothing wrong in
> the attitude. I had to prepare my plates and perform every operation myself,
> if there had been an assistant to prepare the plates, I should have had plenty
> of time for arranging the groups properly.

Waterhouse expressed a common source of complaint of European photographers
attempting to impose an often alien and little-understood technology on Indian sub-
jects: quite apart from fear and discomfort, many of his sitters could not understand
"*why* they should not move, and cannot help turning their eyes to see what is going on

in the camera." But for all these disclaimers (which contain perhaps more than a hint of false modesty), Waterhouse's tour had created a remarkable body of work which, together with his detailed descriptive notes on the history and ethnological peculiarities of the people encountered, were to form one of the most important contributions to *The People of India*. While perhaps exceptional in both the quality of his work and the dedication with which he pursued it, Waterhouse's narrative is not untypical of the outlook and working methods of the many military photographers who contributed to the publication.

Publishing *The People of India*

The credit for the original idea for *The People of India* was put forward by several figures, and at this distance in time it is not possible to disentangle these competing claims with certainty. While Lord Canning may have supplied the impetus and sanction for the collecting of the photographs which were ultimately used, he cannot, as the introduction to the work states, be given the full honors. In fact the earliest documentary indication that the material might be used in published form comes in A. M. Dowleans' letter of 1862, referred to earlier. Noting that in many cases only one copy, rather than the twenty asked for, had been received of the photographs, and that therefore only one complete set of images could be compiled, he proposed putting this together with the descriptive notes in order to make a publication which, he optimistically considered, would be met with a strong demand:

> From the information I have been able to collect, it is evident, that a considerable number of copies would find ready purchasers at a high price. As all the photographs would have to be lithographed, it would take some time before the whole work could be published, unless it be issued in a monthly series, but under any circumstances, the sale would produce a sufficient sum not only to cover the whole outlay, but also to leave a number of spare copies at the disposal of the Right Honorable the Secretary of State. I therefore respectfully solicit to be informed, whether the compilation I am undertaking, may be intended for publication.[39]

Dowleans's letter is the first documentary record of a proposal for such a publication, but he appears to have returned to India without actively pursuing it, and it is possible that the attendant costs of lithographing such a large collection of photographs caused it to be abandoned. Whether he discussed his ideas with the eventual editors is unknown, but they cannot have been unaware of it, since the catalogue of Indian contributions to the London Exhibition, edited by Watson himself, in noting the receipt of photographs which had not arrived in time for inclusion, refers to plans for their "publication as lithographs, along with copious descriptive notes of the various subjects delineated."[40] However, the only surviving account of the publishing of the work, contained in a collection of memoranda prepared by Watson and Kaye, gives no credit to Dowleans for any part of its creation.[41] According to John Kaye, writing as Secretary of the India Office's Political and Secret Department in a memorandum of July 22, 1863, the inspiration for the work evolved from a set of photographs "illustrative principally of the races of Eastern Bengal," which had recently been

received from India and which the department proposed mounting with a descriptive letterpress. The cost of £45 for this work was approved, but while it was in preparation Kaye learned from Watson of the large collection of photographs sent from India for the 1862 exhibition and now housed in the India Museum. Both men felt that "it would be highly expedient to turn these collections to account and to expand the original project of mounting, etc., etc., the Eastern Bengal collection into a comprehensive work illustrative of the ethnology of India." By using all the sets of the original photographs which had been sent from India, Watson estimated that for £300 he could produce eighteen complete sets of photographs, each containing more than eight hundred subjects. Binding and printing of the "illustrative letterpress" would cost a further £100. Thus, for £400, "18 copies of a great national work, illustrative of the principal tribes of India and adjoining countries may be produced." As he reasonably pointed out, since an estimated £3000 had already been spent on producing the photographs in India, now lying unused in the India Museum, "If the matter rests where it is the £3000 will be all but lost. The additional £400 will turn all the past expenditure to account and an essential service will be rendered to literature and science." In furthering the case, Kaye also volunteered to take upon himself the task of arranging the descriptive matter "during the approaching vacation," and to "supply what is wanting to complete the work, as a pure labor of love." This blithe shouldering of what in the event was to prove a massive and onerous task was to have its own repercussions in the production of the final work.

The decision to compile eighteen copies of the collection had been determined purely by the material available. As previously noted, twenty copies of each photograph had originally been requested from India, the object being that, in addition to the material to be displayed at the 1862 exhibition, there should be sets available for presentation to the Queen, the British Museum, and other learned institutions. In fact this order had for various reasons frequently been ignored, and on going through the collection Watson found that of the eight hundred different photographs only 121 contained the full complement of twenty copies, while for a number of subjects only a single copy existed. However, for 318 of the photographs, eighteen copies existed and he therefore suggested that the remaining photographs be brought up to this number by means of making copy prints for those lacking. Already 9310 prints had been acquired: to bring the collection up to the proposed standard of eighteen complete sets would require a further 5080 copy prints, and to produce these some five hundred copy negatives would have to be made. Watson considered that all this work – photography, the mounting of nearly fifteen thousand photographs, printing of text, and binding – could be achieved for as little as £298, a figure which relied on the copy work being done in-house by William Griggs, at that time the messenger and housekeeper at the India Office, but also, "although self-taught, a skillful photographist." This modest outlay would "furnish a permanent and more extensively available record of a most interesting and effective effort on the part of the Indian Government to extend our knowledge of our fellow subjects in the East – bringing us so to speak face to face with them."

Having looked over the complete set of photographs in the India Museum, the two men revised their original proposal. Either because they felt there was a good deal of duplication in the collection, or because portions of it were of low standard, they came to the conclusion that

the different ethnological varieties represented thereby might be sufficiently illustrated and the different castes, professions, employments, etc., of the people of those countries, together with many portraits of individual interest, might be adequately set forth by the reproduction of one half of the photographs (that is, say 400 sets); and that a hundred copies of these might be furnished, at a cost, for the photographs, of £1,000; and £250 for the letterpress and binding.

The new total expenditure of £1250 was authorised by the Finance Committee but within a few weeks Watson and Kaye were once more submitting an expansion to the project. Referring to a recently received series of sixty-five photographs illustrative of the history and ethnology of Central India,[42] they promised to include the most important of these in the proposed work, but, as it was likely that further such material would be received from time to time, they suggested that the Government of India should in future be asked to supply one hundred copies of each photograph. In this way, further supplements for the one hundred sets could be produced at little additional cost. As the original expense of producing negatives in India had already been incurred, "it would be far better to send us 100 copies which might render good public service, and whilst advancing the interests of science confer honor upon the Indian Government, than by sending us only three, which are of use only for official record, unless reproduced at much heavier expense." This suggestion too was passed by the Finance Committee on October 8, 1863 and it was then decided to print two hundred copies of the work, half for public sale and half being retained for distribution by the Political and Secret Department of the India Office. The suggestion that this section of the print run was retained for internal departmental use by this somewhat sinisterly named section of the India Office is not supported by the evidence: in fact the volumes were intended for distribution to libraries and learned societies in England and abroad, and as presentation copies to distinguished persons with Indian connections or interests. A minute of 1880 reveals that, in addition to Members of Council and other prominent individuals, copies were distributed to libraries as far afield as Berlin, Chicago, Ottawa, New York, and Melbourne.[43]

The publishing firm of Day and Company undertook the printing and binding of the work at their own risk, with Watson and Kaye being responsible for the supply of texts and photographs. It was at this point that complications occurred. In Watson's later opinion, if these arrangements had been adhered to, the publication would have covered its costs, with the copies offered for public sale meeting the original outlay. In their enthusiasm to see the work published, the editors had at some stage offered a personal guarantee to underwrite the India Office's outlay, for with the commercial failure of Day and Company, "John Kaye and I became directly responsible for the costs of the work, a responsibility which we never contemplated taking upon ourselves when we undertook the work." The firm of Allen and Company, who had published many works for the Indian Museum, took over the work, but they were willing only to act as agents, the financial expenses and risk remaining with Watson and Kaye. The second problem related to the text which Kaye had confidently volunteered to supply. In the event the shadowy figure of John R. Melville was hired as a writer for a fee of £150 (rashly paid in advance), but the "fragmentary character" of much of the information supplied from India, allied to Melville's inefficiency and "all but useless"

work, meant that Captain Meadows Taylor had to be employed to complete the letter-press at a further cost of £400. By these means a scholarly text worthy of the patronage of the India Office was produced, "but not only with a much larger outlay than was originally estimated, but also with a delay of several years between the issue of the whole, a number of volumes, of which the work consisted."[44] The final disaster was the loss of a large proportion of the last two volumes in a fire at the binders: "the result has been a most serious pecuniary loss on the whole work." In his analysis of the costs involved (written in an attempt, probably unsuccessful, to persuade the India Office to shoulder some of the financial burden), Watson estimated that he personally had lost not far short of £1400 on an altruistically undertaken venture. A letter from the publishers indicated that the sluggish sales of the work would only just allow them to recoup their own costs, without any surplus to cover his own expenditure. While he did not expect the India Office to underwrite "what became (much against our will) a private venture," he suggested that it could be argued that the one hundred official copies had ultimately been produced to much higher standards in terms of text, binding, and paper than could have been provided under the original grant. He therefore suggested that the India Office might pay for its allocation of one hundred copies at the retail public price of 2 guineas a copy or 16 guineas the set. The India Office acceded to this suggestion in 1880.[45]

The published work

The year 1875 saw the publication of the final volume of *The People of India* and the conclusion of a project whose beginnings in the photographic enthusiasms of the Cannings stretched back almost two decades. Perhaps because of this protracted gestation and the irregular appearance of the volumes over a space of eight years, the work had a disappointing reception and appears to have attracted little notice, either from the general public or from those with specific interests in Indian ethnology. Part of the apparent lack of impact of the work may have been due to the over-sanguine expectations of the editors about public interest in the subject as well as to inefficiently organized distribution of the complimentary copies. Public interest in India may have been high in the years immediately after the Mutiny, when the publication was first being discussed, but by the time the final volume appeared in the mid-1870s, popular interest in an arcane topic had no doubt largely dissipated and the market for a work retailing at £2 2s 0d a volume could hardly have been expected to be substantial. A minute of 1880 further reveals the disorganized nature of the distribution of the complimentary copies of the work as successive volumes appeared. This memorandum, clearly an attempt to tie up loose ends in the wake of Watson's retirement and the dissolution of the India Museum in 1879, suggests that once the early volumes had been published enthusiasm waned. Of the hundred sets earmarked for official distribution, more than ninety copies of volumes 1 to 4 were sent out, but thereafter the numbers dropped, and five years after the publication of the final volume, only nineteen copies had been delivered to those entitled to sets.[46]

The apparent lack of interest in the published work was certainly not due to ignorance in the scientific community of the great collection of photographs amassed by the India Office, or lack of interest in the subject itself. In March 1869, for example, the Ethnological Society of London devoted its meeting to the ethnology and anthropology of India, to which photographs from the India Museum were sent by Watson, and in his

opening address the President, T. H. Huxley, referred to the "wonderful collection . . . disposed around this theater in a manner which makes them accessible to everyone."[47] No reference, however, was made to the publication of the first volumes of these photographs in the previous year and no review appeared in the society's journal.

This may have been partly due to shortcomings of which the editors were only too aware. Dowleans himself had earlier drawn attention to the defects of many of the photographs, deeming them "of a very low standard if judged as works of art, though quite good enough for the particular purpose for which intended," and in their introduction Watson and Kaye frankly admitted the overall lack of system in the photographs, which were "produced without any definite plan, according to local and personal circumstances, by different officers." The descriptive notes, too, "varied greatly in amplitude and length" and the work as a whole could "make no claim to scientific research or philosophic investigation." These shortcomings were repeated by Watson in his report on the requirements for an Indian Museum and Library in London, in which, stressing the need for "a knowledge of the character, customs, and manners, and the religious and philosophical aspirations of the various races inhabiting India" as a means of asserting "a moral hold upon them," he argued the need for "a conscientious study of the people." For such a purpose photography was an indispensable tool when used in conjunction with original artifacts, collections of crania, tabular statements in census returns and other data, and while such collections were "ample, and yearly increasing," their organisation and use had hitherto been haphazard, not excluding his own work, which lacked the "scientific character, such as would attend a similar collection if an Ethnological Survey were carried out."[48]

"The want of systematic action and use of method" is perhaps most clearly seen in the final contents of the volumes, where the geographical spread of the photographs appears determined by no criteria beyond the use of available material allied to the political preoccupations of an administration shaken by a rebellion two decades previously, which had exposed frightening depths of ignorance regarding the lives and aspirations of its subjects. This inevitably led to a preponderance of photographs from northern India, while the south, which had remained largely unscathed by the events of 1857–58, was relegated to the final volume. And even within the several volumes, coverage given to particular areas was selected on uneven principles. Thus volume 7 contains over forty portraits (nos 354–96) from Central India by James Waterhouse, with the Begum of Bhopal, her family and court, represented by no fewer than eight studies. This is due in part no doubt to the quality and volume of the work sent in by Waterhouse, but, as the text makes clear, she takes her place in the volume not as an ethnographic study but in recognition of her qualities as a ruler "truly faithful to the English cause in the Mutiny of 1857–58" and therefore as a worthy recipient of the Order of the Star of India, "the only lady who holds it except Her Majesty the Queen." She stands as an exemplar of the enlightened ruler: loyal and prudent, but not lacking in the martial pride of a warrior race:

> The Begum had indeed been a remarkable woman all her life [she had died in 1868]; she rode well, and used the spear and matchlock, she went abroad freely among her subjects, and denied herself to none. She had paid off all the debts of the state, and . . . she had made Bhopal one of the most flourishing states of India.

As for her daughter Shah Jehan, the reigning Begum, in addition to her many accomplishments and her pleasure in European society, "She is having her daughter educated like an English lady. Thus in every way the condition of Bhopal appears to merit the high encomiums recorded of it."

In contrast to such positive models, a number of the portraits are included as examples of potentially hostile or disruptive types, or those whose physical features represent wholly subjective concepts of racial hierarchy, which in turn serve to justify the civilizing mission of British government. Thus, Shair Ali Syud (volume 3, no. 139) confronts the camera with features "peculiarly Mahomedan, of the Central Asian type,"

> and while they vouch for the purity of his descent, exemplify, in a strong manner, the obstinacy, sensuality, ignorance, and bigotry of his class. It is hardly possible, perhaps, to conceive features so essentially repulsive. On the classes to which Shair Ali belongs, time and change, with all the adjuncts of modern civilization, make little progress.

This need to identify such attributes as political reliability or the ingrained proclivities of the so-called "criminal tribes"[49] served further to distort the focus of a work whose terms of reference had never from the start been clearly defined, particularly in its failure to clarify distinctions between races, tribes, castes, and occupations. This "popular and picturesque" approach, embedded so firmly within the political circumstances of its making, was unfortunate at a time when a more rigorously comparative method of ethnographic photography was just being developed, using checked grids and scales to provide the means by which "the anatomical structure of a good academy figure or model of six feet can be compared with a Malay of four feet eight inches in height."[50]

Whatever its shortcomings as the scientific and visual analysis of a subcontinent, however, the work remains a landmark of nineteenth-century Indian photography and its interface with ethnology and issues of colonial control. While many of the subtexts implicit in the work were invisible or unexceptionable to the European administrator, it is perhaps appropriate to close on a rare contemporary response to the work from a viewer native to the subcontinent, for whom the categorizing construction of museums of knowledge and culture was not inherent, but who, while he saw such a scheme from a different and more personal perspective, also allied himself to progressive notions of British rule. Sir Sayyid Ahmed Khan, a judge in the North-West Provinces visiting England in 1869, was shown at the India Office the recently published early volumes of *The People of India*, described by him as "a book in which the races of all India are depicted both in pictures and letterpress, giving the manners and customs of each race. . . Their photographs show that the pictures of the different manners and customs were taken on the spot, and the sight of them shows how savage they are – the equals of animals."[51] Reflecting that young English recruits to the Indian Civil Service would use the work preparatory to going to India, he was shocked by the impression they would thereby gain of the state of Indian civilisation. On one occasion, while visiting the India Office,

> Mahmud [his younger son] commenced looking at the work. A young Englishman, probably a passed civilian, came up, and after a short time asked

Mahmud if he was a Hindustani? Mahmud replied in the affirmative, but blushed as he did so, and hastened to explain that he was not one of the aborigines, but that his ancestors were formerly of another country. Reflect, therefore, that until Hindustanis remove this blot they shall never be held in honor by any civilized race.[52]

This intriguing passage appears to have been misinterpreted by commentators, who have read Sayyid Ahmed Khan's revulsion as disgust "at finding himself the object of such objectifying primitive discourse."[53] But as the foregoing pages of his narrative make clear, Sayyid Ahmed Khan is almost embarrassingly fulsome in his praise of English culture and, in particular, education, holding it up as a model to which India must aspire. For him, the photographs represented a damning truth: the "blot," far from being the insulting photographs in *The People of India*, was the lack of educational and social progress which, he felt, justly relegated his country to an inferior status and shamed his son into disowning it.

Notes

References to records of the East India Company and Indian Government, in the Oriental and India Office Collections of the British Library, London, are cited with the prefix IOR.

1 Sir Herbert Hope Risley (1851–1911) entered the Bengal Civil Service in 1873. In 1885 he was employed in gathering statistics on the castes and occupations of the people of Bengal and was Census Commissioner from 1899 to 1902. He was appointed Director of Ethnography for India in 1901 and served as Home Secretary to the Government of India from 1902 to 1909. Among his various anthropological publications was *The Tribes and Castes of Bengal*, 2 vols (Calcutta: Bengal Secretariat Press, 1891).
2 *Proceedings of the Asiatic Society of Bengal*, February 1900: 35.
3 *Ibid*: 50.
4 H. H. Risley, *The People of India* (Calcutta: Thacker Spink & Co., and London: W. Thacker & Co, 1908).
5 Risley's own working methods were founded securely on a belief in the primacy of physical measurement as the only truly scientific method of analyzing racial differences and similarities, and he no doubt considered the photographs published by Watson and Kaye to be of little use in this respect. However, the reasons he gives for using the lithographs from Dalton's volume, "to preserve from oblivion these fine pictures" – could equally apply to Watson and Kaye's publication. Risley refers to the photographs in the earlier work as being "faded out of all recognition" and this too may have influenced him, although surviving copies hardly justify this criticism.
6 *The Journal of Indian Art*, 3 (1890), n. p. For a history of the establishment, development, and demise of the museum, see Ray Desmond, *The India Museum 1801–1879* (London: HMSO, 1982).
7 See Christopher Pinney, "Colonial Anthropology in the "Laboratory of Mankind'," in C. A. Bayly (ed.), *The Raj: India and the British 1600–1947* (London: National Portrait Gallery Publications, 1990), 252–63, and Christopher Pinney, *Camera Indica* (London: Reaktion Books and Chicago: University of Chicago Press: 1997), chaps 1–2.
8 Of the couple, Lady Canning appears to have had the most active interest in photography, "being herself a distinguished photographer, and admirer and connoisseur in photography" *(Journal of the Photographic Society of Bombay*, February–June 1856: 32). Part of the Cannings' private collection of Indian photographs no doubt consisted of the portfolio of Indian views presented by the Bombay Photographic Society when Lady Canning opened their 1856 exhibition. She was also the patroness of the Photographic Society of Bengal on its founding in 1856, and contributed a number of prints from her own collection to its first

exhibition. An album similar to that presented by the Bombay Society, in the course of compilation at the time of her death in 1861, remained in the Bengal society's hands and its ultimate fate is unknown (*Journal of the Bengal Photographic Society*, 1, 2, September 1, 1862: 44–5).

9 J. Forbes Watson and John William Kaye, *The People of India*, vol. 1 (London: W. H. Allen and Co. for the India Museum, 1868), preface.

10 The methods by which the British attempted to order and classify the subcontinent are described in Thomas R. Metcalf, *Ideologies of the Raj* (Cambridge and New York: Cambridge University Press, 1994). See, in particular, chap. 4, "The Ordering of Difference." For Victorian accounts of the various surveys of India see Clements R. Markham, *A Memoir on the Indian Surveys* (London: Sold by W. H. Allen and Co., 1871) and Charles E. D. Black, *A Memoir on the Indian Surveys 1875–1890* (London: E. A. Arnold, 1891). The imperial context of their evolution is illuminatingly discussed in Bernard S. Cohn, *Colonialism and its Forms of Knowledge* (Princeton, NJ: Princeton University Press, 1996), chap. 4, "The Transformation of Objects and Artifacts, Antiquities, and Art in Nineteenth-century India."

11 India Office Records, Board's Collections, IOR/F/4/2665/177: 202.

12 James Fergusson, *Illustrations of Various Styles of Indian Architecture* (London, 1869), 10.

13 *Proceedings of the Asiatic Society of Bengal*, August 1865: 148.

14 Ibid., 1841: 175–82.

15 *Journal of the Asiatic Society of Bengal*, n.s. 13, 2, 1844: 919–32.

16 See, for instance, the fifty-five lithographs from daguerreotypes of Africans taken by Chief Yeoman of Signals Vernet during the voyage of the *Ducouedic* in 1846–8, in M. Guillain, *Documents sur l'histoire, la géographie et la commerce de l'Afrique Orientale* (3 vols and vol. of plates, Paris, n.d. 1856). Plaster casts of various racial types had been taken during Dumont d'Urville's voyage of 1837–40, but the distortion of features and lack of expression later led Emile Blanchard to recommend the taking of daguerreotypes to accompany each specimen (Jules-Sébastien-César Dumont d'Urville, *Voyage au Pole Sud et dans l'Oceanie sur les Corvettes l'Astrolabe et la Zélée . . . Pendant les Années 1837 . . . 1840*, 23 vols (Paris: Gide, 1842–55), vol. 23, *Anthropologie*, text by Blanchard, preface).

17 L. F. A. Maury, F. Pulszky and J. F. Meigs, *Indigenous Races of the Earth* (Philadelphia and London: J. B. Lippincott & Co.; Trübner & Co., 1857), 609.

18 Detailed descriptions of the daguerreotype process were appearing in the Bombay newspapers by December 1839, and Dr (later Sir) William Brooke O'Shaughnessy, Professor of Chemistry at the Calcutta Medical College was experimenting with photogenic drawings in October 1839 (*The Asiatic Journal*, n.s. 31, January–April 1840: ii, 14–15). By March 1840 he was taking successful daguerreotypes.

19 Bombay Public Despatches, December 29, 1854, no. 59, IOR/E/4/1101 ff. 1449–51.

20 Bombay Public Despatches, December 29, 1854, no. 59, IOR/E/4/1101 ff. 1449–51.

21 In Bombay in 1854, Bengal in 1855, and Madras in 1856.

22 John McCosh, *Advice to Officers in India* (London: W. H. Allen & Co., 1856), 7.

23 *Journal of the Photographic Society of Bengal*, 1, 2, January 1, 1857: 33–8.

24 The work continued in publication for thirty-six issues from 1856 to 1859.

25 See, for instance, B. H. Hodgson, "Aborigines of the Nilgiris" (*Journal of the Asiatic Society of Bengal* 25, 6, 1856: 498–522), with one lithographed plate from a photograph, and the portrait of two Andaman boys accompanying J. C. Haughton's "Papers Relating to the Aborigines of the Andaman Islands" (*Journal of the Asiatic Society of Bengal* 30, 1861: 251–63).

26 E. C. Bayley to the Secretary to the Government of Bengal, dated June 17, 1861. Bengal Proceedings, 1861, no. 3311, IOR/P/15/21.

27 The work of Dr (later Sir) Benjamin Simpson dominated the display of photographs at the exhibition, with some eighty prints on show. Simpson, who was granted leave to make two trips to Assam to photograph tribal groups, was also involved in the printing of other photographers' work for transmission to London. The photographers whose work was received too late for inclusion are listed as Rev. E. Godfrey and Lieutenant Waterhouse (central India), Shepherd and Robertson (Bharatpur), some of Benjamin Simpson's work (Nagpur, Sikkim, and Bhutan), Dr Tressider (North–West Provinces), Captain Fitzmaurice and

Lieutenant R. H. De Montmorency (Oudh), T. T. Davies (Hazara), Captain Houghton and Lieutenant Tanner (Bombay and Sind), plus anonymous material from various sources (J. Forbes Watson, *The International Exhibition of 1862: a classified descriptive catalogue of the Indian Department* (London, 1862): 200). These photographers were the main contributors to *The People of India*. The other credited photographers in the (incomplete) list given in the first volume were: J. C. A. Dannenberg, W. W. Hooper, Captain H. C. McDonald, J. Mulheran, Capt. Oakes, Rev. G. Richter, Dr. B. W. Switzer and C. C. Taylor.

28 Circular of 16 December 1861, IOR/P/15/21. To overcome photography's inability to record colour, a number of photographers who contributed to *The People of India* also contributed written descriptions of dress and in some cases watercolor patches approximating to the skin tone of their subjects.

29 G. Ramsay to E. C. Bayley, dated July 3, 1861, Government of India, Foreign Department, General Proceedings, September 1861, IOR/P/204/51.

30 G. Ramsay to J. T. Wheeler, Assistant Secretary to the Government of India, Foreign Department, dated September 10, 1863, Government of India Foreign Department, General Proceedings, September 1863, no. 40, IOR/P/205/16.

31 For a detailed account of Taylor's photographic career in India see J. P. Losty, "Clarence Comyn Taylor (1830–79), the First Photographer in Udaipur and Nepal," *History of Photography* 16, 4 (1992): 318–35.

32 Losty, "Clarence Comyn Taylor": 323.

33 A number of their photographs of trades, occupations, and castes, taken at Delhi, were also purchased and used in the final work.

34 Colonel C. H. Durand to Governor-General's Agent for Central India, dated January 17, 1862, Government of India Foreign Department, General Proceedings, January 1862, no. 53, IOR/P/205/10.

35 Government of India Foreign Department, General Proceedings, September 1861, nos 415–16, IOR/P/204/53.

36 Hooper to Assistant Secretary to the Chief Commissioner, Central Provinces, dated November 3, 1862, Government of India Foreign Department, General Proceedings, January 1863, no. 24, IOR/P/205/13.

37 It is probable that he was taught photography during his time as a cadet at Addiscombe Military Seminary, where the drawing master Aaron Penfold had held classes in the subject since 1856.

38 Waterhouse to Governor-General's Agent, Central India, dated Saugor (Sagar) April 9, 1863, Government of India Foreign Department, General Proceedings, July 1863, no. 22, IOR/P/205/14. All subsequent references to Waterhouse's narrative come from this source, unless otherwise cited.

39 Dowleans to H. Merivale, dated June 30, 1862, Public and Judicial Department Letters, IOR/L/P&J/2/158.

40 Watson, *The International Exhibition of 1862*, 200.

41 This account, in form of a narrative written by Watson in 1879 and addressed to Sir Louis Mallet, Permanent Under-Secretary of State for India 1874–83, accompanied by various memoranda relating to the progress of the work, is preserved in the records of the Statistics and Commerce Branch of the India Office, IOR/L/E/6/37 item 39. Subsequent quotations, unless otherwise cited, also come from this source.

42 These must be the photographs taken by Waterhouse in the course of his 1862 commission. In his report on his work, Waterhouse notes that "my labours are now completed, making a total of 65 negatives, of which 1,252 prints have been sent in." Waterhouse to Governor-General's Agent, Central India, dated April 9, 1863, Government of India Foreign Department, General Proceedings, July 1863, no. 22, IOR/P/205/14.

43 India Office Commerce and Statistics Department, IOR/L/E/6/43, item 610; IOR/L/E/6/48, item 1188 of 1880. The memorandum also makes clear that as well as the two hundred official copies printed, the editors had also been authorized to have prepared a number of copies on their private account. This additional printing substantially enlarges the final print-run of the work. At least 127 extra copies of volume 1 were made, and a similar number of volumes 2–4. Thereafter the number drops to around a hundred extra copies of volumes 5–8.

44 Vols 1–3 were published in 1868, vol. 4 in 1869, vols 5–6 in 1872, vol. 7 in 1874 and vol. 8 in 1875.

45 Statistics and Commerce Department Papers 1880, IOR/L/E/6/43, item 610.

46 Statistics and Commerce Department Papers 1880, IOR/L/E/6/43, item 610.

47 *The Journal of the Ethnological Society of London*, n.s. 1, session 1868–9, 90.

48 J. Forbes Watson, *On the Measures Required for the Efficient Working of the India Museum and Library, with suggestions for the foundation, in connection with them, of an Indian Institute for enquiry, lecture and teaching* (London: Printed by G. E. Eyre and W. Spottiswoode, for HM Stationery Office, 1874), 41.

49 Their status as inherently lawless had been formalized in the Criminal Tribes Act of 1871. See Pinney, "Colonial Anthropology in the "Laboratory of Mankind"", in C. A. Bayley (ed.), *The Raj, India and the British 1600–1947* (London: National Portrait Gallery, 1990) 252–63.

50 *The Journal of the Ethnological Society of London*, n.s. vol. 1, session 1868–9: 84–5. The system was apparently devised by J. Lamprey in 1868, and by the following year Professor Huxley was planning to use a similar method, "to take photographs of specimens of all races of men in all parts of the globe" for the Colonial Office, "as many tribes of savages are dying out before the progress of civilisation" (*The British Journal of Photography*, October 22, 1869: 513). However, for a variety of reasons, relating both to the practical photographic problems of ensuring uniformity and to the difficulty of extracting valid information from the results, the scheme was never fully instituted. See Frank Spencer, "Some Notes on the Attempt to Apply Photography to Anthropometry during the Second Half of the Nineteenth Century," in Elizabeth Edwards (ed.), *Anthropology and Photography 1860–1920* (New Haven and London: Yale University Press, 1992), 99–107.

51 G. F. I. Graham, *The Life and Works of Syed Ahmed Khan* (Edinburgh and London, 1885), 188.

52 Ibid., 189.

53 Pinney, *Camera Indica*, 45.

UNMASKING THE COLONIAL PICTURESQUE

Samuel Bourne's photographs of Barrackpore Park

Gary D. Sampson

Victorian photographs related to travel or residence in colonized regions of the world offer a provocative window into the Western encounter with peoples and places under occupation.[1] Whether produced in the remote wilderness or in areas of concentrated settlement, colonialist photographs found in extant albums, collections, and illustrated books tend to favor elements that are culturally and geographically amenable to the intellectual concerns and aesthetic sensibilities of the photographers and their projected viewing audience. In the case of locations singled out as having scenic charm in a generically "English" sort of way, certain attributes of racial and cultural difference can be inferred by the particulars within the frame or a relatedness to other images: a bungalow, tropical foliage, or a native or two. Moreover, some of these places will already have been established as suitable for artistic translation because they were earlier conceived in accordance with the cultural idealism of the English picturesque. My objective here is to provide a compelling example of how "the Picturesque," as applied to a program of photography aiming to please, may at once suppress associations of racial confrontation, cultural assimilation, and radical topographical alteration, and thus serve the purposes of empire by affirming the colonized site as an emblem of political authority and racial dominance.[2]

While any one of numerous nineteenth-century amateur and professional photographers might be chosen for having depicted areas subject to colonialism,[3] I have focused on the work of the British photographer Samuel Bourne (1834–1912), who made India his extended home between 1863 and 1870. Bourne is best known for his several arduous treks in the Indian Himalayas, during which he was often obsessively driven to secure photographs of "rarely seen" high-elevation phenomena. These he made available to the public through the Simla-based firm of Bourne and Shepherd.[4] He also produced numerous collodion-on-glass negatives of Indian architecture on his travels around upper and southern India. Still another class of Bourne's pictures, some of which may also be associated with the previous categories, display sites deemed of historic or cultural interest to Western residents and travelers. This latter category includes a large number of works closely related to the aggressive development of India in the interest of British colonialism. In contrast to Bourne's mountain and Indian

architectural views, these images of hill stations, cantonments, cities, memorials, and parks have been almost entirely neglected in recent literature, despite their evident appeal to a large European patronage. Like most previous discussions of Bourne's better-known work, they suffer from a lack of sustained consideration of their wider cultural significance in light of Western imperialism.

Only a small number of Bourne's some two thousand pictures of India will be of concern here: his representation of Anglo-Indian parks and gardens, and especially an intriguing group of seven pictures that he made in Barrackpore in 1867. The key photographs of the Barrackpore group center on "Government House" and the elaborately cultivated grounds of the surrounding park, which for the governor-general of India was a ready retreat from Calcutta, the capital of British India at the time. Like numerous others of Bourne's photographs of India, the Barrackpore group was conceived as a closely interrelated series. This is especially evident by the way the photographer has carefully considered various vantage points and prospects that one would encounter upon approaching the house and wandering about the grounds. Following the numerical order of the images as originally assigned by Bourne and published accordingly in the Bourne and Shepherd catalogues,[5] the first three images sequentially introduce the viewer to the series as a whole: numbers 1744, *Government House Walk, Barrackpore* (not shown), 1745, *Government House, Barrackpore, South Front* (figure 5.1), and 1746, *Government House, Barrackpore, from the South* (figure 5.2). Dynamic perspectives and large overarching trees were features that Bourne frequently used both as primary motifs and to make his compositions more artistically affective, and these devices are readily apparent in his depictions of the main façades of Government

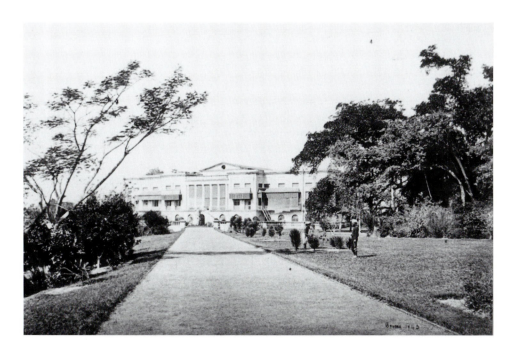

Figure 5.1 Samuel Bourne, *Government House, Barrackpore, South Front*, 1867.

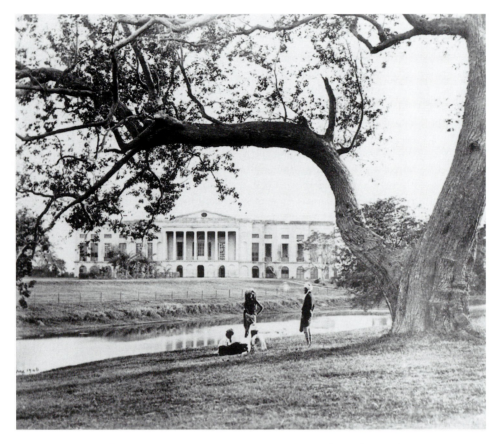

Figure 5.2 Samuel Bourne, *Government House, Barrackpore, from the South*, 1867.

House. He also incorporates a few Indian figures as *staffage*, variously attired in native garb, and representing an infusion of human presence in the landscape that is part of the legacy of the picturesque passed on to photography, and again a common practice of the photographer.

Three of the four remaining photographs in the series incorporate a solitary female figure who, with carefully coifed hair, full dress, and umbrella strikes a pose at different sites in the park at Barrackpore. Number 1747, *Lake Scene in Barrackpore Park*, shows her appearing to have stopped along a road to contemplate the view (figure 5.3). Bourne has positioned her in the middle distance by the water's edge, so that she is enveloped by an arch formed by the limbs and foliage of two trees. This is not unlike the group of four Indians in 1746, who are situated under an enormous tree near the water. In 1748, *Banian Tree in Barrackpore Park, Interior View*, we see the lady seated on a bench, umbrella in hand, beneath a gigantic banyan, an indigenous species of fig tree distinguished by its multiple array of vertical shoots (figure 5.4). Closely related to this is Bourne's 1749, *Banian Tree in Barrackpore Park, General View* (figure 5.5), in which the entire tree is seen at long range, with a pair of Indians rather

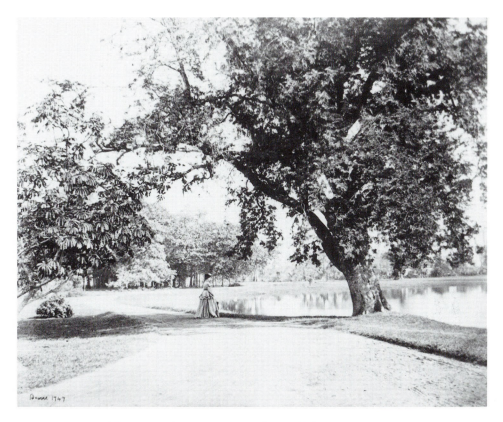

Figure 5.3 Samuel Bourne, *Lake Scene in Barrackpore Park*, 1867.

awkwardly stationed on the expanse of lawn in front. Finally, in 1750, *Gothic Ruin, with Creepers, in Barrackpore Park* (figure 5.6), we return to the woman, who is now seated with her back to a group of palms, head bowed and hands folded in what is undoubtedly an attitude of prayer. All around is an assortment of other plants, and most peculiarly, in the background, is what appears to be a ruined church replete with ivy-clad walls.

Bourne's systematic approach to photography, here illustrated by the Barrackpore group, was innovative for its day. The photographer staked his professional survival on the principle that several views are better than one for presenting the observer with both the topographical facts of place and a vivid impression of recognizably aesthetic features.[6] His methods made good entrepreneurial sense, too, since the public had the option of selecting any one or all of the pictures in a particular series as numbered in the Bourne and Shepherd catalogues. Many of his subjects were chosen because they were already familiar by name, if not visual association, to Anglo-Indians (the colonial designation for Britons living in India) and serious travelers. His patrons would be expected to fill their personal albums with views of historically significant and popular locales such as Delhi, Calcutta, and Simla. Simla, with its strategic proximity to major Himalayan routes, had become a thriving seasonal community of European

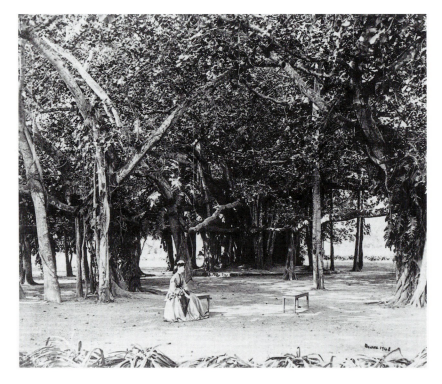

Figure 5.4 Samuel Bourne, *Banian Tree in Barrackpore Park, Interior View*, 1867.

society and the summer residence of the British Raj; it was a logical place for Bourne to set up a base of operations.[7] In 1867 he opened his second studio in Calcutta, which perhaps even more than Simla, was important for the continued success of the business. Bourne's personal written accounts of his experiences in *The British Journal of Photography* and his title notations reveal that he consistently made an effort to learn something of current interest about his destinations, whether scientific, commercial, cultural, or political, depending on the place. In this respect, he had a substantial body of travel literature, illustrated guides, and scientific reports from which to draw. And he benefited from the prior exploits of his own partner Charles Shepherd, who had had a short-lived studio with another photographer just before Bourne's arrival on the scene.[8]

Photography, the picturesque, and colonialism

The portrayal of country estates and surrounding pastures and woodlands was commonplace by the 1860s – really the culmination of a lengthy tradition of topographical illustration and touring "in search of the picturesque."[9] Photographs of figures in a sylvan setting, specifically upper-class women in a garden or picturesquely designed estate can be seen in pictures by other British practitioners of the period, such as Lady Clementina Hawarden's photograph of her daughter Isabella amid the surroundings of

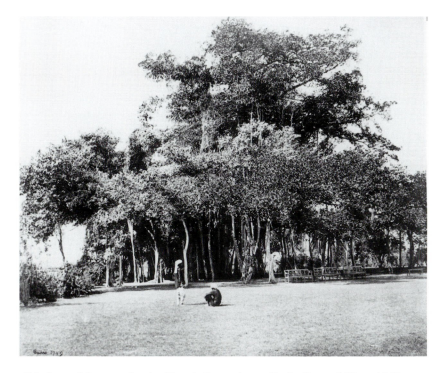

Figure 5.5 Samuel Bourne, *Banian Tree in Barrackpore Park, General View*, 1867.

their home at Dundrum, County Tipperary, Ireland (c. 1857–64).[10] Well-composed and superbly exposed in terms of light and dark gradation and resolution of detail, Bourne's scenic photography was considered a model of artistry and skill by his fellow members of the Photographic Society of Bengal.[11] The key ideals of the picturesque as laid out by the Reverend William Gilpin in the late eighteenth century had been assimilated by photographers of artistic aspirations, as evinced by the criteria with which photographs were judged in British photographic circles, including the Anglo-Indian societies. Bourne's own writings are laced with the jargon of the picturesque. First there is the matter of reconciling details with breadth of effect – a balance of tones expressive of pictorial unity and atmosphere. In a summation of his approach to photography, he advised students of the medium to "let your subject be so chosen that it shall harmonise in composition and be free from unsightly objects in the foreground; and let the best – that is, the most artistic – light which nature ever sheds over the scene be selected by you to photograph it, always securing breadth, especially of shadow."[12] This is comparable to the guidelines by which Gilpin had begun to set a new precedent for the way nature could be viewed. He speaks, for example, of "ruling masses of light and shade" that "harmonize the whole," in his *Observations, Relative Chiefly to Picturesque Beauty, made in the Year 1772, on general parts of England, particularly the mountains and lakes of Cumberland, and Westmoreland.*[13]

Bourne's discrimination against "unsightly objects" points to a second instance of his comprehension of the picturesque, which does not mean exclusion of the rough or

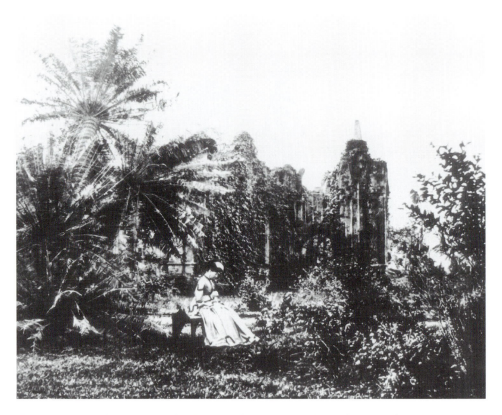

Figure 5.6 Samuel Bourne, *Gothic Ruin, with Creepers, in Barrackpore Park*, 1867.

irregular – an important aspect of picturesque beauty – but that which might detract from the "pure" artistic character of the picture. Thus, again, Gilpin prescribed what Malcolm Andrews has noted as a kind of "depoliticized" landscape, in which "A cottage, a mill, or a hamlet among trees, may add beauty to a rural scene," but too many dwellings and indications of "industry" would spoil the picturesque beauty.[14] Theoretically, then, an avowed follower of the picturesque would not admit elements into the frame suggestive of, say, social conflict between landowners and local laborers. In other words, the scene should not allow for serious social or cultural discourse, but rather foster an emotive vision that would seem to have no connection with present-day political realities.[15] Hawarden's picture of her daughter, for instance, which shows the impeccably dressed young lady strolling along the forested estate drive, leaves one deliberately clueless concerning the turmoil occurring in Tipperary at the time.[16]

The English, Welsh, Scottish, and Irish hills and countryside were considered prime locales for the ideal picturesque. Bourne had cut his photographic teeth in the Lake District, Wales, and Scotland. Thus, from the beginning of his experiences in India, he pursued landscape with zealous attention to physical characteristics that more or less bore a coincidental resemblance to those of scenic Britain – or more extreme, had taken on similar, desirable attributes through the deliberate radical alteration of the land. In his articles for *The British Journal of Photography* one finds Bourne often expressing

disappointment over India's lack of "English" features. In an account of his initial encounter with "the East," for instance, he declared,

> I am perfectly convinced that no scenery in the world is better or so well adapted for photography, on the whole, as that of Great Britain. Its mountain streams and lovely fertile valleys – its rustic cottages, overhung with thickly-foliaged trees – its cascades and waterfalls – its lakes, rivers, and verdure – are especially suited for and often so combined as to meet the peculiar requirements of the camera. Place these beside the arid plain, the naked palm trees, and the absence of water of tropical lands, and the contrast is great indeed.[17]

In the cultural bias of Bourne's words lingers Gilpin's statement that "England exceeds most countries in the *variety* of its picturesque beauty, and surpasses most."[18] The photographer also identifies English features with their suitability for picturesque photography, a curious linkage of technology and aesthetics that would often frustrate Bourne's initial efforts in the Himalayas: for him a topography frequently found so stark or overwhelming in scale that it could not satisfactorily be composed within the limited frame of the camera's viewing field.

Yet however often Bourne would characterize his concerns as pictorial, his artistic objectives were in fact complicated by his place in colonialist culture.[19] In setting his sights on the subcontinent for his professional operations in the early 1860s, he had correctly gauged as high the current level of public fascination with India and the Himalayas. This is tied to the sense of security the British obtained from having recently quashed a violent uprising of sepoys in their employ: the "Mutiny of 1857" (from a later Indian perspective, an important milestone in the long road toward independence), one of various names for the rebellion that lasted into the following year. Among the immediate political consequences of the conflict was the official transfer of rule from the East India Company to the Crown and Home Government.[20] Crucial for the role of photography, public imagination became freshly focused on places associated with the uprising, which led to a further desire to comprehend at least the outward appearance of the subcontinent and its peoples.[21] Bourne's venture in India was thus closely allied with Britain's imperialist claims and continued expansion of cultural and economic enterprise in the region. Accordingly, some of his work served to put a visual face on the politically significant places of traumatic encounter between the British and Indian peoples.

His narratives in *The British Journal of Photography*, where he recounts his Himalayan experiences, reveal an authoritative voice in which one is struck by a dynamic tension between the imaginative conceits of a landscape artist, attention to the physical attributes of place, the challenges of photographing in the wilderness, encounters with the native element, and reference to the institutions of the British Raj. This conflicted composite of transcribed journal entries conveys Bourne's diligence in seeking out and desire not only to photograph but to describe verbally sites of geological phenomena previously visited solely by Himalayan peoples and a mere handful of British explorers earlier in the century. Such features included enormous river chasms, glaciers, and ice caves like the seldom attained source or "Cow's Mouth" of the Ganges River. On one of the few occasions where he remarks on the architecture of the plains of India, he is quick to point out that "Delhi can't fail to be of interest to the

photographer: the 'Cashmere Gate,' the fort, and other noted places must be taken, while its mosques and similar buildings will be photographed for their own merits."[22] Hence, Mughal mosques and palaces were fascinating for their distinctively non-Western attributes and evocative associations with the former splendor of the previous rulers of India (whom the British held in high regard). Other Indian edifices, however, held equal importance for their having been the scene of conflict leading to further establishment of English cultural values, civil institutions, and authority in "the East."

The narratives are also punctuated with incidents related to the inhabitants, a constant factor of ambivalent regard: annoying for their frequent unwillingness to pose or stay immobile for the duration of an exposure, [23] irrational in their religious beliefs, wretched for the squalor of their living conditions, obstinate in their reluctance to bend to his will when hired to bear his equipment. At one extreme, Bourne could be an abusive taskmaster, as when he took it upon himself to beat some "coolies," their having chosen to hide rather than go off on a trekking expedition with the imperious photographer. At best, he was a compassionate observer. In an uncustomary sympathetic remark, for example, he conveyed his indignation over the exploitation of the shawl manufacturers and other laborers, their paltry income resulting, according to Bourne, from the ruling "Rajah's" power and greed. "When such a state of tyranny and oppression is witnessed by every English visitor to the 'happy valley,'" he further notes, "they may well regret that such a noble but misgoverned country should not have remained in the hands of the English when it was once in their possession."[24] He seldom recorded individuals in any ethnographic capacity, save for a series of Kashmiri nautch or dancing girls, and a small group of studies of hill peoples at the very end of his Indian sojourn. Most of the photography of "native groups," however, was left to his partner Charles Shepherd. Hence both Bourne and Shepherd were not unaware of why they, as other Britons, were in India, that their government was in the ascendancy as the dominant political entity, and that the Anglo-European public would buy photographs not only conventionally appealing, but of a decidedly social and political cast that affirmed their presence on the subcontinent.

The photographs themselves accrued meaning within the dynamic discursive structures which inform Bourne's narratives, and this is what I wish to investigate in more depth in this chapter. Looking closely at his writings, one finds that he was much more engaged in cross-cultural encounter and confrontation than his pictures might let on. The picturesque vision adopted by him could conceal this, not of course necessarily by deliberate subterfuge, but in my view through its symbolic or associative relationship with the harmonious reconciliation of discordant elements that underlie the metaphysical aspects of the historical construction of the picturesque. Thus, the scenic waterways of Mughal Srinagar in the Kashmir valley, in whose detailed description Bourne took delight, are portrayed effectively in the photographs. But vignettes of local life and living conditions discussed in the same article have no counterpart in the photographs. The throngs of river bathers and ramshackle dwellings built along the banks, the shawl factories, the bazaars, are all but invisible. Photography in this part of Kashmir was thrilling for Bourne because scene after scene for him could be framed in picturesque certainty. These included irregular masses of varied kinds of foliage, pellucid sections of the canals, rustic-looking bridges, a few unassuming Indians standing or squatting in seeming contemplation, none of which would betray

the social problems that anyone visiting the region would be sure to encounter. The correlation of scenic Kashmir with England is unmistakable: Bourne and at least one other photographer of the period readily made the connection.[25] Yet contemporary British viewers were certain to have at least a modicum of understanding of the historical moment to which Bourne referred in his comment on the raja of Kashmir. Following the Second Sikh War in 1848–49, the raja, a Hindu, had been placed in authority by the government of India over the majority of Kashmiris, who were Muslim (the ramifications of this decision endure in the ongoing violent contest between India and Pakistan).

Similarly, Barrackpore Park had much to recommend it as a site for visual delectation, albeit with potent social and historical implications. What made this varied representation aesthetically and imaginatively appealing for Bourne's patrons was the exotic character of the place as well as its political and historical significance, both of which we will be examining closely in the following discussion. With regard to the former, the fusion of picturesque prospects and Indian flora, the juxtaposition of closely cropped grass and fastidiously swept ground with the wilder growth patterns of "nature," appeared something of a curiosity to the nineteenth-century European observer.[26] The strange incongruities between the foliage, the conventional landscaping, and the structures of aristocratic privilege signaled a rather different reconciliation of topographical features from those of the traditional landscapes of England. Hence one of the main selling points of framing such scenes with the camera.

The fortuitous circumstances of picturesque design that made for the hybridized vision at Barrackpore allowed for the photographic reification of *discordia concors*, the notion of "dialectical tension between antithetical forms" that has its source, as Malcolm Andrews has discussed, in the topographical poems of the seventeenth and eighteenth centuries.[27] Bourne's repeated emphasis on breadth of effect and picturesque composition suggests that he had assimilated the philosophical harmonizing of individual elements – such as light and dark or rough and even textures – into the strategy of landscape photography. More subtle in significance, perhaps, were the contrasting presences of Indian men and a white European woman, which as staffage undoubtedly augmented the pictorial interest of the individual views. Yet, even here, an antithetical motif is apparent, equivalent to the integration of "gentry and peasantry" into the traditional landscape. As will be seen, however, there are further factual and symbolic reasons for the integration of these figures into their corresponding settings at Barrackpore.

Picturesque estate and political haunt

Previously the site of a native village, Barrackpore had assumed a role in the defense of the East India Company's commercial stronghold in Bengal with the establishment of a cantonment at the site in 1775. It was located about sixteen miles north of Calcutta on the banks of the Hooghly River, opposite a Danish settlement at Serampore. One turns to the highly informative and lively account of Lord George Nathaniel Curzon, Viceroy of India between 1899 and 1905, for the chief documentation of Barrackpore. This includes three (uncredited) reproductions of Bourne's photographs, among other illustrations.[28] Richard Colley Wellesley, the 2nd Earl of Mornington (later, Marquess Wellesley), described affectionately by Curzon as "this

splendid and quite impenitent sinner,"[29] lavished great expense on the development of a principal house and grounds during his eight-year administration. The building was never completed, and thus Wellesley's successors had to remain content with a more "humble" dwelling erected just before his recall from India in 1805. This was soon expanded into the classical edifice photographed by Bourne, whose view of the house from the south (figure 5.2) was appropriated by Curzon for an illustration. At the peak of development the grounds themselves extended to nearly 350 acres. The area was described "as flat as a billiard table" when Wellesley took over, but he "resolved to have not merely an English country seat but also an English park around it."[30] The once level terrain of Barrackpore was thus transformed into "hillocks and undulations," and further articulated by waterways let in from the Hooghly. As discussed by Curzon, the "Park" was developed with lengthy prospects and "a good many English trees," but some areas were given to the cultivation of indigenous growth, distinguished as "the Gardens" because they had gradually acquired "in some measure a separate existence" from the rest of the grounds.[31]

On the face of it, then, the design of the Park reflected English sensibilities extended to India in order to satisfy aristocratic pretensions. This was done according to contemporary taste for the picturesque landscape park or garden, which was distinct from the smaller vegetable and flower gardens of the country house. The picturesque came to embody a rejection of rigid formality in landscape design, as it did correspondingly in painting, which generally meant the incorporation of features of a natural appearance marked by "irregularity, variation, decay, and wildness."[32] As noted above, these features were to be visualized with a sense of a unifying principle of distinct elements. In the words of Sir Uvedale Price, one of the chief proponents of change in the design of gardens for the landed gentry,

> The difficulties in gardening, as in other arts, do not lie in forming the separate parts, in making upright terraces and fountains, or serpentine walks, plantations and rivers, but in producing a variety of compositions and effects by means of those parts, and in combining them, whatever they may be, or however mixed, into one striking and well connected whole.[33]

Nature was not to be obscured, but improved upon in order to create a surrounding equivalent to poetry through visual effect. Ideally, the pleasure experienced by visitors to the grounds would not be violated by evidence of provocative social and political issues of the moment. Thus, as a map in Curzon's treatise reveals, the barracks and parade grounds of the nearby military cantonment were kept in an adjacent and separate zone in the overall plan of Barrackpore Park.

This alone of course would contrast considerably with Barrackpore's expansive country counterparts in Britain, but Wellesley, too, was the supreme representative of British power in India. Curzon's lengthy inclusion of the roles of Wellesley and his successors in Barrackpore's history in his massive study of the government houses of the Raj draws attention to the linkage of its political heritage with its aesthetic development. To achieve picturesque effects and regal splendor Wellesley relied on the toil of native convicts, the economic security of the East India Company, and the British military establishment. Such facts are reminiscent of colonizing projects elsewhere, such as Australia, and in this respect signal strong differences between the "mother

country"and the colonies.[34] Wellesley's commandeering of indigenous land and labor hence underscores the instrumentality of the picturesque in the global spread of British rule and commerce as well as culture.

Bourne's photography of the Government House and Park at Barrackpore would have been justified if for no other reason than its easily recognizable status as a political structure attached to the history of the British in India.[35] The stately façades of the residence – actually a much reduced version of the palatial manor Wellesley had envisioned – appearing in the middle distance of Bourne's three photographs fall squarely within the English tradition of paintings of seventeenth- and eighteenth-century houses in their managed, semi-natural settings. His choice of Barrackpore and similar areas of Anglo-Indian development for his photographic exploits, however, was not especially motivated by any aesthetic adoration of English architecture – his dismissal of the grand buildings of wealthy British Calcutta as dull supports this conclusion, as does the relatively small number of pictures actually devoted to the classicizing buildings that mark colonial settlement together with the neo-gothic. Thus, when he undertook to portray them he did so only in areas most affiliated with the administration of India, representative of key social institutions, or related to specifically identifiable sites of profound historic interest to his Anglo-Indian patronage.

As Bourne's own remarks indicate,[36] the events and specifically related sites of the Mutiny loomed large in the psyche of the British public even well after the conflict had

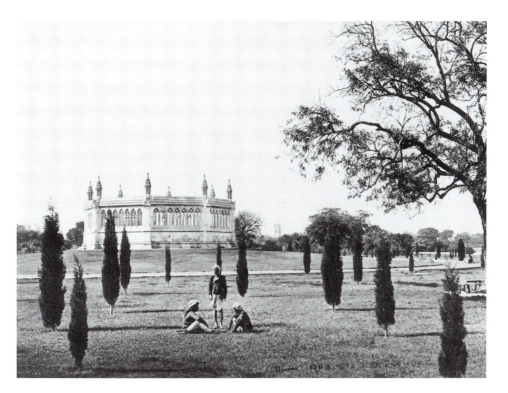

Figure 5.7 Samuel Bourne, *The Memorial Well, with Cawnpore Church in the distance,* 1865–66.

ended. This is further witnessed in an especially striking case involving a memorial to those who died in possibly the worst of rebel hostilities: the slaughter of numerous captive white women and children whose bodies were cast into a well at Cawnpore, a large cantonment on the banks of the Ganges. Lady Charlotte Canning, whose husband was governor-general at the time of the insurgency, conceived of a cenotaph in remembrance of the victims, which would come to symbolize the whole ignominious affair that had threatened British dominion in India. The Memorial Well at Cawnpore was not to be finished until 1865. Before her death in 1861, however, Lady Canning had commissioned the Italian sculptor Baron Carlo Marochetti to execute a full-length seraph – the "angel of the resurrection" – as the central feature.[37] Bourne promptly responded to the immediate popularity of the Memorial Well after its unveiling with a series of photographs of it and the surrounding grounds taken during the winter of 1865–66 (figure 5.7). As in the case of the monument itself, by drawing on religious sentiment in association with the innocent victims the pictures would come to signify the righteousness of victory over those in opposition to British rule. In his book on Cawnpore and the Mutiny, Andrew Ward observes that the park grounds were financed by the native residents of the town by order of the government. Though they had paid a total of £30,000, Indians were not allowed to enter this sacred preserve of the English without special permission. The Memorial Well became Anglo-India's "most hallowed shrine," and at the time of Bourne's photographic campaigns in the region, "it was visited more frequently than the Taj Mahal."[38]

Barrackpore too had figured prominently in the sepoy rebellion. Native troops at the garrison were the first to take violent action against their British superiors in March 1857. One of the former, Mangal Pande, had attacked and wounded two men before he was subdued. A few days after the incident he was hanged from a gallows on the cantonment parade ground.[39] Thus, in addition to its associations with Britain's ruling elite, Barrackpore had its infamous past to attract the notice of curious residents and travelers. Bourne did not photograph the sites where the assault and ensuing execution of Pande had actually occurred, but did so at the beguiling park adjacent to the cantonment. The choice *not* to represent the scene of violence is significant, for as much as it underlines Bourne and his pictorial ideals, the relatively tranquil views of the park, like those of Cawnpore, must have elicited for his compatriots both a sense of relief and of righteous indignation over the events that had recently transpired there. Any lingering fears of native treachery might be assuaged by the implicit knowledge that a pretty locale, once threatened by violation, had been restored to idyllic calm as witnessed in Bourne's photographs.

Other writers who visited or resided at Barrackpore prior to Curzon's administration commented on its renown as a curious hybrid of English and Indian features. Emma Roberts, for instance, author of the illustrated travel guide *Scenes and Characteristics of Hindostan with Sketches of Anglo-Indian Society* (1837), highlighted the picturesque qualities of Barrackpore Park as follows:

> Although, with the exception of the park, which has been raised into sweeping undulations by artificial means, the cantonments and their vicinity present a flat surface, the combination of wood, water, and greensward, in numberless vistas, nooks, and small open spaces, yield scenes of tranquil beauty, which eyes, however cold, can scarcely contemplate unmoved.[40]

Having credited Wellesley with the initial vision to transform the grounds at Barrackpore, Roberts further reconciled the picturesque with her experience of India:

> Though an authoritative mandate from the Court of Directors, dictated by unaffected alarm, put an effective stop to the completion of the Marquess of Wellesley's most splendid projects, Barrackpore is still indebted to him for a park which is justly considered one of the finest specimens of *dressed and ornamented nature* which taste has ever produced. Enough has been done to the mansion to render it a very elegant and commodious residence, and the gardens attached to it are unrivalled both in beauty and stateliness, combining the grandeur of Asiatic proportions with the picturesqueness of European design.[41] [my italics]

Roberts does not make clear what she means by "Asiatic proportions," but suggests they are of an order of "grandeur" that differs appreciably from the natural environment of home, while creating a happy union with the aesthetic refinements of its cultivated landscapes.

Firsthand remarks regarding the hybridized nature of the park are found additionally in the correspondence of Governor-General Lord Dalhousie as well as Lady Charlotte Canning. Soon after his arrival in Calcutta in 1848, Lord Dalhousie paid a visit to Barrackpore and had this to say:

> It is charming, and reconciles me to a residence in Bengal more than anything else has yet done. The rooms are large but livable, the furniture not smart, but not so scandalous and blackguard as that at the Government House [in Calcutta]; a pretty pleasure ground, beautiful garden, an aviary, a menagerie, and all situated on the bank of the river, and surrounded by a park quite home-like in its character, and as English as anything can be, where you have banians and cocoanuts, and palms and mangoes, for oaks and elms, larch and beech.[42]

The exchange of "English" trees for Asian was apparently acceptable to Dalhousie as long as the overarching design was suitably English in character.

Charlotte Canning, on the contrary, displayed a certain ambivalence about the Englishness of the grounds:

> The Park is carefully planted with round headed trees to look as English as possible – more so than I approve, and I am glad when Bamboos and Cocoanuts and Palms have crept in. All the apparent chestnut, elms and ash prove quite unknown on nearer view. The luxuriant growth in the jungly ground outside, of dazzling green during the Rains, is more beautiful than I can describe and I always think of the Palm House at Kew which gives a faint idea of it.[43]

Lady Canning, the wife of Dalhousie's successor, Charles Canning, first encountered Barrackpore as a welcome retreat from the hectic affairs of state in 1856. She embraced not only the indigenous trees established within the park, but the surrounding wilder

element of jungle growth (she once lamented not knowing more of the plants by name). So enchanted was Lady Canning with her adopted country home that she made her own significant alterations in order to favor promenades and prospects in typical high English fashion, but took special care to highlight the splendors of native foliage throughout the grounds. The largest of the banyan trees, with its abundance of surrounding runners, especially fascinated her: "I have had a good deal of amusement in cutting down shrubs and opening out vistas. Such a beautiful banyan tree, like a grove, covered with creepers and orchaedeous plants, is now exposed to view."[44]

Charlotte Canning was both a competent watercolorist and a connoisseur of photography. She was official "patroness" of the Photographic Society of Bengal in Calcutta, sponsoring the work of various photographers at its first annual exhibition.[45] When she died of "fever" at Barrackpore in 1861 (with the death of her husband soon following), a memorial was erected on the park grounds overlooking the Hooghly. She was clearly much loved by the Anglo-Indian community, as Curzon's glowing section on her sojourn in India indicates. Her personal involvement with Barrackpore and Calcutta society and its photography circle are reasons enough for Bourne to pay homage to her memory by photographing the park grounds, and particularly the banyan tree that so delighted her.

The lady in the garden

One suspects that Bourne had Lady Canning in mind not only in his choosing some of more scenic spots around the grounds, but in his posing of an actual woman within these settings. As to the identity of the latter, one need not look far, for Bourne had married Mary Tolley in May of 1867,[46] during a respite in England from the rigors of his occupation on the subcontinent. He had returned to Calcutta with his new bride by November of the same year, and soon thereafter opened the new branch of Bourne and Shepherd. Bourne produced a series of photographs of the city and its immediate environs at this time, which included his Barrackpore pictures, thus supporting the assertion that Mary Bourne is the woman in the garden. Considering that the couple might be on an extended honeymoon, that the beauty of Barrackpore was renowned, and that it had been so popular with the celebrated Charlotte Canning, it is scarcely surprising that Bourne should have taken Mary for a visit and have her appear as a strategic figure within the compositions. Furthermore, it is not difficult to imagine Bourne thinking of the response that her presence might elicit from his patrons as a tangible link to the former "first lady" of British India.

As Bourne's new wife as well as a representative of her gender as part of the new ruling class in India, Mary offers an extended vision of the traditional English view of woman as the fixed, anchoring member of the country estate and household. An upper-class married woman was considered the "queen" of her domain in the eighteenth and nineteenth centuries, a notion which was transferred to the middle class during the Victorian era.[47] In literature, this is particularly reflected in John Ruskin's lecture to young women in *Sesame and Lilies*, "Of Queens' Gardens," in which the critic asserts that man is to guard woman from the "rough work of the open world," while woman is to rule his house. "This is the true nature of home – it is the place of Peace; the shelter, not only from all injury, but terror, doubt, and division."[48] As the organizer of the home, a virtuous wife creates a refuge, a center of calm in the

maelstrom of activities undertaken by her husband. And, according to Ruskin, she has the power to extend this locus of stability beyond the confines of a physically defined domestic space.

> And wherever a true wife comes, this home is always round her. The stars only may be over her head; the glow-worm in the night-cold grass may be the only fire at her foot: but home is yet wherever she is; and for a noble woman it stretches far round her, better than ceiled with cedar, or painted with vermilion, shedding its quiet light far, for those who else were homeless.[49]

Mary Bourne's position within her husband's pictures of Barrackpore conveys a sense of this exalted social and spiritual calling. She adopts a gesture of prayerful humility outside of the surrogate ruins of a gothic church, as if aspiring to spread the peace of God despite the reclaiming of the material Church by the unpredictable elements of the jungle (fig. 5.6). Like Charlotte Canning before her, hers is a conditional embracing of a new domain, an "India" of unknown quantities that seem held at bay by the quiet virtues of her gender and her duty as a civilized English woman.

If Barrackpore represents the making over of India to picturesque advantage by successive alterations, it also reflects a wider ambivalence toward a wilderness under colonialist surveillance. The image of white woman amid tropical foliage indicates that this particular jungle has been subdued: tree ferns, banyans, and creepers, when left to their own devices, are nearly impenetrable. Christopher Pinney has written of the banyan tree's significance in association with a photograph of two standing Chamars (c. 1896), a young boy and older man in front of the trunk of a large banyan. The photographer, one Sergeant Wallace, has presented the man with a pair of shoes to typify and distinguish his caste occupation as a tanner and shoemaker, that is, as distinct from other castes; the picture appeared in William Crooke's *The Tribes and Castes of the North-Western Provinces and Oudh* (1896).[50] They are also coupled with the banyan to associate them with a jungle habitat. As Pinney and others have discerned, the banyan tree became an important nineteenth-century trope for racial difference and complexity, and a metaphor for the dark "inscrutability" of the tropical forest as a whole.[51] Such an image seems a far remove from Bourne's photograph of his wife before the carefully groomed setting at Barrackpore. And yet one can scarcely ignore the sense that, in its quiet way, Bourne's picture accomplishes its own form of racial differentiation and distancing, albeit through the artifice of a picturesque conceit.

Bourne's photographs frequently reveal a mixed message of delight and curiosity concerning exotic specimens of foliage on the one hand, and the picturesque tradition of *concordia discors*.[52] The harmonizing of diverse and potentially unwieldy profusion of limbs and foliage before the camera is accomplished by the photographer's seating of his wife tranquilly beneath a carefully framed and sunlight-inflected canopy that draws the eye toward a deeply shaded center. On the other hand, the "general view" presents the banyan as a singular phenomenon, akin to both natural and indigenously crafted landmarks that Bourne encountered, described, and photographed with great relish on his Himalayan treks. There, "peaks, passes, and glaciers," and other geological spectacles constituted the initial allure. Here the banyan, like other botanical specimens recorded by the photographer, would presumably intrigue patrons with varied degrees of scientific interest in the visual identification of such strange growths

of nature. The two Indians who face the massive umbrage at a distance remain anonymous and oddly dissociated from the evocation of the jungle signified by the banyan, in contrast to the Chamars portrayed in the photograph discussed by Pinney.

Without external evidence Mary Bourne herself would not be identifiable, but her presence suggests a world of privilege and means unavailable to Indians – unless their place in Indian society also allowed for them to assume a role in "polite" European society or perform approved duties within the well-defined perimeters of British colonial institutions (one recalls that most Indians were prohibited from entrance into the park and memorial at Cawnpore).[53] The photographer's frequent insertion of them into his compositions as pictorially conventional staffage and indicators of scale serves only to underplay their specific positions as porters, gardeners, cooks, guides, and laborers. Their typical placement for pictorial effect in itself would suggest a parallel to the contrast of aristocratic or gentry and peasantry that one frequently encounters in British landscape painting, which would offer a benign pastoral vision in keeping with picturesque ideals. One might also be tempted to say that this is a kind of non-aggressive metaphor for their neutralization, or even feminization, enabling them in other words to be perceived by European viewers as unthreatening presences.

Once described by Emma Roberts as nature "dressed and ornamented," Barrackpore Park itself has curiously taken on the connotations of gender. The picturesque, particularly as theorized by Gilpin and his contemporaries, has been discussed by Ann Bermingham as a mode of reading nature's charms as distinctly feminine, as one might gaze at a woman who attends to her dress to accentuate the sensual. Picturesque landscape is essentialized as "all petty surface," in contrast to "the profound depth" of masculinity.[54] Thus, wherever the terrestrial contours of India have been altered to appeal to European cultural sensibilities, whether in the hills or in the plains, they are transformed into a location that masks by surfeit any number of disturbing nuances of race, caste, and culture. Extreme differences of subcontinental geography and peoples are more easily avoided with the availablity of attractive refuges like Barrackpore. The feminization of India through the picturesque may hence be considered a process whereby one's encounter with India could always be a pleasant one. This process was assisted by representations of the Park, as elsewhere, in traditional graphic media that predate photography in the employment of picturesque ideals. Drawings produced in the early nineteenth century by Sir Charles D'Oyly, whose depictions of Barrackpore also appear in Curzon's treatise are a case in point.[55] Together with photographs such as Bourne's, the British artists' pictorial rendering of India's scenic places emphasized their exotic and otherwise aesthetically appealing endowments, which resonated with the tastes of their European audience.

The social undercurrents of Bourne's representations of Barrackpore run deeper still in the notion of India as an extension of the domestic realms of Britain. In the present instance the English woman and the Indian men become ciphers of both aesthetic and political linkage with the colonial experience. They appear in alternate representations of India as adopted site of colonial culture, which reiterate the actual physical transformation of Barrackpore into an exotic, arcadian province of the culturally refined ruling elite.[56] The posturing of the white middle-class Mary Bourne in a manner reminiscent of earlier portrayals of the aristocracy in nature reminds one that Barrackpore was originally intended as a space of privilege. Wellesley's original plan – an ideal country estate that only the old gentry could possibly afford – began nearly a

century and a half of British aristocratic pretensions in India. At the time of the Bournes' visit, Barrackpore apparently had only recently been opened to the general public, much to the annoyance of certain viceregals of the period.[57] In India, the Victorian middle class, with of course no claims to the nobility or upper class in England, often behaved as though they belonged to a higher social order because of their assumed power under the conditions of colonial rule.[58] For those not to the manor born, Bourne's tourist pictures would perhaps have played into such fantasies of wealth and title. Moreover, Mary's chaste attire and essentially passive, contemplative or prayerful role within the frame signals an air of purity and gentility that women in her position were expected to assume as counterpart to the social pretenses adopted by English gentlemen in India.[59] Seen in this light, her personal entry into Anglo-Indian society – at least for a brief period – is symptomatic of the influx of her race and sex, and embodies an image of Victorian femininity safely ensconced in an India that would be further Anglicized by one woman more.[60] The pleasant English inspired residences of India's hills and plains are figuratively possessed by her, as the portrayal of the buildings themselves are confident assertions of their ties to England.

Finally, one ought not to forget that Barrackpore was the site of the first bloodshed of the sepoy rebellion. In contradistinction to their feminine pictorial overlay, the pictures could remind the beholder of Mangal Pande, whose hanging on the Barrackpore parade ground adjacent to the park was (for the moment) a reassertion of British control. Considered in the aftermath of the conflict, the images underscore the triumph of the Raj over native India. The symbol of victory is completed by the English woman, who sits or stands serenely at several key prospects within the Park: she holds the promise of future generations of white progeny on the subcontinent (incidentally fulfilled by the birth of Mary Bourne's first child in India a little more than a year after the photographs were made.[61]). Here, Harriet Tytler's account of her experiences in India comes to mind. The wife of Major Robert Tytler, and an amateur photographer together with her husband, she was the only English "lady" present at the time of the so-called Siege of Delhi during the Mutiny – an assault, initially planned by a small British force, from a ridge outside the walled city.[62] Accompanied by her two small children and her maid, Tytler gave birth to a boy right on the spot. She recollects the soldiers proclaiming immediately afterwards, "We shall have victory now that this baby has come to avenge the deaths of the murdered children."[63] In light of Mary Bourne's own pregnancy and childbirth in India, her presence at Barrackpore provides a coda to the prediction of retribution associated with Tytler's newborn. Unlike Harriet's unusually active presence through the voice of her journal, however, Mary remains quietly present within the representational constraints of her husband's photographs. She is not unlike her Indian counterparts in this respect: they remain anonymous as synecdochic representatives of all Indian peoples. She is caught primarily as a passive object of aesthetic delectation in the garden of the Raj. Others of her gender and race would attempt to transform their experience of native India into a picturesque encounter, but in these images she *becomes* the picturesque.

Marked by the aesthetic tradition of the picturesque and prevailing attitudes towards women and race, Bourne's colonialist pictures in turn visually manifested the cultural sentiments of his contemporaries. With an understanding of Barrackpore's importance in the history of the Raj, one realizes that his photographs had the capacity to be potent symbols of social identity and power. If the private significance of the images

could not be gleaned by the photographer's European patrons, they could not fail to comprehend the appeal to a system of shared cultural values. These same values might subtly mask the equation of national and social identity with their continued presence in a foreign land. Bourne's photographs of colonized space enabled his viewers to make connections between their aesthetic ideals and the subcontinent, while affirming Britain's imperialist ideology that it had a healthy civilizing role to play in the non-Western world. The identifiable picturesque quality of places such as Barrackpore was reassuringly *re*-presented by the photographer, and thus reinforced a guarded sense of colonialist security and entrenchment. Collecting pictures of India rehearsed a related desire to bring order and a sense of mastery to an otherwise vast and confusing subcontinent.[64] And the purchase of photographs from purveyors of views such as Bourne and his partner Charles Shepherd of course supported the continued economic and cultural presence of the British in India. Finally, perhaps one may go so far as to say that Bourne offered to his patrons a symbolically emasculated India, a rendering of India as innocuous, in part engendered by the benignly integrated Indians of the Barrackpore series. In retrospect, this seems a denial of the ever-present threat of renewed native insurrection which might eventually lead to Indian independence. As figured into the construction of a photographic archive of Indian subjects, each image was a commitment to the memory of the past, a profound legacy of the power of the aesthetic object in the drama of human ambitions.

Notes

1 I am considering here a form of "transculturation," a term defined by Mary Louise Pratt to characterize the encounters of late eighteenth- and nineteenth-century European travelers who entered into the "contact zone" or social and physical space of the colonial Other; in *Imperial Eyes: Travel Writing and Transculturation* (London: Routledge, 1992), 4–10.

2 A good point of departure for recent discussion of the meaning and legacy of the Picturesque – capitalized once only here to indicate its eighteenth-century point of theoretical development – is found in Stephen Copely and Peter Garside, eds, *The Politics of the Picturesque: Literature, Landscape and Aesthetics since 1770* (Cambridge: Cambridge University Press, 1994). Also useful with regard to landscape and ideology are W. J. T. Mitchell, ed., *Landscape and Power* (Chicago and London: University of Chicago Press, 1994); and appropriate sections of Malcolm Andrews, *Landscape and Western Art*, Oxford History of Art (Oxford and New York: Oxford University Press, 1999).

3 Despite recent attempts to examine the relationship of photography and colonialism, the topic remains open for careful scholarship and comprehensive treatment. See especially James R. Ryan, *Picturing Empire: Photography and the Visualization of the British Empire* (Chicago: University of Chicago Press, 1997).

4 Details of the establishment of Bourne's firm and the critical reception of Bourne's photographs are given in Gary D. Sampson, "The Success of Samuel Bourne in India," *History of Photography* 16 (Winter 1992): 336–47. Bourne published a fascinating account of his Himalayan travels in *The British Journal of Photography*; a full reference to these, in addition to previous writings about Bourne, is cited in the latter article, p. 345.

5 Bourne signed and numbered *nearly* every one of his large-format negatives which were to be subsequently printed and listed in the Bourne and Shepherd catalogues, *Photographic Views in India, by Bourne and Shepherd* (Simla: n.d. [1866]), and *Photographic Views in India, by Bourne and Shepherd* (Simla and Calcutta: n.d. [1870]).

6 The notion of a system for the cataloging of views was no doubt adopted from similar practices among artists and art dealers. For Bourne, the more immediate influence was his older Scottish contemporary George Washington Wilson, who began to market his views out of Aberdeen in 1855. See Roger Taylor, *George Washington Wilson: Artist and Photographer,*

1823–93 (Aberdeen: Aberdeen University Press in association with the University of Aberdeen, 1981): 63–77. Bourne and Shepherd's inventory, however, reflects an effort to offer the purchaser a greater and more subtle distribution of choices than their competitors.

7 Bourne himself recognizes the social and political importance of Simla in "Photography in the East," *The British Journal of Photography* [hereafter *BJP*], September 1, 1863: 346–7. On the significance of the British Indian hill station, see Anthony D. King, "Culture, Social Power and Environment: The Hill Station in Colonial Urban Development," *Social Action* 26 (July–September 1976): 195–213.

8 Sampson, "Success," 337–8.

9 This tradition is discussed at length in Malcolm Andrews, *The Search for the Picturesque*: *Landscape Aesthetics and Tourism in Britain, 1760–1800* (Aldershot: Scolar Press, 1989).

10 See Virginia Dodier, "Clementina, Viscountess Hawarden: Studies from Life," in Mike Weaver, ed., *British Photography in the Nineteenth Century* (Cambridge: Cambridge University Press, 1989), 143–4, fig. 2.

11 Sampson, "Success," 339.

12 Samuel Bourne, "Landscape Photography," *The British Journal Photographic Almanac, and Photographer's Daily Companion* (1872): 113–14.

13 Gilpin, *Observations*, vol. 1, 2nd ed. (London: R. Blamire, 1788), 94.

14 Andrews, quoting Gilpin, *Landscape and Western Art*, 167.

15 Andrews, ibid., 166–75. For further exploration of the sociopolitical interpretation of the picturesque landscape see David H. Solkin, *Richard Wilson: The Landscape of Reaction* (London: The Tate Gallery, 1982); and John Barrell, *The Dark Side of Landscape* (Cambridge: Cambridge University Press, 1980).

16 Dodier, "Clementina,"144.

17 "Photography in the East," *BJP*, July 1, 1863: 268.

18 Gilpin quoted in Christopher Hussey, *The Picturesque: Studies of a Point of View* (1927; reprint, London: Frank Cass and Company, 1967), 89. See also Gilpin, *Observations*, vol. 1, 126–7, in which he states that other countries may not be as favorably proportioned as England's Lake Country.

19 Nicholas Thomas sheds considerable light on the complexity of racial and cultural confrontation that emerges upon careful reading of historical texts in *Colonialism's Culture: Anthropology, Travel and Government* (Princeton: Princeton University Press, 1994). His analysis of approaches to the issue of cultural and racial dominance extends to the problem of representation and thus is useful for grasping the significance of a photographer such as Bourne in colonialist culture.

20 The literature on the sepoy rebellion and its consequences is vast; for an introduction within the context of British imperialism see P. J. Marshall, "1783–1870: An Expanding Empire," and Tapan Raychaudhuri, "British Rule in India: An Assessment," in *The Cambridge Illustrated History of the British Empire*, ed. P. J. Marshall (Cambridge: Cambridge University Press, 1996), 46–51; 357–61. A popular but detailed treatment of events is found in Christopher Hibbert, *The Great Mutiny: India 1857* (Hardmondsworth: Penguin Books, 1980).

21 Far more work is needed regarding the place of photography in the systematic documentation of India and other regions under European colonialist rule. An excellent introduction to the topic relative to the subcontinent is Christopher Pinney, "Colonial Anthropology in the 'Laboratory of Mankind'," in C. A. Bayly, ed., *The Raj: India and the British 1600–1947* (London: National Portrait Gallery, 1990), 252–63; and in the same exhibition catalogue, John Falconer, "Photography in Nineteenth-century India," pp. 264–77, and related entries, pp. 278–347. See also Pinney, "'Stern Fidelity' and 'Penetrating Certainty,'" in his book *Camera Indica: The Social Life of Indian Photographs* (Chicago: University of Chicago Press, 1997), 16–71.

22 "Photography in the East," *BJP*, September 1, 1863: 345.

23 Bourne's comments on the introduction of human subjects into his landscapes are few, but see his "Narrative of a Photographic Journey to Kashmir (Cashmere) and Adjacent Districts," *BJP*, January 25, 1867: 39.

24 Ibid., January 4, 1867: 4.

25 See Melville Clarke, *From Simla through Ladac and Cashmere* (Calcutta: Savielle and Cranenburgh, 1862).

26 Deirdre David touches briefly on Barrackpore's "hybrid" nature in her essay exploring Victorian patriarchal authority and the subjugation of women and natives in India: "Babu Kalicharan Banerjee and Miss Mary Pigot," in her book *Rule Britannia: Women, Empire, and Victorian Writing* (Ithaca and London: Cornell University Press, 1995), 120–2.

27 Andrews, *Landscape and Western Art*, 170–1; for a more detailed discussion see Andrews, *The Search for the Picturesque*, 17–18ff.

28 Curzon made himself an authority of Barrackpore's history while undertaking a scholarly study of Calcutta Government Houses and their ruler occupants. George Nathaniel Curzon, "Barrackpore Government House," in *The British Government in India: The Story of the Viceroys and Government Houses* (London: Cassell, 1925), vol. 2, 2–46. For a recent introduction to the architecture and monuments of Barrackpore see Philip Davies, *Splendours of the Raj: British Architecture in India, 1660 to 1947* (London: John Murray, 1985), 80–5. The use of Bourne's photographs for illustrations in publications on India is widespread, as seen in Davied, *Rule Britannia*, as well as Curzon; Bourne's no. 1746 of Barrackpore's Government House (our figure 5.2), for a prime example, appears in Davies, p. 82 (again uncredited to Bourne), and Curzon, facing p. 26.

29 Curzon, "Barrackpore Government House," 2: vol. 16.

30 Ibid., 2: 12.

31 Ibid., 2: 40–1. For the history of the picturesque park and garden, and their sometimes confusing relationship to each other, see Susan Lasdun, *The English Park: Royal, Private and Public* (London: Deutsch, 1991), 102ff; and especially Tom Williamson, "The Landscape Park: Economics, Art and Ideology," in *Rediscovering the British Garden, Journal of Garden History* 13 (January–June 1993), 49–55.

32 Copley and Garside, *The Politics of Picturesque*, 3. For our purposes the problematic notion of the picturesque may be *considered* a convergence of eighteenth-century ideas intended to distinguish the rugged aesthetic qualities of nature and the built environment that could be practically applied to painting. This is to say nothing of the controversial relationship between the picturesque and the heightened emotive states of the sublime and the beautiful. See Christopher Hussey's now standard reference, *The Picturesque: Studies of a Point of View* (London: Frank Cass and Company, 1967, new impression of the original of 1927), 65–82.

33 Uvedale Price, *Essay on Artificial Water*, in *Sir Uvedale Price on the Picturesque*, ed. Dick Lauder (1842); passage quoted in full in Hussey, *The Picturesque*, 180.

34 Cf. Mark Rosenthal, "The Penitentiary as Paradise," in Nicholas Thomas and Diane Losche, eds, *Double Vision: Art Histories and Colonial Histories in the Pacific* (Cambridge: Cambridge University Press, 1999), 103–30.

35 On the political symbolism of British architecture in India see Thomas R. Metcalf, *An Imperial Vision: Indian Architecture and Britain's Raj* (Berkeley and Los Angeles: University of California Press, 1986), 1–16.

36 "Photography in the East," *BJP*, September 1, 1863: 3.

37 On Cawnpore and the Memorial Well see Andrew Ward, *Our Bones Are Scattered: The Cawnpore Massacre and the Indian Mutiny/1857* (New York: Henry Holt, 1996), 548–52; and Charles Allen, *A Glimpse of the Burning Plain: Leaves from the Indian Journals of Charlotte Canning* (London: M. Joseph, 1986), 122–4. One of Bourne's photographs of the angel of the Memorial well is reproduced in Pratapaditya Pal and Vidya Dehejia, *From Merchants to Emperors: British Artists and India, 1757–1930* (Ithaca: Cornell University Press, 1986), fig. 74, p. 81.

38 Ward, *Our Bones*, 550–1.

39 According to an account of the hanging appearing in *The Englishman* (Calcutta), April 8, 1857. I have John Falconer, currently archivist at the Oriental and India Office Collections, British Library, to thank for verifying this reference. Davies, *Splendours*, 84–5, notes incorrectly that it was from the Great Banyan in Barrackpore that Mangal Pande was hanged.

40 Roberts, *Scenes and Characteristics of Hindostan with Sketches of Anglo-Indian Society* (London: W. H. Allen and Co., 1837), vol. 2, 273–7, quoted in Curzon, vol. 2, 12.

41 Roberts, quoted in Curzon, "Barrackpore Government House," vol. 2: 13.

42 Dalhousie to Sir George Cooper, February 1848, *Private Letters*, ed. J. G. Baird (London, 1910), quoted in Curzon, "Barrackpore Government House," vol. 2: 21.

43 Charlotte Canning to Queen Victoria, September–October 1856, quoted in Allen, *Glimpse*, 41.

44 Charlotte Canning quoted in Allen, *Glimpse*, 35–6; cf. Curzon, vol. 2: 33–5.

45 *Catalogue of the Pictures in the Exhibition of the Photographic Society of Bengal – 4th March 1857* (Calcutta: F. M. Cranenburgh, Bengal Military Orphan Press, 1857); and "Proceedings of the Society," *Journal of the Photographic Society of Bengal*: II, 2, May 20, 1857: 68. Bourne himself was an avid member of the organization's later manifestation, the Bengal Photographic Society; see Sampson, "Success,": 339.

46 Pauline F. Heathcote, "Samuel Bourne of Nottingham," *History of Photography* 6 (April 1982), 106.

47 The theme of woman in the garden in art has been treated extensively by Susan P. Casteras; see especially her *Images of Victorian Womanhood in English Art* (Rutherford, NJ: Fairleigh Dickinson University Press, 1987), 57–8; 67. See also Walter E. Houghton, *The Victorian Frame of Mind, 1830–1870* (New Haven: Yale University Press, 1957), 341–53.

48 Ruskin, "Of Queens' Gardens," *Sesame and Lilies*, rev. and exp. (New York: John Wiley and Sons, 1884), 99–100. It has been argued that Queen Victoria herself became the very epitome of the middle-class wife as a necessary role for the monarchy, thus providing an appropriate model for her female subjects. Margaret Homans, "To the Queen's Private Apartments: Royal Portraiture and the Construction of Victoria's Sovereign Obedience," *Victorian Studies* 37 (Autumn 1993): 1–41.

49 Ruskin, "Of Queens' Gardens," 100.

50 Pinney, *Camera Indica*, 59–62.

51 Pinney, "Underneath the Banyan Tree: William Crooke and Photographic Depictions of Caste," in Elizabeth Edwards, ed., *Anthropology and Photography, 1860–1920* (New Haven and London: Yale University Press, 1992), 168–72.

52 See above, note 27.

53 In post-colonial theory, the adaptation of the colonized "other" to the dominant culture enters into the discourse of mimicry, i.e., according to Homi K. Bhabha, "the desire for a reformed, recognizable Other, as a subject of a difference that is almost the same, but not quite." "Of Mimicry and Man," in *The Location of Culture* (London and New York: Routledge, 1994), 86.

54 Ann Bermingham, "The Picturesque and Ready-to-wear Femininity," in Copley and Garside, eds, *The Politics of the Picturesque*, 89–90. See also Sara Suleri, "The Feminine Picturesque," in *The Rhetoric of English India* (Chicago: University of Chicago Press, 1992), 76: "The picturesque becomes synonymous with a desire to transfix a dynamic cultural confrontation into a still life."

55 See Mildred Archer, "'The Talented Baronet': Sir Charles D'Oyly and his Drawings of India," *Connoisseur* 175, November 1970: 173–81.

56 Recent discussions of the history of the country estate and landscape garden have clarified the importance of the arcadian associations for the English gentry. See especially, Barbara K. Lewalkski, "The Lady of the Country-house Poem"; and William A. McClung, "The Country-house Arcadia," both essays in *The Fashioning and Functioning of the British Country House*, a 21-article anthology, *Studies in the History of Art* 25 (1989), 262; 281–4.

57 According to Curzon, "Barrackpore Government House," vol. 2: 40, "The first Lord Elgin complained [in 1862] that there was only one private walk left to him, namely that along the river bank to Lady Canning's grave, and that the whole of the Garden as well as the Park was open to the public."

58 Francis G. Hutchins, "British Indian Society: A Middle Class Aristocracy," in *Illusion of Permanence* (Princeton: Princeton University Press, 1967), 107–8.

59 Ibid.

60 By the mid-century the numbers of Anglo women on the subcontinent had increased in part because of improved living conditions and in part as a response to societal pressures for an "appropriate" female complement to the European male contingent, which might be morally

compromised by the allure of dark skins. See Kenneth Ballhatchet, *Race, Sex, and Class under the Raj: Imperial Attitudes and Policies and Their Critics, 1795–1905* (London: Weidenfield and Nicolson, 1980): 5; also Suleri, "The Feminine Picturesque," 76.

61 Heathcote, "Samuel Bourne," 110; the child, Constance Edith, was born in 1869.

62 Harriet Tytler, *An Englishwoman in India: The Memoirs of Harriet Tytler*, intro. by Philip Mason (Oxford: Oxford University Press, 1986), ix–x; 147; 171–2.

63 Ibid., 172.

64 This thesis underlies Thomas R. Metcalf, *Ideologies of the Raj*, part 3, vol. 4, The New Cambridge History of India (Cambridge: Cambridge University Press, 1994); see especially chap. 4, "The Ordering of Difference", 113–59.

6

PICTURING ALTERITY

Representational strategies in Victorian type
photographs of Ottoman men

Ayshe Erdogdu

Photography emerged in the Victorian age during a period marked by ever-increasing British colonial power and the ascendancy of scientifically informed studies of race and culture. This climate fostered a growing enthusiasm among the general public for representations of life and culture in areas of British involvement. In response, itinerant European operators active in remote parts of the world supplied images of the life and culture they encountered to consumers at home. Their ranks were soon swelled by indigenous entrepreneurs who learned the profession from them and produced in part for the same markets. Owing to its proximity to Western Europe, Istanbul attracted a steady flow of visiting photographers and was one of the first capitals to develop its own photographic industry.[1]

An important portion of the commercially marketed photographs from Istanbul (and other non-Western capitals) consisted of representations of men and women considered "typical" of their respective cultures in physical appearance or occupation.[2] When they employed only one or a few models, such photographs were usually taken in the studio and portrayed the subjects in mid-action while practicing their trade, or in settings that characterized their ethnicity (figures 6.1 and 6.3). Owing to limitations of space in the studio, compositions employing several models were most effectively taken outdoors (figure 6.2).[3] These photographs were marketed under the category of "types" in the sales catalogues of major studios in Istanbul throughout the nineteenth century.[4] While the representations of female types from the Middle East have received considerable scholarly scrutiny in recent years, type photographs of Ottoman men have attracted almost no attention.[5] The present discussion therefore concentrates on a representative selection of male type photographs from the 1870s and 1880s as a case study for examining the function of photographs of non-Western male types in general in Victorian markets.

It was more than the rage for Orientalism that triggered Victorian public's interest in images of Istanbul and its residents. Politically aligned with the Ottomans against the Russians, Britain was an enthusiastic supporter of the Empire's territorial integrity and its attempt to modernize its military, administrative, and educational institutions. This reform project, known as the *Tanzimat* movement (1839–1909), was initiated by the growing Ottoman concern over the disintegration of the empire due to independence movements and military defeats.[6] As the leading industrial power of the time,

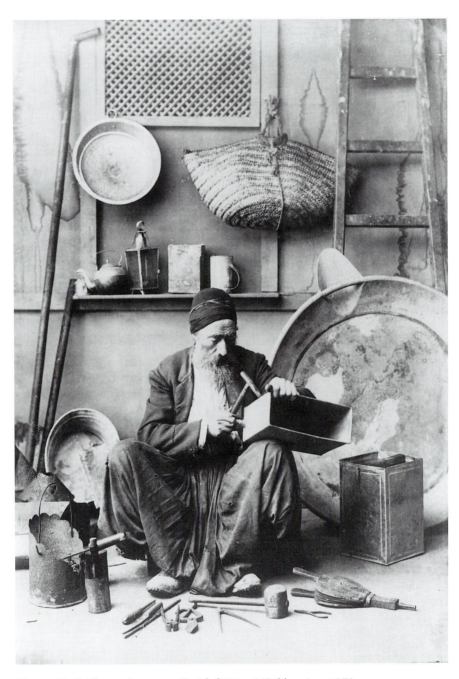

Figure 6.1 Guillaume Berggren, *Untitled (Löter)* (Solderer), c. 1870s.

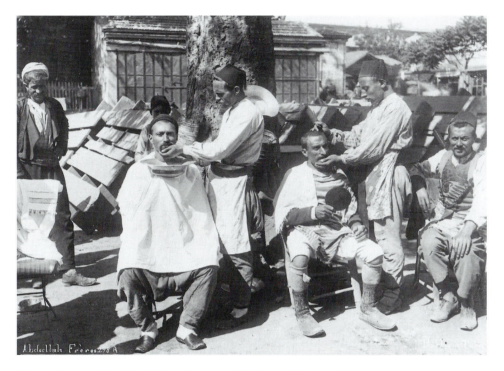

Figure 6.2 Abdullah Frères, *Barbiers turcs* (Turkish barbers), c. 1880s.

Britain exported the technologies the Ottomans needed, and thereby gained a direct hand in the supervision of the modernization process. Especially in times of war (for instance, the Crimean War of 1853–56 and the Turco-Russian War of 1876–78), the *Illustrated London News* and other British periodicals devoted extensive coverage to the "Eastern Question," which further stimulated the reading public's curiosity about Ottoman culture.

The rebuilding of institutions along Western lines provoked transformations in Ottoman society which were particularly striking in the capital. The traditional social structure, consisting of the aristocracy, merchants, peasants, and laborers, was disrupted by modernization and large-scale immigration of Turkic peoples from lost Ottoman territories.[7] The new military and bureaucratic elite, together with the mercantile Christian minority classes, occupied one end of the social scale and accumulated an ever-increasing share of the available capital. These groups expressed their Europhile interests outwardly by adopting Western attire. At the other extreme, the bulk of the population, comprising small-scale merchants, artisans, and a steadily growing economically compromised population of manual and menial laborers, generally retained traditional costumes. These remnants of older (albeit impoverished) Ottoman culture, readily visible on the city's streets, provided rich resources to illustrators and photographers intent on providing images of daily life in Istanbul to Western audiences. Ottoman studios competed with itinerant British photographers for a share of the affluent Victorian market by appealing to their audience's fondness for

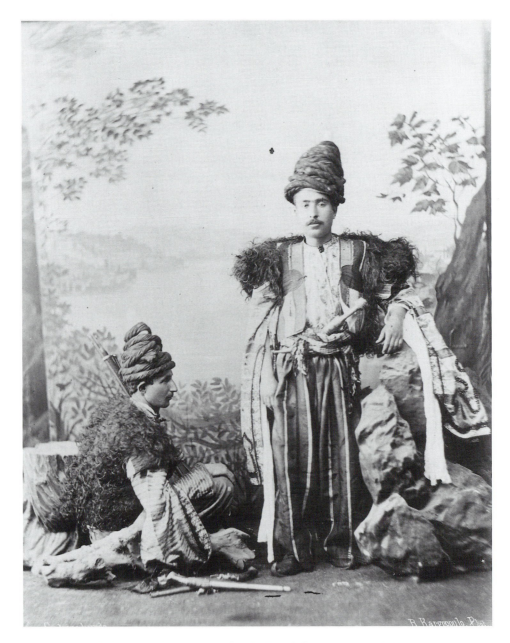

Figure 6.3 Basile Kargopoulo, *Costumes kurdes* (Kurdish costumes), c. 1880s.

the picturesque. In vogue in Britain since the eighteenth century, this taste persisted throughout the nineteenth century as the preferred mode of representing peoples and ways of life on the fringes of industrialized metropolitan modernity.

The demand for representations of types from non-Western areas grew especially out of the intellectual and ideological climate of the Victorian era. As the century

progressed, the Western European sense of difference from peoples in peripheral areas, by which is meant any area that had been colonized or depended on the importation of Western technologies, was increasingly buttressed by an array of race-based theories of comparative social evolution. The common denominator of these views, which ultimately determined audience expectations of what constituted a believable photograph of a non-Western type, was the superiority of the industrialized, Protestant Anglo-Saxons over all other peoples. Commingled with this attitude was a belief that it was incumbent upon Britain to guide those cultures that had fallen behind out of their backwardness. This ideological climate, which indirectly determined the photographers' representational strategies, assured the circulation of their works in a marketplace dominated by the ideologies of the colonialist power structure.

A study of two Kurds from the 1880s by Basile Kargopoulo (active 1850–c. 1910) demonstrates how Ottoman photographers capitalized on representational conventions already popularized by English illustrators of Ottoman types during the first half of the nineteenth century (figure 6.3).[8] One of the elaborately costumed tribesmen is presented in profile sitting on the floor, while the other leans against a papier-mâché rock and faces the viewer directly. An identical arrangement is encountered, for instance, in a lithograph by Frederic Schoeberl (1775–1853) from 1821 that scrutinizes Kurdish costume from two perspectives.[9] This compositional formula, derived from nineteenth-century costume studies, eventually became the established mode for photographic documentation in anthropological studies.

Kargopoulo's inclusion of rustic props in this shot is another legacy from the works of nineteenth-century illustrators. For instance, the expatriate Maltese artist Count Amadeo Preziosi (1816–82) deploys spears and tents in a similar way in his watercolor of a Kurdish warrior (c. 1843) to allude to the nomadic lifestyle of this group.[10] Kargopoulo spices up his representation further with compositional adjustments that capitalize on Orientalist themes familiar from French academic painting. The costumes and the graceful pose of one of the men in the photograph lend an effeminate character to the subjects that reminds the viewer of the themes of homosexuality in paintings such as Anne-Louis Girodet de Roucy Trioson's *Revolt in Cairo* (1810). In this work, an effeminate Mamluk prince in similar dress swoons into the arms of his muscular bodyguard. In both Kargopoulo's study and the painting, the delicacy of the Oriental subject is juxtaposed to a rugged setting: a ferocious battle in the painting and, in the photograph, a rural scene created with props such as papier-mâché rocks and straw spread on the studio floor.

The actual props utilized by photographers did not always measure up those imagined by painters as also seen in a shot of a Turk from the 1880s by the expatriate Swedish photographer Guillaume (Pehr Vilhelm) Berggren (1835–1920) in figure 6.4.[11] The model, casually seated on a divan in a distinctly non-Western manner with one leg folded underneath him, is surrounded by cheap, hand-made objects conventionally associated with the daily habits and the religion of the Turks. Holding the stem of a hookah, with a glass of water and a cup of coffee within easy reach, he seems prepared for a long period of repose and meditation, suggested by the prayer beads in his hand and the Qur'an tucked under his shirt. The uniform light and the flat background spanning two-thirds of the composition direct the viewer's attention to his physiognomy and the lethargy expressed in his face.

A similar theme of indolent sensuality is communicated by the lighting effects and

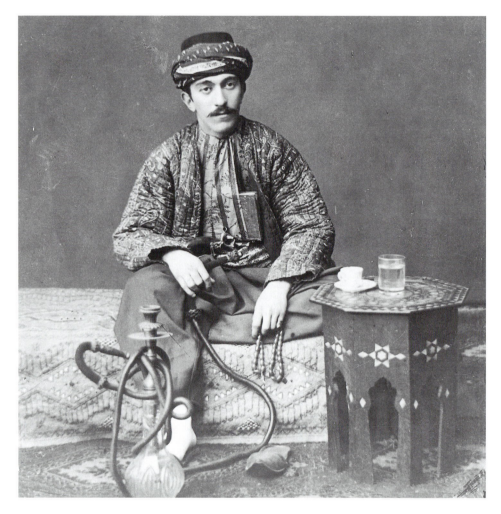

Figure 6.4 Guillaume Berggren, *Untitled* (Junger Türke) (Young Turk), c. 1880s.

setting of Sébah & Joaillier's *Paysan Turc fumant le narguilé* from the 1880s (figure 6.5). A shabbily dressed street vendor sits on a crude stool next to his basket of wares drinking coffee and holding the stem of a hookah in one hand. Just as the leisurely pose of Berggren's young Turk underscores his religiously motivated passivity, the slouching posture of this model implicitly ascribes his impoverished condition to a lack of initiative. A soft light from the left focuses attention on the furrowed face of the old man and his pitiable state. His passivity, contrasting sharply with the energetic and proud bearing of Ottoman street vendors in illustrations from previous centuries, is emblematic of the change in European perceptions of the Turks following the triumph of industrialism.[12] A people that had once aroused anxiety and grudging admiration now elicited disdain and condescension for their alleged indolence.

Such colonialist attitudes were imbedded in artistic practices derived from picturesque conventions. Surrounded by a torch, bellows, tin-snips, and other simple

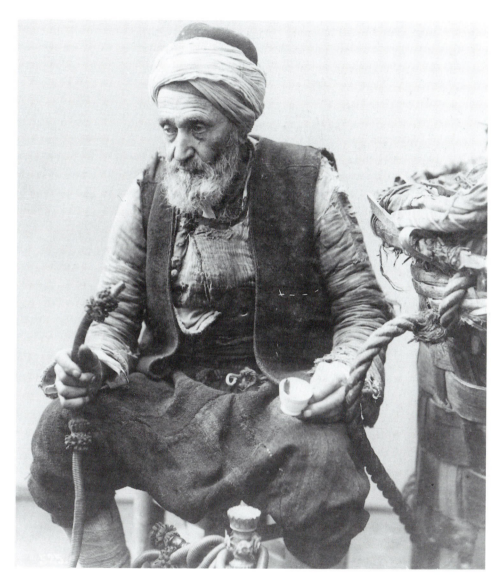

Figure 6.5 Sébah & Joaillier, *Paysan turc fumant le narguilé* (Turkish peasant smoking a *narguilé*). c. 1880s.

tools of his trade, the solderer in an untitled photograph from the 1870s by Berggren is busily engaged in constructing a square metal box (figure 6.1). Daylight flooding in from the left dramatizes the time-worn face of the bearded old man who squats in the middle of the studio floor. Such aestheticizing representations of antiquated modes of production delighted the sensibilities of the nineteenth-century elite. As early as 1810, the influential landscape designer and affluent country squire Sir Uvedale Price (1747–1829) identified the best examples of picturesque beauty in obsolescent aspects of agrarian reality, including certain marginal people:

113

In our own species, objects merely picturesque are to be found among the wandering tribes of Gypsies and beggars; who in all the qualities which give them that character, bear a close analogy to the wild forester and the worn-out cart horse, and again to old mills, hovels, and other inanimate objects of the same kind.[13]

Even several decades later this aesthetic preference continued to inform the technical suggestions in Victorian photography manuals, which advised operators to capitalize on dramatic lighting effects in order to bring out a subject's character.[14]

Many of the type studies that circulated in the Victorian marketplace, however, were produced with much less attention to aesthetic refinements. A shot of a group of seven Mevlevî dervishes taken by an operator of the Ottoman studio, Sébah & Joaillier (established by Pascal Sébah in 1857), which studies a particularly colorful emblem of Ottoman ethnicity and culture, relies almost exclusively on its subject matter to engage the viewer (Figure 6.6).[15] Three of the whirling dervishes play musical instruments, while another sings from a songbook and the remainder raise their arms in random gestures meant to mimic Sufi dances.[16] All seven models are dressed in authentic costumes, but, as in treatments of dervishes by artists from previous centuries, the static poses and gestures of the men could not begin to express the remarkable spinning movements of the Mevlevi rituals.[17] Conventional studio props, such as an inlaid coffee table, a wooden room divider and a landscape backdrop, interfere with the already overcrowded composition. The ineffective positioning of the shortest model between two much taller men further confuses the scene.[18] These formal shortcomings were apparently overlooked by a public

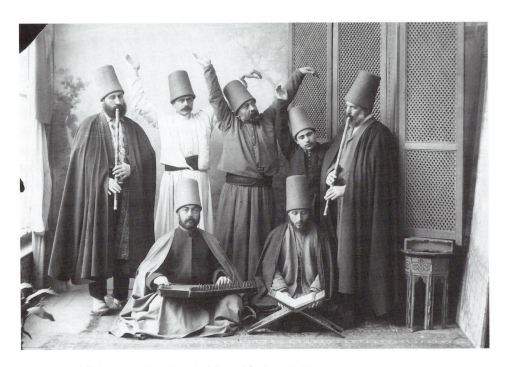

Figure 6.6 Sébah & Joaillier, *Untitled (Dervishes)*, c. 1880s.

interested primarily in unfamiliar Ottoman rituals.[19] In this respect, such photographs followed in the tradition of Orientalist paintings and illustrations of mystic ceremonies which reduced the subject matter to a mere Oriental spectacle.[20]

Limited space and problems with lighting in the studio encouraged photographers to shoot action scenes with multiple models outdoors. A photograph from the 1880s by the Abdullah Frères (active in Istanbul from the 1850s through c. 1920) of a group of barbers at work in the shade of a tree documents different aspects of the practice of that trade within a striking compositional format (figure 6.2). Two barbers with customers occupy the center of the foreground, the one on the left enacting the beginning of the shaving process, while his colleague on the right is busy with the final touches as his customer inspects the results in a mirror. At the far right, a third barber sits waiting for business, and a man standing purposelessly behind his empty chair on the left imparts a casual note to this highly composed photograph. The ragged clothing of the barbers and their customers, the crude chairs, and a heap of discarded boards against the tree in the center of the composition characterize the economic situation in the city.

This approach ignores the orientalizing practices of conventional media. Contemporary illustrations such as Preziosi's watercolor of a barber shaving a customer (c. 1843) drew their appeal exclusively from the colorful costumes and ethnic type of the subjects, evidently Tatars from Central Asia in this case.[21] In the golden light which typically suffused these works, nothing assaults the aesthetic sensibilities of the viewer. The Abdullah Frères, on the other hand, capitalize on the immediacy of their medium to present the impoverished types in a setting of realistic urban squalor that imparts a level of authenticity to the image that has no parallels among works in traditional media.

Sébah & Joaillier's equally well-composed photograph of a fruit vendor displays a far more commonly encountered approach, which draws directly on the conventions of nineteenth-century illustrations (figure 6.7). Here two customers hold a handkerchief between them to wrap up the quinces a vendor has just weighed out. A pleasant sunlight from the right brings out the textures of the cobblestones and the carved fountain while dramatically highlighting the faces of the figures. The overall effect is to aestheticize the composition, despite the economic deprivation betrayed by the shabby costumes and the dilapidated setting.

Whether their images relied on conventional stylistic means or capitalized more directly on the unique capacity of the medium to capture a fleeting moment in the daily lives of the subjects, photographers addressed the most broadly appreciated tastes of the Victorian public. In 1856, the critic John Ruskin (1819–1900), reacting to the shopworn conventions of the picturesque aesthetic, wrote in the fourth volume of *Modern Painters*:

> Now if this sublimity [picturesque] be sought for by the painter without regard for the real nature of the thing, and without any comprehension of the pathos of character beneath, it forms the low school or the surface picturesque; that which fills ordinary drawing books and scrap books But if these same outward characters be sought for in subordination to the inner character of the object, every source of pleasurableness being refused which is incompatible with that, while perfect sympathy is felt of itself in the sorrowful by-words, we have the school of true or noble picturesque.[22]

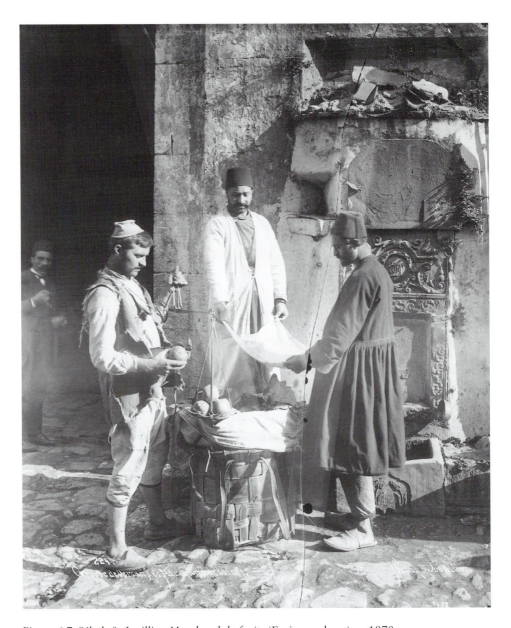

Figure 6.7 Sébah & Joaillier, *Marchand de fruits* (Fruit merchant), c. 1870s.

The distinction between the high and low schools of the picturesque rested in essence on the degree of sympathy aroused in the artist or the viewer by the scene. In this sense, the hard-working, robust subjects in Abdullah Frères' *Barbiers turcs*, the fatigued old man in Sébah et Joaillier's *Paysan turc*, or the poverty of the old solderer in Berggren's study may have been intended to arouse sympathy with the plight of the subjects. As will be discussed, however, such empathetic responses were subverted by the intellectual

116

climate of the positivist era that relegated these photographs to the role of evidence for the new theories of racial and societal development.

Photographic type studies were distinguished from counterparts in traditional media by their ability to combine picturesque signifiers with highly detailed and apparently candid views of the physiognomy and costume of non-Western peoples. This, above all else, was the determining factor that assured their continuous circulation and ultimate triumph over illustrations in the Victorian publishing market. As early as the 1850s and 1860s, prints made from photographs of Istanbul appeared regularly in newspapers such as the *Illustrated London News* and in widely read travel accounts such as Walter Thornbury's *Turkish Life and Character* (1860). As the century and reproduction technology progressed, photographs themselves were increasingly incorporated into books such as De Amicis's *Constantinople* from 1896 and the 1893 edition of Charles Dudley Warner's *In the Levant*.[23]

The picturesque was accepted in the Victorian period as the appropriate aesthetic vocabulary for articulating the racial, political, and economic difference of peripheral peoples from the normative English audience. Thus, photographers in all non-Western areas operated within similar representational parameters; the minor differences in subject matter from one area to another resulted mainly from the political status of the country of origin and the willingness of the subjects to be photographed. In Italy, for example, photographs by Carlo Ponti (1820–93) of vendors from Malta, Venice, and Aden, alone or occasionally with customers, are reminiscent of Ottoman shots such as Sébah & Joaillier's fruit vendors (figure 6.7).[24] Unlike their counterparts from Istanbul, however, Ponti's works underscored the economic difference between the occupational types and their customers by means of differences in quality of attire which are much more striking than those in figure 6.7. Another difference between the Italian and the Ottoman examples is their inclusion of children as marginal types. In *Naples, Street Urchins* by the Alinari brothers, for instance, destitute street children play and make obscene gestures at the camera.[25] Sébah & Joaillier's catalogues, the only extant examples from Ottoman studios, include no photographs of children at all.

Studies of occupational types from Spain correlate more closely to the examples from Istanbul in their almost exclusive concentration on menial service providers. Some outdoor shots, such as José García Ayola's *La cuesta del Aljibertillo, Granada*, in which a Gypsy street peddler and an Andalusian woman are enveloped in a setting with Moorish architecture, resemble Sébah & Joaillier's fruit vendor in their integration of the subjects into culturally specific settings (figure 6.7).[26] In Istanbul, however, the male types are never depicted interacting with women, presumably because of taboos in Islamic society. Lucien Levy's *Barberos en el Puente de Serranos* (c. 1890) from Valencia recalls Abdullah Frères' photograph of barbers in its representation of multiple figures in a nondescript urban setting (figure 6.2).[27] Other occupational type studies such as the shot of a knife-grinder from 1895 by an anonymous photographer working under the pseudonym Zorraquin, resemble Berggren's solderer (figure 6.1) in the aesthetic portrayal of a manual trade with the inclusion of an array of quaint tools and props.[28]

As in all peripheral areas, representations of types from China routinely examine the costume and physiognomy of their subjects through multiple stationary poses and culturally distinctive props. Studio shots by the British photographer John Thomson (1837–1921), for instance, employed this compositional format, which is comparable

to Kargopoulo's photograph of two Kurds, but the Chinese examples lack the sexual undertones of the Ottoman counterpart (Figure 6.3).[29] For his *Itinerant Tradesman, Kukiang, Kiangsi* of 1868, which surveys a range of exotic Chinese occupations, comprising a soup vendor, a public scribe, a barber, and a wood turner, Thomson composed an elaborate outdoor scene resembling the candor of the Abdullah Frères barbers.[30] The British photographer W. Saunders (active c. 1862–88) employed primitivizing props such as straw scattered on the studio floor – evocative of the rustic settings familiar from Ottoman examples – in his representation of a Chinese *Traveling Restaurant*.[31]

Occupational type studies from India taken by European operators span a much wider social range overall than their counterparts from Istanbul. At one extreme, photographs of affluent merchants and noblemen are commonly encountered in India but are virtually unknown among type studies from Istanbul. A study of a merchant from Gujarat (c. 1895) by an anonymous Western photographer, for example, shows the subject in an elaborately embroidered robe, seated in front of a classicizing backdrop and surrounded by equally picturesque textiles and props.[32] A typical example of the many occupational type studies featuring ordinary Indian tradesmen is a studio shot of a tailor from Jodhpur from the 1890s by an anonymous Western photographer. As in Berggren's photograph of the solderer, this subject crouches on the floor amidst the simple tools of his manual trade.[33] Outdoor shots of occupational types from India depict menial occupations ranging from a barber cutting a customer's hair to spinners and snake charmers in generally simple compositions.[34]

The preceding brief overview of photographic studies of types from already colonized countries like China and India suggests that the photographers in those areas chose a broader range of social classes than is encountered among examples from Istanbul, Spain, and Italy. This reflects not only a more intense curiosity among the European viewers, but also the greater availability of subjects to photographers in settings where Western colonial penetration was further advanced. Thus, type studies of affluent merchants and noblemen, while commonly encountered in India and China, are virtually unknown among export photographs from Istanbul, as are, at the other extreme, representations of abject poverty. Overall, however, the preference of photographers in all areas was still the marginal strata of society. In the Victorian era, the vogue for the picturesque determined these subjects as well as most of the stylistic choices photographers made to assure commercial success.

At least as important as geopolitical and aesthetic factors in shaping public interest in type studies from Istanbul and other non-Western areas were the Victorian concern for social reform and the new "scientific" theories of racial and cultural development. These factors impacted audience expectations of the Ottoman type studies and indirectly shaped the photographers' practice through feedback from the marketplace. Collecting and classifying information on the living conditions and mores of marginal groups was the initial step in a Victorian "improvement" project that aimed at regulation and social reform at home, and "civilizing" intervention abroad. Henry Mayhew's (1812–87) *London Labour and the London Poor* (1851) and John Thomson's *Street Life in London* (first published 1877) were two major studies of marginality in the British capital that utilized photographs to address these concerns.[35] The representations of London's underclass in these works, one may note, display striking parallels to photographs of Ottoman types.[36]

Mayhew drew explicit correlations between the morality of the most incorrigible members of the British underclass, in his terms, "those that will not work," and non-Western peoples. His comments on Turkish morality illustrate his perspective:

> the Turk whom poverty does not compel to labor for his bread, passes the day in lounging on cushions, smoking, sipping coffee, winking with half-closed eyes on the landscape, dreamily indifferent to all external objects. Even the poor indulge in this idleness. They measure out the amount of labour sufficient to keep them from want, and spend the rest of their lives drowsily awaiting the sensual bliss promised them by their Prophet in heaven.[37]

Such stereotypes of Ottomans and other non-Westerners were fortified by the current intellectual climate shaped by positivistic theories of cultural development and the rhetoric of the "civilizing mission of Christianity."

Victorian discourse on race and culture was dominated by two major currents of thought: degradationism and progressionism. The first of these views, rooted in biblical notions of a fall from grace, held that peripheral peoples and those Westerners still unspoiled by modernity were spiritually closer to the lost original purity of mankind. In modern intellectual history, its most influential expression was Jean-Jacques Rousseau's (1712–78) notion of the noble savage, which retained considerable currency throughout the nineteenth century.

This appreciation of simpler peoples encouraged photographers to favor those segments of Ottoman society engaged in occupations requiring little if any skill and no education. It also manifested itself in the photographers' preference for ethnic subjects, costumes, and primitivizing props such as papier-mâché rocks and landscape backdrops as essential signifiers of the lifestyles of those allegedly less complicated groups. Even as late as the turn of the century, viewers' responses to such photographs were occasionally still imbued with a nostalgic yearning for the unencumbered spirit of the "noble savage."[38]

The second view, "progressionism," inspired more directly by the natural sciences, gained ascendancy by the 1860s. It held that societal forms were destined to progress from an original state of barbarism to civilization, as epitomized by contemporary English society. The stages of this process could be reconstructed by the comparative study of modern non-Western cultures, which were assumed to correspond to earlier stages in the progression of humankind towards Western civilization.[39]

In this intellectual milieu, the function and value of photographs of Ottoman and other non-Western types was determined primarily by their value as documents of the historical process. Thus, the array of tools in Ottoman photographs of occupational types such as Berggren's solderer was more than a mere stylistic device to structure space; these props were also crucial to the documentation of an earlier, pre-industrial mode of production already obsolescent in Victorian England (figure 6.1). Audience responses to such representations of manual labor were colored by the prominence of manual production in studies of the domestic underclass, where economic marginality was already sometimes associated with ethnic alterity. Viewers with these understandings expected photographic explorations of Ottoman underdevelopment to dwell on racial and religious factors.

Comments by Charles Darwin (1809–82) illustrate the Victorian penchant for

analyzing social and political phenomena in biological terms. In a letter to a friend from 1881, he wrote:

> I could show fight on natural selection having done more for the progress of civilization than you seem inclined to admit. Remember what risk the nations of Europe ran, not so many centuries ago, of being overwhelmed by the Turks . . . The more civilized so-called Caucasian races have beaten the Turkish hollow in the struggle for existence . . . At no very distant date, what an endless number of the lower races will have been eliminated by the higher civilized races.[40]

Darwin's theory of natural selection was applied by social scientists such as John Lubbock (1834–1913) to comparative historical analyses of a variety of societal forms, mores, and religions in which the West, and particularly Britain, inevitably won the highest ranking. In his history of civilization, for instance, Lubbock assigned world cultures on the basis of religion and technological achievement to a hierarchy of seven levels ranging from atheism among "savage" peoples to the (Protestant) Christianity of the West. As a monotheistic religion with a myth of creation, Islam merited the sixth level but was still ranked lower than Christianity because of its endorsement of moral corruption and its irrationality.[41] Leading opinion held that the importation of technology would not suffice in itself to civilize the periphery; it would have to be accompanied by a moral and ethical rejuvenation mediated by Western religious infiltration as well. These speculations were condensed in the press and political discourse into the catch phrase of the "civilizing mission of Christianity," as epitomized, for instance, by Lubbock:

> Thus, then, with the increasing influence of science, we may confidently look to a great improvement in the condition of men. But it may be said that . . . any moral improvement must be due to religion, not to science. This separation of the two mighty agents of improvement is the great misfortune of humanity, and has done more than anything else to retard the progress of civilization.[42]

In the Victorian colonial discourse, civilization was thus a quality that could be gauged by a group's conformity to the British norm. In addition to (Protestant) Christianity, this standard included Anglo-Saxon rationality, the work ethic, and self-restraint. Robert Knox (1791–1863), for instance, in his widely popular *Races of Man*, quoted a mid-century cleric who appealed to British ethnic and religious chauvinism in a sermon to request funds to erect a church in Istanbul:

> England had . . . by the gift of God . . . the most exhaustless opulence, . . . the wealthiest, the most active manufacturers with the most intelligent artisans and the wealthiest, best-clothed, best-fed and manliest peasantry in Europe; she had been gifted with the two great inventions of the age – the steam engine and the railroad . . . and those exclusive grounds of superiority she acknowledged to be the sole bounty of God as His gifts to the professor of the true faith of the scriptures.[43]

Knox interpreted history as a drama of the survival and extinction of different races.[44] A central point in his argument was the superiority of "pure" or homogeneous races over "hybrids."[45] He ascribed the underdevelopment of the Ottomans not only to Islam, but also to their Central Asian Tatar origins and their indiscriminate intermarriage with Byzantines and Semitic peoples after their conquest of Asia Minor. Such race-mixing was believed to predestine them to stagnation and expulsion from their remaining European domains, unless they consented to the civilizing assistance of Britain.

Photographers addressed these understandings with a variety of adjustments that explored the economic, cultural, and moral identity of the Ottoman types with stereotypes of poverty, idleness, irrationality, and homosexuality. These fixed characterizations, as important discursive strategies in the ideology of the civilizing mission of Christianity, played a crucial role in constructing the antithetical identities of the Victorian audiences and the subject peoples alike in the age of high colonialism.[46] Accordingly, the photographers in Istanbul represented occupational types engaged only in menial services or peddling, and never in the production of goods (figures 6.1, 6.5, 6.7). It is striking that the sales catalogues of major studios in Istanbul include no representations of even traditional Ottoman artisans, whose products were valued in the West and who would, one assumes, have been of some interest there. Moreover, the types were commonly photographed in seated or stationary poses suggestive of their innate passivity. Particularly those identified as Turks were represented with lethargic expressions, as if they had interest in nothing other than sensual gratification (figures 6.4, 6.7).

Similarly, the presence of Muslim religious paraphernalia such as the Qur'an and the prayer beads in photographs such as Berggren's study of the young Turk implicitly linked the indolence of the subjects to the lack of a work ethic in their belief system. Comments on such photographs by the travel writer Edmondo de Amicis (1846–1908) indicate the stereotypes they were calculated to address:

> In this art [idleness], however, the Turk yields to none. He can make a cup of coffee . . . last half a day, [and] sit immovable for five hours at a stretch . . . His indolence is a thing absolute and complete . . . a phase of existence completely unknown among Europeans.[47]

Photographers of Ottoman types extensively addressed another aspect of Islam, its presumed irrationality, extensively in sensationalized portrayals of dervishes, represented by no fewer than twenty-three examples in the sales catalogue of Sébah & Joaillier's studio.[48] Simple formal adjustments such as the effeminate pose and costume of the models in Kargopoulo's photograph of two Kurds appealed to the prejudices of a Victorian audience familiar with French academic themes of Oriental decadence. Photographs such as this merely confirmed the fixed European understandings of the moral decadence of Oriental men as expressed in their assumed homosexuality and effeminateness.

As previously noted, the conventions employed by photographers in Istanbul were largely congruent with the strategies of operators in other peripheral areas. Representations of costumed subjects engaged in menial service occupations predominated everywhere, but in areas such as China and India, where Western economic and political penetration was further advanced, commodity producers, albeit working by

hand, were occasionally represented as well. In this respect, studies of Ottoman types more closely resemble those from pre-industrial areas of Europe such as Spain, which were nominally sovereign but economically dependent on exported technologies. The photographers in those marginal parts of Europe constructed the alterity of their subjects on their lack of industrial production, an objection that was supplemented in the Ottoman case by an additional emphasis on religious difference as the source of moral and economic decadence.

The scientific, literary, and visual stereotypes of the Ottomans and other peripheral peoples that circulated in the social body during the Victorian period were examples of the type of pervasive, self-regenerating accumulation of "knowledges" that Michel Foucault has characterized as a "regime of truth":

> Each society has its regime of truth, its "general politics" of truth: that is the types of discourse which it accepts and makes function as true; the mechanisms and instances which enable one to distinguish true and false statements, the means by which each is sanctioned; the techniques and procedures accorded value in the acquisition of truth; the status of those who are charged with saying what counts as true.[49]

This body of understandings accordingly shaped the educated audience's expectations of the style and subject matter appropriate to a study of a peripheral type. In order to be considered authentic enough to circulate in the market, a photograph had to conform to the premises of Victorian society's regime of truth, regardless of the nationality or intentions of the individual photographer who took it.

In search of commercial success, Ottoman photographers and Europeans alike embraced the style and subject matter of picturesque illustrations and Orientalist paintings, which were already coded with the ideology of cultural alterity. Despite its reputation for impartiality and immediacy, the photographic medium allowed skillful practitioners to manipulate camera angles, settings, and lighting unobtrusively for picturesque effect. Consumed as eyewitness documents of Ottoman reality, photographs of male types from Istanbul played a crucial role in authenticating and institutionalizing "scientific" knowledges of the Ottomans as degenerates in need of guidance from the West. In that sense, they participated in a circular exchange between scientific discourses, public opinion, and the mass media, legitimizing the colonial ambitions inherent to the Victorian rhetoric of the civilizing mission of Christianity.

Notes

1 Engin Çizgen, *Photography in the Ottoman Empire 1839–1919* (Istanbul: Haset Kitabevi, 1987).

2 In 1885, the French anthropologist Paul Topinard defined a "type" as "the average of characters which a human race supposed to be pure presents." See George W. Stocking, Jr., *Race, Culture, and Evolution: Essays in the History of Anthropology* (New York: The Free Press, 1968): 58. Also see Elizabeth Edwards, "'Photographic Types': The Pursuit of Method," *Visual Anthropology* 3 (1990), 235–58.

3 The exact birthdates of the three Abdullah Frères, Kevork (d. April 12, 1918), Vichen (d. c. 1899) and Hovsep (d. July 14, 1902) are unknown. This major studio, active in Istanbul from the late 1850s on, participated in all available markets for photography: export photographs, government commissions and private projects.

4 Sébah & Joaillier, Photographes, *Catalogue général des collections des vues photographiques de Constantinople, Brousse, Adrianople, Smyrne, Ephäse et environs* (Constantinople, n.d.), 60 pp., and *Catalogue général des collections des vues photographiques de Istanbul, Ankara, Konia, Brousse, Adrianople, Smyrne, Ephèse et environs. Panoramas et albums* (Istanbul: Imp. L. Mourkides, n.d. [c. 1880]), 48–51.

5 See, for instance, Sarah Graham-Brown, *Images of Women: The Portrayal of Women in Photography of the Middle East 1860–1950* (London, Quartet Books and New York: Columbia University Press, 1988); and Malek Alloula, *The Colonial Harem* (Minneapolis: University of Minnesota Press, 1986); or Leila Kinney and Zeynep Çelik, "Ethnography and Exhibitionism at the *Expositions Universelles*," *Assemblage* 13 (1990): 38; and Irvin Cemil, "Representing Middle Eastern Women: Feminism and Colonial Discourse," *Feminist Studies* 16, 2 (1990): 345–80; among several others.

6 Westernization actually began during the reign of Mahmut II (1808–39), but his reforms were limited to the military. Abdul-Mejid (1839–61) and Abdul-Hamid II (1876–1905) extended them to the civilian and private sectors. See Bernard Lewis, *The Muslim Discovery of Europe* (New York: W. W. Norton, 1982), 85–98.

7 Kemal Karpat, "The Social and Economic Transformation of Istanbul in the Nineteenth Century," in *Istanbul à la jonction des cultures Balkaniques, Méditerranées, Slaves, et Orientales aux XVIième–XIXième siècles*, Actes du Colloque internationale organisé par l'AIESEE . . . Istanbul, 15–20 Octobre, 1973 (Bucharest, 1977), 403, and Tevfik Çavdar, *Millî Mücadelenin Ekonomik Kökenleri* (Istanbul: Kız Yayinlari, 1974), 58.

8 The Ottoman Greek Basile Kargopoulo established his studio in 1850. He additionally served as court photographer to Sultans Abdul-Mejid, Murad V (May 30–August 31, 1876), and Abdul-Hamid II (1876–1905).

9 Frederic Schoeberl, *World in Miniatures: Turkey, being a Description of the Manners, Customs, Dresses and Other Peculiarities Characteristic of the Inhabitants of the Turkish Empire* (London: R. Ackermann, 1821), vol. IV, 1.

10 Victoria and Albert Museum (D.20–1907). Reproduced in Briony Llewellyn and Charles Newton, *The People and Places of Constantinople: Watercolours by Amadeo Count Preziosi 1816–1822* (London: Victoria and Albert Museum, 1985), catalogue no. 5.

11 Pehr Vilhelm (later Guillaume) Berggren (born 1835), immigrated to Istanbul in 1866, and resided there with brief interruptions until his death in 1920. Soon after his arrival he set himself up in a studio at 414, Grande Rue de Pera, which soon became one of the major photography outlets in the city. The majority of his photographs, including his negatives, are collected in the Deutsches Archäologisches Institut in Istanbul.

12 See, for instance, Alexandrine St Clair, "A Forgotten Record of Turkish Exotica," *The Metropolitan Museum Art Bulletin* 27 (1969): 411, and Semavi Eyice, "Avrupalı bir Ressamın Gözü ile Kanunî Sultan Süleyman," in *Kanunî Armağan, Türk Tarih Kurumu Yayınlarından*, VII. Seri (Ankara: Türk Tarih Kurumu Basımevi, 1970).

13 Sir Uvedale Price, Esq., *Essays on the Picturesque as Compared with the Sublime and the Beautiful and on the Use of Studying Pictures for the Purpose of Improving Real Landscape*, 3 vols (London: J. Mawman, 1810), vol. I, 63.

14 See, for example, the widely consulted manual by Mim Halit, *Amelî ve Nazarî Mufassal Fotoğrafya* (Istanbul: Mahmut Bey Matbaasy: 1308 [1892]), 28, 60. See Lady Elizabeth Eastlake, "Photography," *Quarterly Review* (March 1857), reprinted in *Classic Essays in Photography*, edited by Alan Trachtenberg (New Haven: Leete's Island Books, 1980): 61: "Strong light and shade will portray character, though they mar beauty. Rougher skin, less glossy hair, Crimean moustaches and beard overshadowing the white underlip, and deeper lines, are all so much in favor of a picturesque result. Great grandeur of feature too, or beauty of pose and sentiment, will tell as elevated elements of the picturesque in spite of photographic mismanagement."

15 This most prolific of Ottoman photography establishments was continued by Sébah and his successors well into the 1930s. He was joined in the 1870s by the expatriate Frenchman Polycarpe Joaillier (1838–1904). In addition to a large volume of export photographs, the firm also undertook a number of government commissions. Its archive is located in the Deutsches Archäologisches Institut in Istanbul.

16 The ceremonies of the Mevlevî dervishes involve progressively faster spinning to music as the disciples turn in a circle around their sheikh, or leader. Spinning signifies the individual's recognition of the omnipresent God wherever he turns, and the large circle around the sheikh represents the cosmos centered on the Earth. Their arms must be raised, the right hand facing Heaven to receive the blessings and generosity of God and the left pointing down to signify their passing the blessings on to following generations. See Renate Schiele and Wolfgang Müller-Wiener, *19. Yüzyılda Istanbul Hayatı* (Istanbul: Apa Ofset, 1988), 104.

17 See, for instance, Hogarth's engraving *The Inside of a Mosque* (1723), reproduced in *Hogarth's Graphic Works: First Complete Edition*, ed. Ronald Paulson (New Haven: Yale University Press, 1965), vol. II, pl. 27.

18 Mim Halit, *Amelî ve Nazarî Mufassal Fotoğrafya*, 63.

19 See the discussion of Western depictions of peripheral religious practices in Catherine Lutz and Jane Collins, *Reading National Geographic* (Chicago: University of Chicago Press, 1993), 276.

20 Lynne Thornton, *The Orientalists* (Paris: ACR Edition, 1985), see pls. 218 and 121, among others.

21 Victoria and Albert Museum (D.33–1907). Reproduced in Llewellyn and Newton, *The People and Places of Constantinople*, catalogue no. 10.

22 John Ruskin, *Modern Painters* (London: J. M. Dent & Co., 1856), vol. IV: 6.

23 See Walter Thornbury, *Turkish Life and Character* (London, 1860); and Charles Dudley Warner, *In the Levant* (New York and London: Houghton, Mifflin & Co., 1893), 2 vols.

24 Carlo Ponti, in an untitled album of 125 Photographs from Malta and Venice, c. 1862, Gernsheim Collection, Harry Ransom Center, Austin, Texas.

25 It is unknown which of the Alinari brothers – Romualdo (1830–91), Leopoldo (1832–65), or Giuseppe (1836–91) – is responsible for this photograph. See *Alinari, Photographers of Florence, 1852–1920*, edited by Filippo Zevi (Florence: Alinari Edizioni and Idea Editions, in Association with the Scottish Arts Council, 1978): pl. 91.

26 Lee Fontanella, *Photography in Spain in the Nineteenth Century*, Exhibition Catalogue, Jan. 4–Feb. 11, 1984 (Dallas: Delahunty Gallery and San Francisco: Fraenkel Gallery, 1984).

27 Publio Lopez Mondejar, *Las fuentes de memoria: fotografia y sociedad en la España del siglo XIX* (Barcelona: Lunwerg Editores, 1989), vol. I, 200.

28 Lopez Mondejar, *Las fuentes de memoria*, vol. I, 60.

29 Clark Worswick and Jonathan Spence, *Imperial China: Photographs 1850–1912* (New York: Pennwick Publishing Co., 1978), pl. 105.

30 L. Carrington Goodrich and Nigel Cameron, *The Face of China As Seen by Photographers 1860–1912* (Millerton, NY: Aperture, 1978), 65.

31 Worswick and Spence, *Imperial China: Photographs 1850–1912*, 114.

32 Judith Mara Gutman, *Through Indian Eyes* (New York: Oxford University Press, 1982), 62.

33 Gutman, *Through Indian Eyes*, 142.

34 Gutman, *Through Indian Eyes*, 143, 165 and 176.

35 Henry Mayhew, *London Labour and the London Poor: Cyclopedia of their Condition and Earnings*, 4 vols (London: Bohn & Co., 1862). Also see *Street Life in London*, Text by Adolphe Smith, Photographs by John Thomson (London: Benjamin Plom Inc., 1877).

36 For instance, a woodcut after a daguerreotype by Richard Beard, *London Coffee Stall*, from Mayhew's book, depicts the interaction of a street vendor with customers in a style similar to Sébah & Joaillier's *Marchand de fruits* (cf. figure 6.7). See Mayhew, *London Labour and the London Poor*, vol. I, 185. And Thomson's *Covent Garden Labourers* (*Street Life in London*, 74) resembles Abdullah Frères' photograph of barbers in its demonstration of several aspects of the practice of a menial occupation (figure 6.2). Unlike the Ottoman example, however, Thomson's photographs frequently underline an ethnic distinction between the English customers and the Irish, Jewish, or Italian menials.

37 Mayhew, *London Labour and the London Poor*, vol. I, 155.

38 See, for instance, Frances Elliott, *Diary of an Idle Woman in Constantinople* (London, 1893): 4.

39 Stocking, *Race, Culture, and Evolution*, 74. See also Sir John Lubbock, *The Origin of Civilization and the Primitive Condition* (New York: D. Appleton & Co., 1871): 1.

40 Quoted in Annemarie de Waal Malefijt, *Images of Man: A History of Anthropological Thought* (New York: Alfred A. Knopf, 1974), 274.

41 Lubbock, *The Origin of Civilization*, 44–6.

42 Lubbock, *The Origin of Civilization*, 598.

43 Robert Knox, *Races of Man* (London: Henry Renshaw, 1862), 574.

44 Knox claimed support for his discourse on race and culture from prestigious scientists and writers such as Georges Buffon (1707–88), Goethe, Cuvier, Paul Broca (1824–80) of the Société d'Anthropologie de Paris, and, of course, Darwin. See Knox, *Races of Man*, 570.

45 Knox, *Races of Man*, 579; 584.

46 Homi K. Bhabha, "The Other Question . . . The Stereotype and Colonial Discourse," *Screen* 24, 6 (Nov./Dec. 1986): 18.

47 Edmondo de Amicis, *Constantinople* (Philadelphia: Henry T. Coates and Co., 1896), 198–9.

48 Sébah & Joaillier, *Catalogue générale des collections des vues photographiques de Istanbul, Ankara*, 50.

49 Michel Foucault, "Truth and Power," in *Power/Knowledge: Selected Interviews and Other Writings, 1972–1977*, ed. Colin Gordon (New York: Pantheon, 1980), 131.

THE MANY LIVES OF BEATO'S "BEAUTIES"

Eleanor M. Hight

These women have a feeling for the poetry of things, for the vast soul of nature, for the charm cast by flowers, forests, silence, moon-beams . . .

 They say these things in somewhat mannered verses, as graceful as those leaves or reeds painted on silks and lacquer ware, so natural and yet so fantastic . . . Might they be like their grandmothers, hero-ines of poems and courtly legends who valued a point of honor so highly, and revered the ideal of love?[1]

Pierre Loti

From the early seventeenth century until 1854, when the American naval hero Commodore Matthew C. Perry "opened" Japan to the West, Americans and Europeans had little exposure to the people and customs of Japan. From this moment of increased contact, records of the encounters between foreigners and Japanese women were recorded in the diaries, letters, official reports, and other writings of travelers, traders, and diplomats, as well as in the numerous visual records made by artists and photographers. The majority of the photographs made in Japan by foreigners from the 1860s to the 1880s follow along the lines of most travel photography of the time – topographical views, type photographs of the natives, occupation and genre scenes. Among the photographs of women, some fall in these general categories, but many also portray geishas and "beauties." Like the fictionalized romantic travel writings published by the French author Pierre Loti, the *nom de plume* of Louis-marie-julien Viaud (1850–1923), these photographs of women envision Japan as an erotic haven for European and American men. However, the depictions in these photographs, created primarily with prostitutes as models, are at odds with the historical evidence on the social status and daily existence of the women of the "pleasure quarters" set up in treaty ports, such as Yokohama, by the Japanese government for foreigners.

 The continuing pervasiveness of such Western fantasies of Japanese women can be found more than a century later in the juxtaposition of photographs made by nineteenth-century European photographers with selections from Loti's writing in Chantal Edel's book *Once Upon a Time: Visions of Old Japan* (1984). The fantasy of the Japanese woman rapturously described by Loti in passages such as the one above is paired in Edel's book with a photograph attributed to the Austrian photographer Baron Raimund von Stillfried, entitled *Portrait with a Fan*, c. 1880s (figure 7.1). In this

delicately hand-colored albumen silver photograph, a young woman is displayed sitting with her body turned toward her right, her head and gaze to her left. Her kimono is adjusted to bare her arms and right breast; her hands, which rest on her lap, hold a fan. Devoid of setting or other props, the image focuses on her face and partially exposed body. This is a striking comparison, Loti's text and Stillfried's photograph,

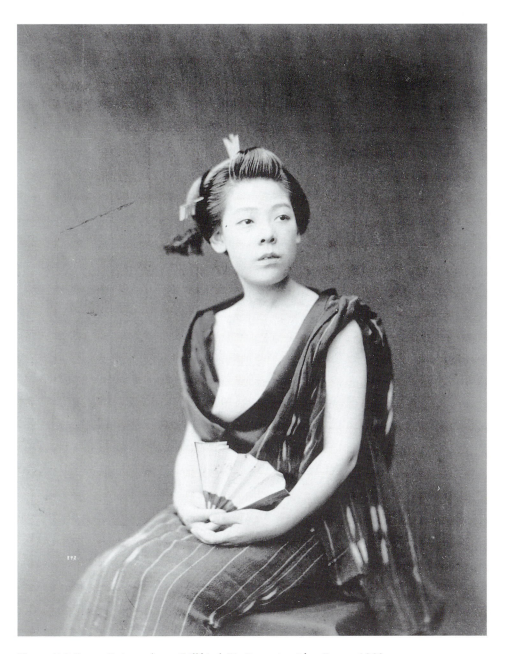

Figure 7.1 Baron Raimund von Stillfried (?), *Portrait with a Fan*, c. 1880s.

because they are conflicting views. The young woman is not a happy participant in the constructed fiction of the Japanese woman's sexual allure and availability. In fact, her expression, as well as the general tone of the photograph, might be better described as sorrowful. Rather than being enticed by an erotic enigma, the viewer today is left with unsettling questions. Who was the young woman? What were the circumstances under which such a photograph was made? And what could the market for such an image possibly have been?

The practice of staging such scenes of young Japanese women and their unfamiliar customs was initiated by the Venetian-born photographer Felice Beato (1825/34?–1908?) in Yokohama and carried on by those who took over his business or were trained by him, such as the Austrian Baron Raimund von Stillfried (1839–1911), and the Japanese native Kusakabe Kimbei (1841–1934). These photographers adopted imagery from contemporary Japanese ukiyo-e prints to create sexual fantasies of Japanese women that seem to conform to the Western construct of Orientalism. However, focusing on the overstretched Orientalist model would limit our understanding of the specific historical circumstances that have shaped and continue to expand the content of the photographs. Rather, this chapter attempts to reconstruct the relationship between the oppressed lives of the prostitutes/models, their contacts with American and European men, and the production and marketing of the photographs in Yokohama. Such a reconstruction demonstrates the manner in which a group of Japanese women – real women, not just women of the Western masculine imagination – unwittingly mediated the cultural differences between Japanese and Western men. Through photography these women, whose inferior social status and often cruel treatment was imposed upon them by the Japanese themselves, were transformed from prostitutes and entertainers into aesthetic and/or erotic images for the pleasure of the foreign male collector. Today many of these photographs languish in ethnographic archives and study collections, while occasionally they have entered the realm of art photography. With each relocation of the photographs over the past 130 years – from Yokohama photographer's studio, to Victorian parlor, to ethnographic collection, to art exhibition – the Japanese women depicted were reinvented for another purpose and became further removed from the lives they led in the nineteenth-century treaty ports of Japan.

Foreign men/Japanese women

The production of photographs of Japanese women by Beato and his followers was tied to the transcultural interactions and political economics specific to Japan in the third quarter of the nineteenth century. Through various entrepreneurial channels, foreign men could have erotic encounters with Japanese women, either with the women themselves or with fictional representations of them, such as those found in the writings of Loti or photographs by Beato. The foreign photograph collectors, who were primarily men, traveled to Yokohama for a variety of reasons. Yet, whether they came on behalf of their governments, for business purposes, or for their own pleasure, their lives seem to follow the general patterns of behavior identified in male travelers by Dennis Porter in his perceptive book *Haunted Journeys* (1991). Particularly relevant here is his thinking on the role of desire as fuel for traveling. According to Porter, "most forms of travel at least cater to desire: they seem to promise or allow us to fantasize the satisfaction of drives that for one reason of another is denied at home."[2]

According to this line of thinking, many American and European men were compelled to travel abroad by more than the upper classes' obligatory cultural education acquired through an extended Grand Tour. They were also lured by the thrill of the unknown, as well as by the possibility of adopting a lifestyle freed from the restrictions of Victorian society. As Porter points out, many male travelers also seem to have been driven by what Sigmund Freud called "scopophilia," or an obsession with the pleasures of looking. In his discussions of the travel writings of authors ranging from Flaubert to Freud, Porter finds evidence of "a scopic drive that we associate with realist description as well as voyeurism."[3] Japan offered foreign men a life that they could not create for themselves at home, and they could hang on to that experience by collecting art, artifacts, and photographs. Or they would adopt Japanese customs and beliefs, even by setting up a temporary Japanese household complete with a mistress. Far from Victorian eyes, foreign men could more easily satisfy their desires in Japan.

In the first several decades following the opening of Japan to the West, many of the limited exchanges that took place between European and American men and Japanese women were sexual in nature and were controlled by Japanese government officials and businessmen. From 1639 until Perry's arrival in the 1853, Japan had all but sealed its ports to the rest of the world; only the Chinese and the Dutch were allowed to trade through a tightly controlled outpost in the Bay of Nagasaki. Such strict control characterized the Tokugawa Shogunate (1603–1867), which sought to protect its authority from European imperialists and missionaries who began to circumnavigate the world looking for prey during the Renaissance. Before Perry's arrival, Nagasaki was the sole port open to European trade, and only to the Dutch, who were secluded in the bay on a small man-made island (perfect for the Dutch) called Dejima. After treaties had been signed in 1858 between Japan and the "Five Nations" – the United States, Russia, France, Great Britain, and the Netherlands – the Japanese opened additional ports to foreigners. Each of these ports had designated areas in which foreigners lived and were entertained. Since gender roles were clearly demarcated and rigidly enforced by Japanese men, Japanese women led extremely sheltered lives. Therefore, foreign men rarely came into contact with women other than "working women" – prostitutes, courtesans, and entertainers, as well as servants, shopkeepers, and peddlers.

The lives of the Dutch traders and their encounters with native women are recorded in their accounts, some of which were collected and then published by the German doctor Philipp Franz Siebold in 1841.[4] This "factory," or trading outpost, was established in 1641 and contained at a time ten to fifteen Dutchmen (rarely any women).[5] Measuring approximately 650 feet by 550 feet, it was surrounded by a stone wall with an opening for the gate to the sole bridge connecting the island to the mainland. Each Dutchman had to sign an oath, in blood, that he would neither develop friendships nor hold any discussions with the Japanese on topics other than trade, especially not on the customs, language, or history of Japan.[6] Travel between Dejima and Nagasaki was restricted in both directions and mostly limited to the necessities of trade. When the Dutchmen were allowed to go onshore, they were entertained at special apartments for foreigners or at teahouses, which were often connected to temples (figure 7.2). These teahouses provided both prostitutes and servants for the isolated foreign men. Female servants, with the exception of prostitutes, were only allowed on Dejima during

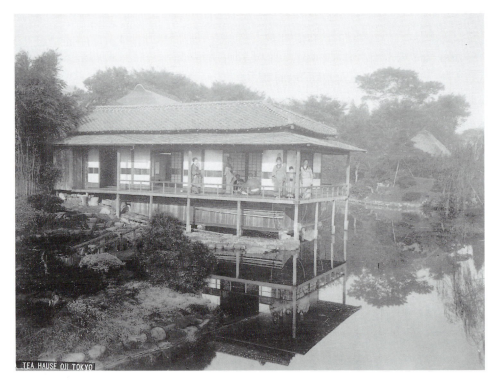

Figure 7.2 Felice Beato, *Women at a Tea House*, c. 1865.

daylight hours. No women whatsoever of "good character" were ever allowed to set foot on the island, as indicated by a signpost on the entrance gate.[7]

With the fall of the Tokugawa Shogunate, Japan underwent a period of unrest and transition during the Bakumatsu Period (1853–67). It was just as the shogunate was collapsing that Commodore Perry arrived in Edo Bay (now Tokyo Bay) on July 8, 1853, with a letter from the United States president, Millard Fillmore, requesting the opening of Japanese ports. For the Americans the primary interest in gaining access to Japan was in facilitating trade with China and whaling in the Pacific; previous attempts had failed. When Perry returned to Japan seven months later, the shogunate lacked the military strength to resist what it thought was Perry's mighty presence, his fleet of "black ships," six armed steamships belching coal smoke in the harbor of Shimoda. The result was an agreement signed on March 31, 1854, that opened the ports of Shimoda and Hakodate for coal and supplies, insured better treatment for stranded American sailors, and provided for the installation of an American consul at Shimoda.

Accounts of Perry's stay in Japan, including contacts with Japanese women, survive in the diaries and the published reports of Perry and his men, as well as in the illustrations made by both the Americans and the Japanese. The diary of Rear Admiral George Henry Preble offers especially revealing descriptions.[8] For example, a supply of women seemed to be an unwritten part of the trade agreement. While anchored in Edo Bay on February 24, 1854, Preble wrote:

The Lieut. Gov. of Uraga told some of our officers of course through the inter-
preters, that when the Treaty was signed we could have plenty of Japanese
wives, but said their women did not like mustachios, and hoped when the offi-
cers came to see them they would shave them off. From this we have decided
that henceforth in Japan, the morality of an officer is to be known by the
length of his mustache.[9]

Preble also found the Japanese lacking in morals. The next day he recounted his open-
ing of a Japanese gift to Perry: "Among the presents received by Com. Perry was a box
of obscene paintings of naked men and women, another proof of the lewdness of this
exclusive people."[10] Preble went on to describe the bathhouse in Shimoda visited by
the unmarried officers:

> from what I can learn the unmarried officers find their amusement in visits to
> the bath house where old and young, male and female are mingled promiscu-
> ously in a state of unblushing nudity to the gaze of strangers. The remarkable
> sensuality of the Japanese is everywhere evidenced by their habits conduct and
> actions.[11]

Such comments by Preble inform us about the contacts the American men had with
Japanese women, but they also indicate his already established prejudice that the
Japanese were strange and uncouth.

As was the custom at the time, Perry took along artists to record the voyage; these
included the American daguerreotypist Eliphalet Brown, Jr. (1816–86), who reportedly
made four to five hundred daguerreotypes on the trip.[12] Although most of Brown's
photographs were lost in a fire after he returned to the United States, reproductions of
some were published in the three volumes, entitled *Narrative of the Expedition of an
American Squadron to the China Seas and Japan*, which Perry presented to Congress
in 1856.[13] The illustrations in the *Narrative* were meant to provide visual records of
various aspects of the trip, such as ceremonial meetings between the Americans and the
Japanese; the life and customs of the Japanese; the topography, flora, and fauna of the
islands. Notations on some of the images indicate that Brown served both as an illus-
trator, who added figures to the views drawn by Wilhelm Heine, and as a
daguerreotypist, whose photographs were turned into lithographs and engravings for
some of the book's plates.[14]

According to Perry's interpreter, Samuel Wells Williams, Brown could not photo-
graph Japanese women since they were not supposed to leave their homes. Brown
managed to take such photographs nevertheless, as indicated by the illustrations made
from his daguerreotypes in Perry's *Narrative* and in a Japanese representation of him
at work.[15] The color lithograph entitled *Japanese Women from Shimoda*, made from
one of Brown's daguerreotypes, offers an example of the kind of "type" photograph he
made of the Japanese (figure 7.3). Brown utilized profile and frontal views of the seated
women to demonstrate the complexity and peculiarities (to Western eyes) of the
women's costume, with the obi tied in the back, and the coiffure, gathered up in a knot
and adorned with hair ornaments.

In the *Black Ship Scroll*, a series of images of Perry's expedition to Japan with
accompanying text from the mid-1850s, the anonymous Japanese artist depicted

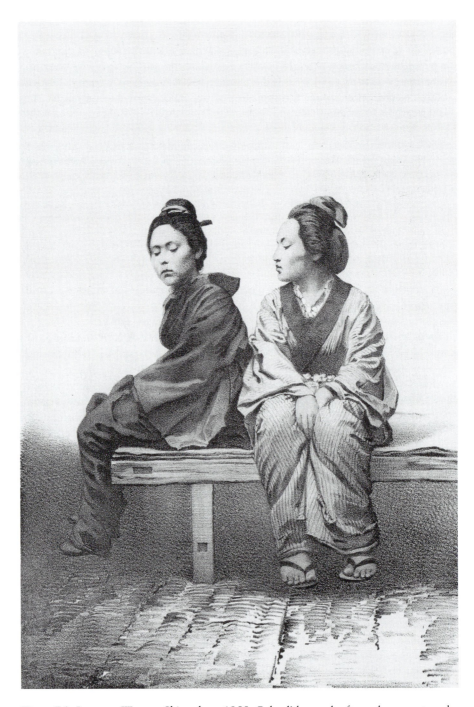

Figure 7.3 Japanese Women, Shimoda, c. 1855. Color lithograph after a daguerreotype by Eliphalet Brown. From Matthew Calbraith Perry, *Narrative of the Expedition of an American Squadron to the China Seas and Japan* (Washington, DC: B. Tucker, Senate Printer, 1856), Vol. 1, plate between pages 418 and 419.

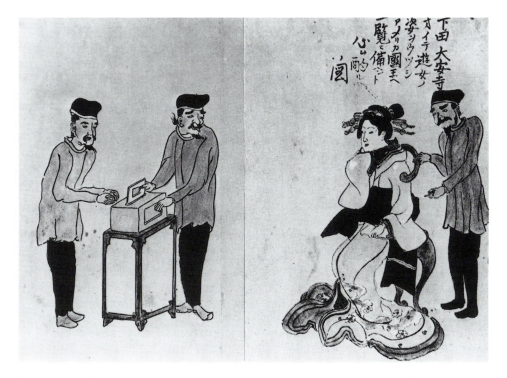

Figure 7.4 Unknown Japanese artist, *Eliphalet Brown and Assistant Taking a Photograph of a Courtesan in Shimoda*, c. 1854. From the *Black Ship Scroll*. Ink and watercolor.

Brown and another man making a daguerreotype of a "courtesan" (figure 7.4). The inscription reads in part: "This picture shows how at Daian-ji, a temple in Shimoda, they took great pains to record the appearance of a courtesan to show the American king." It includes an eyewitness account of the photography session: "The foreigners wanted to take pictures of beautiful Japanese ladies, so the government officials ordered that some of the singing girls be chosen as subjects." Not only does the Japanese artist record Brown at work (is it Brown or his assistant placing the plate in the camera?), but the fact that the man has his tongue sticking out, the inscription says, was "possibly intended to indicate lust."[16]

Regardless of the strict limitations on their contact with the Japanese, from the first American men were provided with courtesans and prostitutes. In another image in the *Black Ship Scroll* entitled *Picture of an American in a Shimoda inn dallying fondly with harlots*, one of Perry's men is shown with five prostitutes in a brothel.[17] The seated American man with a mustache is bending over while receiving the attentions of five Japanese women. Apparently he is drunk, as verified by a portion of the inscription, which was based on a story told by a "certain haiku poet of Shimoda":

> "Hey, don't pull his leg so hard when he's still so high in his cups!" "Oh, come a little closer to me!" "I say, I say, it seems you've had too much and can't stand up!"

... The Americans submitted a petition for permission to patronize the har-
lots in Shimoda. The authorities agreed and notified the brothel operators of
Shimoda, who were delighted at the prospect and passed this news on to the
harlots. Unexpectedly, however, the harlots unanimously pleaded with their
masters, saying, among other things: "We are, to be sure, ill fated, engaged
thus in an ignoble profession. Nevertheless, we have never made any contract
saying we should go so far as to sleep with foreigners!" The surprised brothel-
owners were greatly distressed at this and, after meeting in consultation,
secretly reported the girls' complaint to the Americans.[18]

The Americans then asked merely to eat and drink with the harlots and soon discov-
ered that they could obtain sex from them by bribing them with gifts.[19]

Reports such as these show us how, from the beginnings of renewed diplomatic rela-
tions with the West in the 1850s, the Japanese sought to please foreign men by offering
them the services of Japanese women. What is particularly relevant in the descriptions
of life in Dejima and of the arrival of Perry was not that foreign men sought out the
services of local prostitutes, a common occurrence then as today. Rather, men repre-
senting the governments of the Netherlands and the United States worked with
representatives of the Japanese shogunate to facilitate such encounters. What began as
an arrangement to keep peaceful diplomatic relations and to contain the foreigners in
controlled geographic areas turned into lucrative businesses when Japan began to
respond to Western capitalist development in the 1860s and 1870s.

Prostitute/courtesan/beauty/geisha

The captions of the two images from the *Black Ship Scroll* refer to two types of
women, harlots and courtesans, and in doing so draw attention to the fact that harlot
and courtesan, beauty and geisha, were by no means synonymous terms. Based on their
beauty, education, talents, sexual availability, and financial backing, they represent
ascending levels of occupations in the service industry of the pleasure quarters.
Prostitutes or harlots, of course, were at the bottom of the sex-trade ladder. Courtesans
were essentially high-class prostitutes, while geishas were licensed to entertain men but
not to provide sex. Both courtesans and geishas were generally the best-educated of the
female "entertainers." They spent years learning etiquette and how to please male cus-
tomers, as well as the arts of music, dance, and poetry; objects of these arts became
symbols of their trade. *Bijin*, or "beauty," referred originally to the most stylish cour-
tesans, who, paradoxically, set the fashion for women from wealthier and more
respectable families who could be called *bijin* as well.

Prostitutes, courtesans, and geishas all began their careers as children, usually sold
by their rural families. This was a legal transaction, since at the time both women and
children were considered property and could be legally bought and sold.[20] This prac-
tice was observed in 1859 by Francis Hall, one of the first American businessmen in
Japan, when he was en route between Kanagawa and Yokohama. Hall wrote that he
saw mothers leading their young daughters, who were in nice clothes and make-up, to
be sold "at the shambles of sin."[21] They were to be brought up indentured to the
women who ran the brothels and the courtesan and geisha businesses until they were
in their early twenties. By the time they satisfied their contracts, they were at an age

when they became less desirable owing to the ill effects of abortions, sexually transmitted diseases, or the bad treatment of their owners.

The *yukaku* or "pleasure quarters," created for the entertainment of men, were set up, enclosed, and licensed by the government. Often quite extensive, they contained various public establishments such as brothels, theaters, teahouses, bathhouses, buildings where women trained and lived, and other facilities needed for supporting the district's population and industries. These pleasure quarters were strictly controlled, and those who did not follow the regulations were punished. For example, Hall reported that two hundred prostitutes were arrested in Edo because they were not licensed, and they were then "threatened with banishment to Yeso [Hokkaido] for wives to convicts."[22] The largest and most famous *yukaku* was the Yoshiwara in Edo, which by 1883 had 3156 licensed brothels.[23] Yokohama, which was newly developed for foreigners in the 1860s, also had its *yukaku*, called Miyozaki. Miyozaki was set in a field apart from the residential sections of the port, and, like the Yoshiwara in Edo, was enclosed and surrounded by a moat with a drawbridge. The several hundred women who lived there were rarely allowed to leave; in fact, in the Yokohama fire of October 26, 1866, which started in this quarter, several hundred women who were trapped there died.[24] In Miyozaki, foreign men went to entertainment houses that catered to foreigners, such as Gankiro, the largest establishment in the quarter. They could also hire a mistress for around $15 a month (many had two), or they could pick out a prostitute from the huge two-story building with girls in cages (figure 7.5).[25]

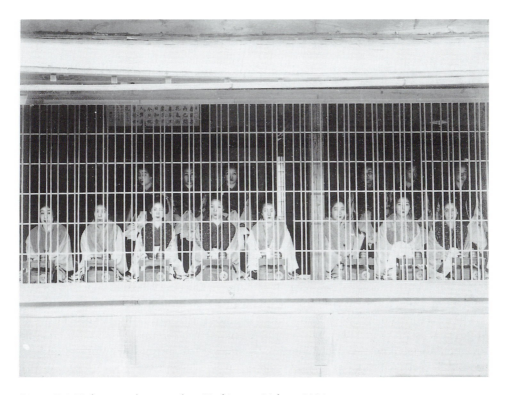

Figure 7.5 Unknown photographer, *Yoshiwara Girls*, c. 1880s.

The differences between these various ranks of female "entertainer" were not always clear to visiting Americans and Europeans. In the summer of 1886 John La Farge, one of the first American artists to go to Japan, was clearly confused about the status of Japanese women, including the models he hired. In a letter from his book *An Artist's Letters from Japan*, published in 1897, La Farge showed his uncertainty when describing two women he had seen on the street. "They might have been ladies," he said. "I am not sufficiently clear yet as to limits: perhaps they were gei-shas If they were, they were far above the two little creatures that posed for me yesterday." Though La Farge understood their higher status, geishas he erroneously called "*voluntarily* exiles from regular society and family" and equated them with the *hetairae* (sic) of the ancient Greeks.[26] La Farge went on to describe the two versatile young girls who modeled for him: "The two who consented to pose for me, at the same price and no more than I should have paid them had I called them in to entertain me and my guests with singing and dancing, were, the one a town, the other a country girl . . . It was a source of quiet amusement for me to see them posture."[27] While La Farge was blindly charmed by the various levels of Japanese women he encountered, the difficult lives of these women did not escape the notice of every foreigner. Aimé Humbert, the Minister Plenipotentiary of the Swiss government in the 1860s, for one, lamented: "Feminine servitude seems to me to present itself under the hardest conditions known to humanity in this wretched place [Yoshiwara in Edo]. Imagination which may conceive the hell of Dante, might fail before the horror of the reality of such lives."[28] The prostitutes were from the lowest social levels and, like all women who catered to foreign men, came to be called *rashamen*, "Western sheep," and were ostracized from Japanese society.[29] From this group of Japanese women the Western artists and photographers found their models.

Beato in Yokohama

As European settlements were expanding in the 1860s, European and American photographers arrived to set up commercial studios, and, in doing so, created new markets for photographs of Japan.[30] At this time, the country was turning away from feudalism toward Western science and technology, including photography. Yet the expensive equipment and chemicals, coupled with religious superstition – a photograph was thought to steal a sitter's soul – were prohibitive, so at first only a few of the wealthier Japanese commissioned photographs, primarily portraits.[31] The larger, more lucrative market was in the increasing number of foreigners who came to Japan after the new trade agreements were signed with the Five Nations in 1858. Americans and Europeans settled primarily in Yokohama, formerly a sleepy fishing village, which had the advantages of a deep harbor and proximity (around 17 miles) to the capital, Edo (now Tokyo). During the 1860s and 1870s, the largest European market for Japanese travel photographs was developed in Yokohama, and in the 1880s it flourished as the number of foreign tourists increased with an additional easing of travel restrictions.

The enterprising Italian photographer Felice Beato settled in Yokohama at an opportune moment in 1863. The port had become a boomtown for foreigners, and owing in no small part to Beato himself, the market for Japanese travel photography took off.[32] Believed to have been born in or around Venice but a naturalized British citizen, Beato had previously established a thriving, as well as innovative, career as a travel and war photographer. While serving in the latter capacity in the Crimea,

India, and China, Beato began his practice of attaching himself to the entourage of a military commander or government official through whom he gained access to restricted foreign sites.[33] As recently discussed by David Harris, during eight months at the end of the Second Opium War in 1860, Beato created a series of images for the Anglo-French expedition that form the first known photographic documentation of a military campaign.[34] Beato's connections enabled him to produce the primary documentation of the battle scene; he then sold these photographs for military reports and the officers' personal souvenir albums. His ability to make influential connections, to establish a pioneering photography practice in an area outside of Europe, and to develop a new clientele for his work were three elements essential to the success of his photography studio in Japan.

In China Beato befriended the English illustrator Charles Wirgman (1832?–91), who was working for the *Illustrated London News* in Asia.[35] Beato's contact with Wirgman undoubtedly influenced the photographer's decision to move to Yokohama, which was already under the control of the British when Beato arrived in 1863.[36] Beato developed a practice, which consisted of portraits and so-called "type" photographs, as well as genre scenes and views of Japan. For the views, he seems to have been able once again to obtain an unusual degree of access to areas of Japan not normally open to foreigners by joining the entourage of a foreign diplomat, such as the Swiss plenipo-tentiary Aimé Humbert.[37] Beato's photographs, as seen in an example of female musicians, were the basis for some of the illustrations in Humbert's book *Le Japon illustré*, first published in 1870 (figure 7.6).[38]

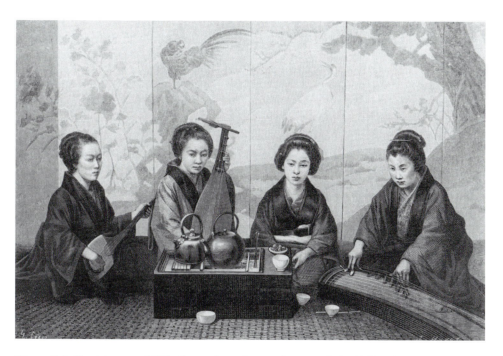

Figure 7.6 Musicians, c. 1870. Engraving after a photograph by Felice Beato. From Aimé Humbert, *Le Japon illustré*, Vol. II (Paris: L. Hachette et Cie, 1870), page 53.

Through his successful photography business, his training of Japanese apprentices, and the publication of his photographs, Beato in effect influenced a whole school of photography in Yokohama.[39] By the 1870s Beato had a staff of eight Japanese assistants – four photographers and four to hand-color the prints – as well as an American assistant, H. Woolett.[40] Beato's various studios created thousands of photographs from 1863 until 1877, when he sold the business to the Austrian photographer Baron Raimund von Stillfried-Ratenicz and his German partner Hermann Andersen.[41] Stillfried and Anderson and subsequent owners of Beato's negative stock continued to print and sell Beato's images for decades. Beato's photographs could also be seen in various publications, such as the journal *Far East* and the two-volume collection of his work entitled *Photographic Views of Japan*, which he published in 1868.[42] The illustrations in this album were albumen silver prints, made from glass plate negatives and "tipped" or glued on to the pages. One volume was entitled "Native Types," and the other, "Views of Japan." The two volumes provide a visual survey of Beato's photographs and in doing so demonstrate the typology of photographs of Japan and its peoples he created for the foreign market. These subjects and the way they are depicted were in turn continued, refined, and expanded upon by Stillfried when he took over Beato's business and by his former Japanese assistants, such as Kusakabe Kimbei, who went on to run their own studios.[43]

In *Photographic Views of Japan*, the photographs were accompanied by text written by James William Murray that explained to a Western audience the customs of the Japanese and the unfamiliar accouterments of the scene. [44] The book caters to the scopic drive of Western men by directly addressing the special fascination Japanese women held for them. "In all countries, the most interesting objects in the eyes of a stranger," the text declares, "are the female population."[45] Beato fueled this voyeuristic curiosity by staging interior and exterior scenes for photographs of women engaged in various activities, such as applying make-up, reclining on mats, playing musical instruments, serving tea or sake, or strolling outdoors. Their poses and activities clearly indicate that they were meant to portray beauties and geishas, or possibly even the mistresses of foreigners.

In an album of his photographs in the New York Public Library, two images provide examples of the aspects of Japanese womanhood that Beato and his male viewers would find interesting, as well as alluring.[46] His photograph *Woman Applying Cosmetic* shows a woman seated before a mirror on a *tatami*, or floor mat (figure 7.7). With a bared shoulder, she applies make-up to her neck, which the Japanese thought one of the most sensuous parts of the body. Though she is shown in profile, we can see her face in the mirror. As is typical of his work, Beato arranged his scenes with only a few furnishings and a plain background. We can see signs of the staging in the studio: the edge of the background screen is visible on the left of the image, and the *tatami* is placed on top of a patterned carpet. In a second photograph, *Declining the Honour*, a woman is shown full-length, standing at an angle toward the viewer (figure 7.8). Smiling coyly, the young woman holds her left hand up, palm out, in a repelling gesture. In both photographs, Beato employed an oval-shaped vignette that blocks out some of the staging elements on the periphery of the view, while it creates a kind of peephole into a private feminine space.

The text accompanying each of these photographs elaborates on the theme indicated by the title and as a result makes the erotic intention of the subject clear. The text for

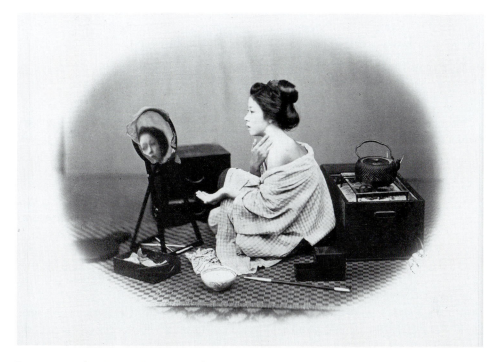

Figure 7.7 Felice Beato, *Woman Applying Cosmetic*, c. 1868.

the first photograph tells of the make-up used – the white powdered face and neck, the lips stained dark reddish purple – while at the same time it questions the Japanese ideal of beauty by referring to the Japanese woman's "mania" for painting herself and her subsequent resemblance to "a wax figure."[47] Through this photograph the nineteenth-century collector, most often a man, could study the Japanese woman's methods for beautification – the photograph is thus in a sense educational – while at the same time he could secretly view the woman in a private, semi-clad moment.

The text for the second photograph describes the enjoyable games that could be played with a young Japanese woman. The "declining" woman is "sweet, – she is gentle; – she is inviting; – she is very coy!" The text goes on to describe women who play the samisen, an instrument associated with courtesans and geishas: "[she] will show you all her little toy-like treasures," while she is curious about "any foreign trifle, trinket or charm, you may permit her to examine."[48] These last phrases, though innocent on the surface, allude to the sexual parts of her petite body ("her little toy-like treasures") and to the practice first described by Preble, when writing of his time in Japan with Perry, of buying women's services with foreign "trinkets." In an ironic turn of phrase, "any foreign trifle, trinket or charm" could refer as well to a foreign man's genitalia. In both photographs, the image, title, and text join together to emphasize the sexual allure and accessibility of young Japanese women for Beato's Victorian clients.

Beato's repertoire of subjects served as the prototypes for photographs made by

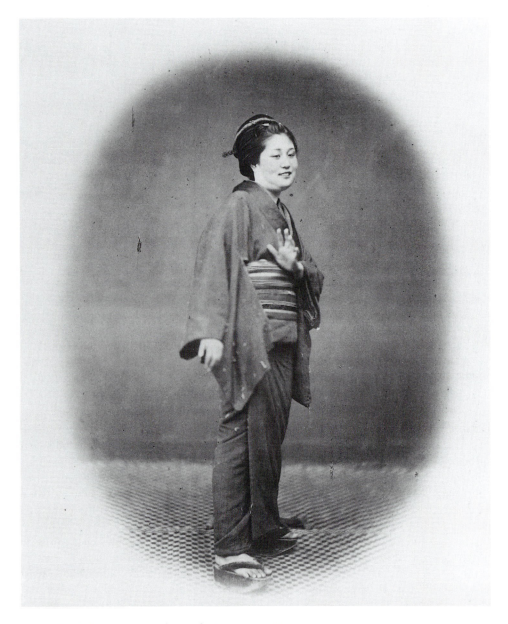

Figure 7.8 Felice Beato, *Declining the Honour*, c. 1868.

Baron Raimund von Stillfried-Ratenicz, an Austrian nobleman, an officer who served in the army of Emperor Maximilian in Mexico, and a trained watercolorist.[49] Yet, while building on Beato's subjects, the photographs of women from von Stillfried's studio differ from Beato's in several ways. First, the high quality of his photographic prints, with their fine hand-coloring and the rich purplish color created with gold-toned albumen

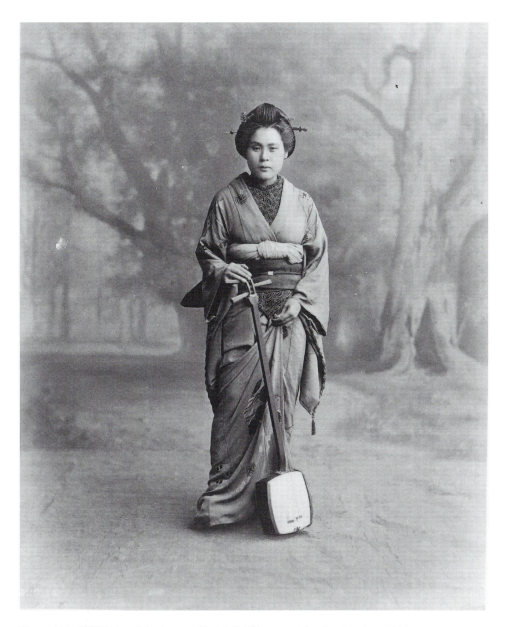

Figure 7.9 Stillfried and Andersen, *Untitled (Woman with a Samisen)*, c. 1880s.

silver, takes Beato's technique to a higher level. Second, his carefully composed scenes and often closer viewpoint likewise might indicate a European art training, which, as far as we know, Beato did not have. Third, he expanded Beato's repertoire of female subjects, especially those involving only partially clothed prostitutes or mistresses. Of Stillfried's photographs of women, there are the usual staged genre scenes, as well as two frequently used portrait formats ("portrait" is used reluctantly here, since we do

not know the names of the sitters).[50] In one type, an unnamed woman with a samisen was posed against a painted backdrop (figure 7.9). This background was reused for photographs of other women.[51] A second type is a half-length view of a woman placed against a solid background (figure 7.10). The prevalence of these two portrait formats in Stillfried's photographs raises the possibility that foreign men brought in their mistresses to have them photographed.

Though today photographs by Beato and Stillfried's studios often seem more ridiculous

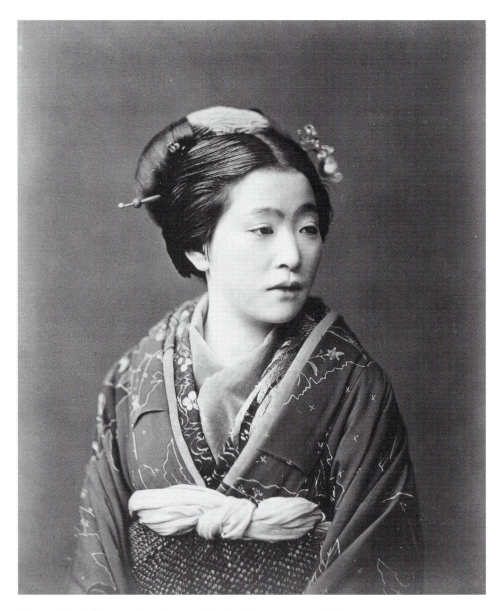

Figure 7.10 Stillfried and Andersen, *Untitled (Prostitute)*, c. 1880s.

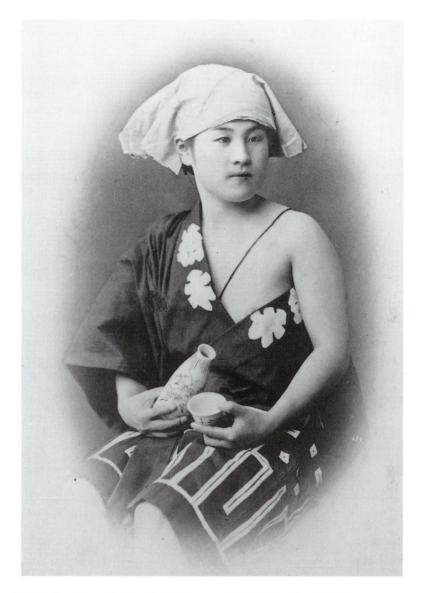

Figure 7.11 Felice Beato (?), *Untitled* (*Woman with Sake Bottle*), c. 1870s.

in their contrivances than erotic, at the time they were made they clearly appealed to the strait-laced yet hypocritical Victorians, who enthusiastically collected them. However, sometimes Beato and Stillfried added a more overt sexual component by partially undressing their sitters. In an unattributed photograph, probably by Beato, a woman wearing a headscarf holds a cup and a sake bottle at an angle, and her kimono is pulled down partially exposing her left breast (figure 7.11).[52] She is thus presented

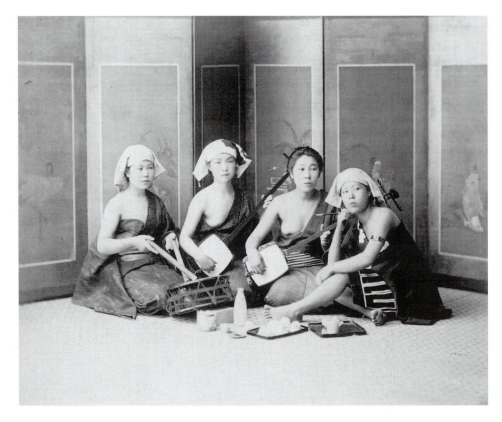

Figure 7.12 Felice Beato (?), *Young Musicians Drinking Sake*, c. 1870s.

as ready to serve, both drink and sex. (With her domestic headscarf, she is perhaps ready to clean as well.) This mixture of alcohol and the state of *déshabillé* reappears in a related photograph presumably by the same photographer, since the model and specific kimono from the previous photograph are repeated in the figure on the right (figure 7.12). Here four partially undressed female musicians sitting on a *tatami* offer a less formal, more sexual counterpart to the photograph used to create the engraving in Humbert's book discussed earlier in this chapter (figure 7.6). The samisen, the sake, and the informal attire, the partially exposed bodies, and the lack of make-up or elaborate coiffures together produce a private, intimate, sexualized moment.

Several photographs of semi-nude women in the Peabody Museum in Cambridge, Massachusetts, bearing the embossed Stillfried-Anderson stamp are less dependent on props and an implied narrative, while they are more aesthetically pleasing.[53] In a half-length photograph of a woman, bearing the hand written inscription "A Prostitute," the woman and her profession are on display (figure 7.13). She is adorned with European jewelry and hair ornaments, while her kimono has been pulled down to bare her arms and shoulders. In another photograph, the same model is shown nude to the waist, with a similar pose and expression of the model (figure 7.14). In both photographs the model's head and gaze are turned toward her left with the effect that the

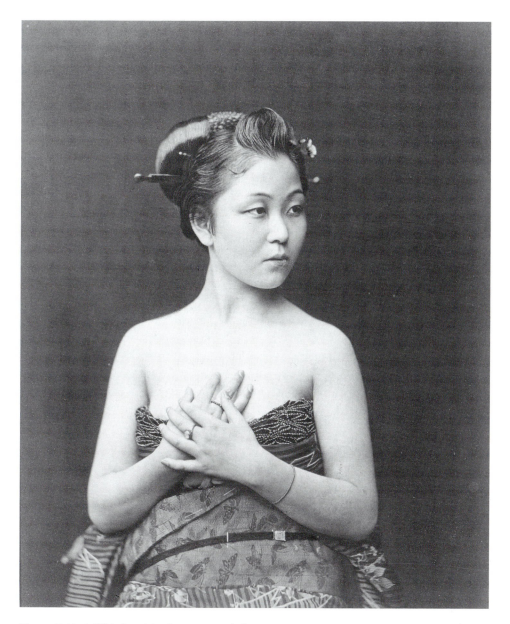

Figure 7.13 Stillfried and Andersen, *Untitled (Prostitute)*, c. 1880s.

viewer can scrutinize her displayed body without having to meet her eyes, nor need her eyes meet those of the photographer (the camera) or the viewer.[54] The natural grace of the model, the refined photographic technique, and the subtle hand-coloring produce the high aesthetic quality of the print. As was the case with the photograph attributed to Stillfried discussed in the beginning of this chapter (figure 7.1), the aesthetics of the photograph tend to mask the predicament and social status of the model depicted.

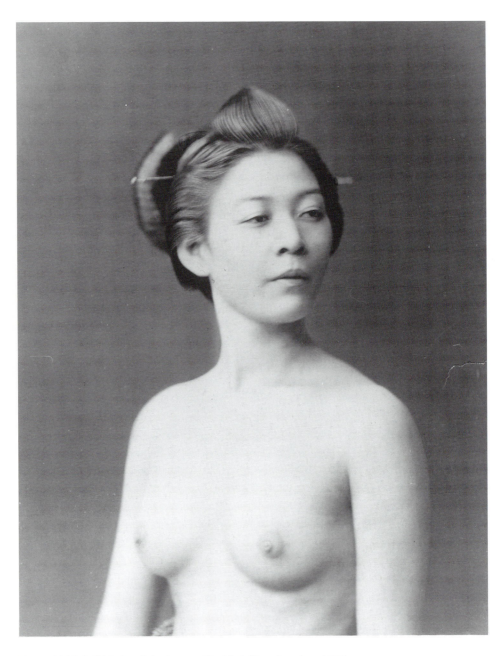

Figure 7.14 Stillfried and Andersen, *Untitled (Prostitute)*, c. 1880s.

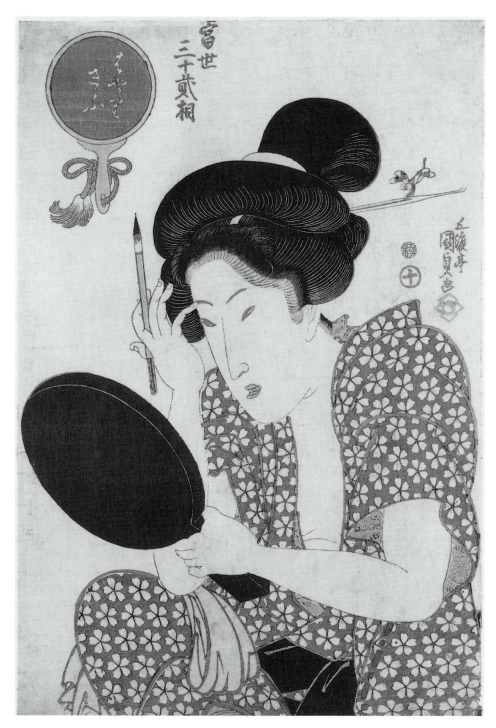

Figure 7.15 Utagawa Kunisada (also known as Toyokuni III), *The Popular Type*, from *Thirty-two Present-day Types*, c. 1822–23. Multicolored woodblock print.

Ukiyo-e prints and Beato's subjects

The photographs by Beato and Stillfried under discussion were clearly not made as "type" studies for the purposes of Western scientific or ethnographic studies of race. Rather, they seem meant to satisfy the scopophilic desires of the male collector. Even though Beato gave the second volume of *Photographic Views of Japan* the title "Native Types," his selection of subjects and their presentation differed from those found, for example, in the British photographer John Thomson's four-volume collection *Illustrations of China and Its People,* published in 1873–74.[55] Occasionally Beato did use the scientific "specimen" format, with a lone figure set against a solid background, but more often he constructed settings mimicking the everyday subjects he found in the Japanese ukiyo-e prints already popular in the United States and Europe. These prints of the so-called "floating world" of the late Edo Period, from around 1780 to 1863, provided an inventory of subjects for Beato and his foreign customers, as well as the model for an art especially collectable owing to its erotic subject matter as well as its colorful and often sumptuous printing.

While ukiyo-e paintings, prints, and illustrated books depicted almost every aspect of contemporary Japanese life in Edo, images of the female entertainers and places of the pleasure quarters in Yoshiwara were the most abundant. The mass-produced prints depicted specific women and sites, as well as generic scenes portraying the lives of prostitutes, beauties, and geishas. Subjects pertaining to women of the "floating world" would fall into three main categories: portraits, daily activities, and scenes at work. Sometimes inscribed with the names of actual women, whose identities were recorded in government records, the prints served as elaborate decorative pieces showing off the latest fashions in clothing and hair ornamentation. Daily activities portrayed included the rituals of preparing for a day's work: bathing, arranging the coiffure, applying make-up, dressing, and strolling or riding in a *jin-riksha* (a rickshaw) through the streets of the pleasure quarters (figure 7.15). They are also shown at work in tea houses or demonstrating their talents playing the samisen, dancing, writing poetry. The social status of the women or the stage of their training can be discerned in ukiyo-e prints through such subtle indicators as their ages, the way they tied their obis, the style of their kimonos, their undergarments and shoes, and their activities.

Like the ukiyo-e prints, the photographs of Beato and his followers combine artifice with realism in representing various aspects of life in the pleasure quarters. Yet, because of the widespread belief in photography's objectivity, for the nineteenth-century collector these photographs appeared to represent real life more credibly. Today, even though we know the scenes were staged, we also know that real women needed to be recruited and then posed in front of the camera. In the photographs, they are isolated, never portrayed with customers, but evidence of their contacts with European customers can be seen in such things as the presence of European jewelry. The more obvious connection to reality of the photographs also contributes to their tenor. Rather than being lively, inviting images as often seen in ukiyo-e art, the resulting mood in the photographs is somber, even onerous. This gloominess could be ascribed to the fact that the models had to remain still during the time needed to expose the photographic plates, but their lifeless expressions tell us otherwise. M. Rodolphe Lindau, a Prussian writing in 1861 about the prostitutes in cages he saw

in the pleasure quarters of Nagasaki, described such a demeanor and his own com-
passionate reaction to it:

> Several were notable for their beauty but all had an air that was resigned,
> weary, above all indifferent which ill-accorded with their young faces and was
> difficult to behold. On display like animals in a zoo, examined and criticized
> at leisure by each curious passer-by, to be sold to or hired to the first who
> made the offer, these unfortunate girls presented a spectacle that caused me the
> most painful impression.[56]

Though the models were probably paid to pose for photographers, their expressions in
the photographs reflect the life of forced submission and social alienation that doomed
the prostitutes and the other Japanese women who served foreign men.

Neither ukiyo-e artists nor Yokohama photographers portrayed the actual horror of
the Japanese women's lives in the entertainment districts. Instead, the primary aim of
the prints and the photographs was to present sexually available women in an aes-
thetically pleasing manner. Some ukiyo-e prints called *shunga* depicted explicit sexual
acts and were intended, as recently analyzed by Timon Screech, as aids to masturba-
tion, but more prevalent were the ukiyo-e *bijinga*, the prints depicting *bijin*, courtesans
or "beauties."[57] The *bijinga* presented courtesans as spectacle, and these popular
prints influenced the taste and fashion of upper-class women. Although pornographic
photographs had been made in Europe since the 1840s, sexually explicit photographs
from Japan are unknown, at least to this author. Therefore, it might be surmised that,
for the Victorian male collector of Japanese photographs, the partially revealed bodies
and the *implied* sexual availability of the photographers' models sufficed.

As in the case of the *bijinga*, the female entertainers in the photographs serve as evi-
dence of the sex trade, while they simultaneously function as both enticing erotic
subjects and colorful aesthetic objects. Indeed, it is an aspect of the latter, the delicate
hand-coloring of the black-and-white albumen silver prints, that is today the most dis-
tinctive characteristic of these photographs of Japan. Although color photography
developed only at the turn of the twentieth century, there were some hand-colored pho-
tographs as early as the 1840s, and it seems to have been Beato who popularized the
technique in Japan. Beato was possibly influenced by the hand-colored engravings
made from daguerreotypes of Italian views sold to tourists at popular sites in cities
such as Rome and Venice, in the vicinity of which he is thought to have been born.[58]
There was also the example of coloring travel photographs for the tourist industry in
Italy and elsewhere. Although it should be kept in mind that little is known about his
early years in Italy, Beato surely was aware of the current practice of coloring travel
photographs, especially since his former partner James Robertson hand-colored, albeit
somewhat crudely, orientalist type photographs of Ottomans.[59] Another precedent
for Beato that has been entirely overlooked is the fact that some of the illustrations
published in Perry's *Narrative*, including some based on Brown's daguerreotypes, were
color lithographs (figure 7.3). Owing probably to financial considerations, only a few
colors were used in the lithographs for Perry's report, which Beato could have seen in
Yokohama. Beato utilized a similar restricted palette of pale shades of blue, green,
yellow, and pink.

It seems likely that at first his partner Charles Wirgman colored Beato's

Figure 7.16 Unknown photographer, *Untitled (Japanese Colorist at Work)*, c. 1880s.

photographs, but it was probably due to Beato's hiring of Japanese artists, who were skilled in painting the wood blocks for ukiyo-e prints, that his studio produced such high-quality colored photographs. The Japanese colorist carefully ground and laid out the organic and inorganic pigments in separate porcelain dishes, as did the painter of photographs in a hand-colored image in the Peabody Museum at Harvard University (figure 7.16).[60] Employing a similar technique, Beato's artists painted selected areas of

the photographs with subtle translucent washes, which allowed the details of the image to remain distinct, rather than applying opaque oil paints as was the usual custom in the United States and Europe.[61] Although eventually color was applied to photographs of all his subjects, Beato used color only in the volume "Native Types" of his two-volume work *Photographic Views of Japan*. Beato's turn to hand-coloring his photographs was an astute marketing move, for, like his use of ukiyo-e subjects, it made his photographs more competitive with both Japanese prints and colored travel prints in the European market. And the more artistic the presentation, the more pleasing Beato's subjects could become.

Collecting

In addition to their appeal to collectors of ukiyo-e prints, photographic portrayals of Japanese women as geishas and beauties were produced to satisfy two primary demands: a perceived need to capture the "old" Japan before it disappeared under Westernization, as well as the traveler's more internalized desire to take home personal souvenirs. During the early decades of the Meiji Restoration (1868–1912), Japan entered a period of transition from a feudal society to a modern state. Yokohama and other treaty ports underwent especially rapid development and change owing to foreign influence. In the process, the Westernization of Japanese culture became widespread among the middle and upper classes. Japan's state of transition was clear to foreign visitors, some of whom wanted to record, or acquire records of, social customs in Japan, a kind of salvage documentation, before the country was irrevocably changed.

In the preface to the 1874 English translation of Humbert's book *Japan and the Japanese*, H. W. Bates described how Humbert wanted to document "the strange life – art, manner and costumes – so graphically portrayed . . . undergoing a rapid change, and soon to be a thing of the past." The verbal descriptions and the illustrations of the book were intended to depict "the hidden scenes of Japanese life and history," a phrase again revealing the voyeuristic desires of the Western male.[62] Since foreigners such as Humbert and Beato (through his travels with Humbert) received special privileges from the Japanese government to travel to areas of Japan not open to other foreigners, their descriptions and images of Japanese life were thus especially appealing to collectors, even those who had been to Japan, as depictions of mysterious places and people most foreigners had never seen, and perhaps never would see because of Westernization.

A second demand that shaped collecting practices stemmed from the fact that many foreign men living in or visiting Japan actually *knew* Japanese prostitutes, courtesans, and geishas. Some possibly commissioned portraits of their mistresses, while the repetition of the same clothes on different women in the photographs by Stillfried discussed above suggests that he also created generic "portraits" by having his impoverished models wear clothes that he kept in his studio.[63] These and other photographs purchased in studios such as Beato's, or later on the streets, would often have been arranged in albums.[64] Having the ability to evoke both memories and fantasies of Japanese women, the photographs they collected would then have special meaning as "souvenirs" of the foreign men's stays in Japan.

We can make the reasonable assumption that often the purchasing of photographs

of Japanese women was directly related to the purchasing of their services. Just as they bought Japanese cultural artifacts, some of which were created specifically for them, foreigners also bought the services of women, from domestic help to prostitutes. Both this service industry and the culture industry indicate a gendered, bipartite view of Japan. Males were often depicted in the noble professions of Buddhist monk, scholar, samurai warrior, or the art of the theater. On the other hand, women were portrayed as servants, entertainers, and providers of sex and were thus subjugated to male (both Japanese and Euro/American) sexual fantasies and behavior. Such a duality reflects more general Western attitudes toward Japan – a respect for some refinements of its culture but a belief that it could be possessed for the economic advantage of Western nations. However, the agency of the Japanese men, while not of the Japanese women, must also be considered here. The careful planning of Yokohama, with its Miyozaki, was intended not only to facilitate trade but also to fulfill the needs of the mostly male foreign population that the Japanese wanted to keep contained within the port's walls. Brothels and other types of female entertainment were also established in Yokohama as another way to profit from foreign visitors.

The entrepreneurial Yokohama photographers, many of whom worked also in other businesses, seized the opportunity to profit from the foreign market.[65] Customers could purchase photographic prints or lantern slides from their printed catalogues or from display albums set up in their studios.[66] Stillfried's studio advertised "photographic views of Japanese scenery and all classes of Japanese society," as well as portraits in "large, cabinet, or carte de visite size."[67] Kusakabe had a catalogue that listed over a thousand photographs, which could be ordered by number.[68] Their successful businesses necessitated the employment of as many as thirty assistants, most of whom were native. As these Japanese assistants then set up studios for themselves, the pioneering European photographers put Yokohama behind them in search of other business opportunities. Beato left Japan for Burma in 1884, Stillfried for Vienna in 1883, and Farsari, the last of this first group of European photographers in the tourist industry, returned to Italy in 1890. The success of this Yokohama "school" of photography is confirmed by the fact that, according to one account, 24,923 photographs, not including those sold to foreigners in Japan, had been exported to Europe and the United States by 1900.[69]

The Japan foreign men "discovered" in the second half of the nineteenth century is a stark contrast to the passage quoted in the beginning of this chapter, but photographs had an uncanny ability to bridge the gap between fantasy and reality. Pierre Loti's fictionalized erotic travelogues inspired countless Americans and Europeans (including Paul Gauguin) to travel to Asia and the South Pacific.[70] Loti's view of Japan was no doubt partly formed before he arrived in Nagasaki in 1885. Beato's subjects, techniques, and book, with its gendered and racially defining text, undoubtedly played a role in this process; European photographs of Japan were already prevalent in Paris, as the great wave of Japonism had already reached France decades earlier. And even if a foreigner had not encountered photographs before traveling to Japan, he could see them as he stepped on shore; Loti wrote that, when he arrived in Nagasaki, his boat was met by men and women selling curios and photographs.[71] Western male travelers could fulfill their fantasies in Japan, while attempting to extend their looking pleasure by purchasing photographs of prostitutes from street vendors, from catalogues and albums in Yokohama studios, or by commissioning photographers to take them. The

Japanese themselves began this process by selling their young girls into the virtual slavery of the sex trade and by setting up entertainment districts for their own economic profit. It was left to the photographers to transform these poor hapless prostitutes into desirable "beauties" to satisfy the scopophilia of Western men.

A photograph labeled *Kago, Traveling Chair, Hakone Road*, now in the ethnographic archives of Harvard University's Peabody Museum, serves as a kind of visual metaphor for the manner in which Japanese women could fulfill the fantasies of the Victorian male traveler (figure 7.17). Twelve Japanese porters carry a man, nicely dressed in a dark jacket and a straw hat, along with four Japanese women and another man (?). Their conveyance consists of chairs hooked together with ropes and elevated above the ground by poles. Its very length necessitates a somewhat distant view in order to contain its entirety within the frame. As a man in a pale kimono looks on from the right, the party stops to have its picture taken in the woods. In doing so, the (now) anonymous photographer creates for the straw-hatted traveler a record of the trip. At the same time, he supplies a broader group of scopophilic clients with an image of the luxury, comfort, and female servitude available in the unfamiliar terrain of Japan. Today such peripatetic photographs, made by Beato and other Yokohama photographers, help us to reconstruct that unique place inhabited by Japanese prostitutes and "beauties" in the late nineteenth century. There reality and desire were held in suspension by the forces of Western colonialism and Japanese economic expansion.

Figure 7.17 Unknown photographer, *Kago, Traveling Chair, Hakone Road*, c. 1880s.

Notes

1 Chantal Edel, *Once Upon a Time: Visions of Old Japan. Photographs by Felice Beato and Baron Raimund von Stillfried. And the Words of Pierre Loti*. Trans. Linda Coverdale (New York: Friendly Press, 1984), 33. Originally published in France as *Mukashi, Mukashi 1863–1883* (Paris: Les Editions Arthaud, 1984).

2 Dennis Porter, *Haunted Journeys: Desire and Transgression in European Travel Writing* (Princeton: Princeton University Press, 1991), 9.

3 Ibid., 279–80. As Rebecca DeRoo points out in Chapter 8, women too demonstrated scopophilic tendencies, but, as the foreign visitors and photographic collectors in Yokohama from c. 1865 to 1880 were primarily men, the focus in this essay is on the male traveler.

 The differences between male and female travel photograph collectors is possibly indicated by a comparison of several New England collections. Men such as the Bostonian aesthete William Sturgis Bigelow and the Salem zoologist Edward Sylvester Morse collected full- and half-length photographs of Japanese prostitutes. For one woman collector, we have evidence that an American woman's taste in photographs of Japanese women could be decidedly different from that of a male collector. In the photographs of Japanese women acquired in 1886–7 by Mary Alice Knox for her new course on Asian history at Wellesley College, there are non-sexual genre scenes, rather than nudity or groups of female "portraits." See Melissa Banta, "Life of a Photograph: Nineteenth-century Photographs of Japan from the Peabody Museum and Wellesley College Museum," in Melissa Banta and Susan Taylor, eds, *A Timely Encounter: Nineteenth-century Photographs of Japan*, with essays by Banta, Ellen Handy, Haruko Iwasaki, and Bonnell D. Robinson (Cambridge, MA: Peabody Museum Press, 1988), 17.

4 Philipp Franz von Siebold, *Manners and Customs of the Japanese in the Nineteenth Century* (New York: Harper & Brothers, 1841; republished Rutland, VT, and Tokyo, Japan, 1973).

5 *Cambridge History of Japan: The Nineteenth Century*, vol. 5, ed. Marius B. Jansen (Cambridge: Cambridge University Press, 1989), 88.

6 Siebold, who lived on Dejima from 1823 to 1828, offers an example of the consequences of disobeying these restrictions. At first well respected by the Japanese, Siebold even taught in an academy in Nagasaki. He had a Japanese mistress, with whom he had a child. However, he was jailed for a year, as were twenty-three of his students, for obtaining maps of northern Japan, before he was expelled in 1829. *Cambridge History of Japan*, vol. 5: 13, 104.

7 Ibid.: 48–9. Von Siebold, *Manners and Customs*, 28. Dejima was closed in 1859 when the Dutch were permitted to establish a consulate in Edo (Tokyo).

8 Perry tried to censor the writings of the men under him by ordering that all notes and journals made by men on his expedition were the property of the government. See Matthew Calbraith Perry, *Narrative of the Expedition of an American Squadron to the China Seas and Japan: Performed in the years 1852, 1853 and 1854, under the command of Commodore M. C. Perry, United States Navy, by order of the government of the United States* (Washington, DC: B. Tucker, Senate printer, 1856), vol. 1, 88. As he makes clear in his diary, Preble did not like this order and got around it by disguising his journal entries as letters to his wife. Preble's diary, which is in the Massachusetts Historical Society, was published posthumously. Rear Admiral George Henry Preble, *The Opening of Japan: A Diary of Discovery in the Far East, 1853–56*, ed. Boleslaw Szczesniak (Norman: University of Oklahoma Press, 1962), xxii.

9 Preble, *Opening of Japan*, 125–6.

10 Ibid., 126.

11 Ibid., 181.

12 Takesi Ozawa, "The History of Early Photography in Japan," *History of Photography* 5 (October 1981), 291.

13 See note 7 above. The *Narrative* was also republished in a smaller, less costly format by D. Appleton, New York, 1857.

14 Some of the illustrations in Perry's *Narrative* were inscribed either "del Brown," "figures by Brown," or "Brown, dag" [daguerreotypist].

15 Ozawa, "History", 291.

16 Translation of the inscriptions from Oliver Statler, *The Black Ship Scroll: An Account of the Perry Expedition at Shimoda in 1854 and the Lively Beginning of People-to-people*

Relations Between Japan and America, trans. Richard Lane (Japan Societies of San Francisco and New York, 1963), 56. Much of the information contained in the images and inscriptions has since been corroborated by other primary evidence.

17 Illustrated in Statler, *Black Ship Scroll*, 60–1.

18 Ibid., 75.

19 Ibid., 76.

20 Sanna Saks Deutsch, "An Abstract from 'Patchwork: A History of Women in Japan,'" in Howard A. Link, *The Feminine Image: Women of Japan*, exhibition catalogue (Honolulu: Honolulu Academy of Arts, 1985), 22.

21 F. G. Notehelfer, ed., *Japan Through American Eyes: The Journal of Francis Hall, Kanagawa and Yokohama, 1859–1866* (Princeton: Princeton University Press, 1992), 72–3. Hall also wrote that he was propositioned by a Yokohama prostitute. Ibid., 75.

22 Ibid., 371–72.

23 Julia Meech-Pekarik, *The World of the Meiji Print: Impressions of a New Civilization* (New York: Weatherhill, 1986), 32

24 Ann Yonemura, *Yokohama: Prints from Nineteenth Century Japan*, exhibition catalogue (Washington, DC: Arthur M. Sackler Gallery and the Smithsonian Institution Press, 1990), 128.

25 Hall in Notehelfer, *Japan*, 249–50. On single foreign men having one or two mistresses see Haruko Iwasaki, "Western Images, Japanese Identities: Cultural Dialogue between East and West in Yokohama Photography," in Banta and Taylor, eds, *A Timely Encounter*, 37, note 13.

26 My emphasis. John La Farge, *An Artist's Letters from Japan* (New York: The Century Company, 1897): 189–90. La Farge's comparison of geishas to the Greek *hetaerae* was an enlightened one. *Hetaerae* were courtesans, or high-class prostitutes, found primarily in Corinth and Athens. They were usually slaves, but they sometimes were able to rise to a position as independent foreign or freed women, who were set up in specific quarters by the government and levied taxes. As respectable Greek girls and women did not participate in mixed society with men, the *hetaerae* became an important aspect of Athenian social life after the Peloponnesian War in the fifth century BCE.

27 Ibid., 190.

28 Aimé Humbert, *Japan and the Japanese, Illustrated*, trans. Mrs Cashel Hoey and ed. H. W. Bates, from the second French volume (London: Richard Bentley and Son, 1874), vi. First published as *Le Japon illustré* (Paris: L. Hachette, 1870).

29 Iwasaki, "Western Images", 34.

30 The first daguerreotype camera slipped into Japan in 1843 through the one point of European access, the Dutch trading outpost Dejima. However, there seems to have been very little photography before the 1860s. For discussions of the first photographers in Japan, see Ozawa, "History"; Terry Bennett, "The History of Photography in Japan," in Hugh Cortazzi and Terry Bennett, *Japan Caught in Time* (New York and Tokyo: Weatherhill, 1995), 29–46; Clark Worswick, *Japan: Photographs, 1854–1905* (New York: Pennwick/Knopf, 1979).

31 Ozawa, "History", 285–6. However, as Peter C. Jones has pointed out, not all photographs made in Japan were for Western consumption. By the 1870s photographs were cheaper, and the existence of numerous ambrotype portraits of Japanese people points to a developing market among the middle class in Japan. (Ambrotypes were relatively inexpensive, one-of-a-kind photographs made by placing a wet plate negative against a dark surface to make a positive image.) Peter C. Jones, "Japan's Best-kept Secret," *Aperture* 138 (Winter 1995: 75–8).

32 In 1868 there were around a thousand foreign residents in Japan, most of whom lived in Yokohama. By 1894 one-half of the approximately ten thousand foreigners in Japan lived there. *Cambridge History of Japan*, vol. 5, 305. O. E. Freeman, about whom little is known today, was an American in Yokohama who seems to have been the first to open a photography studio there. However, Beato seems to have been responsible for developing the market.

33 In the 1850s, possibly in Malta, Beato met the British photographer James Robertson (c. 1813–88), who married Beato's sister around 1855. Beato traveled extensively working with Robertson and his brother Antonio Beato in Greece, Turkey, Egypt, and Palestine. He established a reputation as a war photographer first working with Robertson, who was hired by the

British in 1855 to replace James Fenton as a photographer of the Crimean War. Beato also worked for the British during and following the Indian Mutiny, the Second Opium War in China in 1860, Sudan in 1885, and for the US China Squadron in Korea in 1871. He moved to Burma in 1889 and had a photography studio, as well as a mail-order furniture business, in Mandalay and Rangoon until the time he is thought to have died, around 1908.

The chronology for Beato used here has been pieced together from the following sources, listed in order of publication: John Lowry, "Victorian Burma by Post: Felice Beato's Mail-order Business," *Country Life* 157: 4054 (1975: 659–60; Worswick, *Japan: Photographs,* 132–4; Stephen White, "Felix Beato and the First Korean War, 1871," *The Photographic Collector* 3, 1 (1982: 76–85; Italo Zannier, *Verso oriente: Fotografie di Antonio e Felice Beato* (Florence: Alinari, 1986); Colin Osman, "New Light on the Beato Brothers," *British Journal of Photography* 34 (1987: 1217–21; Osman, "The Later Years of Felice Beato," *The Photographic Journal* 128 (1988): 511–14; Ben Lifson, "Beato in Lucknow," *Artforum* 26, 9 (1988): 98–103; John Clark, John Fraser, and Osman, "A Revised Chronology of Felice (Felix) Beato (1825/34?–1908?)," in John Clark, ed., *Japanese Exchanges in Art, 1850s–1930s with Britain, Continental Europe, and the USA: Papers and Research Material* (Sydney, Australia: Power Publications, 2001, 89–120; Claudia Gabriele Philipp, Dietmar Siegert, and Rainer Wick, *Felice Beato: Viaggio in Giappone, 1863–1877* (Milan: Federico Motta Editore, 1991); Régine Thiriez, *Barbarian Lens: Western Photographers of the Qianlong Emperor's European Palaces* (London: Gordon and Breach, 1998); and David Harris, *Of Battle and Beauty: Felice Beato's Photographs of China,* exhibition catalogue (Santa Barbara: Santa Barbara Museum of Art, 1999).

34 Harris points out that unlike other photographers following military campaigns who made portraits and views of battlefields, Beato made a sequence of photographs indicating the dates and locations of the ongoing events in the Anglo-French military campaign in China. David Harris, *Of Battle and Beauty,* 15, and 38, note 1. This is the most recent and extensive treatment of Beato's photographs from China. Harris reconstructs Beato's working methods and market through his study of existing albums of his China photographs.

35 Charles Wirgman was an officer of the British army and a self-taught artist. By 1860 he worked in China as an illustrator for the *Illustrated London News.* He also made cartoons and caricatures, some of which he published in the journal *Japan Punch,* which he founded and mostly wrote from May 1862 to March 1887. He lived the rest of his life in Yokohama with a Japanese wife and had Japanese art students. See John Clark, *Japanese Exchanges,* 25–88.

36 Yokohama was controlled by the British in much the same way, with extraterritorial rights, as were their treaty ports in China. Many British merchants moved from China to Yokohama in the 1860s, as did Wirgman and Beato. *Cambridge History of Japan,* vol. 5: 306–7. The reported date of Beato's arrival has varied. According to Italo Zannier, the date was 1861. Zannier, *Verso Oriente*: 11. David Harris has pointed out to me that in an article in the *Illustrated London News* of September 12, 1863, Wirgman mentions that Beato was in Japan on July 13, 1863. Beato and Wirgman established a business together, "Beato & Wirgman: Artists and Photographers," which existed from 1864 to 1867. After their studio was destroyed by the Yokohama fire in 1866, they quickly got back into business. As most of Beato's glass plate negatives were presumably destroyed, he photographed some of his surviving prints to make new negatives, and he rephotographed some of the sites.

37 An advertisement for the book after the last page of text says, "Illustrated by 207 Drawings by Italian and French Contacts, and Sketches from Photographs." Though Humbert essentially suppressed the names of the artists and the photographer in his party, at one point he does let it slip out that the photographer was Beato. Humbert, *Japan and the Japanese,* 179.

38 Beato's photograph is illustrated in Philipp, Siegert, and Wick, *Felice Beato,* 188. The illustrations in Humbert, *Japan and the Japanese,* on pages 37, 57, 159, 217, 223, 256, 270 appear to have been made from photographs. The figures in the other illustrations are more distorted, almost caricatures, and the settings more complex than those derived from photographs.

39 For a discussion of Beato and the Yokohama "school" of photography, see Centre National de la Photographie, Paris, *Felice Beato et l'école de Yokohama,* exhibition catalogue (Paris: Centre national de la photographie, 1994).

40 Iwasaki, "Western Images", 29.

41 Beato's studio had a variety of names: Beato & Wirgman (1864–67), F. Beato and Co (1870–3). He sold his business in 1877 to von Stillfried's firm Stillfried & Andersen, which in turn was sold (including Beato's stock) to the Italian-American Adolfo Farsari in 1885. Worswick, *Japan*, 140.

42 Felice Beato, *Photographic Views of Japan by Signor F. Beato with Historical and Descriptive Notes, Compiled from Authentic Sources, and Personal Observances During a Residence of Several Years by James William Murray*, 2 vols (Yokohama: 1868).

43 Kusakabe was the photographer's family name, though he also went by Kimbei, probably because it was easier for foreigners to remember. Kusakabe Kimbei was an apprentice to Beato since the latter's first years in Yokohama and traveled with him to Shanghai in 1867. He seems to have also worked for Stillfried. In 1881 Kusakabe opened his own studio in Yokohama and in 1885 bought some of the Beato/von Stillfried stock. See Bennett, "The History of Photography in Japan", 39. The transfer of negative stock, the purchase of studios, and the fact that photographers such as Kusakabe worked for both Beato and von Stillfried, as well as for themselves, makes the attribution of photographs difficult. However, the focus of this chapter is on the market for photographs of Japanese women, rather than on attribution and connoisseurship.

44 Beato's English was reportedly less than perfect. Yokohama was primarily British at the time, and so was his clientele. This might explain why Murray wrote the text for his book.

45 Letterpress text accompanying Beato's photograph *Out for a Walk* in the Miriam and Ira D. Wallach Division of Art, Prints and Photographs. The New York Public Library. Astor, Lenox and Tilden Foundations.

46 The following two photographs and the accompanying text come from Beato's album of photographs in the New York Public Library.

47 Text accompanying Beato's photograph *Woman Applying Cosmetic* in the New York Public Library.

48 Text for Beato's photograph *Declining the Honour* in the New York Public Library.

49 Stillfried first went to Japan in 1863 and, after a stint in Mexico with Emperor Maximilian, settled in Japan in late 1867. He returned to Vienna in 1893. See Luke Gartlan, "A Chronology of Baron Raimund von Stillfried-Ratenicz," in John Clark, *Japanese Exchanges*, 121–204. Stillfried also had several names for his studio: Stillfried & Co., The Yokohama Library, The Japan Photographic Association, Stillfried and Andersen. In a review from 1884 in the *Photographic News* in London, it was reported that "In Japan . . . nine-tenths of the Japanese photographers [had] been at one time or another, assistants to Baron von Stillfried." "Photography in Eastern Asia," *The Photographic News* (London) 28: 1330 (February 29, 1884): 129.

50 An exception to this is the photograph *O-Kin san, the owner of the tavern "on the 101st step in Yokohama"* from the Alexander Vasilyevich Grigoryev Collection, the Russian Geographical Society, St Petersburg. See Cortazzi and Bennet, *Japan Caught in Time*, 106, plate 67.

51 A number of examples can be found today in the collection of photographs once belonging to William Sturgis Bigelow in the Peabody Museum of Archaeology and Ethnology at Harvard University, Cambridge, Massachusetts.

52 Though the photographer of this photograph cannot be identified definitely, it is in the same album entitled *Costumes and Views of Japan* in the New York Public Library that contains a number of photographs known to be by Beato. Though it shows a similar use of the vignette, the close-up view and partially nude presentation is not clearly characteristic of Beato.

53 Many of the photographs from Bigelow's collection at the Peabody Museum are mounted on card stock that has been embossed with a stamp reading: "JAPAN PHOTOGRAPHIC ASSOCIATION / BARON STILLFRIED / OF THE FIRM STILLFRIED & ANDERSEN / [CREST] / BY SPECIAL APPOINTMENT PHOTOGRAPHER / TO HIS IMP & ROYAL AUSTRIAN MAJESTY'S COURT / YOKOHAMA (JAPAN)." As stated earlier, the photographer and date of a photograph cannot always be determined, as Beato had a number of assistants and his studio and its stock of negatives changed hands a number of times and was expanded by other photographers.

54 Stillfried also took the motif of the reclining woman, whose position on a mat with her head on a box must have seemed peculiar to foreigners, and turned the subject into a more erotic image that mimics popular orientalist paintings, prints, and photographs of the Middle East and North Africa. Apparently, this subject matter also figured in his photographs made in other countries. The 1884 review in *The Photographic News* refers to photographs made over a twenty-year period in Siam, China, Japan, and "other Eastern countries." The author remarks on his photographs of Siam that, "We halt in the summer residence, and in the harem." "Photography in Eastern Asia", 129.

55 John Thomson, *Illustrations of China and Its People. A series of two hundred photographs with letterpress descriptive of the places and people represented* (London: S. Low, Marston, and Searle, 1873–74). Reprint with a new forward by Janet Lehr (New York: Dover Publications, 1982).

56 Lindau writes of his visit to the Maruyama Quarter in Nagasaki in the fall of 1861. Quoted in Timothy Clark, "Utamaro and Yoshiwara: the 'Painter of the Green Houses' Reconsidered," in Shugo Asano and Clark, *The Passionate Art of Kitagawa Utamaro*, exhibition catalogue (London: British Museum Press, 1995), 36.

57 For a recent analysis of ukiyo-e erotic prints, see Timon Screech, *Sex and the Floating World: Erotic Images in Japan 1700–1820* (Honolulu: University of Hawai'i Press, 1999). Screech discusses the function of the erotic prints in Chapter 1.

58 Heinz K. Henisch and Bridget A. Henisch, *The Painted Photograph 1839–1914: Origins, Techniques, Aspirations* (University Park, PA: The Penn State University Press, 1996), 184–5.

59 See Bahattin Öztuncay, *James Robertson, Pioneer of Photography in the Ottoman Empire* (Istanbul: Eren, 1992), plates 5, 6. From the time it was first available to the public, photography was criticized for its lack of color, and many tried to compensate for this by hand-coloring the prints. Manuals and advertisements for materials soon appeared, such as Alfred H. Wall, *A Manual of Artistic Coloring as Applied to Photographs: A Practical Guide to Artists and Photographers* (London: Thomas Piper, 1861; reprint Arno Press, 1973). Several chapters are devoted to using watercolors, and there are advertisements in the back for Japanese watercolor supplies.

60 Banta and Taylor, *A Timely Encounter*, 50, plate 44.

61 Not all photographs made in Japan were so subtly colored; many others on the market have a fairly crude technique and garish colors, most notably an intense red.

62 Humbert, *Japan and the Japanese*, v–vi.

63 Prostitutes could not afford fine clothes, which were very important for demonstrating the status of women in the pleasure quarters. The more elegant and expensive a woman's attire, the higher her status and the more she could charge. Until she was released from her contract, a courtesan or geisha could not own her own fancy kimonos; they were an important investment of the courtesan and geisha houses and stored in a special place to protect them from wear, fire, and theft.

64 Several of these albums once belonging to Edward Sylvester Morse are now in the Essex Institute in Salem, Massachusetts.

65 Stillfried sold his studio to an Italian-American, Adolpho Farsari, who had already tried his hand at several businesses – cigarettes, stationery, books – before turning to photography in 1883. Beato would later export goods from Burma. See Lowry, "Victorian Burma by Post."

66 Margarita Winkel, *Souvenirs from Japan: Japanese Photography at the Turn of the Century* (London: Bamboo Publishing, 1991): 31.

67 For a photograph of a Stillfried studio advertisement from the 1870s, see Bennet, "History of Photography", 41.

68 Ibid., 35.

69 Winkel, *Souvenirs*, 29.

70 Loti's novel *Madame Chrysanthème* (Paris: Calmann-Levy), first published in 1887, was his most popular. He also wrote another fictionalized account of his trip to Japan, entitled *Japoneries d'automne* (Paris: Calmann-Levy, 1889).

71 Loti, *Madame Chrysanthème*, 4.

8

COLONIAL COLLECTING

French women and Algerian *cartes postales*

Rebecca J. DeRoo

Between the turn of the century and World War I, postcards became mass media of communication and collectible objects for the first time in French history.[1] A significant portion of the millions of postcards produced yearly in France displayed Algerian tourist sites and ethnic types. During the 1980s, post-colonial scholarship set out to unmask the colonial agenda in these postcards by linking seemingly non-political Orientalist iconography to the French colonial project. Malek Alloula's *The Colonial Harem*, the best-known of these revisionist texts, provides an important interpretation of the images, yet also demonstrates the shortcomings of an approach that focuses solely on Orientalist imagery.[2] Alloula reproduces postcards of belly dancers and harem women (typical Orientalist iconography) and arranges the images into a narrative so that the models are progressively unveiled. Using metaphors of penetration and possession, he compares the unveiling of the women with the French colonial conquest of Algeria. By rearranging the cards in his book, however, Alloula fails to consider what personal arrangements of the images might have meant for those who collected them. Furthermore, he overgeneralizes the metaphor of sexual conquest and overly delimits both the audience for the cards and their meanings: penetration and possession imply that the viewers and collectors were heterosexual males. Rather than reduce the postcards to a monolithic masculine colonial imperative, as anti-Orientalist readings tend to do, we must investigate how the images functioned differently depending on the context of their use. This chapter seeks to uncover the layers of meaning the cards acquired as "views" and "types" were produced by the government-aided tourist industry and displayed by French *collectionneuses*.

ND Studio's colonial Algeria

Colonial postcards had complex origins, which were emblematic of the complex motivations for their production and obscured by the cards' cross-continental travel. Since 1840, the French presence in the colony had relied on capitalist involvement in tourism. By the turn of the century, the French government was funding Neurdein Frères – ND Photographic Studio, one of the largest French postcard producers. The government used ND images for travel guides and historic records because tourism expanded the colonial infrastructure and postcard publicity stimulated private investment. ND covered Algeria extensively, with the number of Algerian images second only

to their representations of France.[3] Like other Paris studios, ND studios sent photographers to the colonies to take pictures.[4] ND processed and edited the images in Paris, and then marketed them to businesses in Algeria. Because the postcards were bought, sold, and postmarked in Algeria, the role the French company took in their production was suppressed; the cards were understood by the French to originate from the colony and to reflect the sensibilities of the indigenous population.

Neurdein Frères' 1905 catalog divides the postcards into two main categories: "views" of major cities and "types and costumes" of Algerian people.[5] Though records do not indicate how many copies of each image were printed, the catalog lists 1320 views and 201 types. This division between views and types also resembles the breakdown of cards in ND travel souvenir books, which typically begin with panoramic overviews of the city, move in closer to see the sites, and end with a picture of a smiling young woman. Souvenir books focus on one city, but postcards from various cities demonstrate the number of different ways that Algeria was represented. Their expressions of colonialism are idiosyncratic and sometimes contradictory, yet underlying themes emerge. As the following examples are intended to suggest, the cards express the separation of and difference between Europeans and Algerians in terms that were immediately legible to nineteenth-century Europeans: the organization of urban space and racial categories based on physiognomies. These frameworks were used to represent French control over and displacement of the Algerian population and to justify the French presence in Algeria.

Two views of Algiers can be compared to show the implicit contrast in the series between the rational force of modern France and the unknowability of "native quarters."

Figure 8.1 Alger – Le Boulevard de la République, in Georges Duboucher, *L'Algérie: 1870–1930* (Toulouse: Editions Milan, 1983): 26.

Alger – Le Boulevard de la République (figure 8.1) shows the Immeuble Lescat, the site of municipal administration in the capital city of the colony. All the details demonstrate civic order: geometrically aligned streets, evenly spaced lampposts, and a mounted police officer on patrol represent not literal governing, but rather symbolic control of the colony. The Immeuble Lescat on the right is a monument to the imperial dominance and "civilizing" force of France. The classical, permanent style of the building transplanted from France exhibits no influences from indigenous architecture

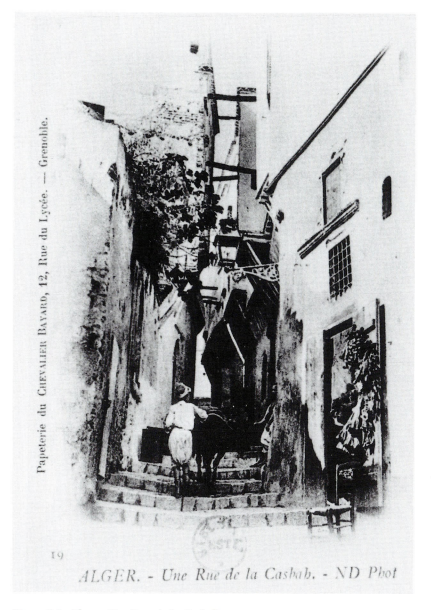

Figure 8.2 Alger – Une Rue de la Casbah.

or adaptation to Algerian ways of life, but it demonstrates that the French have imported their culture with them.[6] Such images of the European quarter promise the tourist modern transportation, luxury hotels, and leisurely activities – all in safe and familiar places offering the comforts of home.

Compared with this modern French administration, *Alger – Une Rue de la Casbah* (figure 8.2) emphasizes that the Turkish reign in the Casbah belonged to a past era. The card depicts the route to the Casbah, the historic palace of the Turkish regency, and presents indigenous ways of life as primitive, mysterious, and disordered. A boy and his donkey climb the sloped terraces that lead to the palace. The jumble of dilapidated buildings with plaster cracking off the walls emphasizes the Casbah's outdatedness compared with the modern streetcar and shops on the Boulevard de la République, where the rational ordering of urban life is readily apprehended. The labyrinthine streets, barred windows, and closed shutters in the Casbah create an ambiance of mysteriousness and impenetrability, one that corresponds to guidebooks' emphasis on its unknowability: "The Casbah . . . still has the same mysterious atmosphere. It still resembles the Moorish women whose veils only allow their eyes to be seen. There are still the same low doors that never open."[7]

City views of French administration, commercial centers, and leisure activities reinforce a comfortable separation between the civilized metropole and the indigenous population. They are the only postcards that depict Europeans as well as indigenous Algerians; however, they portray Europeans as the majority, and the groups do not interact. The cultural divide is instantly visible: Europeans mill around the Boulevard de la République while a single Algerian crosses the street. In the Casbah, the boy is busy with his own "primitive" activities, safely apart from European life.[8]

In contrast to the views which can be sorted according to two utterly opposed manners of life within the city and on the Algerian land, the types exclusively depict Algerians.[9] Captions that classify the subjects according to work and race recall late-nineteenth-century ethnographic practices that themselves developed from mid-century physiognomy.[10] Physiognomy used physical features as a guide to individual character and class; however, the ND ethnic type categories take individual subjects and their clothing to represent traits of an entire race. This labeling by work and ethnicity erases social interaction, turning Algerian society into an ahistorical series of categories served up for novelty and local color. Indeed, it is the pseudoethnographic style of the Algerian postcards that allows for depictions of the unusual, taboo, and erotic, as the following examples demonstrate.

Un Arracheur de dents (figure 8.3) is a typical work scene. Like most of the ND work images of men, it shows what seems to be an uninterrupted view of the bizarre and curious customs of Algerian culture. The tooth-puller conducts business as his client sits in the street; standing over him, a barefoot onlooker (perhaps his assistant) takes in the activity. Such images emphasize the "primitiveness" of the indigenous culture; a plier-like tool and bowl of water are his only apparatus. Because the subjects go about business uninterrupted, the postcard seems to provide a privileged, "authentic" view. Yet here, as in all the ND postcards of Algerians, the background and surrounding situation are actually unclear. By close cropping, the Algerian subjects are isolated from any social or geographic context that would account for their actions or that could problematize French presence at the scene. In dramatic contrast to the views of Algeria that anchor Europeans at sites with city labels and monuments, the types have neither city names nor recognizable landmarks.

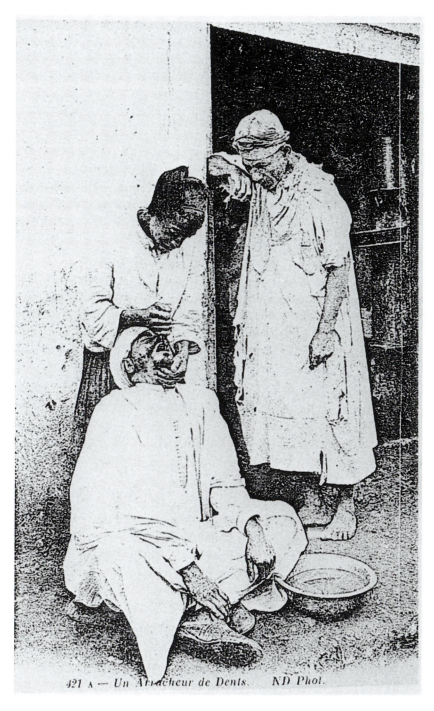

421 A — Un Arracheur de Dents.　　ND Phot.

Figure 8.3 *Un Arracheur de dents*, in Paul Azoulay, *La Nostalgérie Française* (Baschet Editions, 1980): 152.

While work scenes predominantly depict men actively living out cultural traditions (however decontextualized), the ethnic types almost always portray women and present them as the bearers of the culture. The young women wearing "regional costumes" supposedly embody a particular race. They are more obviously posed, as if welcoming the viewer's presence. Men in work scenes look dirty and poor, but because the women are young, partially undressed, and posed in neutral settings, the erotics of the image can often dominate.

In images of the harem, eroticism is inflected by pronounced differences in racial representation. In *Mauresques* (figure 8.4), or "Moorish women," for example, the women seem to look out, inviting us with their tambourines and tea ceremony to join the activities of the harem. Though all are labeled "Mauresques," the dark women are more fully clothed, sit relatively upright, and gaze at the viewer with blank expressions. The light-skinned woman raises her eyebrows, suggestively glances at the viewer, and reclines with her legs spread apart and blouse drawn back to reveal her breasts. Whereas this woman, physically closer to European conceptions of beauty, can offer herself for sexual exhibition, the dark-skinned women are too Other, seeming to lack both the physical traits and the sense of self required for self-eroticization.

The walls of the harem, like the Muslim veil, delineate women's private space, and harem images invite us to transgress these limits.[11] In doing so, the postcards violate private, cultural, and religious boundaries, breaching both the practice of the veil and the law against representation in Islam. Yet, trespassing into women's space does not appear to be a transgression in these images; if they are capable of interaction, the women do not resist but offer themselves.

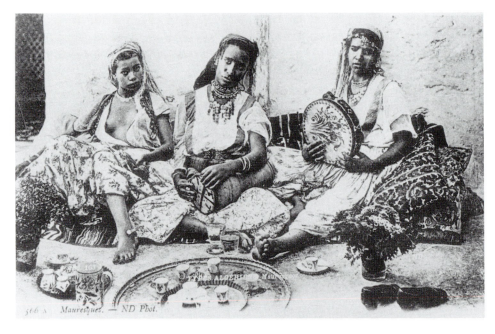

Figure 8.4 Mauresques, in Malek Alloula, *The Colonial Harem* (Minneapolis: University of Minnesota Press, 1986): 88.

When situated in souvenir books, images of Algeria typically moved from city views to smiling young women, as illustrated by the sequence of images in the above account. City views were closer to actual tourist experiences, but the unreal harem scenes were set up to show what tourists never saw. The postcard form itself and the ethnographic labels that accompanied it emphasized authenticity and concealed the staging of the scenes. The images promised the tourist a colony that was alluringly different, and by constructing a reassuringly French framework, attempted to foreclose the possibility that their pictures of colonial difference would prove unsettling.

Circulation and collection

In contrast to their arrangement in souvenir books, when these images were actually used and collected in postcard form, they were often placed in other sequences, categories, and situations that altered their colonial content. Moreover, when postcards were exchanged through the mail, the images were linked with the tourist's text. What do such practices tell us about how the cards were understood through the activities of tourism and exchange?

As tourists, both men and women bought ND cards at kiosks, *tabacs*, and newsstands located near the sites pictured on the cards and exchanged the cards with either members of the same sex or opposite sex. By purchasing a card and writing a message on the back of the image, a French tourist marked or commemorated his or her presence at that place. The sender also asserted his or her position as someone with the money and leisure time to travel.

The small message space was intended for simple greetings. And because the postcard was not private, it was used for general communication. Postcard messages from Algeria were generally abbreviated because the cards could be sent for five centimes instead of ten when they contained only a greeting and closing. Messages may have also been brief because they were traded through exchange societies and sent to collectors not personally known to the sender.[12]

In some ways, a lack of commentary may be most revealing. An absence of descriptive messages characterizes images of Mauresques, Ouled Naïls belly dancers, and the harem. Postcards showing topless women often have no message, stamps, or postmark, suggesting either that they were never sent and instead were kept by the purchaser or that they were sent in an envelope. None of the messages that I have seen on such cards comment on the images; most contain only brief salutations. For example, a postcard of a *Jeune Mauresque* exposing her breasts is signed "Bonjour lointain," with a signature on the front and back of the image (Figures 8.5 and 8.6). Despite such acts of possession, the sender of the harem picture could not, for obvious reasons, be understood to be saying, "I was here, I saw this." Even though it is difficult to determine what hidden message, if any, was conveyed, the striking congruence between explicit sexual imagery and lack of message suggests that in this instance the image, and its possession through a signature, became the exclusive content of the communication.

A similar silence surrounds images of Algerian women in guidebooks. For example, *La France Africaine* shows an ND image of a "Mauresque d'Alger."[13] The woman is unveiled, but clothed, wearing lots of jewelry. The *Guide Joanne* lists cafés with Ouled Naïls belly dancers (many of whom were known to be prostitutes) but does not describe

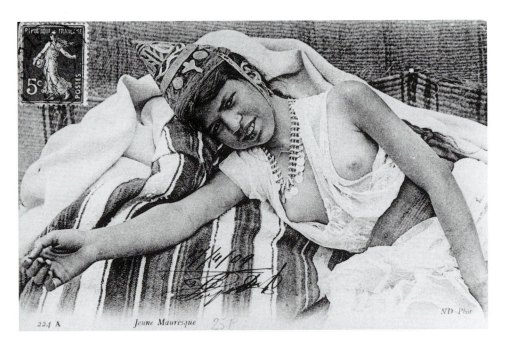

Figure 8.5 Jeune Mauresque.

Figure 8.6 Verso of Jeune Mauresque (Fig. 8.5).

them; indeed, one travel account calls an Algerian woman's dance "indescribable."[14] It is the pictures that promise most about what would be found in Algeria. Images of women smoking and exhibiting their bodies were not discussed, perhaps because such overt references to sexuality were inappropriate in a guidebook, but perhaps also because, paradoxically, texts actually adhered more to the actual sights a tourist might encounter – tourists would never see Muslim women exposed as they are in these pictures.

Thus, to understand postcard images in relation to tourism and colonialism we have to attend to places where textual and pictorial representations diverge, to the discrepancies between the postcard image and the postcard message or the guidebook's pictures and text – to what can be shown but not described. Although it was considered bad taste to send a woman collector a card with French women posing provocatively or exposing their breasts, the ND images of Algerian women were acceptable because it was another culture that appeared to be transgressing French mores. Thus, while French writing conventions made harems unaddressable in tourist texts, and Muslim practices made the locales off bounds for tourist visits, the image on the card introduced eroticism into social exchange.

Collectors were also a significant part of the postcard market. Although there were male collectors, postcard collecting was often represented as a feminine activity, and the ND cards I have discussed were printed after the practice of postcard collecting by women had become established. Thus, the cards must have been produced to some extent with a female audience in mind. In fact, many of the cards previously described were addressed to "Mademoiselle." We need to consider the meaning of the cards in light of this gendered spectatorship of the images, particularly since these were exceptional images for a female audience, affording opportunities for personal expression not available elsewhere.

Women frequently kept postcards in albums, but today it is extremely difficult to locate an intact collection: most images have been separated for sale or reclassification in archives.[15] Though women's magazines and collectors' journals have a promotional intent and do not necessarily represent what a range of women may have done and thought, they do give access to the responses to and the uses of postcards by their readers.

Postcard collecting provided women both opportunities to engage in social exchanges with gentleman callers and to display their creativity. *La Femme chez elle* (1900) describes: "Recently a veritable commerce of polite remarks and courtesies between young men and women has been established due to postcards . . . for a well brought up young lady . . . [postcard collecting] provides thousands of ways of demonstrating her tact and savoir-faire."[16] Thus, postcards allowed women the opportunity to display publicly their taste, education, and individuality, and provided a means of negotiating between social custom and personal desire.

While collectors' journals insisted that organizing a collection through the flexible form afforded by the photo album was a matter of personal taste, they also suggested possible arrangements for both type and view cards. *La Gazette Cartophile*, a journal for women collectors, recommended a geographic arrangement of view cards, by country, department, city, monument, and site, so that the organization would reconstruct a trip city by city.[17] The *Gazette* also suggests arranging "types and costumes" cards by region and ethnic features, as if they were a "scientific" survey of the ethnic

population.[18] The journals gave more guidance for sequencing views by region, but rarely mentioned how to arrange ethnic types, suggesting that the organization of types was more ambiguous and leaving more room for the *collectionneuse* to impose her own order on the cards.

Sources suggest that when arranged for private use collections had more fluid functions than these documentary and didactic objectives.[19] Messages and images might recall personal memories or be used for imaginary travel: "Leafing through an album, is almost taking a trip; even better, it's taking a trip during which one would only see that which is worth seeing."[20] For women whose movement was restricted, postcards allowed them to explore vicariously distant places within the private space of their homes.

The contradictory views of North Africa in ND postcards are repeated in stories of the Orient in popular women's magazines. Both express ambivalence toward Algeria for the female viewer. Though articles specifically on Algeria were seldom published in women's magazines, representations of the Middle Eastern "Orient" were popular. Like postcards, the stories in women's magazines could be used to travel imaginatively to different places, to identify with the depicted characters, and to safely live out exotic fantasies.

In *Femina* magazine's article "Femmes du désert," Mme Jean Pomerol described her study of religious sects, race, and women in the Sahara.[21] A photograph depicted the author in her salon at home in Paris, surrounded by souvenirs from her travel, reflecting her creativity and understanding of language and customs. Pomerol herself represented authority, education, and taste – ideas also aimed at *collectionneuses*. The article conveyed a curiosity about women around the world, perhaps similar to that expressed by women who collected type postcards. The text also reflects the racial hierarchies present in postcards: Pomerol describes blacks in terms of slavery and praises Arabs as the most beautiful race because their skin is closest to a European complexion.

Pomerol suggests a fascination with Algerian beauty rituals:

> [The woman in the Sahara] has long, long periods of leisure . . . She uses them to adorn herself. And what adornment! . . . Flowing draperies, attached by an abundance of barbarous jewelry . . . Henna on her hands that become a mahogany color . . . Make-up on her cheeks, applied without any intention of imitating nature . . . Muslin veils trailing on the ground.[22]

The article seems to encourage French women to try exotic beauty rituals as their own private escape, but then, as to reaffirm the superiority of the colonizer, adds that these women can bathe only once a week because of water shortages. Though the images may provide women an outlet for an erotic fascination, the fascination remains tempered with ambivalence.

In the ND postcards, as in the Pomerol article, Algerian women are presented to French women as both dirty and exotic – in ways that may seem contradictory but that can also work in tandem. In the article, elaborately dressed and bejeweled *danseuses* on a camel wear costumes like those of the women in the Mauresques postcards. At the same time, images of women preparing couscous outdoors resemble gritty ND scenes of people working in the streets. This attitude of simultaneous attraction to and repulsion from the subjects, seen earlier in the view and type postcards, allows the women to experience both identification and distance.

Collecting postcards of harem scenes was a rare socially sanctioned occasion for women to view and display images of other women in exhibitionist and sexually provocative poses. The public explanation for this license was that women took interest in the details of cultural difference and in the foreign costumes in the images. Yet collection practices also suggest that French women identified with the erotic sexuality that Algerian women represented. This identification could have taken a variety of forms for women collectors, such as assuming an exotic identity and participating in Arab mystery. Through these possibilities for identification, women could use postcards within the boundaries of social convention as a way to actively imagine and desire sexuality.

The contradictory representation of colonial subjects in the postcards allowed women to mobilize a tactical identification. At times in their collections women seem to have played off the racial and economic differences of the models, expressing their sense of the racial superiority of whiteness and bourgeois elitism toward menial labor. Yet, women could also "forget" race and class: while the cards codified and marketed racial and economic others, they simultaneously allowed a complicated but productive identification by gender. For French *bourgeoises*, enjoying advantages of class and race, Algerian women exemplified the free expression of erotic sexuality. French women may have used images of the harem (ironically, a notoriously unfree site) to rewrite sexual domination at home; at the same time, however, their means for self-expression fit within the patterns enforcing colonial domination abroad.

The ND postcard images reflected the interests of the commercial tourism industry and the French colonial government and appealed to viewers because they reinforced bourgeois attitudes about race, work, and gender. The silence around the images in guidebooks and in the personal messages written on the cards, however, indicates viewer ambivalence about the images and evoked other interpretations of them. French women's exchange and collection of the postcards demonstrates that they accepted colonial depictions, including racial hierarchies, degraded labor, and eroticized feminine stereotypes. Yet, by reordering, recategorizing, and displaying the cards in collections, these women found in the images possibilities that exceed those imagined by the colonial and commercial industries that produced them. Thus, the colonial postcards did not merely reinscribe accepted hierarchies; they were also used to displace and expand definitions of bourgeois femininity.

Notes

I would like to thank Martha Ward, Joel Snyder, and Katie Trumpener for their helpful comments on this chapter and David Prochaska, who generously shared his research with me. I am grateful for the support of a Kathleen J. Shelton research fellowship, which enabled me to visit archives in France in 1994. This essay first appeared in *Parallax* 4, 2, (1998): 145–157.

1 See Frank Staff, *The Picture Postcard and its Origins* (New York: Frederick A. Praeger, 1966), 53–81. The 1900 World's Fair, at which millions of postcards were sold, is usually considered the beginning of the golden age of the postcard in France. Aline Ripert and Claude Frère, *La Carte postale: son histoire, sa fonction sociale* (Paris: Presses Universitaires de Lyon, 1983), 26. By 1902, David Prochaska believes that sixty million postcards had been produced in France. David Prochaska, "The Archive of Algérie Imaginaire," *History and Anthropology* 4 (1990): 375. Naomi Schor argues that, through sales at world exhibitions in France, the postcard was not only popularized but also came to be associated with

commercial exchange and nationalistic self-promotion. See Naomi Schor, "*Cartes Postales*: Representing Paris 1900," *Critical Inquiry* 18 (Winter 1992): 213.

2 Alloula and Monti take this anti-Orientalist approach; Banta and Hinsley examine colonial imagery in the context of anthropology, but are ambivalent about the circumstances in which the images were produced. See Malek Alloula, *The Colonial Harem*, trans. Myrna Godzich and Wlad Godzich (Minneapolis: University of Minnesota Press, 1986); Melissa Banta and Curtis M. Hinsley, *From Site to Sight: Anthropology and the Power of Imagery* (Cambridge, MA: Peabody Museum Press, 1986); and Nicolas Monti, *Africa Then: Photographs 1840–1918* (New York: Knopf, 1987). In their review of the literature on colonial photography, Annie Coombes and Steve Edwards call for an account which would investigate the sale and circulation of the images; I take up their challenge in this chapter. See Annie E. Coombes and Steve Edwards, "Site Unseen: Photography in the Colonial Empire: Images of a Subconscious Eroticism," *Art History* 12, 4 (Dec. 1989): 511.

3 ND printed and sold images to tourists, big businesses, and branches of government involved in the tourism industry, and the images continued to be reproduced thereafter in various formats. For example, *La France Africaine: Le Tourisme et l'hivernage en Algérie-Tunisie*, published by the Compagnie Générale Transatlantique cruise company, and *Le Tourisme en Algérie*, published by the French government, reproduced ND images similar to those used as postcard scenes.

4 Prochaska has argued that ND and Levy Studios sent photographers "into the field" (Prochaska, "Archive" : 376).

5 Neurdein Frères, *Catalogue des collections et sujets édités dans le format carte postale* (Paris: Neurdein Frères, 1905). To my knowledge, this is the only extant record of postcards published by the studio.

6 In fact, to make way for these monuments to French culture, indigenous quarters were often destroyed, with streets renamed and reconstructed to converge in French strategic and commercial centers. Michèle Salinas, *Voyages et voyageurs en Algérie, 1830–1930* (Toulouse: Privat, 1989), 182–6.

7 "La Casbah . . . a toujours son même air mystérieux. Elle est toujours semblable à ces Mauresques dont le voile ne laisse voir que les yeux. Ce sont toujours les mêmes portes basses qui semblent ne s'ouvrir jamais." Pierre Batail, *Le Tourisme en Algérie* (Alger: République Française, Gouvernement Générale de l'Algérie, 1906), 9. *La France Africaine: Le Tourisme et l'hivernage* (1908, unpaginated) compares the disorganized Casbah and the orderly city streets of the French quarter: ". . . the Casbah whose houses are jammed one on top of another guides one's gaze toward the European city with its marvelous gardens, open, vast boulevards, full of animation, and its stylish apartments" (". . . la Casbah dont les maisons accrochées les unes aux autres guident le regard vers la ville européenne aux jardins merveilleux, aux voies vastes et claires bourdonnantes d'animation, aux immeubles de style").

8 Although space does not permit me to discuss rural views, these, too, tended to represent the superiority of the colonizer's use of the land. Images of Tebessa, for example, depict Byzantine ruins to allude to a history of a Western, Christian presence in North Africa. These contrast with contemporary scenes of tents and Arab markets that are intended to suggest a more primitive and inconsequential occupation of the land.

9 ND produced work and type postcards in Algeria *and* France. Prochaska has shown how the work scenes of Algeria presented a folkloric view of work, similar to representations of people in provincial France: both emphasize handicrafts and portray a precapitalist, preindustrial age. See Prochaska, "Archive": 373–420. Strategies for "typing," however, diverge dramatically: in France, people are labeled by provincial region whereas in Algeria the population is typed by race. For this reason, it seems more fruitful to compare representations of French and Algerians in Algeria than representations of each in their native contexts.

10 Although the postcard captions that labeled the subjects according to race evoked ethnographic practices, the images were not intended to constitute a scientific study of race; a number of postcards classified the same models as different ethnic types and recycled the models' "ethnic" costumes. For a discussion of French ethnology, focusing on William Edwards's work and its impact on subsequent studies of race in nineteenth-century France,

see Claude Blanckaert, "On the Origins of French Ethnology: William Edwards and the Doctrine of Race," in *Bones, Bodies, Behavior*, ed. George W. Stocking, Jr (Madison: University of Wisconsin Press, 1988), 18–55. Nélia Dias situates late-nineteenth-century practices of anthropology, ethnology, and ethnography in their institutional contexts: *Le Musée d'ethnographie du Trocadéro (1878–1908)* (Paris: Editions du CNRS, 1991). On more popular representations of ethnography and race, see Zeynep Çelik and Leila Kinney, "Ethnography and Exhibitionism at the *Expositions Universelles*," *Assemblage* 13 (1990): 34–59, and William H. Schneider, *An Empire for the Masses: The French Popular Image of Africa, 1870–1900* (Westport: Greenwood Press, 1982).

11 I am indebted to Alloula's analysis of the harem for my argument here. See Alloula, *Colonial Harem*, 105–22.

12 When a sender did not personally know a collector, collectors' journals suggested limiting comments to polite remarks and salutations. One postcard collector's guide suggests covertly conveying romantic sentiments by specially positioning the stamp on the postcard. Though it is impossible to know how often this was done, the article suggests that postcards could be used to communicate ideas and sentiments beyond those written in the message. See "Echange et correspondance," *Le Cartophile* 8 (May 1901): 1–3.

13 *La France africaine*: 3.

14 G. Jacqueton, Augustin Bernard, and Stéphane Gsell, *Guides Joanne: Algérie-Tunisie* (Paris: Hachette, 1903), 5.

15 This research draws on the postcard collections of dealers, the Bibliothèque Nationale, and the Centre des Archives d'Outre Mer in France.

16 "Depuis peu, il s'est établi entre jeunes gens et jeunes filles un veritable commerce de politesses et de courtoisie dû aux cartes postales. . . . pour une jeune personne bien élevée . . . il y a là mille manières de donner des preuves de tact et de savoir-vivre." Griseline, *Le Cartophile* 3 (Dec. 1900): 7, trans. Schor, "Cartes Postales": 212.

17 Pierre Sarrazin, "L'Art de collectionner: Le Classement," *La Gazette Cartophile* 7 (n.d.): 104.

18 Ibid.

19 A woman author who was nostalgic about a trip described how postcards reawakened her memories: "I wouldn't know how to gaze at these wonders without a feeling of personal satisfaction! . . . I have, before my eyes, the same valley and it is reproduced so well in the print that it awakens a whole legion of memories in me" ("Je ne saurais contempler ces merveilles sans éprouver une satisfaction intime! . . . J'ai sous les yeux cette même vallée et le cliché en est si bien reproduit que toute une légion de souvenirs s'éveille en moi"). Marie-Thérèse, *L'Intermédiaire des cartophiles* 5 (Nov. 1904): 1. An author from *La Famille* explained how a woman asked traveling friends to send her cards regularly. With images and messages from friends: "It is no longer an ordinary album of photographs, it is also [an album] of memories" ("Ce n'est plus seulement l'album banal de photographies, c'est en même temps celui des souvenirs.") Mary Florian, "La Famille", reprinted in *Le Cartophile* 14 (Nov. 1901): 7.

20 "Feuilleter un album, c'est presque faire un voyage; même mieux, c'est faire un voyage durant lequel on ne verrait que ce qu'il y a de digne d'être vu." *Revue Illustrée de la Carte Postale*, 15 Jan. 1901: 123.

21 Jean Pomerol, "Femmes du désert," *Femina* (15 Sept. 1902): 288–9.

22 "Elle a de longs, longs loisirs . . . Elle les emploie. . . à se parer. Et quelle parure! . . . Des draperies flottantes, rattachées par des profusions de bijoux barbares. . . Du henné sur les mains, qui deviennent couleur acajou . . . Du fard aux joues, mis sans aucun intention d'imiter la nature . . . Des voiles de mousseline traînant à terre" (ibid.: 289).

9

PHOTOGRAPHY AND THE EMERGENCE OF THE PACIFIC CRUISE

Rethinking the representational crisis in colonial photography

Michael Hayes

In 1884 almost simultaneously Australia and New Zealand launched the first voyages of what are now commonly referred to as South Pacific cruises. The Aotearoa/New Zealand shipping firm, Union Steam Ship Company of New Zealand (USSC), and Burns Philp (BP) Australia instigated the totally new and untried project that joined a variety of leisure practices (sightseeing, walking, observation) to a nautical schedule of port visits, deckboard games, and dinner with the Captain. In examining these cruises I want to elaborate on the connection between colonialism and tourism by suggesting that tours to the Pacific are one aspect of Australian and Aotearoa/New Zealand colonialism in the Pacific.[1] More specifically, I wish to concentrate on the utilization of technologies of representation, in particular photography, which operated in the formation of a South Pacific cruise. Having colonial terrain represented, collected, pictured, and observed through photography is perhaps one of the most insidious forms of colonialism, where indigenous terrain becomes an object of a representational knowledge to Australia and Aotearoa/New Zealand, and the site for reproducing colonial relationships of power. Importantly, tourism allows colonialism to be *practiced* in that the tourist is involved in a number of disciplines dealing with observation, recording, and consuming which produce relationships of power in a specific colonial context.

In suggesting a "first" Pacific cruise at this specific time I do not want to imply a magical origin in which a cruise spontaneously occurred, and from which all later cruises can be understood. Nor is this the origin of a determinedly new form of colonialism, in which the cruise can be situated in a developmental history of imperialism when "modern" technology (such as maritime travel or photography) proves that imperialism is ever growing and improving. The question is, rather, why at this moment did a desire to produce the cruise manifest itself? In answering the question I want to show the discursive regularities, regimes of truth, and apparatuses of power that made possible, and disseminated, the practice of tourism. I take this point of departure from Geoffrey Batchen's study of the "invention" of photography. Batchen criticizes the idea that photography was invented in 1839, as traditional histories

172

posit, and instead locates photography's emergence in a changing epistemology of representation. Rather than searching for an origin as a singular, unique event, Batchen asks, following Foucault's lead in *The Archaeology of Knowledge*.

> at what moment in history did the discursive *desire* to photograph emerge and begin to insistently manifest itself? At what moment did photography shift from an occasional isolated, individual fantasy to a demonstrably widespread, social *imperative*?[2]

Similarly, a possible question to ask is: at what moment did the discursive desire to cruise the Pacific emerge, at what moment did the cruise become a widespread social imperative? This is not about documenting a date for the first cruise, but locating the epistemic conditions and institutional support for this activity. Thus, while these cruises may have been the first, they are not the origin, or starting point, for Pacific tourism because they are more like the crystallization of numerous desires: imperial, colonial, economic, sexual, and so on. The maritime technology and infrastructure (hotels, wharves, ports, roads) necessary to cruise the Pacific had been available for many decades previously. However, it was only when the "social imperative" transformed these disparate events into a cohesive practice that the Pacific cruise emerged.

The utility of Batchen's study of photography is not simply his criticism of origins, as I am also interested in the use of the camera itself by tourists as a signifier of Western superiority, and through this how observation is constructed as a practice which stages a privileging of the colonizer. Batchen situates the inception of photography within the reproduction of certain forms of power that can reorganise, map, and penetrate the body (25). In this vein, it is important that a photographer, Alfred Burton, was on the first 1884 cruises recording the activities and sights. There is a refiguring of representational power in colonizing nations to incorporate the technology of photography and use these representations to describe the superiority of the colonizing nations themselves. The methods and technologies of representing the cruise and the colonized terrain institute a privileged space for the Western viewer to make stereotypical representations of Pacific Islanders and hence reproduce relations of power through marking the Islanders as feminized, "primitive," or anachronistic. The Western mythologies constructing the Pacific Islander stereotypes were made into practices of observation for the tourists, who could record and reproduce the stereotypes through the camera or a written account of the cruise. These stereotypes are powerfully used in tourism to validate the economic and cultural intervention of the colonizing nations and position a tourist to see the "sights" and events while on holiday in this particular way. The sites, then, become an object consumed by the colonizer, a practice in which the tourist sights captured on film, or seen from a viewing point, are conscripted into an economy of representation. And this economy, I wish to argue, is justified through the articulation of a specific discourse of representation sympathetic to the political ambitions of colonialism.

Observation and consumption

The predominant reading of Western observation from the time of Pacific colonization (which was perhaps a hundred years before the first cruise), and including the advent

of tourism, posits a post-Enlightenment revolution coined "the crisis of representation" by theorists such as Jonathan Crary, Jean Baudrillard, and Geoffrey Batchen; these theorists are elaborating on Foucault's thesis in *The Order of Things*. Foucault considers fundamental changes in European culture when the classical age gave way to the modern age around the beginning of the nineteenth century, a transformation which inaugurates a "profound historicity"[3] in place of the general taxonomy of the classical age. The fundamental changes in how Europeans thought and perceived things lead to the emergence of the modern sciences such as ethnography and anthropology, the technology of photography, and modern art movements. However, the term "crisis" as it is employed here is problematic as it infers a coherent European society that is disrupted by this transformation; such narratives produce a unified teleology of history. Far too often this change has been described as autonomously European, brought about by some form of internal evolution, and not contextualized within European conquests and inscriptions of non-European terrain. I want to bring this colonial context into the predominantly Eurocentric history by a brief examination of Jonathan Crary's *Techniques of the Observer*, which problematically attempts to source rationalism and knowledge in the West and perpetuates the consumption of the non-Western other.[4] The emergence of the "modern observer" coincides with extensive observation of unprecedented imperial expansion into the Pacific.[5]

The "crisis" is not so much an evolution of Western technology and art, but an emergence of colonial discourses in diverse fields such as photography and children's stories, bringing representations of the Pacific Islander into the imperial lexicon. Crary relies heavily on Foucault to structure the historicity of his "crisis." The changing understanding of observation, which Crary relates to investigations of the observer's physiology, derives from the "docile body" thesis in *Discipline and Punish*[6] while the discursive context of this transformation comes from the representational "crisis," or "threshold of our modernity,"[7] in *The Order of Things*. Foucault's discussion of modernity focuses on the doubled role of the observer: for the first time man emerges as the object of "his" own study. [8]

There is an important point to be drawn from this. The broad generalization with which Foucault employs the term "man" is unquestioned by either Crary or Batchen. Crary explains the increasing biological interest in sight by using Foucault's argument of the emergence of "man" studying himself, yet he edits out one of Foucault's two analyses necessary to this study of "man": while Crary elucidates on those studies which "operate within the space of the body" and determine what Foucault calls the "*nature* of human knowledge" (319) – specifically of Goethe's work on the "inward experience" (72) or physiological aspects of sight – Crary ignores Foucault's twinned proposal that the history of human knowledge, its antiquity, its "historical, social or economic conditions" (319) was similarly brought to the fore. Thus anatomy emerged with anthropology, human biology with ethnology; and though, as Foucault states, these knowledges "claim to be able to rest entirely on themselves" (319), they are results of the same critique and "necessary to one another" (322). Quite obviously Crary's "inward" study dismisses the transformations occurring in imperial sciences due to new practices such as ethnography, and elides the historicity of the "man" to be studied. Though Crary's concerns, which he cogently analyzes, are the transformations operating on the user of technologies such as photography, he too easily ignores what the camera was pointed *at* to contextualize these changes. Crary's "docile" observer

becomes a passive subject who is the "historical product *and* the site of certain practices, techniques, institutions and procedures of subjectification" (5);[9] the camera-user's agency, his reproduction of colonial relationships of power is not considered. I am not advocating an intentionality of the observer here, but a particular agency involved in the relationship of viewer and viewed, a power relationship that Crary ignores. For in Crary's concentration on the disciplined formation of the observing subject he elides the privilege allocated to this subject; frequently, in an imperial context, the photographer is privileged by "his" (as almost all photographers were men) gender, race, and class. Through following perhaps too closely Guy Debord's suggestion in *The Society of the Spectacle*, that sight was "elevate[d] to the special place occupied by touch,"[10] Crary suggests it is the *sense*, and not the *subject*, which is privileged. At some points in the introduction Crary signals the importance of the context,[11] particularly the institutional and discursive production of the viewer, but in his detailed examination of the camera obscura the only relationship discussed is between the user and the object. The viewer – a product and site of the history – also produces and transforms this site by determining what is *viewed*. As Paul Fox comments, "the photographer can be seen to be not only a contributor to the visual imagery of the primitive but also as a significant contributor to the institutions of classification."[12] Practices of observation and critiques of verisimilitude were mapped within colonial discourses by agents who were willing the construction and categorization of the so-called "savage" and the "primitive" through their camera viewfinders, and were cataloguing these bodies for the later observation by Western tourists.

Photography and tourism

A crucial aspect of the tourist representative regime is the categorization of the "sight" or "scene," a view that the tourist must observe, possibly record, and admire. Around tourist activities various practices of vision are condensed. Judith Addler has described the growing reliance on vision in European travel during the seventeenth and eighteenth centuries as the "historical development (and eventual popularization) of post-Baconian and Lockeian orientations toward the problem of attaining, and authoritatively representing, knowledge."[13] The rise of Natural Philosophy, according to Addler, led to the privilege of the eye over the ear for verification, with accurate descriptions taking the form of a speculum. The technology of photography enters at a time of the increasing importance of representational practice, and the association between the photograph and "truth." Photography came to be used in a variety of colonial activities. The "voyage of exploration" found the importance of photography, for instance the exploration of Papua by Thomas Bevan.[14] Bevan traveled with a photographer with specific instructions to keep a journal record of exposed plates and act as the leader's assistant.[15] The first Pacific cruise by the *Wairarapa* had a photographer to record the places visited, and then to sell the photographs as souvenirs or collectors' items. The "truth" of the photograph, for the tourist, reorganizes the colonized terrain into a form of knowledge made "true" by assuming veracity of representation lies solely with the colonizer's technology. That tourism was actively supporting and using photography emphasizes the growing centrality of the camera as a method of documentation and verification.[16] Many BP brochures, and the *BP Magazine*, advised tourists where to obtain good scenic views to photograph, and what type of cameras

and film to buy. In BP's *Picturesque Travel*, the tourist upon arriving in the Solomons is advised to "wander through the native villages, viewing the novel sights and trafficking for curios, or, with Kodak in hand, take snapshots of the natives and their primitive surroundings."[17] Kodak similarly advertised "Make the most of your travels; use your Kodak," or "Showing is better than telling when it comes to what you say and did abroad!"[18] The camera employs both an artistic formation in discerning the "picturesque" and "scenic," and an authority produced from discourses of science that recorded and constructed cultures and artifacts, especially in areas such as anthropology and ethnography where this medium demonstrated the measurements and characteristics of what were defined as races.

In these two genres of nineteenth-century photography, Alan Sekula writes, was "a fundamental tension . . . between uses of photography that fulfil a bourgeois conception of the *self* and uses that seek to establish and delimit the terrain of the *other*."[19] The dual purposes for photography that Sekula highlights are pertinent, but they are not necessarily different uses. Tourism photography could establish the concept of self as colonizing viewer while simultaneously representing the terrain of the other. The subject positions in photography, both of the photographer and of the subject, are effects of transformations in the science of representation that were to reposition the body of the colonizers and colonized in terms of vision, truth, and science. On the photographs of the first cruise one newspaper comments: "Nothing can picture strange scenes more faithfully and effectively as the camera, and anyone viewing this series [by Alfred Burton] will acquire a far more exact and familiar knowledge."[20] The conflation of realism and the photograph is evident in this evaluation, a conflation which charges European textuality with a value of verisimilitude and truth. John Frow, in a contemporary analysis of photography and tourism, states that photography's centrality to tourism is "its power of capturing any piece of empirically witnessed reality and transforming it into a sign of itself."[21] Precisely the materiality of this "capturing," the violent effects on the colonized body through representational "capture," is elided in discussions that concentrate on the "faithfulness" of photography rather than focusing on the procedures of shooting and capturing by the West. Photography enables and prepares terrain for colonization, as Patricia Albers and William James demonstrate in their work on the ability of postcards and photographs to transform the "historically specific and culturally unique experience of indigenous people into stereotyped images that can be marketed as commodities."[22] The photograph as souvenir becomes a commodity in the economy of imperialism in which cultural artifacts and scenic vistas are valued and exchanged. In these exchanges is a contest of ownership with the colonizers "worlding"[23] the colonized terrain and the Pacific Islanders resisting, or trading, in this market. The authority of the camera as representative of "empirical reality" needs to be questioned specifically in the context of constructing the photograph as the "natural" and faithful text of reality: how is the camera's failure to produce the "real" broached, how does the Pacific Islander's agency rupture the "faithful" text discussed within colonial discourse?

Representations of tourism before the camera

Before photographic reproductions became commercially widespread, one method of representing the Pacific to a large audience was the lantern-slide show. Using a similar

technology to photography, the slide is produced from a photographic negative – slide shows were seen in many church halls and chapels. John MacKenzie argues that these shows were frequently devoted to imperial events, especially travel and missionary subjects.[24] Scottish photographer George Washington Wilson produced a lantern-slide lecture titled "Cannibal Isles or Rovings among the Coral Reefs and Palms" that toured around England in the 1880s.[25] A booklet that accompanied the lecture gives a paragraph description to the sixty slides. The lecture traces a linear movement through the Islands of Fiji, Tonga, Samoa, and the Solomon Islands, with the commentary focusing on houses, women, and on the "scenic." The first slide, "Map of Oceania," contextualized the movement in terms of European geography; the commentary reads in part:

> It is our intention . . . to give our audience some glimpses of the beautiful scenery to be found in the sunny islands of the South Pacific, and to furnish illustrations of the interesting native races and customs as they exist there at the present today. The islands of Polynesia . . . [are] so numerous that it would be impossible, in the limited time at our disposal, to touch all the different groups. (5)

The violence of colonialism here is played down by implying that the Europeans are only "touching" the islands and their observation is "glimpsing." Similar tropes are used in tourism brochures of the cruises: islands are touched or acquainted, the view is partial or "glimpsed" because the region is too big. However, the omnipotent view remains as a desirable possibility to Wilson. The terrain is reduced to readings of "nature," a "nature" which homogenizes the indigenous peoples, the vegetation, terrain, and culture. Other slides in the collection regularly include a plantation and viewers are asked to "Note the luxuriant foliage of the bananas growing in the plantation below the [native] house" (5). Representations of European industry such as the plantation or wharf, the regular signifiers of European commerce, are shown so the viewer is "at once reminded of the influence of British rule in the busy life of the wharf" (5–6).

Among these slides are pictures of laboring Fijians who are "taught" the various skills of fetching coconuts on the plantation representing them as naturally servile to the managing British. Beatrice Grimshaw in a tourist brochure emphasizes this servility of the Pacific Islanders: "Any native, if politely asked . . . will readily climb the nearest tree . . . and throw down a nut or two."[26] The implied servility of the Pacific Islander and the practice of ordering by the tourist are crucial concepts in colonial discourse. It is assumed by Wilson that the British possess the knowledge to grow and harvest coconuts while the Pacific Islanders have the "natural" skills such as climbing trees to labor in the plantation. The slides infer an economy waiting for British control, with willing labor and plentiful resources and, as later described, a "good living off a fair-sized plantation" (9). Details of the copra, banana, breadfruit, and sugar cane economies are given in the reading. The Fijians are unable to take advantage of these resources because, as the slides show, they "take life easy" (8) and the "absence of knives and tools hinders native works from advancing" (10). Seizure of the land is justified because the abundance of vegetation growing "plentifully in all directions" implies the wealth of the plantations in contrast to the "thinly populated" and "impenetrable" (7) interior of the Fijian hills.

Wilson introduces Samoa by a differing process of colonization – that of engendering the culture as feminine: "As our first Samoan view, we beg to introduce to notice a young Samoan princess. We will allow the little beauty, dressed in her costume of tapa or native bark cloth, to speak for herself" (16). Patronizing the Samoan woman as "little beauty," the association of the colonial gaze with patriarchy, and the focus upon so-called royalty, produces sexualized and stereotypical representations in colonial discourse. Colonial photographers frequently titled representations of Pacific Islanders with King, Queen, Princess or Chief's daughter, which satirizes Islander systems of authority (suggesting they are a mimicry or artificial version of British systems of authority) while attempting to universalize monarchy (and hence biological inheritance) as a natural form of government. Wilson's comment of letting the "Princess" speak for herself assumes it is her body which is communicating to the voyeuristic English audience, setting up the mind–body dichotomy between the Western audience and the Pacific Islander's body. The "voice" of the indigene is silenced and replaced with a Western representation of the body, her passive silence a sign of her domination by the colonizer's gaze. The viewer, whose notice is asked for, necessarily constructs through "his" gaze colonial and patriarchal power.

Yet, the viewer must simultaneously have a disembodied gaze and corporealized, fetishistic desire of the stereotyped other, for the very process of sight is corporeal.[27] The viewer is asked to "observe" and understand Samoa through the woman's body, yet the knowledge is formulated by a sexual economy; knowledge comes about through figuring Samoa as sexually desirous. With this sexualized ambiguity in mind, I will turn to the account of the 1884 cruise and through the politicized figures of Pacific Islander women examine issues around the colonial authority of the camera in the first tourist cruises in the Pacific. The representation of women in colonial photography is underscored with the practices inscribing indigenous bodies that are commodified to make possible their seizure by the "observers." Sexual observation makes way for the seizure of the terrain, the labor, and the commerce of Pacific Islanders. As Annette Kolodny argues in relation to what she calls the American pastoral vocabulary, "to make the new continent Woman was already to civilize it a bit, casting the stamp of human relations upon what was otherwise unknown and untamed."[28] The focus on women in a plethora of tourist literature operates within a fetishization of the non-Western other that attempts to apprehend and contain the colonized in submissive positions already "stamped" in colonial relationships of power by gender roles. As I will argue, the photographers devote much time to discussing the picturing of women, yet this activity is fraught with problems such as the "faithfulness" of the camera.[29]

Alfred Burton's photography on the *Wairarapa*

The 1884 *Wairarapa* excursion is a valuable event from which to map tourist activities because the designated sights were recorded by the on-board photographer Alfred Burton, one of the brothers in the well-known Aotearoa/New Zealand Photographic studio, the Burton Brothers.[30] Burton wrote an account of this excursion, a "Photographer's Diary" which was published in a pamphlet to accompany the advertised catalogue of photographs.[31] The catalogue lists 250 photographs, including panoramas of Levuka and Apia, and twenty-four stereoscopic slides, which were intended for individual sale.[32] One section of this diary outlines the ideological gaze of

the photographer, particularly the ways that aesthetic, sexualized and economic evaluations are signified through controlling sight. The photograph, it can be argued, constitutes the space of the colonized as always subject to the colonizer's reality. However, Western representational power is constantly ruptured by its own omissions and incapacities, especially where the colonial viewer is corporealized as desirous – a movement where the tourist or photographer is no longer a rational mind but a seduced body. The tourist, as a "civilized" observer, is positioned as "naturally" superior to the colonized subject; yet this contradicts the very reliance of the colonizer's authority on the technologies of representation. Even though at points the authority of Western representation is problematized, this does not negate the entrenched positions of power held by the colonial observers. Addressing the contradictions in the representational economy does not suggest that colonialism is a fragile ideological and political system. Rather, the rationalization of colonialism is specious at these points. This can occur as a divestment of colonial authority, literally when tourists dress or undress to become Islanders. Dressing cannot merely be considered "going native," or the "fall" of the colonizer from "civilization," but must be conceived as a clandestine intervention into and appropriation of Pacific Islander culture. On July 16, Burton writes of a one-day excursion made by the ship to the island of Mango in the Lau Group, Fiji. It was planned as a "grand field day" including a picnic, and Burton gives this account of the tourist party landing on the Island:

> The force was divided; one body, consisting chiefly of the ladies, pulled round to attack the island by a flank movement . . . while the larger division pushed on boldly to the front, [and] gallantly cleared the coconut groves . . . Meanwhile the Engineer corps represented by the Photographer-in-chief and a small but effective following of dingy mercenaries – had hovered on the skirts of the column, making a diversion ever and anon as some tempting scene would invite capture. (11–12)

The excursion, figured in militaristic tropes describing an offensive movement, articulates tourism as an invasion, where the picnic is not simply for "prospecting" (11), as Burton claims, but for the expressed purpose of "capture." At once the excursion is contextualized in *lexias* of patriarchy: the military, the men move "boldly to the front" while the women travel circuitously "round the side." Interestingly, the camera's role as "hovering mercenary" or "on the skirts" suggests its role ambiguously as a spy or an apparatus for surveillance – a disguised technology which can infiltrate and then observe the unknowing Pacific Island communities.[33] Burton continues the military trope; vegetation is "falling" to the camera, before a panorama of valley was "covered by [the camera's] fire" (12). The camera as a loaded weapon suggests the frequently used metaphor of the "shot," the fired-upon landscape is in a colonial struggle for representation. The "wilderness" is both the chaotic foliage which must be conquered by Burton if his camera is going to have a successful representational "campaign," and the area the tourists see themselves in, as shown in the title given to the on-board printed newspaper: the "Wairarapa Wilderness."[34] While the tourists see themselves as traveling through the "wilderness" and indeed "capturing" it through technology such as the camera, Burton's limited shots of this vegetation in his advertised catalogue, titled "studies native foliage" were taken within the Fijian Botanical gardens, hardly

suggestive of the "gallant clearing" of the wilderness. The capturing of "wild" nature for specimens from a European-cultivated garden emphasizes the disjunction between the apparent power of the camera to "capture" the wilderness and the actual photographs of a cultivated garden.

"Capturing" the landscape is only one struggle at this juncture, for soon after taking the panorama the "Engineer" group found that "good fortune awaited them . . . they were confronted by a large body of coolies (female) . . . Their disposition was excellent, but after a very brief engagement they were all 'taken'" (12). This 'engagement' details the strategy of contesting colonized space; the sexualization of the colonized subject as feminized and weak attempts to naturalize "capture" as patriarchal superiority – to penetrate and "take" the colonized. But this desire is cross-hatched with the violent history of colonial conquest:

> The chieftess of the party (a Brahmin [*sic*], it afterwards appeared) was decorated with silver anklets and wristlets . . . Despite the temptation, no attempt was made to "loot." This lady, on the approach of the victors, appeared to consider it the correct thing to veil herself, which she did, partially, with a corner of her robe; but on the Photographer-and-chief imitating her with a corner of his robe (coat-lap), she laughed at the joke, dropped the garment, and let all who would gaze their fill. After this the whole coffee estate [was] duly captured. (12)

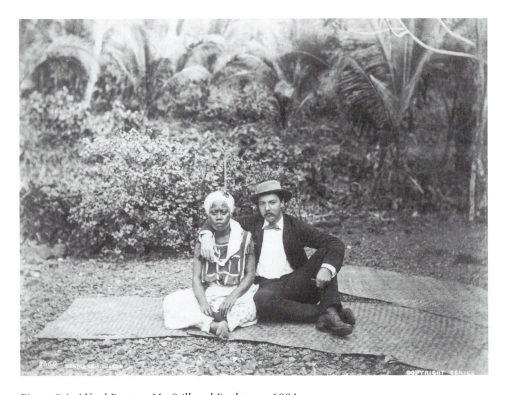

Figure 9.1 Alfred Burton, *Mr. Still and Faolatana*, 1884.

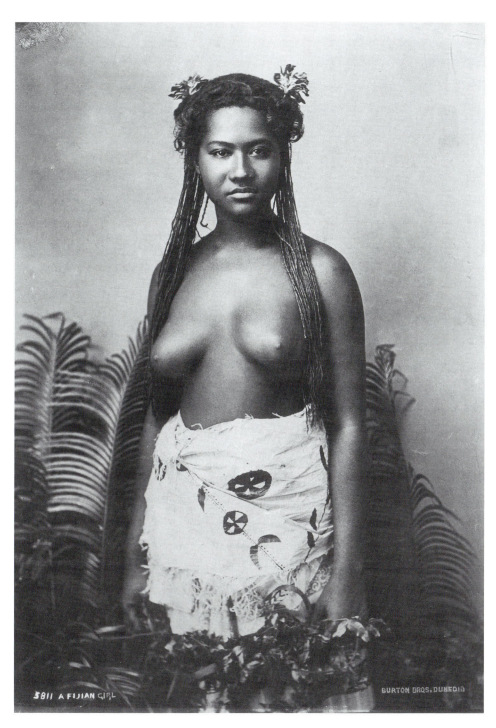

Figure 9.2 Alfred Burton, *A Fijian Girl*, 1884.

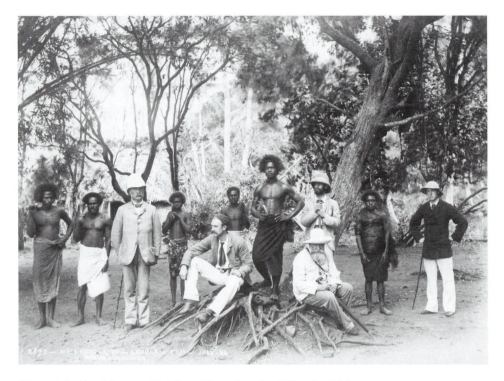

Figure 9.3 Alfred Burton, *Nai-Koro-Koro, Levuka, Fiji*, July 1884.

The woman is commodified into a material economy; like silver she is considered a spoil of war. Her "capture" is coterminous with the coffee estate's capture, the military "engagement" paralleling the representational capture. The violence of war with the association of rape and looting is avoided only by the apparent good will of the photographer, as if colonialism is a far more benevolent practice than war. The woman attempts to match the "civility," or perhaps prudery, of the tourists by veiling herself from their view. However, to continue the demarcation of the woman as sexualized object available to the gaze of the tourist, the photographer mimics her to suggest the "joke" of her covering. The mimicry suggests that the tourists consider the "proper" behavior of the woman is to undress for them.

Yet the participation of the photographer reverses the return to an "original" state – for the photographer must initiate the undressing to construct the "natural" state of the woman. Displays of nudity by Pacific Islanders are not always passive, and in specific instances can register a defiance of colonial authority. Malama and Penelope Meleisea, when outlining the acceptance of tourism in contemporary Western Samoa, describe some young Samoans' attitude to tourists: "Samoan attitudes to foreigners who venture outside Apia . . . might best be judged by the irreverent young children who, unconstrained by adult requirements of dignity and courtesy, bare their bottoms at passing cars and buses and shout obscene invitations."[35] While the gesture of the Brahman woman is not in this context of defiance, she does demonstrate that her supposed "amorality" of exhibiting her body to the tourists is copying an amoral gesture

from the tourist party itself, and hence her "disposition" is produced by the colonized viewer.

To get the Brahman to do what he wants, Burton must mimic taking off his clothes, and in numerous other passages of his text this is quite literally done by the tourists. Burton describes a large party from the ship at a bathing area who were "disporting themselves in primitive – even biblical fashion, for *they* were naked, and the native ladies on the banks were evidently not ashamed" (13). The myth of "going native" is played out here, with the passengers taking on the role of Islanders, yet the tourists are now subject to the gaze of the Islanders. The mimicked gesture of pulling the coat lap or swimming naked describes moments where the authority of the observing tourist is shown to be invested in signifiers such as clothes, the slight action of disrobing quickly problematizes the tourist's authority. Burton's text frequently references what he calls the "perceptible relaxation of the moral fiber" (15) of the tourists, but in many cases these "relaxations" are either the tourist assuming the subject position of the colonized, or mimicking the colonized. Burton at one point describes a "decorous and rigid churchgoer . . . lying upon a mat in a native house, his head pillowed upon the lap of a dusky charmer who . . . toyed seductively with his hair" (15). The seduction of the prudent churchgoer is both a criticism of the hypocrisy of moralists and a cautionary warning of the "allure" or "temptation" of the exotic and sexualized Pacific: the Pacific Islander woman is named "Circe," the Greek goddess who enchants Odysseus. The tourist in the "lap" of the Islander corporealizes colonial desire in the weak figure of the prostrate churchgoer "seduced" by participation in what are considered Islander practices. However, the churchgoer's power is not erased by this situation: when the Pacific Island woman asks his name he displays a handkerchief on which his name appeared in "permanent ink." The woman then asks if he is married, at which point "the photographer left, and diligently minded his own business" (15). The tourist with a proper, but undisclosed, name (compared to the stereotype given to the woman) is not passively seduced but actively controls information to gain his gratification, and is joined in this conspiracy by the photographer.

Scenes of mimicry are found in the catalogue of photographs where, on various occasions, the passengers would climb a tree; Burton stating, "the sad spectacle was witnessed of affluent 'globetrotters' and substantial Fijian merchants all 'up a tree'" (10). Sad, because a useful signifier of racial inferiority associated with non-Western others is the monkey; the apparent tree-climbing ability of Pacific Islanders is often hedged in genetic terms, as if they are somehow closer to the origins of human evolution. The passengers "going native" are satirizing the evolutionary ladder with these "uncivilized" habits and negating their colonial authority. The loss, however, must be contextualized within the unequal relationships of power, specifically around controlling the production of representation through technology such as the camera. I would not go so far as to say, as does David Bate in his study of photographs of "Orientalists" dressing up as "Orientals," that mimicry undermines the colonizing gaze through its ambivalence, as if this gaze is fluid within colonialism.[36] The Pacific Islander women watching the naked swimmers are in turn watched by the photographer. The photographer, with the technology to reproduce the "real," can "document" the ambivalence as a site of conflict between the exotic other and the seduced colonizer; photography asserts the body of the colonized is a desired object like the "loot" of the battlefield; the weakness of corpo-reality or the threat of degeneration to a "monkey-like" state is an even greater reason

for tourists to vigilantly adhere to scientific observation of Pacific Islanders and maintain "rationalism." The photographer, in effect, has the last word. In this sense I call the Brahman's return gaze a gesture because she can stage her response only within the representational economy of the photographer.

Within the parameters of colonialism's technology of representation the Brahman is only part of the "conquest," for behind her is the coffee estate, one of the spoils of war. After their capture Burton writes that the

> force returned to the landing place, covered with honour and self-satisfaction. . . . [A]ll the best (i.e., most picturesque) positions duly secured on that occasion. The whole force . . . generously abandoned the whole of their conquests to the original occupiers, reserving only the glory. The engineers, though, retained their spoils – namely, twenty-two exposed plates. (12)

The trip is called an "excursion" in the program during which the ship "touched" the land,[37] the harbors are described as "commodious,"[38] and the tourists are named the "innocents abroad" (6). These descriptions are part of the lexical tactic to negate the intercessory and destructive features of colonialism. Though Burton considers he leaves the terrain to the "original occupiers," there are numerous inconsistencies to this claim. Firstly, Indian indentured labor is a legacy of the exploitative British labor policy in which Indians were imported for labor on Fijian plantations, a migration that, in Burton's account, threatens to erase the indigenous Fijian from their ownership of the land. Secondly, the reputed exit of the "force" does nothing to alter the British ownership of the plantation. The "glory" of the tourists is far from their only "spoil," for not only do they naturalize indentured labor and plantation economy on the terrain while seemingly neglecting their appropriation of the land, their "capture" in the form of the exposed plates makes possible the viable containment of the terrain and its economy. The ambivalence of the power does not hinder the commercial profit of colonialism.

The representational crisis of post-Enlightenment Europe is brought about not simply by the power, but also by its limitations. The apparent infallibility that signifies European control of representation is often questioned. Photography is perceived as a technology which signifies Western superiority: the newspapers comment that the Islanders, "Whether they clearly understood the process of photography or not, they seem to have been singularly willing to lend it their passive assistance" (7). Yet there are numerous points where the camera seems far from able to describe the reality that is associated to it. The abundance or excess made possible by the camera is undercut by the dross of the photographer's labor. Burton frequently comments on the effort needed to haul the camera about with him, and having to engage a young Samoan as a "beast of burden" (14). Not only the physical exhaustion of "dragging" (10) the instrument around, the weather is often "anti-photographic" (10), the days "too short for the camera to secure all it could see" (10) and subjects frequently cover up or, in one particular instance, a subject "turned abruptly on her heel, saying, 'Me go now,' and this photographer saw her no more" (14). The possible excess of "reality" from the "faithful" (6) camera cannot totally represent the colony. On a discursive level the availability of an excess of vision is repeated: Burton's diary repetitively describes the posing of women in terms of surfeit: the Brahman woman letting the voyeurs "gaze their fill"; or "a bevy of Tongan girls . . . were easily induced to form groups for the

insatiable camera" (19). The repetition and cataloguing of these poses, with descriptions such as "shapeliest native girls" (10), of the "most delicious abandon" (15), "shapely limbs being freely revealed" (15), and "nature's own children" (19) enforce the importance of sexualized representations. Burton speaks most often of photographing women, and only in passing mentions some other sites he photographs. However, out of the 250 photographs advertised in the catalogue, twenty-eight are of women; the most predominant photographs are of "scenes," especially colonial buildings and streets (there are approximately one hundred). However, the relative lack of photographs of women does not indicate they were less circulated or considered unimportant compared to the street scenes, only that these representations emerge from an overdetermined signification.

Any crisis, therefore, is more about the disjunction between the ideal of representation and the limitations of the technical capabilities of the tool. Burton's guide shows master narratives of colonialism functioning with tourism to enable the epistemic control of Pacific Islander knowledges and representations. While this may not seem exceptional, as colonial ideology was pervasive in Australian and Aotearoa/New Zealand society around the turn of the century, the effects of these discourses profoundly structure the practice of tourism, and have continued to do so. I am not proposing that every time a tourist takes a photograph s/he is adopting the subject position of colonizer and is subjecting the indigenous people to a colonial relationship. However, the photograph's possibility, and the naturalized and valorized acceptance of them, comes from a history of privileging Western modalities of observation. The tourist industry commonly reproduces many of the concepts and practices of Australian colonialism in its advertisements and representations of the Pacific Islands.

Notes

1 Studies of Pacific cruises tend to ignore the context of colonialism. For instance see George M. Foster, "South Seas Cruise: A Case Study of a Short-lived Society," *Annals of Tourism Research* 13 (1986): 215-38.
2 Geoffrey Batchen, "Desiring Production Itself: Notes on the Invention of Photography," *Cartographies: Poststructuralism and the Mapping of Bodies and Spaces*, eds Roslyn Diprose and Robyn Ferrell (Sydney: Allen and Unwin, 1991), 15.
3 Michel Foucault, *The Order of Things: An Archaeology of the Human Sciences* (New York: Vintage, 1973), xxiii.
4 Jonathan Crary, *Techniques of the Observer: On Vision and Modernity in the Nineteenth Century* (Cambridge, MA: MIT Press, 1994).
5 Bernard Smith considers that the Pacific radically changed European science which he cautiously associates with Thomas Kuhn's thesis of a scientific revolution. Thomas Kuhn, *The Structure of Scientific Revolutions* (Chicago: University of Chicago Press, 1962). Bernard Smith, *European Vision and the South Pacific*, 2nd ed. (1960; New Haven: Yale University Press, 1985), viii.
6 Michel Foucault, *Discipline and Punish: The Birth of the Prison*, trans. Alan Sheridan (Harmondsworth: Penguin, 1977). Crary's reading of Foucault concentrates on reinvigorating the spectacle, which Foucault considered less important than surveillance, as a means to discipline the body's vision.
7 Foucault, *Order*, 319.
8 Geoffrey Batchen, in reviewing Crary's text, jokingly repeats this cycle of observation by emphasising Crary's reliance on Foucault in the title to his review: "Enslaved Sovereign, Observed Spectator." In modern human sciences there is an uneasy vacillation, Foucault

contends, between the observed object of study and rational observer, much like the critical genealogy Batchen's title suggests: Batchen studies Crary studies Foucault. Geoffrey Batchen, "Enslaved Sovereign, Observed Spectator: On Jonathan Crary, *Techniques of the Observer*," *Continuum* 6.2 (1993): 80–94.

9 Crary studies the use of numerous technologies and machines such as the kaleidoscope, stereoscope, zootrope, phenakistiscope. Crary's simplistic dependence on the object to produce a different reaction by the viewer has led Geoffrey Batchen to criticize his technological determinism; Batchen, "Enslaved": 89-90.

10 Guy Debord, *The Society of the Spectacle*, trans. Donald Nicholson Smith (New York: Swerve, 1990), quoted in Crary, *Techniques*: 19.

11 Crary lists three "developments inseparable from the institutional emotion of art historical practice." Roughly they are evolutionary theory, introduction of a classed leisure time, and technologies of mass reproduction (21).

12 Paul Fox, "The Imperial Schema: Ethnography, Photography and Collecting," *Photofile* 7.4 (1989): 10.

13 Judith Addler, "The Origins of Sightseeing," *Annals of Tourism Research* 16 (1989): 8.

14 I have been unable to locate the photographs of the New Guinea exploration, though Bevan's *Discovery of Two New Rivers* contains some ink drawing copies of the fifty photographs taken.

15 "Report of the Expedition Committee," *Proceedings of the Royal Geographic Society of Australia* 3-4 (1887): 199-201. The objectives are in: Vivian R. Bowden, letter to Cpt F. A. Boone, May 16, 1887. National Library of Australia, ms 2301/1.

16 For studies on the association between photography and tourism as mutual technologies enunciating colonialist discourses see: Patricia C. Albers and William R. James, "Travel Photography: A Methodological Approach," *Annals of Tourism Research* 15 (1988): 134-58; Gordon Maitland, "Two Sides of the Camera Lens: Nineteenth-century Photography and the Indigenous People of the Pacific," *Photofile* 6.3 (1988): 47-58.

17 Burns Philp and Company, *Picturesque Travel* (Sydney: Burns Philp and Company, 1913), 10.

18 Quoted in Ngaire Douglas, *They Came for Savages: 100 Years of Tourism in Melanesia* (Astonville, NSW: Southern Cross University Press, 1996), 83–5. Douglas is quoting from two Kodak advertisements in the *BP Magazine*.

19 Alan Sekula, "The Traffic in Photographs," in *Photography Against the Grain*, ed. Alan Sekula (Halifax: Nova Scotia College of Art and Design, 1984), 79. Emphasis in the original.

20 Quoted in Alfred Burton, *Camera in the Coral Seas* (Dunedin: *Daily Times*, 1884): 6. The quotation is taken from a review of Burton's photographs in the Otago *Daily Times*.

21 John Frow, "Tourism and the Semiotics of Nostalgia," *October* 57 (1991): 144.

22 Patricia C. Albers and William R. James, "Tourism and the Changing Photographic Image of the Great Lakes Indians," *Annals of Tourism Research* 10 (1983): 145. I do have reservations about this article as its strategy is to use the postcards to "study the way tourists 'see' people" (125), a theoretical standpoint which leaves intact the privileged site of the Western observer, and assumes there is a "real" image and "authentic" Native American culture which is misrepresented.

23 "Worlding" is a term I borrow from Gayatri Spivak to indicate how the tourist or colonizer assumes a "complete" subject position and the subaltern assumes the marginalized subject position of "other." Spivak describes this point using the example of a colonial officer who, when riding through the colonized terrain, is "actually engaged in consolidating the self of Europe by obliging the native to cathect the space of the Other on his home ground. He is worlding *their own world*, which is far from mere uninscribed earth, anew, by obliging *them* to domesticate the alien as master." Gayatri Chakravorty Spivak, "The Rani of Samur," in *Europe and Its Others*, ed. Francis Barker *et al.* (Colchester: University of Essex, 1985), 133.

24 John MacKenzie, *Propaganda and Empire: The Manipulation of British Public Opinion, 1880–1960* (Manchester: Manchester University Press, 1984), 32.

25 G.W.W. [George Washington Wilson], *Cannibal Isles or Rovings among the Coral Reefs and Palms: A Reading. Descriptive Series of Lantern Slides* (Aberdeen: n.p., n.d.). Wilson also

produced a similar series titled *A Trip to the Paradise of the Pacific: The Great Hawaii. Volcano and the Leper's Home* (Aberdeen: n.p., n.d). Authorship of these two pamphlets is uncertain and attributed to Wilson by Sir William Dixson, in whose collections these pamphlets are found. Further, the dates of the lectures vary widely. The British Museum considers the pamphlet was published in 1865, which is totally inaccurate. The Mitchell Library considers the date before 1882, for it describes Levuka as the Fijian capital (it became Suva after 1882); however, the author mentions Shirley Baker who had been a missionary in the islands for thirty years (he arrived in 1860), which should place the publication around the late 1880s and before 1893 before the death of King George Tupou I (who is described as the living monarch). The 1865 date is given, possibly because there was a George W. Wilson photographer in England who took Royal portraits; one of Queen Victoria features in Roland Barthes, *Camera Lucida: Reflections on Photography*, trans. Richard Howard (London: Jonathan Cape, 1982), 56.

26 Beatrice Grimshaw, "Three Wonderful Nations": 13.
27 I take this theoretical strategy from Joseph Pugliese, "Embodied Economies of Desire in Hegel's Empire of Reason," *Social Semiotics* 4, 1–2 (1995): 163-83. In this article Pugliese argues that Hegel's disembodied *Geist* returns in the figure of the corporeal non-Western other.
28 Annette Kolodny, *The Lay of the Land: Metaphor as Experience and History in American Life and Letters* (Chapel Hill: University of North Carolina Press, 1975), 9. There are many points in Kolodny's text that I find problematic, particularly gestures of a universally recognized gender difference. However, her text is an apt examination of the rhetorical strategy of feminizing the land.
29 For a related investigation of the exoticization of Malaysia in tourist brochures see Harry Aveling, "Representations of Malaysia in Current Tourist Brochures for Australian Travellers," Australia-Malaysia Relations, Conference at the Centre for Malaysian Studies, Monash University, April 1995.
30 For details on the Burton Brothers see Hardwicke Knight, *Burton Brothers Photographers* (Dunedin: John McIndoe, 1980); Hardwicke Knight, "Burton Brothers of New Zealand," *History of Photography* 3.2 (1979), 167-79.
31 Burton, *Camera in the Coral Seas*. All following references will be made in the text.
32 The stereoscope, according to Jonathan Crary, "for decades . . . defined a major mode of experiencing photographically produced images." Crary, *Techniques*, 118. Other photograph collections include an 1887 collection published as *Picturesque New Guinea*. Douglas, *They Came for Savages*, 45.
33 A recurring project in colonial intervention is the clandestine invasion of colonized territory while in disguise. This forms the basis of Rudyard Kipling's *Kim*, and the practice of the orientalist William Lane, described by Edward Said as an "Orientalist device for capturing . . . valuable [and] otherwise inaccessible information." Edward Said, *Orientalism* (London: Penguin, 1978), 160. See also Anne McClintock, *Imperial Leather: Race, Gender and Sexuality in the Colonial Contest* (London and New York: Routledge, 1995), 70.
34 It was common on the early cruises for the passengers to publish their own on-board newspaper, often with satirical stories about the crew or other passengers.
35 Malama and Penelope Meleisea, "'The Best Kept Secret': Tourism in Western Samoa," in *Pacific Tourism: As the Islanders See It*, eds Freda Rajotte and Ron Crocombe (Suva: Institute of Pacific Studies, University of the South Pacific, 1980), 42.
36 David Bate, "Photography and the Colonial Vision," *Third Text* 22 (1993): 81–92.
37 Burton, *Camera in the Coral Seas*: 6. This is a summary of a newspaper review of Burton's photographs.
38 Union Steam Ship Company, *Excursion to the South Sea Islands*, 5.

10

ADVERTISING PARADISE

Hawai'i in art, anthropology, and commercial photography

Patricia Johnston

November 1940. Vogue arrives in the mail. Open the cover; just inside, in full living color, Edward Steichen's dramatic image captures an alluring Hawaiian woman sitting atop a rugged volcanic outcrop. A picturesque lighthouse occupies the ledge below, with a wide stretch of sea beyond (figure 10.1).[1] Distinctive emblems of Hawai'i adorn the woman: the hibiscus flower in her hair, and the *kikepa*, a simple Polynesian sarong with a tropical floral pattern.[2] The text beckons potential tourists, just as it warns them: "prepare to be captivated by these isles of unparalleled charm."

March 1941. Open *Harper's Bazaar;* spy Steichen's innocent Eve in the Garden of Paradise (figure 10.2). Her arms are full of flowers she has gathered in the lush forest. She looks gently past her viewer, whose distance from this Arcadian life is demarcated by the frame of broad leaves and bird-of-paradise flower surrounding her face. "Primitive" femininity and nature are one. Peace on the eve of war.

From the mid-1930s into the early 1940s, advertising agencies sent a number of well-known photographers, including Edward Steichen, Toni Frissell, and Anton Bruehl, to Hawai'i on assignment for corporations involved in the emerging tourist industry. The color photographs they shot were featured prominently on the inside covers of fashion magazines such as *Vogue* and *Harper's Bazaar*, or upscale home magazines such as *House and Garden*. The agencies targeted women's magazines because they believed women planned family travel. While the ads promoted Hawai'i as an exhilarating spectacle for affluent consumers, these large, colorful images also crystallized a popular image of the United States territory as protected. Compliant natives, breathtaking flora, and spectacular landscapes thrilled mainland tourists, who, as the caption in figure 10.1 noted, could "sail in safe American ships, across peaceful seas."

Travel advertising photography developed simultaneously with an organized tourist industry and the rise of nationally distributed picture magazines. This new need to represent native peoples in mass-media advertising forced advertising agencies to rethink their customary strategies. For in travel advertising, successful marketing depended on difference and the promise of adventure rather than on familiarity and assured results. But difference had its limits; the travel experience could not be presented as too daring or dangerous. Depicting indigenous peoples in advertising thus challenged the agencies

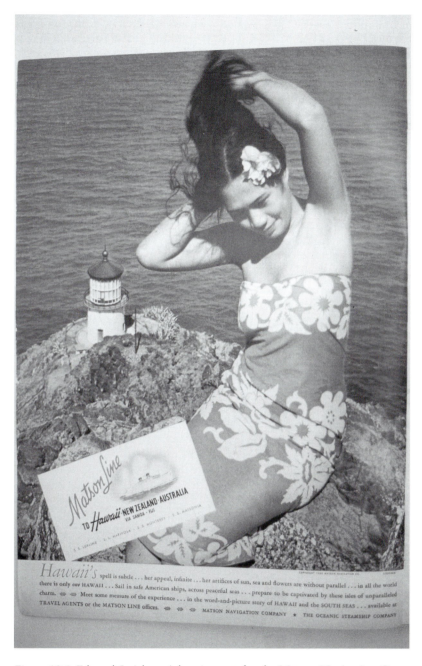

Figure 10.1 Edward Steichen, Advertisement for the Matson Navigation Company, *Harper's Bazaar*, November 1940, inside back cover. Art director: Lloyd B. Meyers. Advertising agency: Bowman Deute Cummings.

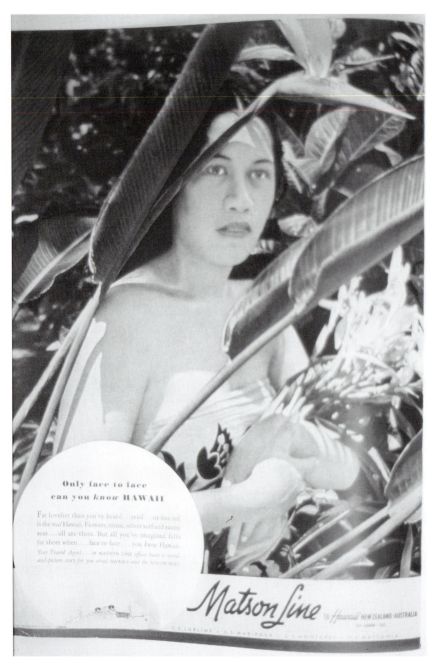

Figure 10.2 Edward Steichen, Advertisement for the Matson Navigation Company, *Harper's Bazaar*, March 1941, inside cover. Art director: Lloyd B. Meyers. Advertising agency: Bowman Deute Cummings.

and their photographers in two key ways: they had to develop visual conventions to make the other culture enticing, and they had to reinforce the viewer's identity as a consumer without a model with whom the viewer could immediately identify. The advertisements accomplished these goals by realigning the typical spectral relations in the ads. Rather than enabling the viewer to change places with the model, as advertisements typically did, these advertisements encouraged the viewer to objectify the native woman as part of a travel experience the consumer might possess.

Despite this colonizing gaze, the Hawai'i tourist advertisements are notable in that they are among the very few American mass-media advertising campaigns prior to World War II that represent racial difference as a plus. Certainly the track record for representing racial difference in advertising was poor. Few advertisements in the popular press had dared stray from the strict formula of using attractive, white, seemingly affluent models. Those occasional advertisements that included African-American or Native-American figures were typically informed by demeaning racial stereotypes.[3] The Hawai'i travel advertisements, by contrast, count racial difference as part of the magnetic allure of the islands.

Advertising paradise with racial differences thus required the commercial photographers to diverge from their standard advertising formulas. With no well developed precedents in advertising to draw from, they relied heavily on more general cultural paradigms for the South Seas already established in the American imagination. These sensational commercial images drew, in different degrees, from varying types of visual culture – scientific observations, fine art interpretations, and commercially produced tourist souvenirs – that had been developed by Western artists to represent indigenous peoples ever since their earlier contacts with them in the eighteenth century. Though the specific goals and contexts of science, art, and commerce varied dramatically, most Pacific images shared an insatiable curiosity for fresh details of the fascinating dress, unfamiliar material culture, and mysterious customs of the newly encountered peoples. Image-makers translated their experiences according to well-established Western stylistic conventions and allegorical allusions. By the 1930s, when advertising photographers went to Hawai'i, a rich and diverse visual image bank had developed.

This imagery ranged from the documentary renderings of eighteenth-century mariners to the romantic narratives of Paul Gauguin's paintings to commercial images. Early travel imagery, particularly commercial photography, trod a middle ground between science and art – absorbing and displaying both strict topography and a more fanciful style of depiction. Description melded with exoticism as the early postcard and tourist-view industry turned a seemingly neutral eye toward striking indigenous peoples and dazzling locales. With the expansion of tourism in the 1920s and 1930s, visual interpretations originating from these diverse sources became popularized through fairs and expositions, textbooks, magazines, film, and other media.

The borders between various types of visual culture were and still are highly permeable. Though created for specific historical needs – science, art, commerce – visual practices were not mutually exclusive and often overlapped. And removed from their immediate origin, images are ambiguous. The many instances in which images were reused in different contexts with different captions, with resulting differences in meanings, demonstrate how fluid and arbitrary are the categories, how much borrowing image-makers engage in, and how treacherous the exercise of classification.[4] But patterns and tendencies may be observed in these cross-influences. It is the iconography

and romanticism of high art filtered through the lens of popular culture, I will argue, rather than a more linear trajectory from within the history of photography, that most inspired the enchanting figures and the wondrous landscape that came to signify Hawai'i in the advertising photography of the late 1930s and early 1940s.

Images of Hawai'i evolved as scientists, artists, and, later, mercantile interests brought Western conventions of visual representation to the specific conditions of Hawai'i's colonial past. In the early nineteenth century, trade with the West, first in sandalwood, then in services for whaling ships, introduced capitalism to the Hawaiian Islands and began the breakdown of the strict pre-contact social structures. Protestant missionaries from New England arrived in 1820 and seeded divisions over religious practices. In 1848, the Western-pressured monarchy allowed the sale and private ownership of land, thus opening the door to large-scale capital investment and the establishment of sugar plantations. Taxation and the end of communal land management forced most Hawaiians into the wage economy. Sugar interests had no tolerance for native resistance, and a United-States-backed overthrow of Queen Lili'uokalani in 1893 ended Hawaiian self-rule. Five years later the United States formally annexed Hawai'i as a territory, and then, in name as well as fact, Hawai'i became a colony of the United States.[5]

Concurrently, there was rapid depopulation of the islands due to disease; some estimate the number of native Hawaiians fell from perhaps five hundred thousand when the British explorer Captain James Cook arrived in 1778 to fewer than sixty thousand one hundred years later. As a result, Chinese, Japanese, Filipino, Korean, and even Portuguese and Puerto Rican workers were imported to labor on the sugar plantations. By the 1930s Hawai'i was a very ethnically diverse place.[6]

The advertising photographs of the 1930s assisted in the transition of the colonial Hawaiian economy from sugar growing to tourism. Although the number of tourists in the 1920s and 1930s was small, the myth of Hawai'i as an idyllic and extraordinary destination was well established. In the nineteenth century adventurous authors such as James Jackson Jarves, Mark Twain, and Robert Louis Stevenson journeyed to the islands, and recorded their experiences in letters, poetry, and popular travel guides.[7] Hawai'i's exoticism was featured in the 1915 Panama–Pacific International Exposition in San Francisco and later in feature films with Hollywood stars such as Betty Grable and Bing Crosby. As Elizabeth Buck has observed, by the 1930s "tourism had constructed enduring images of Hawaiians as happy-go-lucky beach boys, friendly bus drivers, smiling *lei* sellers, funny entertainers, or beautiful women performing an exotic and somewhat erotic form of dance – all were part of a heavily marketed image of Hawai'i."[8]

The advertising images for the Hawaiian Tourist Bureau and the Matson Navigation Company considered in this chapter are very much a part of this marketing for the new tourist industry. With images of beautiful, pensive indigenous women in stunning settings, the advertisements invite viewers to share a private native experience otherwise inaccessible to a Euro-American (figures 10.1, 10.2). Captions encourage viewers to believe that through the photographic medium they can experience the referent of the photograph: to "know Hawaii," the "real Hawaii," that surpasses all their fantasies. The caption's insistence on the realist ambitions of the image, even when paired with a highly mythologized image, has been a common strategy of cross-cultural imagery ever since the Enlightenment. Thus the Hawai'i travel advertisements can be seen as a product of an extensive and complicated history of clashing perspectives: Western

and non-Western, art and science, documentation and interpretation, realism and romanticism, commercial art and fine art, viewer and viewed. As we will see, the intersections of these contrasting perspectives and modes of representation in historical images of the Pacific were mobile; images incorporated them alternately, simultaneously, or partially.

The exploration era: art, science, commerce

From the earliest European images of the Pacific, realism and romanticism coexisted, sometimes even within the same image. As Bernard Smith made clear in his pioneering study *European Vision and the South Pacific*, starting with Captain James Cook's expeditions in the 1760s and 1770s the artists' illustrations generally took one of two directions: either they sought empirical observations of geography, physiognomy, nature, and material culture, or they provided a more romanticized, artistic presentation.[9] Even when scientific intent was primary in creating the images, a view of the images as strict empirical documents must be moderated since the artists intuitively employed the stylistic language of their academic art training.[10]

The cultural biases of the ships' draftsmen can be seen in their vocabulary as well as their style. Because Europeans were unable to assimilate their vast new knowledge of Pacific peoples on its own terms, they often tried to interpret the peoples they encountered in classical and Christian frameworks. Thus, this early imagery demonstrates a limited range of cultural paradigms: the noble savage (a neoclassical idea) or paradise (a biblical metaphor).[11] The depiction of the noble savage details his strangeness to Europeans yet incorporates classical form. Within a spectacle of difference lies familiarity. Biblical references, likewise, encouraged understanding the startlingly new cultures as antecedents to contemporary European culture.

The more empirical direction is seen in a portrait *c.* 1769, of a Maori chieftain by Sydney Parkinson (c. 1745–71), one of the natural history draftsmen on Cook's first voyage (figure 10.3). Parkinson had been hired by the expedition's head scientist, Sir Joseph Banks, to provide close-up, accurate botanical and zoological studies. Following the tragic death of artist Alexander Buchan in Tahiti, Parkinson added figural and cultural subjects to his purview. His initial attempts to draw indigenous peoples were timid, but the artist soon developed a figural style informed by his intensive scientific scrutiny. In his portrait of the Maori chief Otegoowgoow, the artist presents an unsentimental record of the New Zealand chief's tattoos, jewelry, hairstyle, and clothing, including such details as the expressive carving on his fish-tooth necklace and delicacy of his bell-shaped ear ornaments. Parkinson's intent, in the era before photography, was to present as accurate an account as possible for his audiences, both for the scientists who had access to the original drawing and for members of the elite educated public who would view the engraved image in an illustrated travel book.[12] The image seems to fulfill perfectly the aims of Cook's voyages, as expressed in the *Secret Instructions* from his sponsors, the Royal Society and the Navy: to observe the people, animals, fish, and topography, "to describe them as minutely, and to make as accurate drawings of them, as you can."[13] The minimal suggestion of landscape kept the focus on the individual's portrait and made the image less subject to idealization.[14]

A more romantic representation of an island native is John Webber's (1752–93) portrait c. 1780 of Poedua (Poetua), the daughter of Orio, chief of Raiatea, one of the

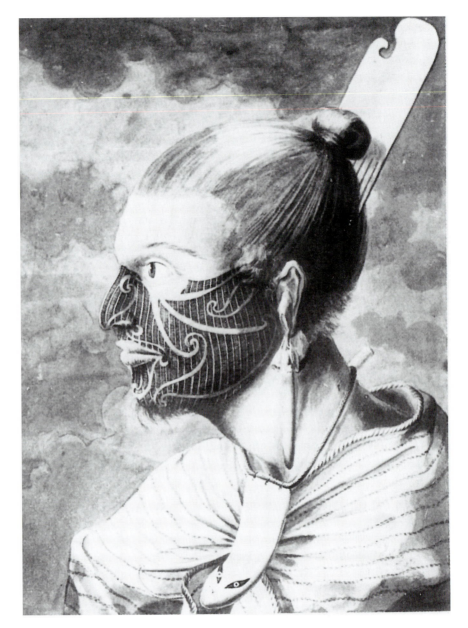

Figure 10.3 Sydney Parkinson, *Portrait of a New Zealand Man*, c. 1769. Pen and wash.

Society Islands (figure 10.4). In this image Webber, a professional draftsman who sailed on Cook's third voyage, generalized the woman from individual to exemplar of island beauty. Webber was trained in the academic art tradition.[15] His use of oil paint, rather than pen and wash, indicates his intention of making this image into fine art.[16] His depiction of Poedua moves back and forth between the specific and the timeless,

194

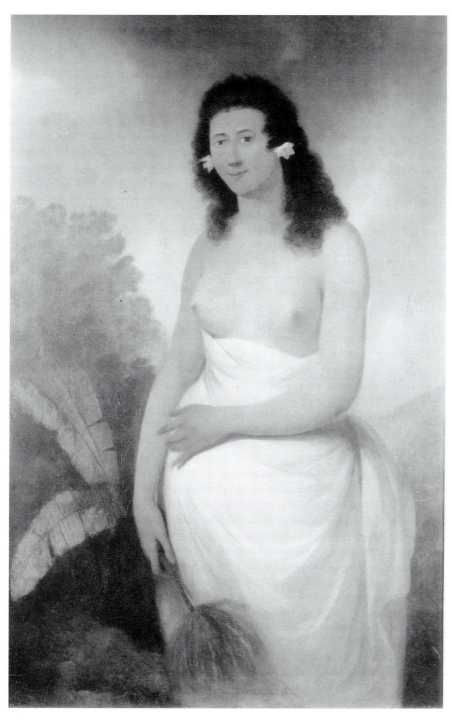

Figure 10.4 John Webber, *Poedua (Poetua), Daughter of Oree, Chief of Ulietea (Raiatea), one of the Society Islands,* c.1782. Oil on canvas.

between the real and the ideal, between science and art. Poedua looks directly at the viewer, suggesting her self-awareness as a member of the indigenous elite and perhaps acknowledging her role here as spectacle for the Western viewer. The subtle tattooed patterns on her arms and hands indicate specific cultural difference, while the jasmine flowers adorning her hair, the large plantain at the left, and her feather fan provide a more general sense of tropical place. The verdant landscape and softly modulated sky are even more generic markers of nature. To a European viewer, the enclosure of the "precivilized" woman in nature suggested idyllic Eden. In this heavenly paradise the artist poses Poedua in the manner of an antique statue, with subtle contrapposto and a graceful disposition of her arms. He sexualizes her through the depiction of her bare breasts, but such representation speaks equally to European ideals of both the primitive and the fashionable – and to both romantic and neoclassical art. The high empire waistline of Poedua's drape and her bare breasts parallel the formula that Webber's countryman Henry Fuseli (who, like Webber, was a Swiss artist working in England) utilized for the central female figure in a number of his highly charged romantic history paintings of the 1780s and 1790s. In Fuseli's hands this iconography could be developed to suggest a range of genres, from the theatrical to the erotic.[17] The manner of dress and pose also evoke contemporary neoclassical Europe, where a woman of aristocratic status such as Pauline Borghese commissioned the renowned Italian sculptor Antonio Canova to create her bare-breasted portrait sculpture in the form of Venus.[18] Webber's exotic Poedua thus becomes familiarized as both Eve and classical goddess.

The early ideas about Pacific peoples that derived from scientific explorations worked their way into the larger culture through visual means, typically lavishly illustrated books and art exhibitions. This process started as soon as the explorers, scientists, and artists returned to Europe. The natural history draftsmen turned their images over to engravers, who further accentuated the poses and proportions to increase the neoclassical elegance expected by their educated audiences.[19] And, following standard studio practice, some of the ships' artists later used their sketches, drawings, and watercolors as the basis for their own more fully developed oil paintings for exhibition, a practice that indicates they were interested in artistic interpretation as well as scientific documentation.[20]

John Webber's 1784 image of a double canoe paddled by masked Hawaiian natives, probably priests, in Kealakekua Bay exemplifies the process of turning a scientific study into a widely circulated picture (figure 10.5). The original drawing on paper (1779, Bishop Museum) pays close attention to the particulars of costume, the construction of the boat, and the coastal view, and in doing so blends anthropological inquisitiveness with amazement.[21] The fascination with detail was carried from the drawing executed on site to the engraving produced under Webber's supervision after his return to England. In the process changes were made: the number of rowers was reduced from twelve to ten, details of the shore and sail were filled in, and the image was reversed by the printing process. Although Webber and the other members of the expedition were unsure of the precise meaning of the gourd head coverings, this image was included in the first suite of published images of Hawai'i, illustrating the 1784 official report of the voyage, with the caption "A Canoe of the Sandwich Islands, The Rowers Masked."[22] Purchasers of the attractive folio had their choice of having the engravings folded and bound into the appropriate points in the text or having the illustrations

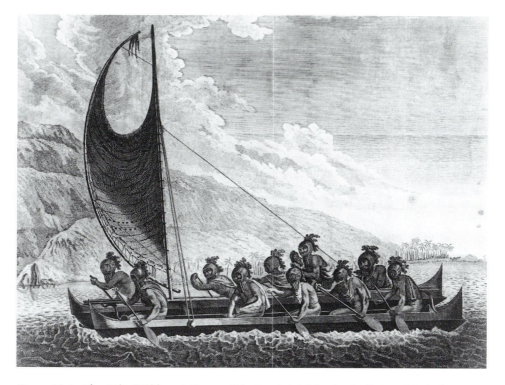

Figure 10.5 After John Webber, *A Canoe of the Sandwich Islands, the Rowers Masked*, engraving, *Gentleman's Magazine*, July 1784.

bound flat into an accompanying atlas. Initially conceived as a scientific record of the expedition, this particular image must have been a popular sensation in England, for the engraving was also distributed as a separately published print and as a featured image in the *Gentleman's Magazine* of July 1784. Then the image was reengraved in a reduced size for the less expensive 1796 octavo "American edition" of Cook's third voyage.[23] This popularity was perhaps no accident, for Webber carefully cultivated the market for his Pacific images after his return, and print sellers stocked his work for at least thirty-five years after his death.[24] Thus, Webber's image had two lives: its origin as a scientific observation, and its distribution as a commercial print.

The colonial era: anthropology, popular imagery, modern art

By the mid nineteenth century, when photography was introduced to the Pacific, the Enlightenment idea of the Polynesian as "noble savage" had given way to a perceived battle between the "sons of civilization" and savage "heathens."[25] The nineteenth-century missionaries who followed the explorers demonstrated far less curiosity and were far more judgmental. Hiram Bingham, the famed New England fire-and-brimstone Congregationalist, arrived in Hawai'i in 1820 and set the tone. "The heathen system," he said, "tends to immeasurable evil; but the Christian system to immeasurable good." Bingham considered any "romance of heathen purity" ill conceived,

naming infanticide, human sacrifice, polytheism, idolatry, cannibalism, and politically motivated murder among the Hawaiians' sins. Bingham saw his role as a missionary as a "means of elevating nations, and removing barbarism, intemperance, oppression, and idolatry from the world."[26]

The introduction of evangelical Christianity in the Pacific coincided with the emergence of social Darwinism. Ironically, organized religion opposed evolutionary theory in Europe, yet Europeans embraced "the survival of the fittest," transformed from a biological to a social explanation of history, as a justification for dominating Pacific peoples.[27] Thus evangelical Christianity, social Darwinism, and European imperialist domination developed hand-in-hand. As Bernard Smith astutely observed, by his third voyage, Captain Cook, a man of the Enlightenment, recognized that he was opening up the Pacific for commerce as well as science, and he suffered a "loss of hope" in the face of damages wrought by the earliest European visitors: "For what [Cook's contemporary] Adam Smith's free-market economy offered the South Seas was not really the difference between civilization and savagery but the difference between exploitation and extermination."[28]

The content of Pacific images evolved as colonial relations developed. For example, the increasingly racist views of the colonial powers – evidenced, for example, in the transition from the curiosity of the early explorers to the disdain of the missionaries – can be tracked in the changing imagery of Pacific peoples. The three catalysts for exploration imagery – science, art, and commerce – were also the primary catalysts for the development of photography in the Pacific. And the visual strategies of cross-cultural imagery remained remarkably stable as they crossed media. The vast archive of late nineteenth-century photographs of the Pacific includes both empirical (or anthropological) descriptions and romantic artistic interpretations. Popular commercial tourist illustrations, combining description with exoticism, which were nascent in the eighteenth century, became a much more dominant part of image production after the introduction of photography. As in earlier visual culture, the borders between these categories continued to be fluid. Photographs made in the service of anthropology and ethnography demonstrate the Christian and Darwinian cultural biases of European imperialism, and in turn such photographs provided models for art and tourist photography.

With the emergence of anthropology in the nineteenth century, cross-cultural scientific photography assumed an important place in advancing the study and documentation of dominated cultures. Photographs provided the ideal tool for physical anthropologists, a sub-field within the discipline that emphasized body measurement and physiognomy. Some anthropological photographs included demeaning scientific apparatuses such as rulers or grids so that viewers could use the images to study body size and proportion. Aboriginal peoples were turned into an objects of scrutiny, treated much as the artifacts of material culture that the scientists examined. Like sculpture, architecture, weapons, clothing, and fishing nets, indigenous people were photographed, and their images labeled, numbered, and filed away for the future researchers in European and American museums.[29]

More often anthropological photographs in the collections of American museums combine a focus on material culture along with physiognomy. In an image from Harvard University's Peabody Museum of Archaeology and Ethnology an unknown photographer has gathered three generations of native Hawaiians in front of their

characteristic indigenous architecture (figure 10.6). Their material culture is every-
where in evidence: traditional carved and polished calabashes, paddles (which often
have symbolic value), and a newer aspect of Hawaiian culture, the *muʻumuʻu*, a
women's dress introduced by the missionaries. As in travel advertisements, the inclu-
sion of material culture is an important part of making the meaning of the photograph.
But unlike travel advertising, the straightforward camera angle and sharp focus suggest
a goal of "documenting" Hawaiian culture rather than creating for the viewer a
romantic desire to visit the islands.[30]

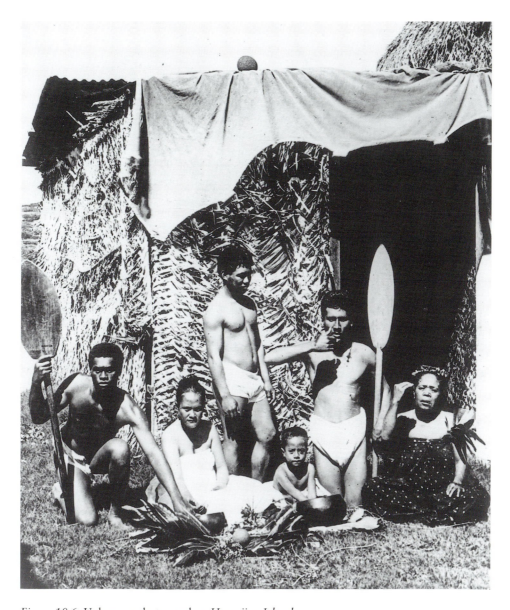

Figure 10.6 Unknown photographer, *Hawaiian Islanders*.

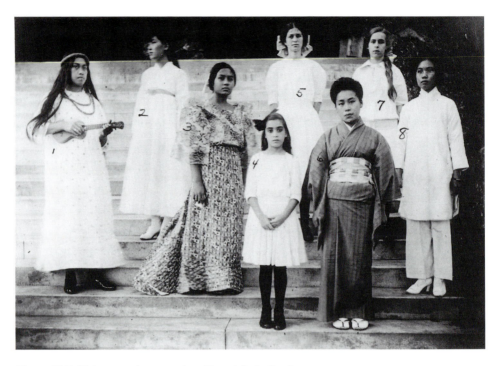

Figure 10.7 Unknown photographer, *Kawaiaha'o Seminary*.

Another image, though free of literal native signs, shows that scientific interest in ethnicity continued, even as Hawaiians became more assimilated to Western ways. The photograph, donated to the Peabody Museum in 1914 by the anthropologist A. M. Tozzer, depicts a group of Kawaiaha'o Seminary students, who were selected to represent differing nationalities and ethnicities (figure 10.7). The image of each student bears a number in pen, and on the verso a key lists their background:

1. Pure Hawaiian
2. " Korean
3. " Filipino
4. " Portuguese
5. " German
6. " Japanese
7. " American
8. " Chinese

Though today such an interest in the subject's ethnicity might celebrate the multicultural character of twentieth-century Hawai'i, Tozzer's other work dispels such a view. Like most of Harvard's anthropology department at the time, Tozzer sought to define the physical characteristics of "race" and focused his Hawaiian fieldwork on charting body measurements and closely observing facial characteristics.[31] Recording physiognomy, however, was not sufficient for the photographer to convey ethnic difference.

Some of the students in figure 10.7 wear traditional dress and others hold props to signify their heritage. The Japanese student, for example, wears a kimono, while the Hawaiian student holds a ukelele.

Ten years after this image was accessioned into the archives of the Peabody Museum, an image, so similar – even down to the hand-written numbers – that it must have been part of the same series, was included in the February 1924 special issue of *National Geographic Magazine* devoted to Hawai'i. The magazine captioned the photograph "Thirty-two girls, each of a different race or racial combination, all attending the Kawaiahao Seminary, Honolulu: A striking illustration of the mixture of races that is taking place in Hawaii," and the story's text mentioned that more than forty per cent of the islands' population was Japanese.[32] Thus, this image could function both as a specialized anthropological photograph and a popularized educational photograph. But the acknowledgment of an ethnically diverse Hawai'i by early twentieth-century anthropologists or popular scientific magazines had no impact on the cultural messages in the travel advertisements. These two photographs mark an important precedent: then, as now, Polynesians typically represented Hawai'i in the mass media.

While anthropological imagery included both men and women, nineteenth-century commercial photography and twentieth-century travel advertising featured native women almost exclusively. Though an emphasis on the sexuality of aboriginal women was present from the very beginning of South Seas imagery, as we have seen in Webber's portrait of Poedua (figure 10.4), by the nineteenth century the classicizing and biblical efforts that lent it subtlety were gradually supplanted by more sensationalized imagery. Published in an 1822 "picturesque" travel book and print portfolio, Louis Choris's

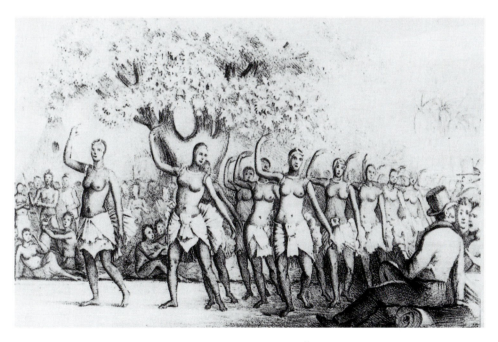

Figure 10.8 Louis Choris, *Danse des femmes dans les Îles Sandwich*. Lithograph, *Voyage pittoresque autour du monde* (Paris, 1822), plate XVI.

(1795–1828) *Dance of the Women of the Sandwich Islands*, is typical of the titillating imagery that soon appeared in Europe (figure 10.8).[33] One might say that Choris had anthropological concerns: the women's costume, the movements of the dance, the community participation. The dancers' minimal attire contrasts with the formal clothing of the male European onlookers, dressed even to their top hats. This striking difference suggests a more salacious agenda, even if one of the men might plausibly be explained as the artist's self-portrait included to assure faithful witness.[34]

The Choris illustration is an ancestor of the many commercial "hula girl" photographs exported to the West. These travel images use cultural details in an exoticizing and eroticizing discourse that objectifies the Hawaiian woman and turns her into a tourist commodity. In a late-nineteenth- or early-twentieth-century postcard, this objectification is accentuated by the garish colors that overlay the highly decorated, impassive women confronting the camera (figure 10.9).[35] Their decision not to smile for the camera (common in many non-Western cultures) contributes to the process of objectification, as does the prominent caption printed in bottom center: "DANCING GIRLS, HAWAII." This is one of the types of images that tourists, businessmen, and government emissaries purchased for their travel albums or mailed back home.

Another photograph makes more clear the erotic aspects of the dance that so upset the missionaries (figure 10.10). The model sits posed on a stool, one breast exposed, her "grass skirt" suggestively parted, and her ukulele strategically placed. The printed caption in the lower right labels her: "HULA GIRLS" (*sic*). Although the photographer seems to be counting on the convergence of the anthropological and the sexual to compel

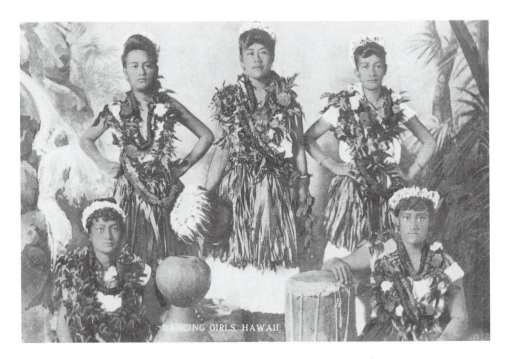

Figure 10.9 Unknown photographer, *Dancing Girls, Hawaii*. Postcard.

viewer interest, the obvious studio backdrop and her likely status as a professional model undercut the eroticism of this commercial image.

Jane Desmond has argued that the trope of the "hula girl" was one of the first markers of Hawai'i in commercial touristic imagery and soon became the most significant.

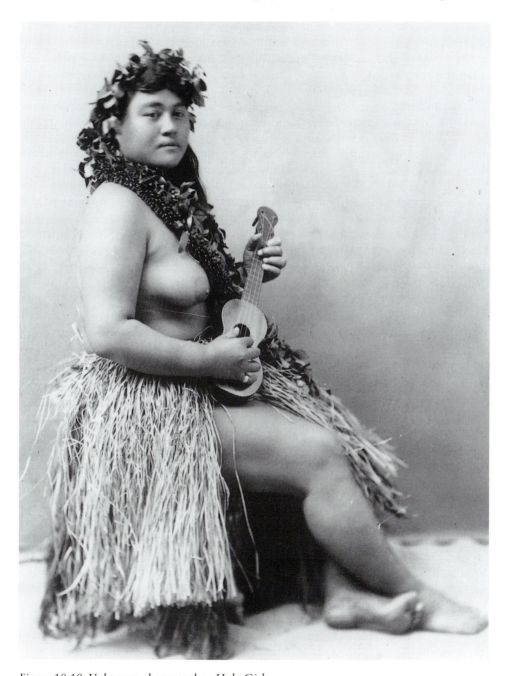

Figure 10.10 Unknown photographer, *Hula Girl.*

The "hula girl" became "Hawai'i's synecdoche"; that is, during the period in which Hawaiian tourism emerged, the costumed dancer "came to stand in for Native Hawaiian culture as a whole."[36] Hula girls were imported to dance at the 1893 World's Columbian Exposition. Following the annexation of the islands, interest in Hawai'i intensified. Tourist images multiplied; hula girls inhabited stereographs, postcards, and mass-media imagery. Indigenous men and women were never pictured together; the isolation of women worked to make Native Hawaiians seem friendlier and more available. As the tourist industry commodified the hula, it commodified cultural difference.[37]

But commercial images varied, and some relied greatly on established artistic conventions. In a photograph of four women wearing native dress and adorned with *leis*, the subjects are idealized like the angels and madonnas of Julia Margaret Cameron, or the archetypal Native American chiefs of Edward S. Curtis (figure 10.11). And the formal vocabulary, with its soft-focus background and sepia tones, recalls the Pictorialist art photography of the turn of the twentieth century. Nothing is recorded in the archives of the Harvard's Peabody Museum about this photograph. It is filed with the other anthropological and tourist photographs, and the lack of a caption means it is not immediately labeled as a commercial image, though that is most likely its origin. That a caption could orient the viewer to anthropology, or the tourist trade, or art photography, further evidences the fluid nature of these categories.

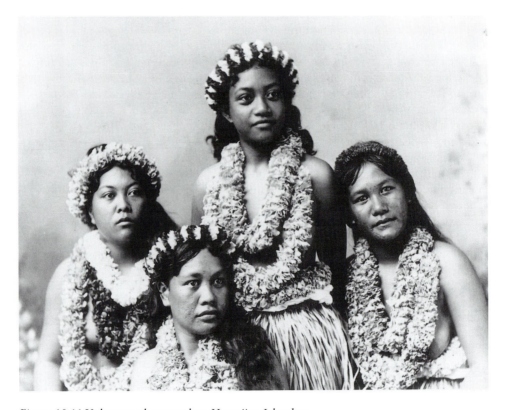

Figure 10.11 Unknown photographer, *Hawaiian Islanders*.

By the late nineteenth century artistic imagery in the Pacific was produced in all media, and, like commercial images, artistic images often employed depictions of indigenous women to distill and explicate cultural ideas about the Pacific.[38] In 1889 a group of photographers who considered themselves "amateurs," that is artists rather than commercial photographers, formed the Hawaiian Camera Club. The members, a group of gentlemen, and some ladies, all of European descent and most trained in science or engineering, avidly read the Pictorialist art journals published in London and San Francisco. Their goal was to replicate the interpretative norms typically associated with painting, rather than the scientific norms associated with ethnographic photography. Though they included occasional references to Westernization or economic activity, their pictures usually presented a romanticized view of the islands' people and places but without the characteristic Pictorialist soft-focus that was found in abundance in Europe and the United States.[39]

Landscape and family were the most typical themes for members of the group, but a few photographs shown at Camera Club exhibitions pictured aboriginal Hawaiian peoples. Walter Giffard's portrait of *Ka'iulani in Kimono*, 1889, layers its exoticism, depicting the exotic (for him) Hawaiian princess dressed in exotic (for her) Japanese costume (figure 10.12). But Ka'iulani was an exceptional subject: a woman of the Hawaiian royal family. Of half-Scottish and half-Hawaiian heritage, thirteen-year-old Ka'iulani later became the heiress-apparent once her aunt Queen Lili'uokalani ascended to the throne.[40] Because of her Scottish father's prominence, Princess Ka'iulani also moved comfortably among the European and American elites.[41] The choice of Japanese exotica – kimono and parasol – likely reflects Ka'iulani's interests, Giffard's aesthetics, and the contemporary rage for *Japonisme*. Giffard's use of costume parallels the fancy dress used in many English Pictorialist images at the time and his work incorporates more softened focus than is typically seen in his contemporaries' work. The young woman's placement encircled by the welcoming and protective arms of the tree and terrain suggests the prevalent high-art theme of close association between woman and nature. Thus, Giffard used many artistic strategies to make the image of the native woman appealing and fashionable. His artistic photograph of a native subject was the individual portrait of an Hawaiian princess rather than an ethnographic curiosity. As happened in many parts of the world, the indigenous elite enthusiastically embraced photography and actively collaborated with photographers in its representation.

The identification of the indigenous woman with nature is one of the most enduring themes in high art, and Paul Gauguin produced perhaps the most archetypal version of this myth. In his *Two Tahitian Women*, 1899, Gauguin's arrangements of color and composition demand that the central theme of the painting be read as his celebration of the ancient metaphoric parallel between women's breasts and fruit (figure 10.13).[42] Gauguin also developed metaphoric parallels between island natives and European religious figures. For example, in *Ia Orana Maria (We Hail Thee Mary)* (1891–92, Metropolitan Museum of Art), the Tahitian mother and child with haloes become Mary and the Christ child, their holiness more at home in the idealized purity of the Pacific than in decadent Europe. Other Gauguin paintings explicitly cast the Polynesian woman as Eve, even to the point of holding an apple, as in *Where Do We Come From? What Are We? Where Are We Going?* (1897, Museum of Fine Arts, Boston).[43]

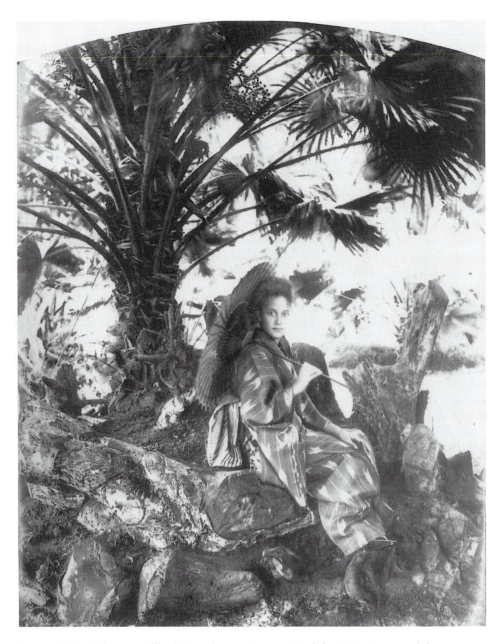

Figure 10.12 Walter M. Giffard, *Ka'iulani in Kimono, Waikíkí, 1889*. Lantern slide.

In *Two Tahitian Women* Gauguin has replaced the traditional European apple with fruit more appropriate to his setting, but he could be sure this substitution would not upset conventional readings; in fact, the fluidity of the sign reinforced traditional meanings. Linda Nochlin has demonstrated that, well before Gauguin painted this interpretation, the breast/fruit analogy was solidly established in French popular

culture, distributed widely through venues as diverse as salon paintings, erotic post-cards, and classical poetry. Nochlin commented on its versatility, "One of the major elements involved in any successful language system is that it can be universally under-stood, so that its tropes have a certain mobility and elasticity, as it were – they can rise from the lowest levels of popular parlance to the highest peaks of great art."[44]

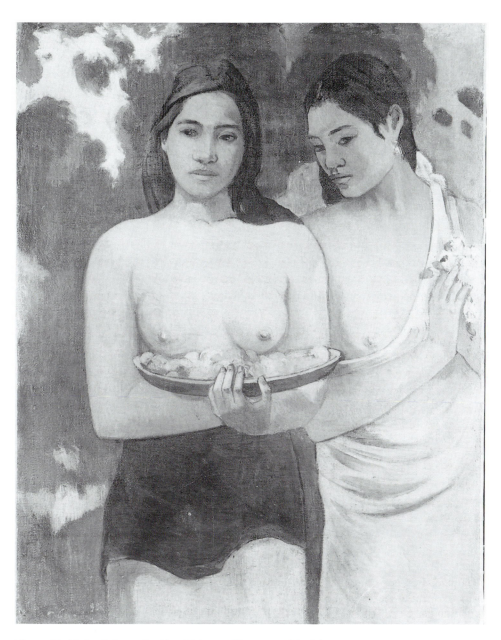

Figure 10.13 Paul Gauguin, *Two Tahitian Women*, 1899. Oil on canvas.

Though Gauguin is now frequently criticized in the art-historical literature for his sexualized stereotypes of Tahitian women and his lack of ethnographic accuracy, he developed tropes that became widespread in the common culture.[45] Gauguin, of course, had no ambition to reach a popular rather than an elite audience, though he worked hard to arrange for exhibitions to get his work seen, reviewed, and sold. He typically sold his paintings through Parisian art dealers such as Ambrose Vollard, who, while he might not be able to get top franc for the absent, struggling artist, still marketed the work as fine art. Yet, much of Gauguin's work, and this painting in particular, diffused into the popular realm. Perhaps this is due to the languid beauty of his Tahitian women. Or perhaps it is due to a fascination with Pacific exotica. Or maybe the desire to demonstrate sophistication through appreciation for modernist high art. Certainly, this was accessible high art. *Two Tahitian Women* was one of the most acclaimed works shown in Gauguin's 1906 posthumous retrospective exhibition and has been widely reproduced ever since. As one Gauguin scholar noted, "The figures have a quality of classic ease, innocence, and grace that would have been immediately acceptable to a French bourgeois public accustomed to nudes from the Salon."[46] This public would easily understand Gauguin's indirect biblical and allegorical references and translate his vision of idyllic Pacific islands into the Garden of Eden.

The tourist era: advertising

By the 1930s, the interpretations of the Pacific developed in scientific, commercial, and artistic images had become an integral part of American popular culture. Hawai'i held a great fascination for the American public that was triggered to a large degree by American imperial expansion and the subsequent geography education movement.[47] In the wake of the Spanish-American war, many newspapers and magazines ran political cartoons that celebrated or criticized Hawai'i's annexation.[48] Jane Desmond has traced American exposure to Hawaiian culture, focusing on the hula, from isolated nineteenth-century performances for California gold rush miners and Columbian Exposition attendees, to the widespread circulation of Hawaiian motifs in the early decades of the twentieth century. A few examples demonstrate the incorporation of Hawai'i into American popular culture. The Broadway show *Bird of Paradise* opened in 1912, ran in different versions for forty years, and was twice made into a feature film (1932, 1951). In the 1910s and 1920s, Hawaiian dancers toured the country, performing everywhere, from New York nightclubs to small-town halls. Some "Hawaiian" dancers achieved celebrity status, even though, like the black-faced minstrels of the nineteenth century, they derived their racial identity from their theatrical performance. More than fifty feature films, mostly romances, were made in or about Hawai'i from 1920 to 1939. After the 1915 Panama-Pacific Exposition, a Hawaiian "music craze" swept the country, culminating in hits such as Rudy Vallee's 1934 "My Little Grass Shack." And *Hawaii Calls*, a radio show promoting Hawaiian music, was on the air for forty years between 1935 and 1975. The strong presence of Hawai'i in American popular culture shaped mainland ideas about the islands. As Desmond observed, these cultural imports "helped codify a vision of Hawai'i as feminized, embodied, sensual, and *hapa haole* [half-white]. These renditions of a Hawai'i imaginary contributed to the growth of a tourist destination image and prepared the way for substantial growth in tourism in the 1920s and 1930s."[49]

The advertising photographs of the 1930s incorporated visual precedents from all types of visual culture, but primarily fine art and popular culture. Photographic practices offered some guidelines to draw from, but none filled the bill entirely. The goal of advertising was to make Hawai'i a fascinating and desirable destination for affluent travelers, not a scientific curiosity. Demeaning anthropological scrutiny, or material culture studies, or kitschy postcards, or the very few artistic compositions of the Hawaiian Camera Club could not alone provide visual precedents. For this marketing task, these corporate photographers turned primarily to the repertoire of motifs in painting that had already become a fixture in popular culture. Most commercial photographers had an art background and easily translated fine art motifs into mass-media imagery. They were also experienced in working for business clients and understood well that their work should advance their clients' sales strategies and be readily accessible by the public.

In particular, the established cultural theme of equating native women with nature – a theme that went back to the first European explorers and later fascinated Gauguin – made an easy transition into advertising imagery. In one of Toni Frissell's images from the January 1940 *Harper's Bazaar*, a native woman offers the tourist a feast drawn from her bountiful display of watermelons, bananas, and other tropical fruit. In another Frissell image for the Hawaiian Tourist Bureau, from the October 1939 *Harper's Bazaar*, the woman's welcoming offering is the *lei* she has assembled from the flowers in the four woven baskets that encircle her (figure 10.14). Like the flowers, the organic fibers of the *lau hala* mat on which she sits also reinforce the nature theme and at the same time make a specific reference to this important Polynesian woven craft. The text emphasizes the uniqueness of Hawai'i, telling potential tourists "that the particular spot of earth known as Hawaii has been especially blessed – and set apart." In such an Eden, it is possible to forget that the tourist, in a random exploration of the islands, likely would not happen upon a native woman such as this one, who inhabits only the tourist district. If our potential tourist reflected for a moment, it would be clear that the woman is a worker in the tourist industry and that their exchange is economic as well as enchanting.[50] Frissell photographed the model from above, looking down on her obliquely, and thus replicated the tourist's encounter with her. The Polynesian woman smiles warmly as she greets the tourist. Hawai'i, full of fruit and the flowers, has become a mythic Eden. But it is an Eden in which the visitor can engage in very contemporary pursuits: the inset squares feature entertainments of beaches, boating, and barefoot football.

Toni Frissell (1907–88) was one of the most successful commercial photographers of the interwar years – not an easy accomplishment for anyone, but a particularly impressive achievement for a woman. While women always had a limited presence in art photography, the travel and corporate demands of the advertising industry proved more exclusionary. But Frissell was a maverick. As the daughter of a New York City doctor, she had a privileged childhood. Though her first professional interests were in theater and painting, through family connections she began her career as a writer for *Vogue*. She was soon fired, and editor Carmel Snow advised her to take up photography professionally. Frissell had learned photography from her brother, who was a documentary filmmaker; she then apprenticed to Cecil Beaton. By the late 1930s Frissell's fashion images were a regular feature in *Vogue*. As her career became more intense, she was often away on assignment nine months of the year, leaving her two

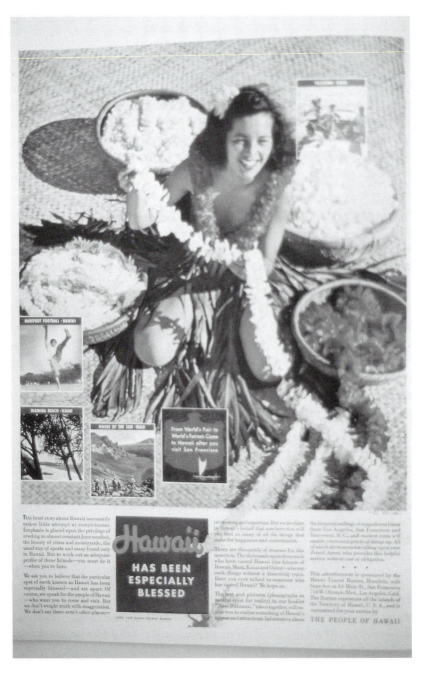

Figure 10.14 Toni Frissell, Advertisement for Hawai'i Tourist Bureau, *Harper's Bazaar*, October 1939.

small children in the care of her husband and their nannies on their Long Island estate. Frissell had a particular gift for outdoor photography, and she favored small cameras to achieve more natural, spontaneous results. It is no surprise she went on to produce journalistic photographs for the Red Cross and US Army Air Corps during World War II and action photographs for *Sports Illustrated* in the 1950s.[51]

Since she was an outdoor specialist, photographing Hawaiian women in nature was comfortable for Frissell. It was perhaps more of a challenge for Edward Steichen, who preferred to work in the studio where he could control every shadow and glare.[52] At the beginning of the century, Steichen (1879–1973) was an internationally acclaimed Pictorialist art photographer and an active participant in photographic art circles in New York and Paris. As a specialist in the gum-bichromate process, he was a photographer who used the medium's technical properties to great advantage to produce highly romanticized nude studies or dreamy landscapes layered with soft color.[53] He had had some brief training in academic painting in Paris, and early in his career he was particularly drawn to Symbolist and romantic aesthetics. He saw Gauguin's painting of *Two Tahitian Women* and a roomful of other Tahitian pictures at Gauguin's 1906 retrospective in Paris. But modern painting was an acquired taste for Steichen. He did not respond enthusiastically at his first exposure to Gauguin's work, though during his Parisian residency he came to recognize the importance of modernism and functioned as the chief scout for modern art to exhibit in New York at Alfred Stieglitz's gallery 291.[54] After service as chief of aerial photography for the United States Army during World War I, Steichen turned to a commercial career. His new corporate patrons, as well as his facility with the newer modernist straight photography that began to predominate in artistic photography after the war, influenced his highly successful advertising style. He was arguably the most successful commercial photographer of the 1920s and 1930s in terms of pages commissioned and financial reward.

The images Steichen made on his 1939 trip to Hawai'i highlighted the fascination that native Hawaiian culture held for the American tourist. Steichen pictured the Polynesian women as great beauties and included enough ethnographic and natural detail to transmit the exoticism of place. This strategy of carefully describing, then romanticizing place was certainly calculated on Steichen's part, and no doubt was part of the instructions he received from his client. For this was Steichen's second trip to Hawai'i for the Matson Navigation Company. In 1934, as he cruised to Hawai'i on the SS *Lurline*, he recorded the glamorous shipboard life: the luxury of the first-class cabins, the cocktail parties, and the romantic moments spent gazing at the moonlit seas. In the 1934–35 campaign, the destination hardly mattered at all.[55]

But all this changed in the 1940–41 campaign. In this new series, it was culture and site that were captivating, with the luxury of cruising a secondary theme. In a photograph published in *Harper's Bazaar* in 1941, Steichen developed his own version of the standard trope of "primitive woman in nature" (figure 10.2). Like John Webber's *Poedua*, the Polynesian woman is surrounded by nature (figure 10.4). Also like Webber's painting, Steichen's photograph provides the realism of a specific individual's portrait generalized into an archetypal representation of a beautiful, sensuous island dweller. Her expression – slightly startled, and slightly perplexed by the intrusion by her Euro-American viewer – reinforces the theme of woman alone in nature, perhaps like the first woman, Eve.

Steichen's primary model for his Matson Line campaign was Doveline "Tootsie" Notley (later Steer). According to her oral history recorded in 1985, Steer modeled as the "Matson Girl" in 1939, 1940, and 1941. In her reminiscences, she described how Steichen controlled every detail in his quest to make the image seem "natural." He asked her to stop trimming her hair, and to give up the manicures and pedicures she thought essential to her career as a professional hula dancer. She remembered that he searched for "the beautiful, natural places to take pictures." And he knew exactly the effect he was after: "he used to work me to death. Sometimes we work[ed] for eight hours to get what he wanted."[56]

Steer, who described herself as a "full-blooded Hawaiian" was quite proud of these advertising photographs. She had been born in Honolulu in 1915, and thus was about twenty-five when she modelled for Steichen. She was keenly aware of the racial implications of her selection as the "Matson Girl." "Well, they were so excited about those pictures because it's the first time they've had someone that's so Hawaiian."[57] Previously, Hawaiians pictured in the mass media and Hawaiian performers tended toward what is called on the islands the *hapa haole*, or half-Caucasian look, which was not uncommon owing to the large degree of intercultural mixing. This was the look typically presented in performances and advertising on the mainland soon after Hawai'i became a territory. The early media construction of Hawai'i as populated by Polynesian-Caucasians made it easier for the public to accept the islands as a United States territory. And, for entertainment purposes, the look was again the best of both worlds: it was partly Polynesian, and therefore some-what exotic, but not so much that the promoters feared they might alienate their audiences. It also reinforced the idea of Polynesians as a unique people – "brown-not-black," as Jane Desmond described the trend – and ensured that the audience would perceive the Hawaiian natives as a pleasant and compliant people. Other ethnic populations, who together made up a majority of the islands' people, were essentially invisible in tourist publications.[58]

The greater acceptance of fully Native Hawaiian women in advertising had a paral-lel in hula dance performances on the mainland. The hula stars of the World War I era were often working-class whites, some of whom had never been to Hawai'i before they became exotic dancers.[59] But by the 1930s, exclusive clubs such as the Hawaiian Rooms at the Lexington and St Regis hotels in New York assured their patrons that their celebrated hula dancers were "authentic" Hawaiians. And the media cast these dancers as goodwill ambassadors, with more "class" than their sisters of yesterday.[60] In the 1930s, as Steer pointed out, a more fully Polynesian look became acceptable in the media. But this was not universal. Steer commented that Toni Frissell did not like her looks and would not hire her, preferring models with a more "Oriental" appearance.[61]

Steichen was sensitive to the uniqueness of the Hawaiian landscape, dress, and cus-toms, but he blended them with standard Western iconographic conventions, much like the earliest European artists who imaged the Pacific. Steichen's solitary woman from the November 1941 issue of *Vogue* engages in a picturesque, even if obscure, activity, the lifting of a bundle of long-stemmed flowers on to a basket-weave stage (figure 10.15). Wearing a characteristic Hawaiian *ti*-leaf skirt, a *lei*, and a hibiscus in her hair, she is perhaps the most mythologized of Steichen's images of native women. She is photographed from a close vantage point, and the emphasis on the striking contours of her body against the vibrant landscape, with its volcanic mountains and bright skies,

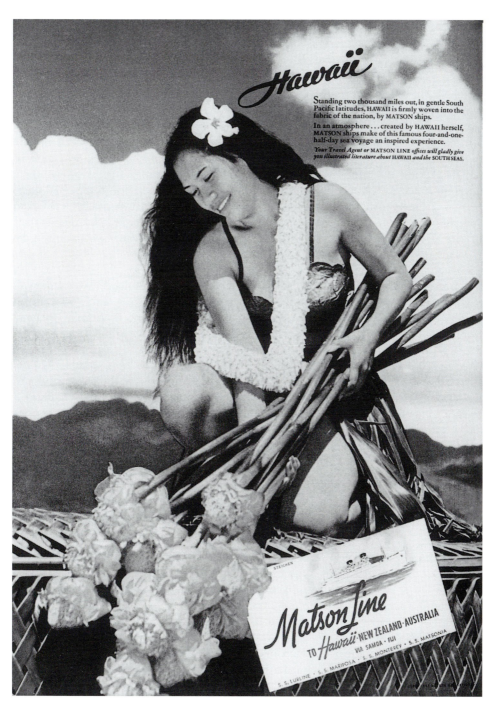

Figure 10.15 Edward Steichen, Advertisement for the Matson Navigation Company, *Vogue*, November 1, 1941, inside cover. Art director: Lloyd B. Meyers. Advertising agency: Bowman Deute Cummings.

lends a sculptural quality to her body that recalls the solidity of classical figures. There is a composed, even contemplative, feeling to the image. As she works, her *lei* falls seductively off her shoulder, her hair cascades down her back, and she smiles. Her pose, dress, demeanor, and beauty make her alluring to Westerners. While she does not engage directly with the tourist viewer, her smile may indicate she is aware of being watched. The effectiveness of the advertisement depends on her implied happiness from working close to nature for her livelihood, for the image draws on Western romantic connections among women, nature, beauty, and contentment.[62] There is also a calculated sense of timelessness pervading such advertising photographs. The ads picture indigenous costumes and activities to promise the tourist an authentic, even anthropological, view of traditional cultures, preserved despite the pressures of economic development.[63] This historical amnesia also eliminates all references to political domination or the imposition of a capitalist economy. Indigenous people are depicted as so content working in the tourist industry that these activities seem as "natural" as their pre-contact economy. Such images highlight the contrast between the viewer and the viewed, and in the process reinforce the viewers' identities as members of a "modern" society.

Another common theme in 1930s Hawaiian advertising is the native woman as teacher to her less fortunate, nature-deprived Western counterpart. In a 1939 photograph by Anton Bruehl, the Euro-American tourist is learning traditional weaving techniques by observing a Hawaiian woman (figure 10.16). Like Frissell and Steichen, Bruehl (1900–82) was a highly regarded, successful New York advertising photographer. Bruehl had discovered the Clarence H. White School of Photography, with its curriculum emphasizing design and composition, after he emigrated from Australia to work as an electrical engineer for Western Electric in New York. When Bruehl decided to turn to commercial photography full-time in 1925, he was an instant success. He developed a distinctive modernist style that emphasized the reduction of forms into geometric shapes and dynamic composition. In the 1930s Bruehl became celebrated for his experimental color photography developed in collaboration with photo-technician Fernand Bourges and financed by publisher Condé Nast. Like Steichen, and unlike Frissell, Bruehl was very much a studio photographer who controlled his image through carefully constructing his sets, planning his lights, posing his models, and using a large studio camera. Working on location must have been quite a challenge for him.[64]

This photograph demonstrates Bruehl's characteristic modernist vantage point, above and to the side of his subject, resulting in a dynamic diagonal composition (figure 10.16). He focuses carefully on the two women, whose ethnic difference is made more obvious by their clothing: one wears the *kikepa*, and one wears a fairly formal short-sleeved suit, indicating her status as an affluent consumer. Both wear *leis*, and sit encircled by tropical vegetation on the *lau hala* mat. The Euro-American woman gazes admiringly at the Hawaiian woman.

In another image Bruehl's swimsuit-clad tourist is mesmerized by the Polynesian woman's abilities as a musician and dancer (figure 10.17). The native woman is dancing a *hula noho*, performed kneeling or seated. There is no background, except for the suggestion of sitting on a sandy beach; the consumer can devote full concentration to the encounter depicted. The Western woman is positioned in front of and below the native woman. Their relative positions in the advertisement make an odd composition

and complicate the representation of social hierarchies. On one hand, the Western woman looks up to the native woman. On the other hand, she is in the foreground, presumably the figure with whom the viewer would identify. The native woman takes on the role of teacher – teaching the American woman how to express herself through music and dance, how to experience nature, how to appreciate flowers and the simple things in life – and mostly how to be happy.

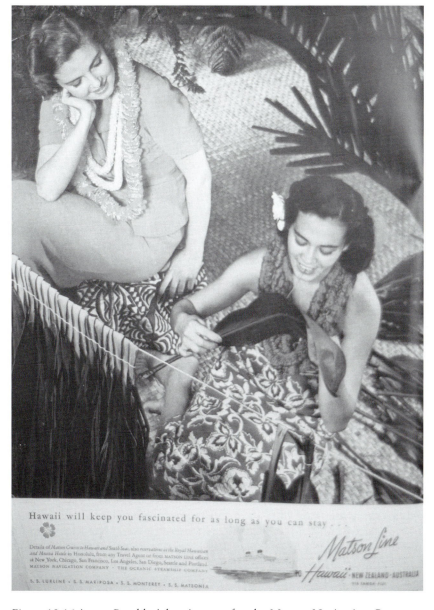

Figure 10.16 Anton Bruehl, Advertisement for the Matson Navigation Company, *Harper's Bazaar*, November 1939.

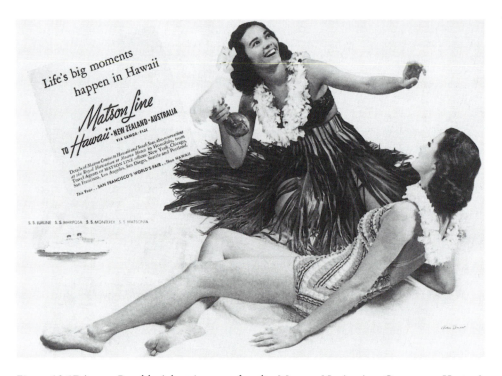

Figure 10.17 Anton Bruehl, Advertisement for the Matson Navigation Company, *Harper's Bazaar*, March 1, 1939.

While advertising agencies found a ready source of themes and visual vocabularies in the romantic fine art images of the Pacific, they also had other reasons to turn to the fine arts for inspiration. Trips to Hawai'i were expensive, so the ads were placed in the more upscale mass media. Within the logic of 1930s advertising theory, the fine arts were believed to add "class" when marketing to more affluent consumers. But, more importantly, fine-art styles and motifs reinforced the advertising agencies' claims, frequently stated in trade journals, that advertising elevated the consumer's artistic taste. Fine-art references also made a statement about a particular advertisement's exceptional aesthetic significance as more than just ordinary commercial art. All of these claims are operative in the Hawai'i advertisements. The professionalization of art directors and commercial illustrators was rising in the 1920s and 1930s, and many wanted to demonstrate their artistic skills, raise the level of visual sophistication of advertising, and with it, popular taste.[65] A number of celebrated advertising campaigns adopted this strategy in the 1930s, among them art director Charles Coiner's campaign for Dole pineapple juice for which he sent artists Georgia O'Keeffe and A. M. Cassandre to Hawai'i.[66] Other famed accounts that employed well-known artists included Steinway pianos, DeBeers diamonds, and the Container Corporation of America. Such ads as the Hawai'i cruise advertisements appropriated motifs from the fine arts not only to sell their product, but also to sell the ads themselves as art. A case in point: Steichen's image of the native woman atop the mountain with the sea beyond won an Art Directors' Club Medal for color photography in 1941 (figure 10.1).[67]

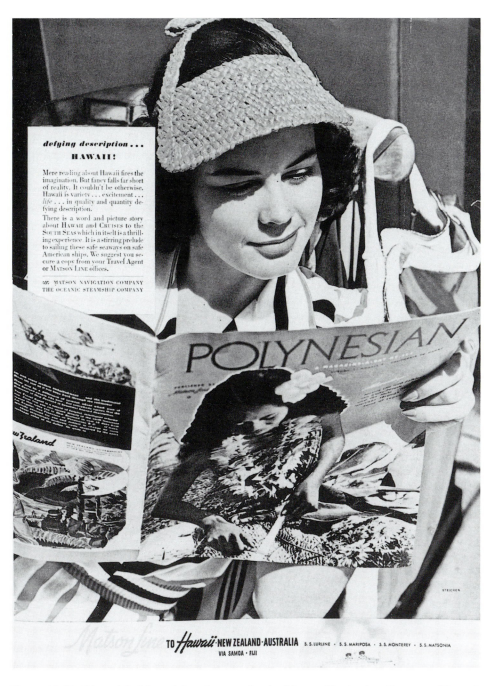

Figure 10.18 Edward Steichen, Advertisement for the Matson Navigation Company, *Harper's Bazaar*, March 1940, inside back cover. Art director: Lloyd B. Meyers. Advertising agency: Bowman Deute Cummings.

Though I am arguing that such mass-media commercial images were meant to be artistic more than anthropological, they also drew some visual conventions from the long history of scientific representation. Like anthropological imagery, advertising images trained a seemingly neutral, yet obviously Western eye on indigenous people and carefully highlighted material culture. In the advertisements, as in earlier exploration and colonial imagery, the indigenous women may be friendly, yet they remain apart – spectacles who educate and entertain adventuresome Euro-American tourists.

Advertising with images of indigenous peoples required the agencies to restructure the usual dynamics of advertising. Typically advertising images had been (and still are) built on the assumption that the middle-class viewer, to whom they were directed, identified with the model and wished to exchange class status, goods, or romantic partners with her. In Steichen's more typical advertising photographs, the lovely (always Caucasian) model often wore evening dress or jewels as she applied Pond's cold cream or Jergens' lotion in preparation for her evening out. Steichen's advertisements for these and many, many other clients encouraged their female audience to read in a participatory – one might say empathetic – way.[68] These Hawaiian cruise ads were placed in the same women's magazines as the beauty product ads. But, as in earlier anthropological photographs, the exoticism and racial difference depicted in these images closed off the viewer's active identification with the model. The Western woman might admire the native woman's beauty, or attempt to learn her skills, but she could not trade places.

The distance imposed by this mode of viewing implies unequal social and economic relations – a colonial relationship – between the affluent visitor and the passive native. This colonialist gaze reinforces the viewer's identity as a consumer and objectifies the Hawaiian woman. These color photographs transformed the Hawaiian woman, and Hawai'i itself, into commodities. This commodification promised the tourist the possibility of knowing "the real Hawaii" as the ads said, but in fact, the commodification eliminated the possibility of real knowing. We learn more about American fantasies of the islands than about the islands themselves.

The advertiser then had to include the figure of the tourist, as Bruehl's photographs often did, in order to retain the standard relationships of viewing in advertising photography, that is, the viewer's identification with the model (figures 10.16, 10.17). In an advertisement placed in *Harper's Bazaar* for September 1, 1939, another of Bruehl's images shows a Hawaiian woman adorning a triumphant Euro-American tennis player with a *lei*, outlining the hierarchies of race and class. And a 1940 Steichen image of a tourist reading *Polynesian* magazine even more obviously illustrates the commodification of Hawai'i (figure 10.18). Here the indigenous woman appears only as a photograph on the cover of the magazine, her culture available for purchase and consumption by the Euro-American tourist. Vivid coloration encourages the reader to identify with the Western model and fantasize about her own dream trip to Hawai'i. By the process of reading, study, and recording, the dominant culture intellectually defines the native culture and solidifies its status as other – a curiosity to investigate, study, and consume. Consumption defines the interaction between the cultures; it functions as a substitute for genuine cultural exchange.

Racial difference is a complex and multifaceted theme in the Hawaiian travel advertisements of the 1930s and 1940s. In one sense, these ads celebrate difference as exotic and exciting – something the adventurous tourist has to experience. There is no obvious condescension to the indigenous models, and certainly not the scrutinizing and

demeaning gaze of anthropological photographs. Rather they retain the sense of wonder and fascination seen in the earliest Pacific scientific drawings, while they incorporate the romantic primitivizing and idealized classical and biblical references of artistic interpretations. Yet, inherent in this celebration is a colonial relationship that turns Hawai'i into a commodity. As these advertising photographs serve their commercial purpose, they take from and contribute to ideas about the islands in popular culture. As we have seen, the genealogy of advertising photography is not a linear photographic one, but one that incorporates forms and interpretions from all aspects of visual culture. The three catalysts of Pacific imagery – science, art, and commerce – merge and diverge as they continually reshape the complexities of intercultural representation and present them to the mass-media audience.

Notes

1 This image also appeared in the November 1940 issue of *House and Garden*.
 An earlier version of the advertising section of this chapter appeared in my book *Real Fantasies: Edward Steichen's Advertising Photography* (Berkeley: University of California Press, 1997). I thank Arlette Klaric, Len Klekner, Joanne Lukitsh, Castle McLaughlin, Eleanor Hight, and Gary Sampson for their careful reading of the present text.
 The Hawaiian *okina* (') is a symbol that replaces a consonant. Essentially, okinas are letters in the word (though sometimes they are called pronunciation stops). Early typesetters often dropped the okinas. I have followed preferred practice today, that is, to use the *okinas* in Hawaiian words, unless quoting a source in which they are missing.
2 This garment, often called a *pareu*, is found throughout the South Seas and has become a symbol of Polynesian identity. The *pareu* evolved after Christian missionaries condemned traditional native dress. See, for example, Stephen F. Eisenman, *Gauguin's Skirt* (London: Thames and Hudson, 1997), 202–3.
3 For a survey of advertisements with non-Western subjects see William M. O'Barr, *Culture and the Ad: Exploring Otherness in the World of Advertising* (Boulder, CO: Westview Press, 1994). O'Barr deals primarily with travel advertisements placed in *National Geographic* in 1929 and compares them to recent examples. The number of examples he found is larger than in the popular press, since *National Geographic* is a magazine where travel advertisements concentrate. See also the exhibition catalogue *Ethnic Images in Advertising* (Philadelphia: Balch Institute for Ethnic Studies, 1984); Stuart Hall, ed., *Representation: Cultural Representations and Signifying Practices* (London: Sage Publications, 1997); Gail Dines and Jean M. Humez, eds., *Gender, Race and Class in Media: A Text-Reader* (London: Sage Publications, 1995); and Marlon Riggs's 1987 documentary film *Ethnic Notions* (distributed by California Newsreel, San Francisco).
4 For a case study of changing meanings through the reuse and recaptioning of photographs see Alison Devine Nordström, "Paradise Recycled: Photographs of Samoa in Changing Contexts," *exposure* 28 (Winter 1991–92): 6–13.
5 This history is summarized from Elizabeth Buck, *Paradise Remade: The Politics of Culture and History in Hawai'i* (Philadelphia: Temple University Press, 1993).
6 For a recent study of Hawai'i's multiculturalism see Michael Haas, ed., *Multicultural Hawai'i: The Fabric of a Multiethnic Society* (New York: Garland Publishing, 1998).
7 James J. Jarves, *Scenes and Scenery in the Sandwich Islands, and a Trip through Central America: Being Observations from my Note-book during the Years 1837–1842* (Boston: James Munroe and Company, 1843) and Mark Twain, *Mark Twain's Letters from Hawaii*, ed. A. Grove Day (Honolulu: University Press of Hawai'i, 1975). Stevenson's letters, poems, and prose writing were gathered together later. See Robert Louis Stevenson, *Travels in Hawaii*, ed. A. Grove Day (Honolulu: University Press of Hawai'i, 1973).
8 Buck, *Paradise Remade*, 173–4. Crosby starred in the 1937 film *Waikiki Wedding*, and Grable in the 1942 film *Song of the Islands*.
9 Bernard Smith, *European Vision and the South Pacific*, 2nd ed. (New Haven: Yale University

Press, 1985). Smith's book was first published in 1959. For another extended, insightful analysis of anthropological and natural imagery see Barbara Maria Stafford, *Voyage into Substance: Art, Science, Nature and the Illustrated Travel Account, 1760–1840* (Cambridge, MA: MIT Press, 1984).

10 Smith has argued that the expeditions' figural studies were based on previously established European conventions of ethnographic representation, as well as on classical traditions. See Bernard Smith, *Imaging the Pacific in the Wake of Cook's Voyages* (New Haven: Yale University Press, 1992), 80–5.

11 Smith, *European Vision*, 5. These two themes are referenced periodically in Smith's book. He notes that the explorers' image of the Pacific islands was not always as a simple "deist paradise of innocence and virtue"; they were well aware of some of the darker sides of the society (for example, p. 44).

The concept of the noble savage is usually attributed to Jean-Jacques Rousseau. Contemporary political ideals made this concept compelling in the age of revolutions, particularly in France. Pacific warriors, patterned on the poses of the Doryphoros or Apollo Belvedere, could be mistaken for the stoic heroes of Jacques Louis David. Smith noted, "Savages were endowed with the virtues that good republicans aspired to. Simple in his needs and desires, self-disciplined, courageous, and with a great capacity for endurance, the savage became a symbol of revolutionary freedom and ideal perfectibility." Smith, *European Vision*, 149.

The noble savage was a motif with great mobility and staying power, frequently used in the nineteenth century for images of Native Americans. For example, see Julie Schimmel, "Inventing 'the Indian'," in *The West as America: Reinterpreting Images of the Frontier*, ed. William H. Truettner (Washington, DC: Smithsonian Institution Press, 1991), 149–89.

12 Figure 10.3 was redrawn, most probably by John James Barralet, then engraved and included as Plate 13 in John Hawkesworth, *An Account of the Voyages undertaken by the Order of His Present Majesty for Making Discoveries in the South Hemisphere*, 2nd ed., 3 vols (London: W. Strahan and T. Cadell, 1773). A variation on the image (engraved by T. Chambers) also appeared in Parkinson's own account of the voyage: Sydney Parkinson, *Journal of a Voyage to the South Seas in his Majesty's Ship, The Endeavor* (London: Charles Dilly and James Phillips, 1784), plate 21, following p. 108. Because Parkinson died from malaria on the last leg of the voyage home, his journals had a complicated publication history. His brother first had them published in 1773, then, after a legal battle with Joseph Banks, they were republished and made more widely accessible in 1784. A modern reprint is available (London: Caliban Books, 1984). The engravings in Parkinson's journals are smaller and of less fine quality that their corresponding images in Hawkesworth. For a comparison of these editions, see Rüdiger Joppien and Bernard Smith, *The Art of Captain Cook's Voyages: with a descriptive catalogue of all the known original drawings of peoples, places, artefacts, and events and the original drawings associated with them* (Melbourne: Oxford University Press in association with the Australian Academy of Humanities, 1985–88), vol I, 34–43, 184–5.

Smith notes that a contemporary reviewer of the 1784 edition for *Gentleman's Magazine* praised the Parkinson account for greater "fidelity" than that presented by books (such as Hawkesworth's) that "have departed from the simplicity of Nature to give a scope to the decorations of Art." Smith, *European Vision*, 40–1. For further information on Parkinson see D. J. Carr, ed., *Sydney Parkinson: Artist of Cook's Endeavor Voyage* (London: British Museum, Natural History, in association with Croom Helm Ltd, 1983).

13 Smith, *European Vision*, 108. These were the instructions for the third voyage. The *Secret Instructions* for the first voyage were similar, requiring close observation, but without the specific mention of art work: "carefully to observe the Nature of the Soil, and the Products thereof; the Beasts and Fowls that inhabit or frequent it, the fishes that are to be found in the Rivers or upon the Coast and in what Plenty" (p. 16).

Though Parkinson specialized in natural history drafting and likely had no academic art training, he was aware of European art styles. He brought his own copy of Hogarth's *Analysis of Beauty* on board with him. Joppien and Smith perceive European style and ideas of facial beauty in the head of the Maori chief. *The Art of Captain Cook's Voyages*, vol. I, 36, 74–5.

14 Smith, *European Vision*, 40–1.

15 An excellent brief biography of Webber is in Joppien and Smith, *The Art of Captain Cook's Voyages*, vol. III, 171–202. Though born in England, Webber was trained in Bern, Switzerland, the hometown of his artist father. Webber exhibited frequently in the Royal Academy from 1784 to 1791. His work was praised by Sir Joshua Reynolds, and he was elected an Associate of the Royal Academy in 1785, then a full member in 1791. His *Death of Cook* (c. 1781–83, Mitchell Library, State Library of New South Wales, Sydney) utilized the vocabulary of neoclassical history painting. See also David W. Forbes, *Encounters with Paradise: Views of Hawaii and Its People, 1778–1941* (Honolulu: University of Hawai'i Press and Honolulu Academy of Arts, 1992), 18–19, 52–6.

William Hodges, the artist on Cook's second voyage, was also a trained fine artist, though he specialized in plein-air landscapes. See Smith, *Imagining the Pacific*, 111–34.

16 Webber may have used oils in this case because he had more time than usual to study his subject since Poedua spent five days on board ship. Joppien and Smith summarize: "On 24 November 1777 two men of the *Discovery* deserted at Raiatea. In order to ensure their return Captain Cook enticed Orio's son Te-eura, his daughter Poedua, and her husband Moetua on board the *Discovery* and held them hostage in his cabin until the return of the deserters." Webber likely painted his first portrait of Poetua, with its "thinly applied colour and coarse cloth" at this time (National Maritime Museum, London). He later painted two copies, one in a private collection, and this one in the National Library of Australia, Canberra. Joppien and Smith, *The Art of Captain Cook's Voyages*, vol. III, 67, 403.

17 For examples, see Peter A. Tomory, *The Life and Art of Henry Fuseli* (New York: Praeger, 1972), particularly *The Cave of Spleen* (1799), 85; *The Daughter of Herodias with the Head of St. John the Baptist* (c. 1779), 122; and *The Awakening of Titania* (c. 1785–90). See also the catalogue raisonné by Gert Schiff, *Johann Heinrich Fussli, 1741–1825* (Zurich: Verlag Berichthaus; Munich: Prestel, 1973).

18 For an analysis of the sensuality of Canova's sculpture see Carol Ockman, *Ingres's Eroticized Bodies: Retracing the Serpentine Line* (New Haven: Yale University Press, 1995), 38–9, 43–4. Ockman notes the sculpture was controversial but also very popular. Art admirers crowded in, especially for nighttime viewing.

19 See Smith, *European Vision*, 39, for an example of how the draftsman Cipriani and the engraver Bartolozzi created classicizing interpretations of a drawing of natives of Terra del Fuego by Alexander Buchan, an artist on Cook's first voyage. Sometimes additional landscape details, drawn from the taste for Claude Lorraine and Salvator Rosa, embellished the engravings.

20 For example, William Hodges, the artist for Cook's second voyage, exhibited paintings based on his travels at the Royal Academy in 1776 and 1777. Smith, *European Vision*, 54–80. And after his return from Cook's third voyage, Webber completed oil paintings based on his drawings done on site and exhibited them at the Royal Academy. Joppien and Smith, *The Art of Captain Cook's Voyages*, vol. III, 121, 127, 129.

21 This drawing is discussed in Forbes, *Encounters with Paradise*, 46–8.

22 The engraving was included as plate 65 in James Cook and James King, *A Voyage to the Pacific Ocean: undertaken by the command of His Majesty for making discoveries in the northern hemisphere: performed under the direction of Captains Cook, Clerke, and Gore in His Majesty's Ships the Resolution and Discovery; in the Years 1776, 1777, 1778, 1779 and 1780*, 2nd ed. (London: H. Hughs for G. Nicol and T. Cadell, 1785).

King conveyed his impression of the majestic sight: "There remains to be mentioned another ornament (if such it may be called), the figure of which may be better conceived from the annexed print, than any written description. It is a kind of mask, made of a large gourd, with holes cut in it for the eyes and nose. The top was stuck full of small green twigs, which, at a distance, had the appearance of an elegant waving plume, and from the lower part hung narrow strips of cloth, resembling a beard. We never saw these masks worn but twice, and both times by a number of people together in a canoe, who came to the side of the ship, laughing and drolling, with an air of masquerading. Whether they may not likewise be used as a defence for the head against stones, for which they seem best designed, or in some of their public games, or be merely intended for purposes of mummery, we could never inform ourselves." King, *A Voyage to the Pacific*, vol. III, 139–40.

23 James Cook and James King, *A Voyage to the Pacific Ocean: for making discoveries in the northern hemisphere: performed under the direction of Captains Cook, Clerke, and Gore, in the years 1776, 1777, 1778, 1779 and 1780* (New York: Printed by Tiebout and O'Brien, for Benjamin Gomez, 1796).

24 Joppien and Smith, *The Art of Captain Cook's Voyages*, vol. III, 189–96.

25 These terms are used in Hiram Bingham, *A Residence of Twenty-one Years in the Sandwich Islands* (1847; reprinted: Rutland, VT: Charles E. Tuttle Co., 1981): 39.

 For a succinct history of Hawai'i and a guide to early primary sources, including first-person missionary accounts see "Introduction: Historiography," in Patrick V. Kirch and Marshall Sahlins, *Anahulu: The Anthropology of History in the Kingdom of Hawaii*, vol. I: *Historical Ethnography* by Marshall Sahlins with the assistance of Dorothy B. Barrère (Chicago: University of Chicago Press, 1992), 1–14.

26 Bingham, *A Residence of Twenty-one Years in the Sandwich Islands*, 10, 21–2.

 A few dissenting voices raised concerns over the missionaries' aggressive activities. In his journal, Lt Charles Wilkes, commander of the Wilkes Expedition, officially known as the United States South Seas Surveying and Exploring Expedition, which circled the world from 1838 to 1842, debated the positive and negative effects of the missionaries on the Hawaiian peoples. His expedition artist was far more critical, questioning the efficacy and morality of the evangelical project. Titian Ramsay Peale noted that a war on Fiji had "been provoked by the *Weslyan Missionaries*." And, Peale noted, "The ultimatum of the allies is Christianity and a Missionary amongst you or – Extermination – the result ought to be obvious, when we know that the Missionary party is the strongest & best armed." Jesse Poesch, *Titian Ramsay Peale and His Journals of the Wilkes Expedition* (1961; reprinted: Philadelphia: American Philosophical Society, 1979), 80, 169. See also Herman J. Viola and Carolyn Margolis, eds, *Magnificent Voyagers: The U.S. Exploring Expedition, 1838–1842* (Washington, DC: Smithsonian Institution Press, 1985).

27 Smith, *European Vision*, vii–ix. Smith's major concern is the impact of the Pacific on Europe. In this regard, he notes that the discovery of the wealth of the Pacific challenged biblical creation ideas and argued for a scientific theory of evolution – not as ideology but as an attempt to account for what had been observed. Smith's analysis of the effect on the Pacific was even more biting. He noted that trade, commerce, and scientific theory followed the flag; religion "combined with social Darwinism, in the business of destroying traditional Pacific societies."

28 Smith, *Imagining the Pacific*, 207–9.

29 For examples of studies of native peoples see David Green, "Classified Subjects: Photography and Anthropology, the Technology of Power," *Ten. 8* 14 (1984): 30–7; Elizabeth Edwards, ed., *Anthropology and Photography, 1860–1920* (New Haven: Yale University Press, 1992), and the special issue on "Ethnographic Photography," ed., Patricia Johnston, *exposure* 28 (Winter 1991–92). The Peabody Museum at Harvard has dozens of detailed studies of material culture in its "Sandwich Islands" collection, a type of image typically included in photographic collections from other geographical regions as well.

30 It may be that some photographic subjects asserted their own authority in the creation of their images. In this photograph, two men hold up their paddles for the photographer, even though it is not clear there is a boat or water nearby. Paddles, in many sea-going cultures, have symbolic value; thus their prominence in the image may imply desire for a measure of control over the representation of their cultural identity in the photograph. Five figures look directly at the photographer, one looks away.

 For a case study of native self-construction and collaboration with the Euro-American photographer, see Victoria Wyatt, "Interpreting the Balance of Power: A Case Study of Photographer and Subject in Images of Native Americans," *exposure* 28 (Winter 1991–92): 21–31.

31 A. M. Tozzer, "The Anthropology of the Hawaiian Race," *Proceedings of the Pan-Pacific Scientific Conference* (Honolulu, 1920), Part I: 70–4; and Leslie C. Dunn, "Anthropometric Study of Hawaiians of Pure and Mixed Blood, based upon data collected by Alfred M. Tozzer," *Papers of the Peabody Museum of American Archaeology and Ethnology, Harvard University* 11 (1928): 89–211.

drawings, the two forms were essentially equated as having scientific worth, but both were primarily subjective, rather than positivistic, documents.

The correspondence between Luschan and the artist Hermann Struck about the drawings further demonstrates the blurred boundary between the subjective and the empirical in Luschan's mind. The evidence suggests that Struck altered the drawings to match Luschan's preconceptions about race. In a response to Luschan, Struck wrote:

> Your remarks in relation to the Negro-Type were thoroughly correct, and I immediately did his hair. He now has received the very pretty, frizzy Negro hair, and I believe that he will please you. In addition, on the Russian that you already eliminated some time ago, I have enlarged the skull and ear. I will present these new prints to you after your return, and then bow very happily to your dictum.[37]

This passage makes it clear that Struck often took orders from Luschan on how to draw features such as the hair of the "Negro-type" and that Luschan also rejected certain drawings, such as that of the Russian, which he felt were somehow inappropriate or inaccurate. Luschan implied that these drawings had scientific value as objective documents, and yet he had them altered to suit his own mental images of racial characteristics.

The assumption of equivalence between Struck's drawings and the photographs of POWs persisted into the postwar period. After the war, Egon von Eickstedt planned an anthropological work based on the POW studies and asked Luschan for permission to use Struck's drawings in his study. Eickstedt decided to write on the racial characteristics of the Sikhs, a group that Struck had sketched while visiting the camps. Eickstedt's correspondence suggests that he viewed Struck's drawings, like his own photographs, as objective documents useful for purposes of comparison. In a letter to Luschan, he described how he had judged the quality of his photographs of Sikh "racial types" by comparing them to Struck's charcoal sketches. He wrote, "I photographed about 15 Sikhs. I presume that I captured the average type, and it appears to deviate only slightly from Struck's drawings . . . Could a few of his beautiful heads appear in my work?"[38] Here the drawings and the photographs are easily comparable forms, used to judge the accuracy of a type. The notion that the drawings and the photographs confirmed one another persisted in Eickstedt's publication on the POW studies. When Eickstedt's article was published in 1921, Struck's drawings appeared alongside photographs to illustrate the various racial elements present in the Sikh population.[39] The drawings, like the photographs, were labeled with captions identifying the four kinds of racial types that Eickstedt identified among the Sikhs. Both kinds of images were included as scientific documents, as hard evidence of anthropological fact, but it was their subjective qualities that united them. Like the anthropological drawings of the POWs, the photographs were created on the basis of subjective judgments of what was "typical" for various peoples and racial "types." In the case of the POW images – both the photographs and drawings – the artistic and the scientific collided and merged.

Anthropological photography and German power

Despite claims of objectivity from the anthropologists, the POW photographs also functioned as a means of conveying a sense of German power. While the photographs

of POWs may have been threatening to Germans unused to seeing supposedly "savage" colonial soldiers on German soil, the images were also potentially reassuring because they depicted the enemy soldier not only in the controlled environment of the camps, but also in the disciplining format of the "type" photograph. By the early twentieth century, photography had long been an instrument of repressive power and social control. Allan Sekula has argued that by defining the typology of criminal deviance in the nineteenth century, the criminal "mugshot" pioneered by Alphonse Bertillon operated according to a repressive logic.[40] The photograph functioned as an instrument designed not only to identify and apprehend criminals, but also as a tool to define what criminality looked like in general. In criminal photography, the image was the first step in the identification of the criminal as outsider by the state, and the camera functioned as a tool of state power.[41]

There were several similar levels of control and power at work in the POW photographs. First, on a physical level, the anthropological format of profile and frontal views forced the body of the prisoner into a prearranged position, thus taking away agency from the subject. In fact, anthropologists borrowed the methods of criminal photographers and applied them to the POW projects. Pöch followed Bertillon's instructions for photographing individuals and even employed a "Bertillon chair" that forced the photographic subject to hold his back straight.[42] His photographic equipment was also directly connected to criminal photography. He began his studies using a "Bertillon camera," which he later replaced with a "police-anthropological camera" designed for travel.[43] Moreover, the status of the subjects as prisoners regularly appeared in the photographs. In the photograph of a Siberian Jew taken by Egon von Eickstedt's assistant, for example, the subject wears a prisoner's number on his chest (figure 11.5). This photograph depicted a captured enemy who was nonetheless under control, objectified by the format and clearly detained in a prison camp. For the viewer, images such as these confirmed that this particular soldier was in custody and no longer a threat.

Photographs from the camps that included anthropologists also emphasized the power of the scientist over the subject. In a photograph of Egon von Eickstedt at work measuring a Nepalese man, the anthropologist is depicted in the white coat of scientific authority, subjecting the naked body of the prisoner to investigation (figure 11.6). The unclothed colonial subject, his body open to examination by the probing fingers of the anthropologist, is subjugated and objectified. The nakedness of the prisoner underscores not only his vulnerability and powerlessness, but also emphasizes the position of the scientist as the person in control. A photograph of the ethnologist and anthropologist Paul Hambruch with a group of men from Madagascar depicts a similar power relationship (figure 11.7). Hambruch stands wearing a fedora at the center of the crowd, holding a piece of paper, clearly in charge. The caption reads, "Paul Hambruch and Malagasy of the three main types."[44] The caption not only reminds the viewer that three "types" are present in this crowd, but it also identifies Hambruch as the only individual among them. This photograph was published in 1925, during a period in which a weakened Germany often sought reminders of its previous power. In the context of the postwar era, in which Germany was struggling economically and black French colonial troops occupied the Rhineland, this photograph may have served as a reminder of Germany's earlier power and a confirmation of the "correct" relationship between the races before the arrival of black troops as occupiers. In short,

the photographs of POWs, both in and out of the standard anthropological "type" format, underscored the authority of the anthropologists and, by extension, the power of Germans over their enemies.

Power also had a concrete side that influenced the process of forcing POWs to sit for the camera. The anthropologists had to secure control over their subjects in order to photograph and measure them. The POW population was ideal for conducting

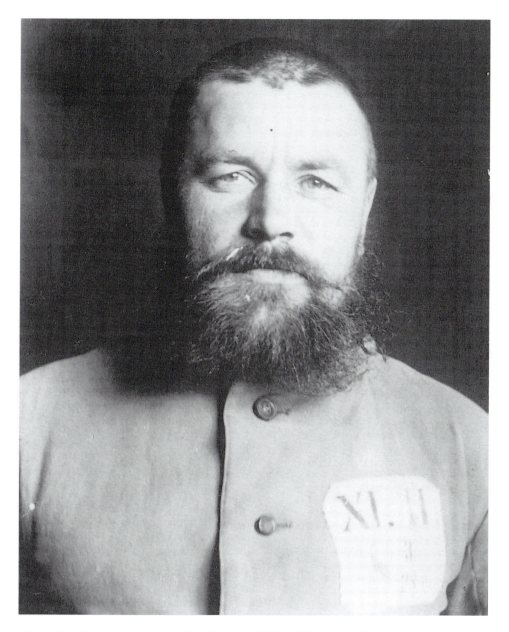

Figure 11.5 Unknown photographer, Egon von Eickstedt's project, 1916.

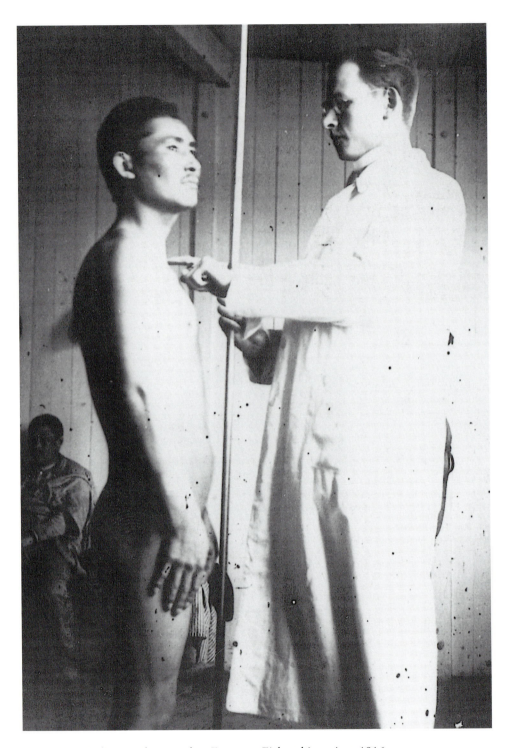

Figure 11.6 Unknown photographer, Egon von Eickstedt's project, 1916.

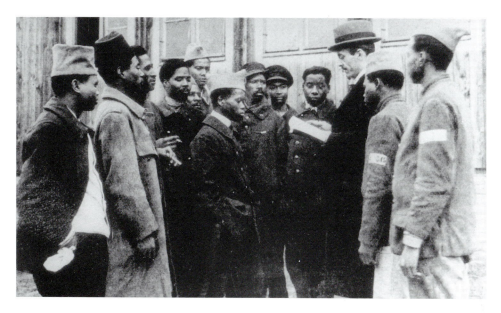

Figure 11.7 Unknown photographer, Wilhelm Doegen's project, *Paul Hambruch and Malagasy of the Three Main Types*, c. 1915–16.

anthropological investigations, because as prisoners the subjects had little room to refuse. Some anthropologists, such as Rudolf Pöch, claimed that the participants in the studies were volunteers who willingly took part to relieve the boredom of camp life.[45] While this may have been true in some cases, the writings and correspondence of anthropologists suggest a more complicated picture. Rudolf Martin, a leading figure in German anthropology and soon-to-be professor at the University in Munich, pointed out in 1915 that the circumstances for scientific work in the camps were good because the prisoners lived under the authority of the military. He wrote, "Also the . . . conditions under which anthropological investigations can be conducted in the camps are relatively favorable. The people are not busy (or only partly), and because they stand under military guard, are more accessible for bodily measurements than they would be in their homeland."[46] Convincing subjects to strip naked and undergo bodily measurements was no easy task, and the increased accessibility to the bodies of the POWs that the anthropologists enjoyed was directly related to the power that the military maintained over the camp population.

The struggle for dominance and the dynamic of power were also evident in the subtle resistance of many prisoners to anthropological investigation and photography. Some anthropologists complained in their correspondence that certain prisoners would not co-operate. Egon von Eickstedt reported that, "I have begun to measure the Russian Jews. Most of these find little pleasure in anthropology and seek . . . to get out of my nice [*nett*] measurements in every way possible."[47] Eickstedt's "nice measurements" were clearly disagreeable to these POWs, who were not volunteers and sought to avoid participation. In order to photograph and measure the prisoners, the anthropologists needed access to the bodies of their subjects, and the interactions in the

camps suggest that the scientists used a mixture of coercion and persuasion to achieve it. Eickstedt often tried to become friendly with his subjects, even though his attempts remained strained and false.[48] When referring to the prisoners with whom he remained on good terms, Eickstedt used the term "befriended" in quotation marks, indicating his view of the relationship's obvious inauthenticity and pure instrumentality. The prisoners responded in kind by resisting the measurements and photography.

A group portrait of Algerian troops taken by Eickstedt's assistant in a Darmstadt camp illustrates the dynamic of control and resistance in the camps (figure 11.8). Despite its unusual framing as a group portrait, Eickstedt wanted to use the photograph as an anthropological document. The subjects, however, resisted his attempts to discipline them in small but significant ways. In a letter to Luschan, Eickstedt wrote:

> Of the sitting ones, the three to the left are [Berbers], and I assume this also of the man creeping in from the left. I had bad luck with the body photographs – the people wouldn't stand still! It was also very shortsighted of me not to have told the people in the group portrait that they should put my cigarettes in their mouths only after the picture.[49]

The cigarettes with which Eickstedt bribed the POWs to sit for the photograph were part of his attempt to "befriend" his subjects, but the soldiers put the cigarettes in their

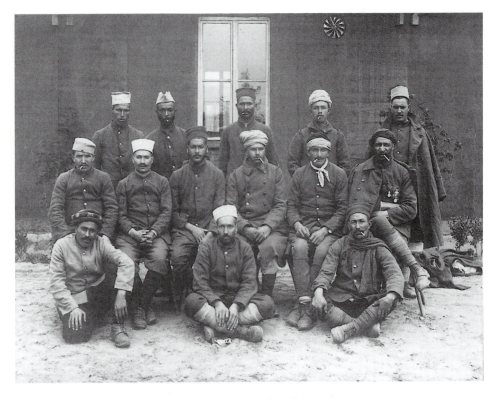

Figure 11.8 Unknown photographer, Egon von Eickstedt's project, 1916.

mouths too early and nearly blocked his attempts to analyze the faces. Moreover, the Algerians in the photograph refused to "stand still," thereby disobeying Eickstedt's instructions. With tiny acts of disobedience such as these, the subjects resisted Eickstedt's attempts to discipline and photograph them.

Other POWs tried to avoid participation altogether. Eickstedt wrote that he "got along famously" with another group of Algerians, but that, despite this apparent congeniality, the prisoners purposely gave him false information about their ethnic backgrounds and home regions. "Now it has gotten around [the camp] what [the studies are] about, [and] many try to shirk through inexact or obviously false information."[50] The reference to "shirking" here and elsewhere indicates that the prisoners were indeed required to take part. And, despite attempts to resist, most prisoners had no final choice but to participate, allowing anthropologists access to their bodies and faces. The process of measuring and photographing the POWs suggests that German anthropologists enjoyed a high degree of control over the POWs, which contributed to the messages of power that emanated from the images.

The photographs also demonstrated German power in the larger realm of knowledge. The photographs confirmed that it was German and Austrian scientists who had the authority to recognize, define, and label racial groups from all over the world. Just as the state had the authority to define the criminal type in Bertillon's criminological photography, here the peoples of the Central Powers (both the anthropologists and the viewers of the photographs) possessed the power to define the racial makeup of the enemy. In addition, the POW studies were often described at the time as evidence of energetic mood of German science during wartime and proof of the strength of Germany and Austria-Hungary. In an article on the POW studies for a popular science journal in 1916, Pöch emphasized the larger meaning of the POW studies, as he saw it:

> It is to be hoped that these different scientific investigations will not only be a worthwhile enrichment of our knowledge, but also will lay down evidence of the unconquerable strength of the Central Powers. While the homeland is threatened on all sides by enemies, and battles rage on all fronts, science is in a position to perceive the unique opportunity offered by the war and complete its work during the [conflict], just as during peace![51]

In this passage, Pöch portrays the POW project not simply as a scientific undertaking, but rather as a patriotic enterprise that proved both the power of the Central Powers and the indefatigable spirit of the German-speaking scientific community. The refusal of German and Austrian scientists to discontinue research, even during wartime, was a source of pride. Pöch saw the POW studies as a scientific endeavor that had international meaning, a project that attested to the might of Germany and Austria-Hungary.

Nearly all the elements of the POW photographs – the format, the setting, the process, and the overall enterprise – reinforced a notion of German power. In the context of total war, an unfailing belief in the strength of the Central Powers was crucial to morale and victory. The POW studies and the photographs that emerged from them not only transmitted an image of Germans and their allies as confident and powerful, but also represented the enemies of the Central Powers as disciplined and under control.

Racializing the enemy

On still another level, the images of POWs from the camps functioned as racial portraits of the enemy. In the photographs and the commentary on them, anthropologists implicitly represented the wartime enemy as a racial stranger, not only different from Germans, but also redolent with savagery and menace. Just as the photographers' pre-existing racial categories often crept into the images, so too did the context in which the photographs were taken. In spite of Pöch's strict instructions to eliminate the context, to keep the background blank and the subject naked, the war became a presence in the images and influenced their interpretation. In other words, the status of the subjects as foreign soldiers appeared in the photographs, and the remarks accompanying the images often identified the prisoners as opponents of the Central Powers. The result was a highly racialized view of the enemy, both European and non-European.

It is important to note that the racialized images of the POWs, which signified difference and even threat, were published primarily in the mass media. Although several participants such as Pöch and Eickstedt published scholarly pieces based on the POW project, a large number of popular publications by anthropologists also appeared on the subject. Luschan's *Prisoners of War* [*Kriegsgefangene*] (1917) was a popular work, and articles on the POW studies appeared in a leading popular science journal, *The Review* [*Die Umschau*]. The anthropological and ethnological work of the Doegen team did not appear in print until after the war, but was also intended for a lay audience. Doegen, the editor of the series and head of a national commission for the study of POW rights after the war, set up a committee in 1920 specifically to promote the distribution of the first volume, a popular work that defended German treatment of POWs.[52] The second volume, published in 1925 under the title *Among Foreign Peoples* [*Unter Fremden Völkern*], was a collection of ethnological treatises on the variety of ethnic groups in the POW camps illustrated with anthropological portrait photographs. The writings on the POW studies – and the photographs that accompanied them – were far from limited to the scientific community alone. The public was exposed to racialized images of POWs both during and after the war.

The anthropological photographs from the camps racialized the enemy by allowing the status of the subjects as soldiers to enter the images in fundamental ways. The dress and bearing of the POWs, for example, combined with the racial connotations of the anthropological format to produce racialized images of the national foe. In many of the photographs of colonial POWs, the subjects wore foreign uniforms, which underscored not only the military context in which they were taken but also clearly identified the POWs as enemy soldiers. This was true of a collage of four Nepalese "types" published by Wilhelm Doegen in the mid 1920s (figure 11.9).[53] The headgear of several of the subjects is part of a foreign uniform, and the text which accompanied these pictures identifies the subjects as colonial soldiers by emphasizing their military ability and affirming their affiliation with British forces:

> What makes the [Nepalese] such a valuable soldier for the Englishman is his physical condition. The [Nepalese] are the best material available to the Indian Army. Small, but powerful and muscular, they are superior to the weak and frail Hindus in their ability to endure hardships.[54]

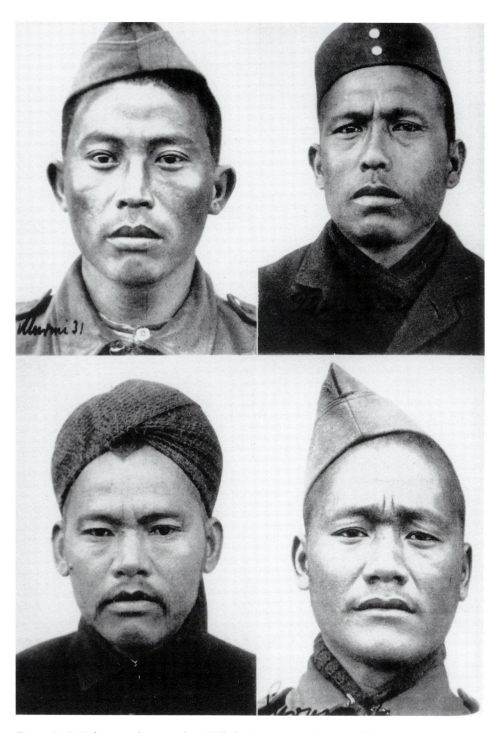

Figure 11.9 Unknown photographer, Wilhelm Doegen's project, *Gurkhas*, c. 1915–16.

The photographs, in combination with the text, designate the subjects as enemies who are strong, powerful, and tough. Images such as these of colonial POWs in uniform depicted the POWs as threatening enemies, as soldiers who not only were fighting against Germany and its allies, but also, because they were pictured in the "type" format, were racially different.

Popular photographs of colonial POWs by those not directly involved in the anthropological studies also influenced the representation of the POWs as a menacing racial enemy. This image paralleled the view in newspapers and popular journals that colonial troops, particularly those from Africa, were wild savages turned loose on civilized Germans.[55] In popular publications, stereotypes about colonial POWs, which were often replete with military threat and racial difference, made up the bulk of the substance. Wartime articles in popular illustrated journals, such as A. Korbitz's "Types from the German Prisoner-of-war Camps," combined galleries of POW photographs in the classic anthropological style of profile and frontal views with textual descriptions of colonial troops. The author of this particular article reported that "wild" Senegalese Africans had been transported to the front "fully naked, wearing only loincloths, and many with rings in their noses."[56] He also described the tactic of Nepalese and Indian troops of "creeping through the German trenches like tigers, with broad, crooked knives between their teeth, cutting off the heads of those they overrun."[57] Most importantly, the author connected these descriptions with the images of the POWs by inviting the viewer to "read" the photographs in the physiognomic vein. The look of a Belgian solider was described as "brutal," while the head of a Nepalese soldier expressed a "massiveness and brutality" typical of the "yellow soldier people."[58] Viewers of these photographs were enmeshed in a context in which colonial soldiers were considered savage and inferior, and physiognomic readings of photographs were normal. The popular audience often believed that race determined character, and in popular articles writers such as Korbitz openly employed physiognomic assumptions that went unstated in the anthropological publications, both popular and scholarly.

Popular propaganda not connected with the POW studies also used references to anthropology and photographs from the camps to circulate negative stereotypes about colonial troops and condemn the Entente powers that employed them. A prime example of this phenomenon was a collection of photographs from the POW camps, *The POWs in Germany* [*Die Kriegsgefangene in Deutschland*], published in 1915. The author of the commentary that accompanied the images was Alexander Backhaus (1865–1927), a professor of agriculture employed by the War Ministry during the war. Both Backhaus's connection to the military administration and the content of the volume, which included a vigorous defense of Germany's treatment of POWs, suggest that this book was pure propaganda, aimed at refuting the charges of "barbarism" leveled against Germany by the Allies. In a section entitled "Types of peoples" [*Völkertypen*], Backhaus hailed the opportunities for anthropological study in the camps and proceeded to analyze several anthropological photographs. Although he had no connection to anthropology and the anthropologists in the camps did not take his photographs, he made references to the discipline in order to lend scientific weight to his discussion of the images. His commentary consistently emphasized the physical (and implicitly racial) differences between Germans and their enemies. Describing a group of Russian prisoners, Backhaus wrote, "A typical

[group] of Russians is visible in next photograph, in part handsome men with intelligent faces, in part vastly inferior to German soldiers physically, with dull facial expressions. The Mongolian type is clearly expressed in an entire series of Russians."[59] Using physiognomic assumptions, the Russian troops are described as slow-witted people of inferior Mongolian stock, a group more associated with Asia than Europe and fundamentally different from Germans. Backhaus also used quasi-anthropological portrait photographs of Africans and POWs to ridicule the Entente powers and further racialize the enemy. Mobilizing all the racial stereotypes and physiognomic assumptions at his disposal, Backhaus described a gallery of African and Middle Eastern POWs as follows:

> The fourteen individual pictures [of African and Middle Eastern POWs] . . . demonstrate . . . the kind of riff-raff that Germany must fight with and what the "Champions of Freedom and Civilization" [the Entente Powers] lead into the field against the "German barbarians." With bitterness and anger we must meet the thought that many hopeful and highly educated German brothers found their ends through the bullets and knives of these hordes . . . if it had been up to [England and France], such journeymen would have raided flourishing German regions and turned back European history one thousand years.[60]

Using the photographs as his central evidence, Backhaus portrayed the colonial troops as dangerous masses who were without civilization or culture and stood in stark contrast to Germans. These statements are all the more significant because Backhaus expected the faces of the POWs to provide concrete proof of savagery and barbarism. In a context in which physiognomic assumptions and racial inferiority were taken for granted by much of the public, he clearly believed that the photographs would speak for themselves.

Unlike more popular writers such as Backhaus and Korbitz, anthropologists cautiously avoided crude stereotypes and the explicit use of physiognomy, but the photographs of POWs that emerged from the anthropological studies still played on prejudices and depicted a racially strange and menacing enemy to the public. Photographs from the anthropological studies of POWs, for example, such as two profile and frontal views of soldiers from Sierra Leone and the Mosi tribe, represented a threatening enemy to viewers (figure 11.10). The filed teeth of the man in the two lower photographs, in combination with the battered uniforms of both subjects, combined to create an impression of threat and racial strangeness. The commentary in the caption highlighted the "otherness" of the POWs by drawing attention to the "artificially filed teeth," "peppercorn hair," and the "tribal marks of the Mosi: three cuts on the cheek and chin" on the face of lower subject.[61] During and after the war, many Germans expected to find savagery, brutality, and menace inscribed in the faces and expressions of colonial soldiers, and in anthropological photographs such as this one the caption guided them where to look for physical "oddities" and evidence of "savagery." The anthropologists in the camps were careful never directly to ascribe these qualities to the faces of the POWs, but their photographs, by drawing attention to physical differences, certainly fit into a physiognomic tradition that did.

245

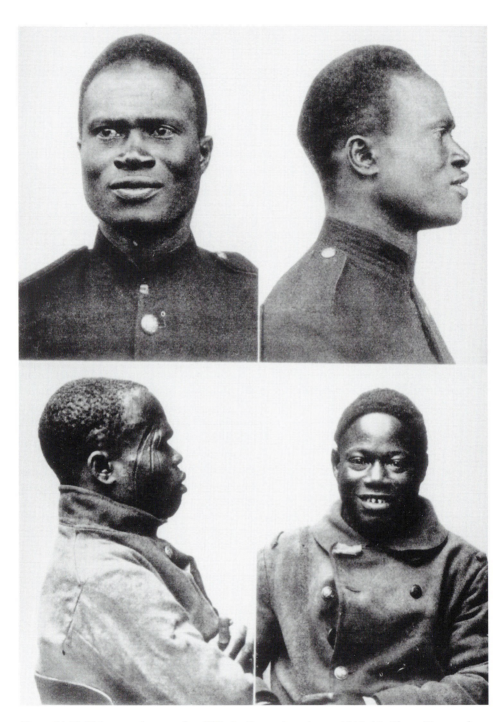

Figure 11.10 Unknown photographer, Wilhelm Doegen's project, c. 1915–16. *Above*: Negroes from Sierra Leone. *Below*: Mosi Negro with the peppercorn hair and tribal marks of the Mosi – three cuts on the cheeks and chin. A Baule Negor with artificially filed teeth.

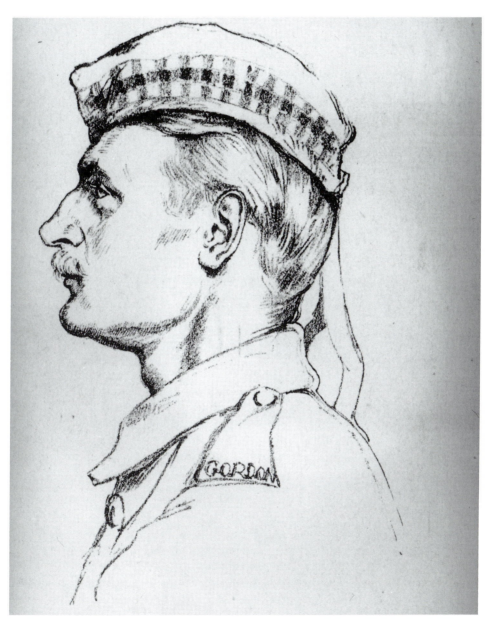

Figure 11.11 Hermann Struck, c. 1915. *I. Anderson, Scot.* Reproduced from *Kriegsgefangene: ein Beitrag zur Völkerkunde im Weltkriege: Einführung in die Grundzüge der Anthropologie* (Berlin: Dietrich Reimer, Ernst Vohsen, 1917).

The colonial soldier was not the only subject photographed and categorized by anthropologists in the camps: Europeans also became a major focus of study. Pöch, Eickstedt, and members of the Doegen group took photographs of European POWs from all regions and populations, including Scots, English, Irish, French, Lithuanians, Russians, and others. In so doing, they placed the European prisoners in the same anthropological format as the non-European colonial subject, and in the process designated European peoples as racially different from the peoples of the Central Powers, and Germans in particular. In a surprising reversal of roles, European POWs from nations such as France occupied the place of racial outsider in these anthropological images, a position usually reserved for colonial peoples. By using a technology – photography – to measure and objectify enemy bodies from a distant and hidden perspective, the anthropologists in the camps placed European POWs in the line of what James R. Ryan has called "colonial vision."[62] In this sense, camp anthropologists treated the European prisoners like "exotic" colonials and implicitly classified them as racially distinct from Germans. The historian Robert Procter has suggested that after 1919 the attention of German anthropologists turned to European subjects, especially Jews, once the German Empire lost its overseas colonies.[63] Judging by the POW studies, this "turn inward" can already be seen during the war years, when German anthropologists turned their attention to European POWs. By pitting Germans in a defining struggle against other Europeans, the war created a context in which the European enemy could be more easily seen as physically, even racially, distinct from Germans.

In the process of defining European POWs as the "Other," the anthropologists implied that a unity of German physical characteristics must also exist. Photographs of the European soldiers racialized the subjects, setting them in a group apart from those viewing the photograph. The publications of the Doegen group, for example, featured type photographs of soldiers from Russia, France, and the Ukraine in the classic anthropological format that invited the viewer to see racial difference.[64] In the images that emerged from the camps, both Western and Eastern Europeans were racialized in this way. Of the one hundred published drawings of POWs by Hermann Struck, there were thirty-five charcoal representations of European POWs. In the anthropological format, Struck drew French, English, Russian, Irish, Flemish, and Scottish soldiers. In a drawing of a Scottish soldier, the shoulder epaulet reading "Gordon" and plaid cap clearly identified the subject as a Scottish member of the Gordon Highlanders, while also placing him in an anthropological profile meant to highlight race (figure 11.11). Equally significant were the images that did *not* appear in the publications drawn from the POW studies. Even though the camp populations included Russian POWs of German descent, such as Volga Germans, anthropologists on Doegen's team neither examined nor photographed them.[65] Germanness was the implicit standard by which the anthropologists judged the "otherness" of the POW population and produced anthropological images of the enemy.

The photographs that emerged from Rudolf Pöch's studies also racialized European enemy, but the process of creating the racial "Other" differed slightly in the multiethnic context of the Austro-Hungarian empire. Pöch's racialized images provided an implicit contrast not just with Germans, but with the peoples of the Dual Monarchy. He was careful, for example, not to publish or display anthropological images of ethnic groups who were represented in the POW population but were also part of the

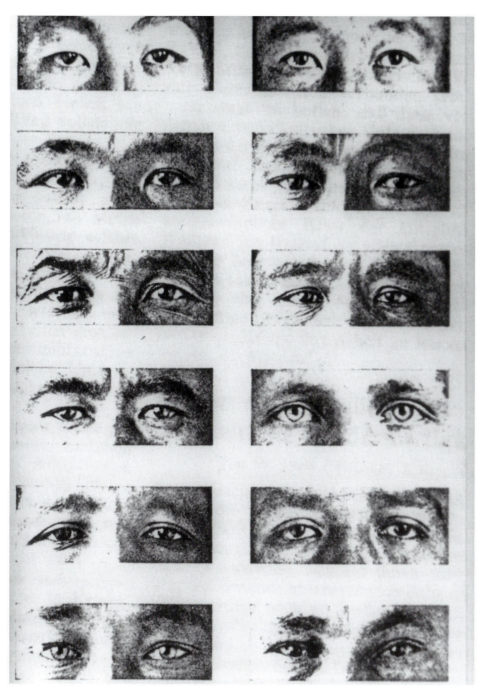

Figure 11.12 Unknown photographer, Rudolf Pöch's project, c. 1915–16. *Different Grades of Expression of Mongolian Character in the Eyelids of the Peoples of European and Asiatic Russia.* Reproduced from "Anthropologische Studien an Kriegsgefangenen," *Die Umschau* 20 (1916): 990.

Habsburg empire, such as Poles. Instead, he concentrated instead on the chief enemies of Austria-Hungary. The photographs from Pöch's studies presented a particularly racialized view of Russians, for example. Images such as Pöch's collection of Russian eyes, published in 1916, not only disembodied and thus dehumanized the subjects, but also pointed to the supposed markers of racial difference (figure 11.12). The words beneath the photographs read, "Different grades of expression of Mongolian character in the eyelids of the peoples of European and Asiatic Russia."[66] The caption implied that many Russians had some degree of Mongolian character in their physical make-up, and furthermore that Russians were a markedly different racial group from the peoples of the Central Powers. Pöch's racial photographs of Austria's European enemies also reached the public through other avenues. At the request of the Austrian War Ministry in 1917, Pöch and the Anthropological Society of Vienna contributed forty-eight life-sized photographs to the POW section of the popular "war exhibit" in Vienna. These enormous images "represented twenty racial types of POWs from the Russian Empire, Italy, and Serbia," the three chief enemies of the Austro-Hungarian Empire.[67] Images of "exotic" peoples from Africa or elsewhere, whom Pöch had also studied in the POW camps, played no role in the display, which focused only on the European enemies of the Central Powers. There were also no photographs of ethnic or national groups who were present in the POW population but also lived in the Austro-Hungarian empire. The exceptions were the Italians and the Serbs, who, as a central enemies of the Dual Monarchy, apparently warranted racialization. The effect of Pöch's photographs at the "war exhibit" was to present a highly racialized view of the enemy for public consumption that stood in contrast to the peoples of the Austro-Hungarian empire. Here was the antagonist, literally life-sized, and the message was that he differed fundamentally from the person viewing the exhibit.

Anthropologists also took photographs of Jews and Gypsies in the POW camps using the anthropological style (figure 11.13). These photographs, eerily indicative of later efforts at racial definition under National Socialism, defined both Jews and Gypsies as members of a separate race, as people who were physically different from Germans. The chapter on Jews in Doegen's volume, from which these images are taken, is the only section in the entire collection to include captions beneath the photographs that identify the profession of each subject. Following clockwise from the top left, the subjects are identified as "teacher and prayer leader," "lawyer," "teacher," and "merchant." Captions for other groups in the collection, such as the Russians or Nepalese, did not include mention of occupation. These vocational designations not only highlighted the religious difference of the Jews ("prayer leader") but emphasized the presence of Jews in intellectual and professional life (the two "teachers," the bespectacled "lawyer") and commerce ("merchant"). In this way, the captions reinforced stereotypes about Jews and Jewish vocations while the photographs simultaneously marked the Jews as physically and racially different.

Conclusions

Definitions of race and racial categories among the anthropologists in the POW camps and the popular audience often diverged considerably. Even after the war, for example, Eickstedt claimed that there was no such thing as an Aryan or German race, only

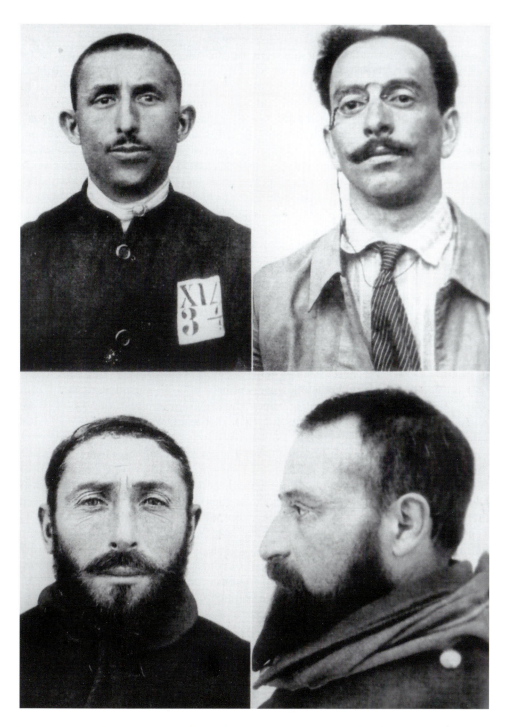

Figure 11.13 Unknown photographer, Wilhelm Doegen's project, *Jewish Ethnic Types*, c. 1915–16. *Above left*: teacher and prayer-leader from Volhynia. *Above right*: lawyer from Moscow, leader of the Jewish theater in the Carsel prisoner-of-war camp, Niederzwehren. *Below left*: trader from Podolia. *Below right*: teacher from Lithuania.

characteristic groupings of physical differences determined by genetics.[68] Felix von Luschan expressed similar views, claiming that the categories of race and nation had little to do with each other.[69] And yet despite these assertions, the photographs from the anthropological studies of POWs during World War I demonstrate a blurring of the boundaries between race and nation in the context of war. The format and the context of the photographs placed the POWs – and by extension entire populations – into racial categories that were understood to be other than the peoples of the Central Powers, and Germans in particular. The process was slightly different in the case of the Austrian anthropologist Rudolf Pöch, but he too created racial contrasts between the peoples of the Dual Monarchy and their national enemies in the Great War. As Sander Gilman has pointed out in his work on the Jewish body, the physical make-up of Jews was always understood in contrast to an idealized "Christian" body, and later in comparison to an idealized and secularized "German," "English," or other national corpus.[70] A similar process took place in the POW studies, as anthropologists sought to categorize their subjects by physical characteristics, but always implicitly in contrast to themselves. By defining their enemies racially, anthropologists necessarily defined a racial identity of their own. Clearly, Jews were not part of that identity, and the Russians and the French were different as well. In a great number of the characterizations from the camps, some notion of "Germanness" lurked at the center of that category. The POW photographs were representative of a larger process at work within German society in the late nineteenth and early twentieth centuries: the infusion of "Germanness" with racial meaning.

In the end, the anthropological portraits of prisoners-of-war taken during World War I reveal more about the people behind the camera than about the people in the photographs. The anthropologists at work in the POW camps considered the camera a technology that reflected reality accurately. They believed that the photograph functioned as an objective recorder and indicator of racial types, categories that lay at the heart of their discipline and their science. A close examination of the POW studies, however, demonstrates that the creation of racial typologies was anything but an objective enterprise. Pöch, Eickstedt, Luschan, Hambruch, and members of the Doegen project often fashioned racial groupings and types by depending on their "anthropological eye" and subjective evaluations. German anthropologists allowed the background of the war to influence images that were supposed to be free of context and without outside accompaniment. In the process, they helped create and disseminate a vision of the enemy based on race. The inverse of that image, however, proved even more potent. The POW photographs served the Central Powers in their attempt to represent themselves as powerful allies united against a common, racialized enemy. Moreover, the images aided the efforts of many Germans to define themselves as a racially unified people in their drive to establish themselves as a dominant military and political power. In 1916 and 1917, strength and unity were considered imperative to a German victory in the Great War. Fewer than twenty years later, the pursuit of these same two characteristics would come to define a later period of German history, when the search for power and racial cohesion ushered in another, more destructive world conflict and, most tragically, the Holocaust.

Notes

I would like to thank Eleanor Hight, Gary Sampson, Lydia Murdoch, Tim Pursell, Tim Schmitz, James Diehl, William Cohen, and Jeff Wilson for their generous help with earlier drafts of this chapter. Abbreviations:

GStA PK	Geheime Staatsarchiv Preussischer Kulturbesitz, Berlin
NL Luschan	Nachlass Felix Luschans, Handschriftenabteilung, Staatsbibliothek zu Berlin – Preussischer Kulturbesitz
StA Hbg	Staatsarchiv Hamburg
AA	*Archiv für Anthropologie*
MAGW	*Mitteilungen der Anthropologischen Gesellschaft Wien*
ZfE	*Zeitschrift für Ethnologie*

1 Rudolf Pöch, "I. Bericht über die von der Wiener Anthropologischen Gesellschaft in d. k. u. k. Kriegsgefangenlagern veranlassten Studien," *MAGW* 45 (1915): 221.

2 Wilhelm Doegen, "Einleitung," in *Unter Fremden Völkern: eine neue Völkerkunde* (Berlin: Otto Stohlberg, Verlag für Politik und Wirtschaft, 1925), 9. See also Minister der geistlichen und Unterrichts-Angelegenheiten, Berlin, to Meinhof, October 27, 1915. StA Hbg, 361–5 II Hochschulwesen II, W a 8 (Wissenschaftliche Untersuchungen der Kriegsgefangenen), 5.

3 Meinhof to von Melle, Bürgermeister, October 9, 1915, StA Hbg, 361–5 II Hochschulwesen II, W a 8 (Wissenschaftliche Untersuchungen der Kriegsgefangenen), 1.

4 Kriegsministerium to Luschan, December 28, 1915, NL Luschan, File Preussen, Kriegsministerium. See also, Luschan to Magistrat Erfurt, February 27, 1916, NL Luschan, File Eickstedt.

5 Throughout this chapter, I refer to "race" not as concept with a basis in biological reality, but as a social and ideological construct shaped by the historical circumstances in which it is used. The term has such a wide variety of problematic biological, political, and ideological meanings that the historian must place "race" within quotation marks in order to show an understanding of its precarious ambiguities. In this chapter, quotation marks should be considered implied whenever the term is used. On the dangers of reifying the concept of race see Douglas A. Lorimer, "Race, Science, and Culture: Historical Continuities and Discontinuities, 1850–1914," in *The Victorians and Race*, ed. Shearer West (Aldershot: Scolar Press, 1996), 12–33.

6 A number of members of the Doegen team, such as Paul Hambruch, were physical anthropologists as well as ethnologists. See Doegen, "Einleitung."

7 Pöch to Luschan, August 29, 1915, NL Luschan, File Pöch. Pöch to Luschan, September 13, 1915, NL Luschan, File Pöch.

8 Unlike in the Anglo-American tradition, the term anthropology (*Anthropologie*) in the German context referred primarily to physical anthropology. The German terms *Ethnologie* or *Völkerkunde* referred to what in the Anglo-American realm was generally known as cultural anthropology or ethnology. See George W. Stocking, Jr, "Paradigmatic Traditions in the History of Anthropology" in *Ethnographer's Magic and Other Essays in the History of Anthropology* (Madison: University of Wisconsin Press, 1992). For an excellent treatment of German physical anthropology see Benoit Massin, "From Virchow to Fischer: Physical Anthropology and Modern Race Theories in Wilhelmine Germany," in *Volksgeist as Method and Ethic: Essays on Boasian Ethnography and the German Anthropological Tradition*, ed. George W. Stocking, Jr (Madison: Univ. of Wisconsin Press, 1996). For a general history of European anthropology see Wilhelm E. Mühlmann, *Geschichte der Anthropologie* (Frankfurt am Main: Athenäum, 1968).

9 George W. Stocking, Jr, *Race, Culture, and Evolution: Essays in the History of Anthropology* (Chicago: University of Chicago Press, 1982), 57–8, 168–9.

10 Rudolf Martin, "Anthropologische Untersuchungen an Kriegsgefangene," *Die Umschau* 19 (1915): 1017. See also Rudolf Pöch, "Anthropologische Studien an Kriegsgefangenen," *Die Umschau* 20 (1916): 989–90.

11 For an ethnographic analysis of photography and life in Brandenburg POW camps during the war see Margot Kahleyss, *Muslime in Brandenburg: Kriegsgefangene im Ersten*

Weltkrieg: Ansichten und Absichten (Berlin: Museum für Völkerkunde, 1998). See also Margot Kahleyss, "Muslime als Gefangene," *Rundbrief Fotographie* 7 (1995): 43–5.

12 Melissa Banta and Curtis M. Hinsley, *From Site to Sight: Anthropology, Photography, and the Power of Imagery* (Cambridge, MA: Peabody Museum Press, 1986), 57–71.

13 Elizabeth Edwards, "'Photographic Types': The Pursuit of Method," *Visual Anthropology* 3 (1990): 235–7.

14 Frank Spencer, "Some Notes on the Attempt to Apply Photography to Anthropometry during the Second Half of the Nineteenth Century," in *Anthropology and Photography, 1860–1920*, ed. Elizabeth Edwards (New Haven: Yale University Press, 1992), 99–106.

15 Andrew Zimmerman, "Anthropology and the Place of Knowledge in Imperial Berlin" (Ph.D. Dissertation, University of California, San Diego, 1998): 194–214.

16 Ibid: 202–12.

17 Theodor Mollison, "Die Verwendung der Photographie für die Messung der Körperproportionen des Menschen," *AA* 37 (1910): 305–21. See also Rudolf Martin, *Lehrbuch der Anthropologie in systematischer Darstellung* (Jena: Gustav Fischer, 1914), 34–43. There were also critics within the anthropological community who emphasized the limitations and distortions of photography, but even these men allowed that the camera had scientific uses. See, for example, Otto Schlaginhaufen, "Die Stellung der Photographie in der anthropologischen Methodik und die Pygmäenfrage in Neuguinea," *ZfE* 47 (1915): 53–8.

18 Rudolf Pöch, "IV. Bericht über die von der Wiener Anthropologischen Gesellschaft in d. k. u. k. Kriegsgefangenlagern veranlassten Studien," *MAGW* 48 (1918): 156.

19 Ibid: 151.

20 See Rudolf Pöch, "IV. Bericht," 150–7. Other uses of photography during the war also encouraged the notion that photography represented reality accurately. Aerial photography, for example, was understood to be an exact reflection of the tactical situation on the battlefield. See Allan Sekula, "The Instrumental Image: Streichen at War," in *Photography Against the Grain: Essays and Photo Works, 1973–1983* (Halifax: Press of the Nova Scotia College of Art and Design, 1984).

21 Edwards, "Photographic Types": 235.

22 Roslyn Poignant, "Surveying the Field View: The Making of the RAI Photographic Collection," in *Anthropology and Photography, 1860–1920*, ed. Elizabeth Edwards (New Haven, Yale University Press, 1992), 42–73.

23 George Mosse, *Toward the Final Solution: A History of European Racism* (Madison: University of Wisconsin Press, 1978), 17–35.

24 Rudolf Pöch, "IV. Bericht," 155. See the images of Russian POWs (Tafel I and II) in Rudolf Pöch, "III. Bericht über die von der Wiener Anthropologischen Gesellschaft in d. k. u. k. Kriegsgefangenlagern veranlassten Studien," *MAGW* 47 (1917): Tafel I and II.

25 Rudolf Pöch, "I. Bericht," 225–6. Also see Pöch, "IV. Bericht," 157.

26 Edwards, "Photographic Types": 241.

27 Doegen, ed. *Unter Fremden Völkern*, plate opposite p. 128.

28 Eickstedt to Luschan, May 4, 1916, NL Luschan, File Eickstedt.

29 Egon von Eickstedt, "Die Rasse beim Menschen," *Die Umschau* 26 (1922): 6.

30 Rudolf Pöch, "III. Bericht": 79.

31 Pöch gave instructions to this effect in his "I. Bericht": 226. Of the group selected for measurement, usually only half would be again selected to be photographed. These subjects were either considered typical or an interesting deviation from the norm. Eickstedt sent to Luschan only photos that he considered "typical" in some way.

32 The translation of the German term "wissenschaftlich" is problematic because *Wissenschaft* refers to any organized body of knowledge, not just to the natural sciences. The term is usually rendered into English as "scientific," but it can also mean "academic" or "scholarly." In the context of Luschan's chapter and his other comments, however, there is little doubt that the best translation of the term in this case is indeed "scientific." Felix von Luschan, *Kriegsgefangene: ein Beitrag zur Völkerkunde im Weltkriege: Einführung in die Grundzüge der Anthropologie* (Berlin: Dietrich Reimer, Ernst Vohsen, 1917), 2.

33 Zimmerman, "Anthropology": 194–212.

34 Luschan, *Kriegsgefangene*, 2.

35 Eickstedt to Luschan, May 4, 1916, NL Luschan, File Eickstedt.

36 Luschan, *Kriegsgefangene*, plates 55/56.

37 Struck to Luschan, March 14, 1916, NL Luschan, File H. Struck.

38 Eickstedt to Luschan, March 3, 1919, NL Luschan, File Eickstedt.

39 Egon von Eickstedt, "Rassenelemente der Sikh," *ZfE* 52 (1920/21): 317–94.

40 Allan Sekula, "The Body and the Archive," *October* 39 (Winter 1986): 3–64. For more on photography and power see John Tagg, *The Burden of Representation: Essays on Photographies and Histories* (Amherst: University of Massachusetts Press, 1988).

41 Jennifer Green-Lewis, *Framing the Victorians: Photography and the Culture of Realism* (Ithaca: Cornell University Press, 1996), 200–1.

42 Pöch, "IV. Bericht": 156.

43 Ibid.: 150.

44 Doegen, *Unter Fremden Völkern*, plate opposite p. 65.

45 Pöch, "Anthropologische Studien an Kriegsgefangenen": 990.

46 Martin, "Anthropologische Untersuchungen an Kriegsgefangene": 1017.

47 Eickstedt to Luschan, January 11/12, 1916, NL Luschan, File Eickstedt.

48 Eickstedt to Luschan, March 1, 1916, NL Luschan, File Eickstedt.

49 Eickstedt to Luschan, May 20, 1916, NL Luschan, File Eickstedt.

50 Eickstedt to Luschan, March 18, 1916, NL Luschan, File Eickstedt.

51 Pöch, "Anthropologische Studien an Kriegsgefangenen": 991.

52 Doegen, Rechstudienkommissar für Kriegsgefangenenwesen und Direktor des Lautabteilung an der Preussischen Staatsbibliothek, to Ministerium für Kunst, Wiss., und Volksbildung. December 22, 1920. GStA PK. I HA, Rep 76 Vc Sekt. 1, Tit. XI, Teil VII. Nr 41, Bd 2, p. 178.

53 Doegen, *Unter Fremden Völkern*, plate opposite p. 81.

54 Heinrich Lüders, "Die Gurkhas," in *Unter Fremden Völkern*: 127.

55 The *Norddeutsche Allgemeine Zeitung* reported that Africans at the front had been seen wearing necklaces made of ears from German soldiers. The *Berlin Lokal Anzeiger* reported that African troops were "human slaughterers" who followed behind the advancing French lines to murder the wounded. Africans were often portrayed as cannibals, while Asian troops were considered a "yellow danger" and threat to European civilization. See "Die Farbigen und ihre Greuel," *Norddeutsche Allgemeine Zeitung*, November 8, 1918, Abend; "Neger als Menschenschlächter," *Berlin Lokal Anzeiger*, March 9, 1917; Govenneur von Puttkammer, "Der Krieg und die Rassenfrage," *Der Tag*, September 20, 1914; Georg Irmer, "Englands Verrat an der weissen Rasse," *Kreuz-Zeitung*, October 10, 1914. See also Dr Wygodzinski, "Weiss, Gelb, Schwarz," *Der Tag*, September 5, 1914.

56 A. H. Korbitz, "Typen aus den deutschen Kriegsgefangenlagern," *Zur Guten Stunde* 2 (1916): 600.

57 Ibid.: 600.

58 Ibid.: 600.

59 A. Alexander Backhaus, *Die Kriegsgefangenen in Deutschland: Gegen 250 Wirklichkeitsaufnahmen aus deutschen Gefangenenlagern*, ed. Walter Stein (Siegen, Leipzig, Berlin: H. Montanus, 1915), 22.

60 Ibid.: 23.

61 Doegen, *Unter Fremden Völkern*, plate accompanying pp. 40–64.

62 James R. Ryan, *Picturing Empire: Photography and the Visualization of the British Empire* (London: Reaktion Books, 1997), 147–55.

63 Robert Proctor, "From Anthropologie to Rassekunde in the German Anthropological Tradition," in *Bones, Bodies, Behavior: Essays on Biological Anthropology*, ed. George W. Stocking (Madison: University of Wisconsin Press, 1997), 152.

64 Doegen, *Unter Fremden Völkern*. See, for example, the plates opposite p. 273.

65 Doegen's ethnological team collected songs and tales from Russian soldiers of German descent in German POW camps, but no photographs or anthropological data appear in the writing devoted to them. Adolf Lane. "Deutsche Bauernkolonien im alten Russland," *Unter Fremden Völkern*, 274.

66 Pöch, "Anthropologische Studien an Kriegsgefangenen": 990.

67 "Sitzungsberichte der Anthropologischen Gesellschaft in Wien: Jahrgang 1916/17," *MAGW* 47 (1917): 57.

68 Eickstedt, "Die Rasse beim Menschen": 8.

69 Felix von Luschan, "Rassen und Völker," in *Deutsche Reden in schwerer Zeit: Gehalten von den Professoren an der Universität Berlin*, vol. 3 (Berlin: Ulrich von Wilamowitz-Moellendorff, 1915), 350–1. See also Felix von Luschan, *Völker, Rassen, Sprachen* (Berlin: Welt Verlag, 1922).

70 Sander Gilman, *Jew's Body* (New York: Routledge, 1991), 38.

GERMAINE KRULL AND
L'AMITIÉ NOIRE

World War II and French colonialist film

Kim Sichel

In her book *Shooting War*, Susan Moeller offers a useful definition of war photography, one that can be extended to war films as well:

> Images of war are defined by the moral position of the individual photographer, the institutional structure of the media, the official censorship of the military, the propaganda needs of the government, and the technological advances of both the photographer's equipment and the armed forces' weaponry.[1]

Moeller's multileveled view of how war photographs are made and, more importantly, used, contributes to an understanding of how one seventeen-minute French film, *L'Amitié noire* (1943), held a complicated role within the Free French war effort in World War II. Her model also illuminates how the film was subsequently reappropriated in the interests of peacetime French unification and colonialist policy. As Moeller points out, photographs and films such as these reflect multiple needs. In the case of *L'Amitié noire*, these include the roles of an idiosyncratic photographer (Germaine Krull, 1897–1985) and filmmaker (François Villiers), the needs of the wartime press, the Allied military mandate, the shifts in government alliances and structure both during and after the war, and the importance of technology (in this case, the lack of it). Furthermore, the film illustrates the multiple colonialist roles that the media played in the European construction of French colonial Africans in the early and mid-1940s. Even its title, *L'Amitié noire*, can be variously translated to signify black friendship, black alliance, or black sexual love. All three concepts were used and distorted in the film's creation and distribution.

L'Amitié noire was a collaborative project involving the Free French documentary filmmaker François Villiers (director), the prominent modernist interwar photographer Germaine Krull (prominently listed in the credits as "collaborator") (figure 12.1), and poet, playwright, and Surrealist Jean Cocteau (screenplay) (figure 12.2). Cocteau's World War II involvement was ambiguous; he remained in Paris, but the Nazis censored his play *Les Enfants terribles*. Krull, who was known throughout Europe before the war for her photographs of abstracted industry and urban life, joined up with De

Gaulle's forces at the outbreak of World War II, and from 1942 to 1944 was the head of the Free French photographic service in Brazzaville. Villiers made war documentaries, and after the war continued with feature films in France. The three figures had similar but slightly different aims. Krull provided the background and research, as well as many still images that inspired the film's subjects. She both honored the native cultures and industries and hewed to standard French colonialist views for the early 1940s. Villiers expanded the still images into energized and lyrical moving views for use as war propaganda films. Cocteau romanticized and Europeanized the entire effect with full-blown literary allusions linking the African culture to European customs and myths.

The film opens with footage of the new radio station of Charles de Gaulle's resistance government, based in Brazzaville, French Equatorial Africa. It then ranges across a selection of African tribes people and customs, and ends with a shot of mounted riders charging the screen, accompanied by the cryptic phrase "Saluons-les!" (Let us salute them!), uttered in sonorous accents by Cocteau, the film's narrator.

L'Amitié noire was filmed in Africa in 1943 but released only in 1946 after the war's end. The film was shot as propaganda for Charles de Gaulle and the Free French in Africa, but it also embodies a complex view of the relations between France and its African colonies, both during and after the war. A short film full of beautiful imagery, it has received critical attention until now only as a lyrical ethnographic film, and neither its powerful propaganda and colonialist messages nor the relationship between Krull's still photographs and the completed film have ever been explored.[2] This chapter will attempt to unlock the propaganda and colonialist imagery, and to explore the relations between photographer and filmmaker.

Germaine Krull's role in the film and her collaboration with her colleagues encapsulate many of the aims and myths of the French efforts in World War II. Krull was one of the best-known artistic and journalistic photographers in Europe and had worked in Germany, the Netherlands, and France during the 1920s and 1930s. By the time she left Europe at the outset of the war, she had exhibited and published avant-garde geometric abstractions, photo-chapters of Paris street life, nudes, and industrial reportages. Krull had been a central fixture in the artistic, intellectual, and leftist political avant-gardes of interwar Europe. In joining De Gaulle as a staff photographer, she brought multiple ideas to the war effort. These included her rigorous formal experimentation, her passion for the freedom of her adopted France, her years of experience in reportage and industrial photography, a strong practical streak, and, not incidentally, all the accepted colonialist attitudes of the French towards their African colonies. She made still photographs for the Free French and worked on several films. The films, in particular, offer a unique glimpse into the link between personal and political issues in this era. Krull's vision enriched the various uses and packaging of the film, first during and then after the war.

The Free French government commissioned Villiers and Krull to create this film (and another short film, *Autour de Brazzaville*) with definite war propaganda aims. During the war, the film's original goal – cited in the wartime liberation press – was to persuade the Allies to continue funding what were the sole Free French industries on unoccupied soil. One hundred thousand Africans fought in the Free French armies, and the colonies of French Equatorial Africa, Cameroon, and eventually French West Africa were asked to contribute materials such as gold, rubber, and hemp at great

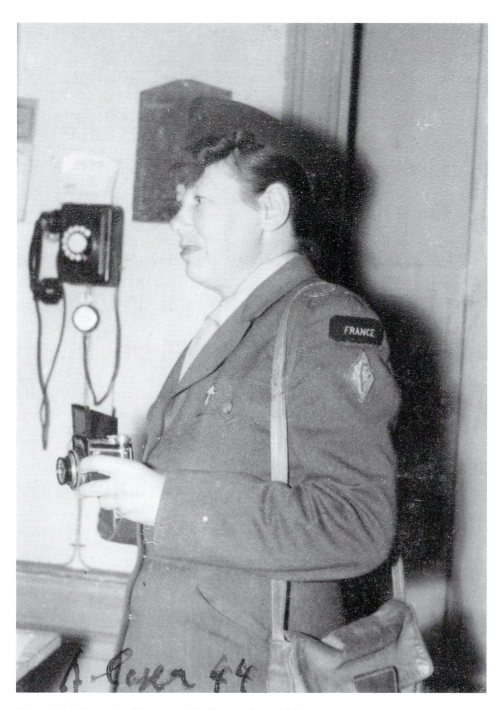

Figure 12.1 Portrait of Germaine Krull in uniform, 1944.

Figure 12.2 Germaine Krull, *Jean Cocteau*, c. 1929.

human cost. However, when *L'Amitié noire* was finally released in 1946 after the war's end, the film was differently marketed in France, this time to foster gratitude among the newly reunited French population for the African war effort.[3] The film also participated in the emergent dialogue about colonialism, amidst growing pressure for colonial progress toward autonomous management, that would lead – by a bumpy path – to independence.

L'Amitié noire was a collaborative project, created over time, and its mixed messages reflect the variety of collaborators. At least three individuals – Villiers, Krull, and Cocteau – made their stamps on its construction. Villiers was assigned to make the film and traveled to French Equatorial Africa specifically for the project. Krull was designated to help him on site – owing to her position as head of the photographic service in Brazzaville. Her previous stills of many of the sites are remarkably close to the final footage, although there is no hard evidence that they served as a shooting script. Cocteau's contribution to the narration came later, in preparation for the film's release in France.

In addition to these three main figures, the political meaning of the film was controlled by two other agencies: the Free French war information office (during the war) and the makers of colonial policy (in postwar France). What began in 1943 as a wartime information film metamorphosed in 1946 into a colonialist statement extolling France's continued involvement in Africa. Both Krull's still photographs and Villiers's film sent a message to their Allied and French audiences that black Africans were noble and patriotic French men and women. Sexual imagery and a strong emphasis on classicizing representations were their main tools for packaging the Africans for French consumption both during and after the war. Villiers, Krull, and Cocteau employed these two most popular styles of colonialist imagery as they cast Africans in the conventional orientalizing roles of alluring but subjugated women and brave soldiers for their white masters. Despite its postwar reputation as a "sensitive ethnographic record," this film is clearly not about African culture, but about European perceptions of Africa, formated for various ideological uses. Underlying the heroic rhetoric is an attempt to package East African culture for European consumption, first to promote the war effort and then to preserve French hegemony in Africa.

The political situation in French colonial Africa during World War II was quite complicated, including Free-French-controlled zones, Vichy-controlled zones, and areas that changed allegiance or manifested no clear loyalty to one side or the other (figure 12.3). As military imagists for De Gaulle, Krull and Villiers became embroiled in the Free French view of these affairs, as well as in the task of broadcasting radio transmissions and publishing texts and pictures to send across Europe and America. A bastion of Free France, French Equatorial Africa offered a much more solid Gaullist base than the territory of then-Vichy French West Africa.

Brazzaville, the capital of French Equatorial Africa, had a dual role in World War II, and, thanks to the vision of its Governor General, Félix Eboué, it had from the outset been Free French, not Vichy, territory. Brazzaville was not only the center of the colony of French Equatorial Africa, which consisted of Chad, Ubangi-Chari, Middle Congo, and Gabon, but also the heart and soul of Free French soil. From 1940 until 1943, French Equatorial Africa was the only land freely controlled by the Free French, under Charles De Gaulle, and it held worldwide significance for this fact – a fact

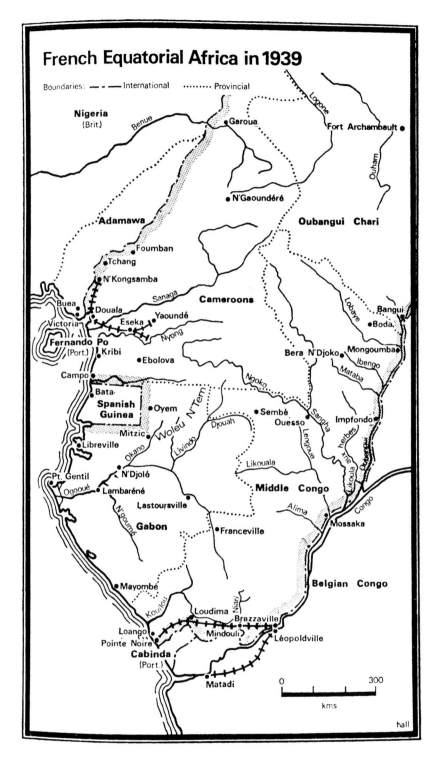

Figure 12.3 French Equatorial Africa during World War II.

262

exploited fully in the film. The other French colonies also included French North Africa and French West Africa, which sided with the Fascist-backed Vichy government until 1943 or later.[4]

French Equatorial Africa's allegiance to the Allies was largely due to one man, the colony's Governor-General, Félix Eboué (figure 12.4; Eboué is on the right). Born in French Guyana in 1884, he was not an African, and, furthermore, he was a black colonial administrator – a product of the French École Coloniale. As early as August 1940, a mere two months after the Germans invaded Paris, he supported Charles de Gaulle (figure 12.5), opposing the Fascist-backed regime of Vichy France. After his move to support De Gaulle, the French General declared Brazzaville the capital of "Fighting France," and created the Council for Defense of Empire there on October 22, 1940. De Gaulle named Brazzaville the birthplace of Free France (without telling London beforehand), and the African city assumed an enormous symbolic importance as a lonely outpost of freedom.

Eboué was a highly unusual colonial leader for several reasons. First, he asserted his courage and independence in supporting De Gaulle so early in the war at a moment when most of his colleagues chose the safer path of accommodating the Vichy government. More importantly, he had a particular vision of French African colonies that respected tribal autonomy while preserving French dominion. He was the first to propose giving chiefs local authority, for instance. However, he never envisioned independence. Eboué's interest in a limited measure of regional decision making, in fact, would be adopted by the French colonial government after 1944, when French colonial

Figure 12.4 Germaine Krull, *AEF Brazzaville, Les généraux de Gaulle et LeClerc et le Gouverneur général Eboué sur l'aérodrome*, 1943.

rule gradually allowed more regional control, although independence was a decade or more away. Krull was a lifelong admirer of Félix Eboué, to whom she dedicated one version of her war memoirs.[5] She mentioned her admiration for his leadership several times in her memoirs, and made numerous portraits of him in the course of her duties. Despite Krull's respect for him, his far-reaching vision was not reflected in the film's much more crudely controlling vision – crafted in the midst of the war and then honed in postwar Paris.

Figure 12.5 Germaine Krull, *General de Gaulle*, Algiers 1944.

Figure 12.6 Germaine Krull, *Cases d'habitation du service de l'Information*, 1943.

As the capital of French Equatorial Africa, therefore, Brazzaville was important not only as one of the birthplaces of French resistance against Hitler, but also as a military base and strategic site as a Free French communications.[6] Thus, Brazzaville was an outpost of freedom for another, more directly strategic reason. In October of 1940, De Gaulle established a Free French Radio information service in Brazzaville, whose purpose was to globally broadcast Gaullist news from Free French soil.[7] News was broadcast as of December 1940. Daily programs went out to England, South Africa, the United States, and Canada in February 1941. Radio Brazzaville was building a new radio transmitting station and was itself the subject of much media coverage, and the new long, low, white building where Germaine Krull also ran her photographic service played an important role as an image of freedom (figure 12.6).

In the autumn of 1942, Lieutenant Pierre Desjardins, the director of the information service, planned a photo service to augment the radio transmissions. Alerted to her availability by a war minister in London, André Diethelm, he recruited Krull to run the bureau and to create images of African war efforts to use in the Allied war press.[8] Germaine Krull had left France for Brazil in January of 1941, and departed from Brazil in August 1942, landing in the Belgian Congo after a voyage of about three weeks with a stop in South Africa. After her arrival on September 4, she stayed in Brazzaville for about a year and a half, until at least January of 1944, before moving on to Casablanca and Algiers in preparation for the August 1944 invasion of southern France.[9]

With her military oath on July 29 1942, Krull (born in Germany, a Dutch citizen, and intellectually and emotionally a Frenchwoman) became an active soldier in the battle against Hitler. Her enlistment declaration, signed in Rio de Janeiro to where she had fled and stamped by the Comité de France Libre du Brésil, read as follows:

I swear before those present and confirm by my signature that I put myself at the disposition of the FORCES FRANÇAISES COMBATTANTES and that I desire to be attached to the army of the FRANÇAISES COMBATTANTES wherever my professional skills can be used. I declare that I will assume my obligations as soon as I am called and that I will go wherever I am sent and will serve in whatever professional mission I am given.[10]

Her military mandate is clear. Krull further recounts what she perceived to be Desjardin's aims in her wartime memoir *Ceux de Brazzaville*. The bureau aimed, she wrote:

To show everyone that [French Equatorial Africa] is actively part of the war effort, economically. To show landscapes, indigenous people, schools, constructions, plantations, customs, all that can make this part of Free France better known. All that can validate the participation of Free France on French soil.[11]

Krull photographed indigenous industry ranging from gold mining and latex (rubber) processing to road building. She also traveled to the various regions of the territory, and documented different peoples as well as different villages. Her still photographs were published in Allied newspapers and Resistance publications, exhibited in Africa for local fund-raising, and sent to the London office as visual evidence of patriotism, progress in war supplies, and pressing needs.

When Krull arrived in the autumn of 1942, Brazzaville was a pivotal site in the African campaigns. De Gaulle was visiting Brazzaville on the day she landed, and the Americans invaded French Morocco and Algeria that autumn. West Africa, which previously had been allied with Vichy France, would soon rejoin the Allied fold. For several years after, the tensions between Vichy French and Gaullist French were high. In addition, Brazzaville was right next door to the notoriously pro-fascist Belgian Congo. Krull's patriotic work for De Gaulle was simultaneously a struggle for the purity of the Radio Brazzaville forces against the compromises that occurred when Algiers became the information center for French Africa in 1944. Krull's opinions were uncompromising; she wrote: "for the Free French of Brazzaville or those of the 'first hour' of London, Algiers was a basketful of crabs."[12]

Krull formed part of a small group of war photographers in Africa and was, as far as is known, one of the only woman photographers working in central Africa and the only one who collaborated on wartime films.[13] She may have been excluded from battle reportage because of her gender, although this restriction did not hold true for the European campaigns she later recorded. For whatever reason, her African work seldom documents battlefields, instead concentrating on culture and industry for the war effort. In contrast, Bernard Lefebvre, otherwise known as Ellebé, made industrial reportages and military photographs. Lefebvre also worked for De Gaulle in Africa and photographed many of the same places as Krull.[14] Ellebé recounts that the archives of the "Service Photographique" of the Information Service in Brazzaville contained photographs by Jean Costa, Robert Carmet, Germaine Krull, and himself.[15] Ellebé photographed more military gatherings than Krull, although he, too, photographed indigenous industry and culture in French Equatorial Africa, and accompanied

Germaine Krull and Robert Carmet on a trip to Messabé to photograph the Tchikombi people and their material culture.[16]

Although she herself acknowledged no ambivalence about the military work she did, Krull's photographs of French Equatorial African industry and its war production mirror the complexity and problematic involvement of these African peoples in the French war effort. Krull's photographs appeared in a variety of official Allied and illegal resistance war magazines and newspapers, including *Les Cahiers Français*, *Les Documents*, *Free France*, *Rafales*, and *Libération*. *Les Cahiers Français*, for instance, reproduced imagery documenting the buildings of the Service de l'Information and the new offices of Radio Brazzaville in a three-page photograph spread on "Radio Brazzaville" (figure 12.6).[17] The opening of the new information outpost was widely covered in the European and American press as well.

When in 1943 she was called to advise filmmaker François Villiers on his film, he paid homage to the role of Brazzaville's radio and photography services by beginning the film with shots of its famous new building. *L'Amitié noire* commences with the June 1943 opening of the new transmitter at the Radio Brazzaville post, with close-up shots of machinery, the workshop, the tickertape machine, and other offices. Many of these images closely resemble the type of machine abstractions found in Krull's war photography, published in various wartime Allied magazines.

L'Amitié noire is described both in 1946 French distribution catalogues and in the current Museum of Modern Art (New York) film catalogue as an excellent and lyrical film on the life and customs of indigenous blacks of French Africa, and Jean Cocteau's commentary was seen by the distributors as sympathetic to the Africans. Its immediate wartime purpose – to garner support for the African involvement in the war – had faded, and the film had assumed a greater role as a colonialist statement. Cocteau became involved with the project later than 1943, probably in 1945. His exploitation of the imagery is ignored. In fact, he adds drama to the footage and infuses animism, sexual metaphors, and European classical references freely into the mix. Cocteau begins his narration of the radio offices with the words: "A new monster has just been born in Africa: a marvelous animal waving its antenna. It is Radio Brazzaville." He goes on to extol the capital of "la France Combattante," which has kept contact with Paris and the world. In a flight of oratory that only increases during the film, Cocteau declares, as the tickertape appears, "Here is the ribbon that France sends to her lovers to remind them that she is beautiful." Patriotism and the language of love permeate the film from its opening moments, and the unfolding views continue to build a song of praise for French loyalty in Africa by combining nude bodies, gyrating dancing, and patriotic talk. War information and ethnographic fact take a decided back seat to romantic patriotism and nude imagery.

The film, however, soon strays from the industrial coverage of radio broadcasting and evolves into a musical and lyrical ethnographic display of different tribes in French Equatorial Africa. Rather than studying them in their cultures, filmmaker, photographer, and narrator distort and craft their subjects into displays of French patriotism and colonial exoticism. The tribes people depicted were ones to whom Krull had led the filmmaking team on their travels, beginning in September of 1943, travels that she clearly documented in her war travel dossier and in her memoirs. Although Villiers downplays Krull's role in the film, the sites, tribespeople, and images are often markedly similar to Krull's still photographs.

Villiers and Krull received orders to leave Brazzaville on October 1, 1943, heading to the region's various towns – Dolisie, Mouila, Lambaréné, Port Gentil, Libreville, Douala, Yaoundé, Garoua, Maroua, and Fort Lamy – and supposedly to Cairo by plane after the project ended.[18] The filming party consisted of two pickup trucks, three chauffeurs, Krull and her assistant "Malonga," another photographer, Pierre Bernard, and his assistant, and the film's director, Villiers. Krull conflates the colonialist and wartime messages in her memoirs, when she recalls – fictitiously or accurately, no one can know – the farewell words of Governor-General Eboué. She writes: "I will never forget this intelligent and excellent man smiling at us from his window and crying out 'Good luck, children, work well and show the world how beautiful is this French Equatorial Africa.'" Even Eboué, in her memory of him, realized the impact the film would have not only in promoting the war effort but also in propagating a certain vision of French colonies in Africa.

The film is remarkable for what it omits: we see no troops, no war material, no military engagements. Nor does it show the hardships the Africans endured working for the Free French. This is in contrast to another filmic collaboration between Villiers and Krull. *Autour de Brazzaville*, also produced by the Office Français d'Information/De Gaulle in 1943, is a twenty-two-minute film, narrated by Richard Francoeur, shot by François Villiers, and "realized with the collaboration of Germaine Krull."[19] The exact nature of her involvement is unknown, although she is clearly and prominently credited. Film catalogues describe it as a short film on the effort of the Free French in Black Africa, describing their military and economic aid to the Allies. From the available descriptions published in film catalogues of the mid-1940s, *Autour de Brazzaville* seems to be the straightforward war documentary that *L'Amitié noire* avoids. *Autour de Brazzaville* depicts the kinds of industrial effort that Krull was photographing on her travels around Africa, such as views of men with pick and shovels similar to Krull's road building photographs (figure 12.7). Images include maps and aerial views of French Equatorial Africa. In these images Villiers followed Krull's lead in depicting the various industries in French Equatorial Africa, concentrating as she did on the rubber production, indigenous cotton growing, and sisal harvest. Villiers's film is particularly close to Krull's images in its depiction of gold mining, and the film documents washing the dirt, the gold "tables," and the water sluices (figure 12.8). Both film and still photographs showed the underpaid and ill-treated workers – little more than slaves to the war effort, as documents show – as heroic and elegant figures, as a sales ploy to recruit more funding. This film ends with a summary of two years of progress, and depicts tanks and palm trees as symbols of the modernization of the colony during the war effort.

In fact, the activities in French Equatorial Africa were not as rosy as the photographs and films depicted them. From November 1942 onwards, the African colonies had been cut off from France. The Free French needed materials and supplies for the African war effort, and Eboué did not hesitate to use extreme measures to ensure their production. Rubber, cotton, wood, coffee, and gold were squeezed out of previously under-performing or exhausted plantations and mines, and the labor exacted an enormous toll on workers. Although many of these industries were staffed by forced labor, which she mentions only briefly in her memoirs, Krull's still photographs tended to heroize their hardships, and the films followed their lead. These photographs served a dual propaganda purpose: to ensure continued funding for

mining and industry and to convince French resistance fighters and Allied troops to respect and honor the black African troops who were fighting the African campaigns.

Krull's travel in Africa is difficult to map, but she traveled widely and frequently. Her official documents showed that she traveled to Pointe-Noire in October 1942 to photograph the port and to Gabon and Cameroon in 1943.[20] According to her memoirs, Krull was sent on three excursions around the colonial territories to photograph industrial activities and produce pictorial records of the ways in which Africans were aiding the war effort (figures 12.7, 12.8).[21] She described her trips into the jungle to document rubber plantations in Cameroon and the sisal harvests in Ubangi-Chari.[22] Krull's other travel assignments were to photograph gold mining, wood harvesting, rubber processing, and the fabrication of rope from hemp and cotton – all indigenous industries that were strained to breaking point to support the war effort. Almost impossible demands were made from the very primitive industrial plants in the colonies to eke out raw materials for the war effort, and her photographs show the effectiveness of the effort while highlighting the heroic labor of the workers. For example, one celebrated and often published story tells of the case of a military official who received an order to supply honey. He responded in a wire, "Honey OK, Send Bees."

Among these assignments were Krull's records of gold mining in M'Vouti, a site halfway between Pointe Noire and Brazzaville in Middle Congo. She documented the

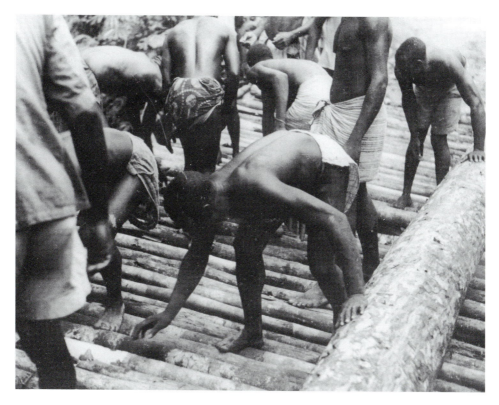

Figure 12.7 Germaine Krull, *Construction on the Route Mouila to L'Onoi, Gabon*, 1943.

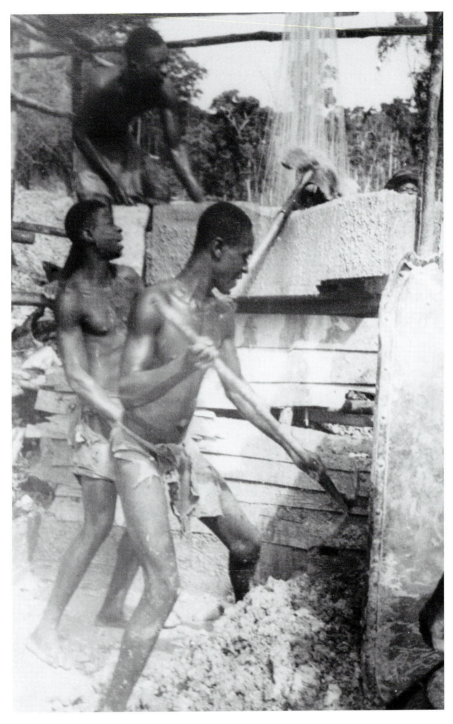

Figure 12.8 Germaine Krull, *M'Vouti Gold Mine*, "Exploitation minière de Mr. Vigoureux, travail à une 'table.'" April 1943.

various stages of the process, and nine photographs from August 1943 survive in her archives. These compelling photographs document the mining process, illustrating the gold washing table that separates gold from dirt. One closely framed image shows the massive quantities of water and dirt to be washed and the sluicing tables manned by the workers. Although the caption typed and attached to the back of the photograph adopts an impersonal tone, Krull's composition suggests the overwhelming difficulty of this work.[23] Dirt pours out of all four frames of the photographs, and although the work looks backbreaking, the men are not represented as heroes. They squat or sit above the sluices, surrounded by the gold-laden dirt, occupying no visible space other than their sea of sand. A second photograph in this series is even more grim (figure 12.8). Here, Krull shows the workers in a closer view; they shovel ceaselessly while water pours down from above their heads. Three workers are depicted, their bodies emaciated and muscles straining. Although Krull frames and lights the workers heroically in the photographs, the glistening light on their skin serves only to highlight their emaciated limbs. The photographer clearly returned to these sites with François Villiers for the films.

Krull's memoirs reinforced the impression of hardship yet adhered to colonialist aims nonetheless. For instance, she recalled that "the work was hard and long," remarking that workers got only two meager meals a day, were recruited by force from their village, and were not allowed to have women living at the mines.[24] Yet none of the ambivalence of her recollections enters the captions or the photographs in their primary usage, and she herself had no political arguments with this task, writing in her memoirs, "It was important to show the war efforts of [French Equatorial Africa]."[25] In fact, Krull was aware that the war production occurred at enormous physical cost to the African workers, and she dispassionately recounted that Eboué wrote, "In order to produce gold for the war, that requires reducing the blacks to slavery; the alternative is not forcing them and not obtaining the gold."[26]

Krull also recorded the military subjugation of African bodies. The building of the roads and the huge amount of industrial work done in French Equatorial Africa required brute force. As it was the least modernized of the French colonized areas, with no industrial base, many of these indigenous industries were built on the backs of workers coerced into labor. Krull emphasizes this in a beautiful but disturbing image that highlights the glistening backs of the doubled-over workers, contrasted with the neat rows of logs that form the road's surface (figure 12.7). She frames the dark backs and loincloths as isolated elements which contrast with the grain of the log roadbed, allowing no faces, no expressions, and no personalities to emerge. The upright figures are cropped to appear headless, and the ones bent double are framed so their faces are invisible; this is a picture of brute labor, not of laborers.

Krull also photographed the tribes and crafts of the areas she visited. *L'Amitié noire* and *Autour de Brazzaville* include much footage directly quoted from Krull's still images, although *L'Amitié noire* was edited or crafted to create a different message, especially for its 1946 postwar release. Krull led Villiers to the areas where she had photographed beautiful landscapes and various tribes people and clearly encouraged Villiers to make the same close-up and elegant portraits that she herself made for the army's still photographic archives. Many scenes in the film are very close visual counterparts to her photographs, although neither Villiers nor Krull specifically calls them a shooting script. Her subjects – and the film footage – include a wide compendium of

people: the Tchikombi women, the Pygmies of Gabon, the plate-lipped women of the Banda in Chad, and the mounted Bororo horsemen of Ubangi-Chari. These images offer an ethnographic dictionary that conforms to the long-standing tradition of European colonialist depictions of non-European otherness.

Krull's still portraits embody her subjects with dignity and poise, and she often frames them from below to monumentalize them. These were accepted ploys in the colonializing views of African women, and European photographers Marie-Pauline Thorbecke in Cameroon (1911–12) and Anna Wuhrmann in Bamum (1913) provide just two of many examples of this colonialist photographic tradition. In writing about the images from the kingdom of Bamum in then-German Cameroon, Christraud M. Geary explores how "European photographers in Africa reinforced and perpetuated stereotypes of Africa and Africans."[27] (Cameroon came under French rule in 1916.) A few photographers, such as Anna Wuhrmann, came to know their subjects well and photographed them more personally, but most, like Krull, remained formal and distant, emphasizing beauty and strangeness alike.

In most respects, Krull's photographs of women conform to the colonialist stereotypes of her other European colleagues. Many of her predecessors, male and female, were either missionaries or anthropologists. Krull's military assignments differed in that her European audience had more immediate and practical needs from its African images. Therefore, she concentrated less on the fiction of dangerous sexuality that prevailed in images from pornographic postcards to serious documentaries, but shared the European fascination with black semi-nude bodies and differing standards of beauty.[28] Although she was a woman traveling among women, there are few signs of personal interactions between the photographer and her subjects. For example, one of her portraits presents a Banda woman whom Krull photographed in Fort Archambault, Chad, in August 1943 (figure 12.9). Krull frames this woman from the thighs up, and shows her closely enough to identify her plate-lips and other ornaments. She gestures in a natural way, but does not look directly at the camera. Krull recounts her first experiences with these women in her memoirs. With a strange mixture of pity and fascination, she describes the process by which a small wooden object was placed into the incision of a child's lip and exchanged for progressively larger wood plates as she grew. She recalls "the result that a beauty of sixteen years had a lip which supported a wooden plate the size of a saucer. A girl adorned with colored glass beads in her hair, her ears and on her arms, carrying before her a plate, is quite strange to see, but still sometimes of a certain beauty."[29] In this way Krull employs photographs to highlight deviance from European customs and to package the subjects for her European audience.

Villiers continues her emphasis in his film. In following her lead to certain regions, and recording the tribes and towns that she had come to know, he cedes her the authority of choosing the subjects to include in this film; in this case the Banda tribe. He also adopts many of her general compositional effects, but where Krull's women, in particular, remain static, Villiers depicts them in motion, allowing his camera lens to follow the shapes and movements of their bodies much more closely. Jean Cocteau's narration takes an even more extreme position, and frames his description of the Banda women in language that emphasized the European fascination with their ornamentation as both sexually alluring and unappealingly strange – a marked contrast to European mores. He narrates, "Don't laugh. It's an extreme fashion pushed beyond its

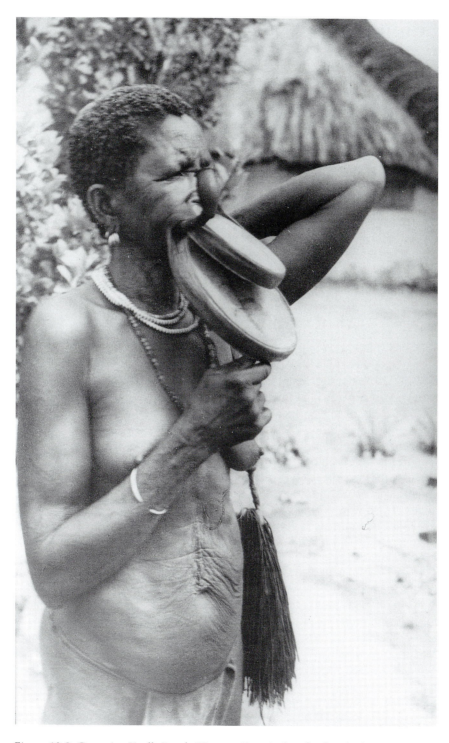

Figure 12.9 Germaine Krull, *Banda Woman, Fort Archambault, Chad*, August 1943.

logical end. On the other hand, it is less odd than a crinoline skirt, a corset, or a lamb chop sleeve. They [the men] keep this style carved into the flesh to distort their women, so that no one else will take them." A short clip of this section of the film illustrates his sexualizing of this tribe's customs, and his constant comparisons to European habits, even those as extreme as crinolines.

A second woman in the film clip is similar to Krull's April 1943 portrait of a betrothed Tchikombi woman in Pointe Noire (figure 12.10).[30] Krull documents the dozens of bracelets and necklaces worn in the customs of this group. Various captions on the photographer's still photographs describe the custom among the Bavilis-Loanges of isolating their young women, shaving their heads, painting them with a special red paint, and adorning them with heavy bracelets. They danced in village after village, searching for husbands the first year and were permitted to see them the second year. In this frontal view, the woman looks directly at us, her head framed by the hanging straw of her hut, and her upper torso encased in row upon row of beads and jewelry. The direct gaze allows her a certain dignity, although Krull represents her as a different cultural type from any European woman. In the film, Villiers adopts a closer view that is more voyeuristic, and the viewer is confronted with her sexuality rather than her ornamentation.

Krull's portrait of the Tchikombi woman differs very little visually from, for example, a Samoan woman photographed around 1890, whose portrait is in the Royal Anthropological Institute in London; both share the conventional topless pose, ornamentation, frontal gaze, and accessoried backdrop of the earlier document.[31] By embracing the formal tools of anthropological photography, Krull adopts its unspoken colonialist message as well as its style. Although she gives less credence to the sexual allure of these women than her two collaborators, she shows varying tribes with their identifying attributes. They fascinate their European audience by their strangeness intermixed with their beauty.

Finally, in L'Amitié noire Cocteau – less circumspect than Krull – adds an extraordinary cultural interpretation in speaking of these Tchikombi women. He poetically and romantically equates the tribeswomen with the birth of civilization – his own Western, European civilization. He declaims, "Let us resume with the nobility of this profound race. Her arm is a miracle of beauty. Silence. [Here the musical backdrop ceases.] The Woman of the Rope Bracelet, another young woman. She is not the Venus of Bronze, who marries her victim but kills him." His reference to a bronze Venus clearly links these women with easily recognizable European ideals of beauty. Furthermore, he describes the straw skirts as the precursors of the tutus worn by dancers in Serge Diaghilev's Ballets Russes production of Shéhérazade, equating these black African tribespeople with the story-telling heroine of the Arabian Nights. Elsewhere, he intones, "We re-enter the legends of Apollo," as we see goat herders and women crushing grain. These comparisons are meant both to fascinate and to repel the film's European audiences.

Cocteau frames the tribal people according to the basic "grand rites" of life, death, funeral rites, war, ceremonies of engagement and marriage, and in each case links the African men and women he describes with Western cultural types – Venus, Scheherazade, classical ballet. At this point in the narrative, we discover a clue that suggests that Cocteau wrote the script well after the filming (and we know for certain that he did not travel to Africa with Villiers and Krull). Here he concludes that the women

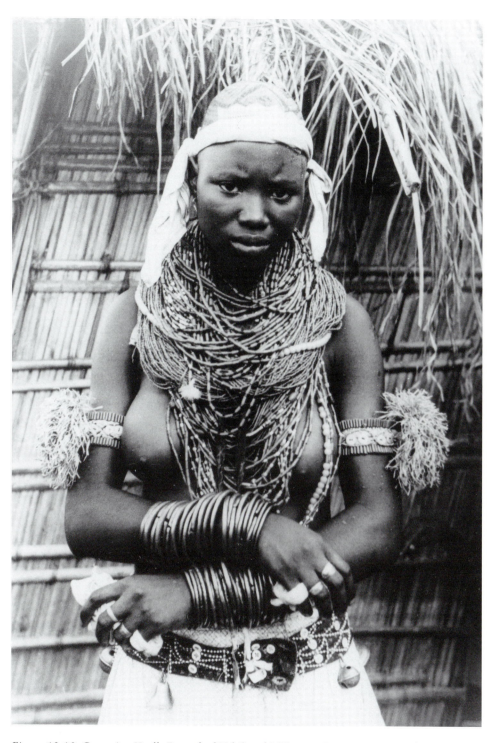

Figure 12.10 Germaine Krull, *Betrothed Tchikombi Woman*, *Pointe Noire*, April 1943.

"live out the perspective of the centuries today, in 1945." Cocteau's physical and temporal distance from the actual filming, and from African tribes he supposedly promotes, is an important element in the tone of the film's fictionalization of French Equatorial Africa.

In the closing sequences of the film, Villiers follows the lead of Krull's still photograph to center in on the Bororo horsemen and their great races across the open territory of the arid African land (figure 12.11). Krull clearly led the filmmaker to this area, as her earlier photographs show horsemen like this one similarly silhouetted against the sky. Krull's mounted Bororo horseman in Ubangi-Chari was photographed in August 1943, a month or two before the filmmaking expedition began. Sitting on a rearing horse, with his white turban and garments silhouetted against a dramatic cloudy sky, this man is a romantic representation of the ceremonies of these nomadic people that is meant to evoke European memories of Rudolf Valentino's filmic sheikh

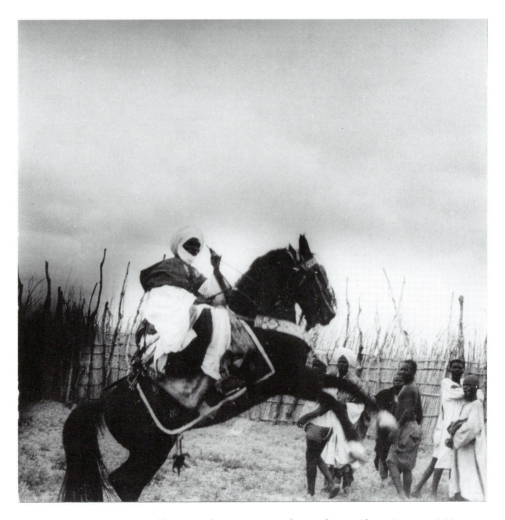

Figure 12.11 Germaine Krull, *Bororo horseman, Bambari, Ubangi-Chari*, August 1943.

rather than African customs. Krull's photograph has only a distant relation to the specific role of African tribesmen in the war itself, however. The drama of thundering horsemen had a clear precedent in the enactments such as 1890 performance at the French Exhibition at Earls Court. There Arabs on horseback created a *life-picture* that supposedly provided a riveting experience and proved that "things seen are mightier than things heard."[32] Cocteau, however, draws a much more direct comparison. In narrating the closing footage of the film, which shows several scenes of mounted horsemen, Cocteau both romanticizes and heroizes them, in historical and contemporary terms. He first calls them "sultans revolving in a fantasia," and "knights of the crusades." Then his crusade moves from the historical to the contemporary in his closing comments. "For centuries, these great races, Muslim and animist, have been massacring each other." Then, in a good plug for the power of the French colonials: "Since the arrival of General de Gaulle, they have ceased their hatred. They have united to undertake a long voyage to defend France. Let us salute them!" The film ends as the horsemen raise their swords and stop before a man in a white robe; the gesture of swords raised before the white-clad man intertwines with the sonorous words "Let us salute them!" (Saluons-les!). The cinematic marriage of Africans and French warriors, of indigenous and European cultures, is encased in the resonating tones of Cocteau's unforgettable voice. This involves using classicizing European cultural language to cast these Africans in the conventional orientalizing roles of subjugated women and soldiers for their white masters.

Cocteau's rhetoric almost convinces us that the diverse tribes dropped all their history and their own affairs voluntarily to fight for a European victory very far removed both from their tribal concerns and from their ongoing relations with the French colonial government. The film is itself a colonizing act: it appropriates the Africans for European fictions of patriotism and sexuality. Under the rhetoric is an attempt to whitewash the sacrifices imposed on Africans during the war and to frame the population of French Equatorial Africa so that it can continue to be admired and visually possessed or controlled by Frenchmen. Krull's magisterial still photographs, Villiers's closer and more activated views of the same subjects, and Cocteau's dramatization and sexualization of the mix all combine to create a complex narrative of possession and control. Clearly De Gaulle and progressive French colonialism, under the lenient administration of men such as Eboué, was preferable to Hitler, but the real victor in this war is Europe, and African cultural autonomy is the loser.

Coda

In addition to its use as wartime and postwar propaganda for French African colonialism, *L'Amitié noire* had a powerful afterlife in the 1950s. The colonialist message it so effectively packaged was both broadened and aestheticized. It was read as an aesthetic and sexualized ethnographic film, robbed of its primary political meanings. It also achieved renown as a model propaganda film, and its format was much emulated by the next generation of wartime filmmakers.

In the 1950s, the film was broadly known among French documentary filmmakers as a model film that incorporated aesthetic elements to strengthen its message. It also had an international impact due to its distribution through the French documentary film agency Actualités Françaises, which was run in the late 1940s by the film

distributor Rosalind Kossoff. Kossoff, a former associate of the documentary film-maker John Grierson at Canada's National Film Board, administered the French agency and later moved to New York, where she began her own distribution company, Film Images. She bought the best of the French documentary films – including *L'Amitié noire* – and sold them independently to the Museum of Modern Art and other archives.[33] In the Museum's collection, the film was perceived as lyrical and aesthetic rather than militaristic.

L'Amitié noire also had an afterlife as a military film. For example, American film-makers working for the United Nations Korean Reconstruction Agency in the Korean War apparently valued the film.[34] Theodore Conant, working in Korea for the UN agency in the early 1950s, knew it from his college interest in art-house films and found that his French colleagues also cited it as the best of the World War II propaganda films.[35] Conant even obtained a copy of the film and showed it to Korean documentary filmmakers such as Lee Hyung-Pyo and Shin Sang-Ok.

L'Amitié noire successfully combined sexuality and allure to packaging the culture of a non-European nation so that Euro-American military forces would fund and support it. Although in later years its jingoism was criticized, peacetime admirers and critics also valued the aesthetic quality of the filming, the lush imagery, the depiction of tribal art and music, and the extensive coverage of different cultural customs of the country being colonized. Overall, filmmakers recognized that the film's conflation of non-Western customs with European cultural icons was an effective means of creating a perception of alliance between vastly differing cultures and of making a foreign cause attractive to Euro-American audiences. The cultural colonialism of *L'Amitié noire* proved equally effective in war and in peace.

Notes

1 Susan Moeller, *Shooting War: Photography and the American Experience of Combat* (New York: Basic Books, 1989), 24.

2 Krull had practiced as an avant-garde and commercial photographer of great renown during the 1920s and 1930s. Although she had worked largely in Europe before the war began, her exposure to the ways in which photography and the popular media can shape and effect European perceptions of the rest of the world dated from the 1920s. Krull sold an image (possibly a postcard) to Ullstein publishers in Berlin in 1926 that was reproduced in a popular magazine called *Uhu*. It depicted several loincloth-clad figures working inside stone walls on the island of Nias, near Sumatra in Indonesia. With a disregard for factuality that would become part of the colonialist message, Krull had labeled this image "Africa, Landscape, Nias." No documentation suggests that Krull traveled to Southeast Asia or to Africa before the 1940s; she must have found this image in Paris. She was also aware and complicit with interwar European looting and imperialist attitudes towards Asia, and photographed for *Vu* the Parisian return of the explorer Titayna with the Khmer sculpture that she stole and brought back in 1928. (See "Landschaft aus Nias," *Uhu* (February 1926): 70–1; and Titayna, "Comment j'ai volé la tête d'un bouddha d'Angkor," *Vu* 6 (April 22, 1928): 165.) Krull's photographs document the explorer flaunting her find at such popular Paris spots as the obelisk in the Place de la Concorde, itself a French trophy from Napoleon's day. Thus her involvement with colonialist ideas began in the 1920s, not only with the war.

3 At this time De Gaulle's Free French group and the Vichy French regime were recombined into one government, under De Gaulle's leadership, with well-documented difficulties.

4 The major French colonies in Africa encompassed three distinct territories: French Equatorial Africa, French West Africa, and French North Africa. The territory of French North Africa included Algeria, Tunisia, and Morocco. French West Africa included Senegal,

Mauritania, (French) Sudan, Guinea, Ivory Coast, Dahomey, and Niger. The French Equatorial African Federation (FEA), where Krull worked, comprised four provinces: Middle Congo, Gabon, Ubangi-Chari, and Chad. Brazzaville served as the capital both of Middle Congo and of the whole Federation (FEA) from its inception in 1910.

5 Although he died in May 1944, Eboué was also a major contributor to formulating the ideas that would propel the French African colonies to freedom in the years after World War II. He was a prime organizer of the Brazzaville conference of January 1944, shortly after all African colonies were reorganized under a central government in Algiers that spearheaded these concepts. See "French Colonial Policy in Africa," *Free France* 2 (Special Issue, September 1944).

6 Soon after declaring the Free French cause in June of 1940, when Paris fell, General De Gaulle suffered a major defeat in Dakar, the capital of Senegal in French West Africa that was in the hands of the Vichy government. Immediately after this September 1940 setback, De Gaulle turned to French Equatorial Africa, where three cities – Fort-Lamy, Douala, and Brazzaville – had declared themselves loyal to the Free French. De Gaulle rewarded Félix Eboué, the Guyanan-born governor of Chad, with the governorship-general of the French Equatorial African Federation in 1941. On October 22, 1940, with a firm base of Free French soil beneath his feet, De Gaulle established in Brazzaville the Council for Defense of the Empire. In November of 1942, soon after Krull's arrival, General Eisenhower disembarked in Algeria. By June of 1943, anti-Vichyism was declared in French West Africa. Although French West Africa now changed allegiance, its leaders had previously supported the Vichy government, and only French Equatorial African had remained steadfastly in support of De Gaulle. For a lengthy account of De Gaulle's African campaigns see Jean Lacouture, *De Gaulle* (London: Hutchinson and Co., 1970).

7 De Gaulle believed it necessary to broadcast each day from Free French soil to the French citizens struggling all over the world. The Vichy government had captured all the French short-wave broadcasts in 1940, and De Gaulle wanted to broadcast his message. He appointed two brothers, Lieutenant Pierre Desjardins and his older brother Captain François Desjardins, to run the information service. For discussions of the early history of Radio Brazzaville see "Le nouveau Poste de Radio-Brazzaville," *Les Cahiers Français* 47 (August 1943): 46–50; and Gordon Galskill, "Voice of Victory," *American Magazine: In the Service of the Nation* I (December 1942): 355, 106–8. News was broadcast as of December 1940, and daily programs went out to England, South Africa, the United States, and Canada in February 1941. On 18 June 1943, more powerful short-wave transmitters, capable of transmitting 50,000 watts, were installed to replace the smaller transmitter.

8 André Diethelm, to whom Krull had written from Rio de Janeiro, had personally contacted Desjardins about Krull, "Ceux de Brazzaville" (unpublished memoir, 1940s, Germaine Krull Nachlass, Museum Folkwang, Essen), 50–51. While still in Brazil, Krull had seen a letter in a newspaper from André Diethelm, a commissioner of Finance, Economy and the Merchant Marine on General De Gaulle's London-based Comité Nationale de la France Libre in London. Diethelm's letter asked: "When the war ends and you are asked what you did during the war, what will you say?" Outraged, she wrote directly to London to offer her services and to reprimand the central office for moralizing and yet not accepting all volunteers, such as herself.

9 Ordres de Mission, Germaine Krull Nachlass.

10 Document signed by Germaine Krull-Ivens, July 28, 1942, and stamped by the Comité National Français on July 29, 1942 (Germaine Krull Nachlass).

11 "Ceux de Brazzaville": 48.

12 Germaine Krull, unpublished memoir, "La Vie mène la danse," 1980–81 (Germaine Krull Nachlass), 184. Italian published edition: Germaine Krull, translated by Giovanna Chiti, *La vita conduce la danza* (Florence: Giunti Gruppo Editoriale, 1992), 240.

13 Constance Stuart Larrabee, a South African photographer, followed the African campaigns and also photographed ethnic peoples in her part of Africa. In 1944, her travels took her with the South African Sixth Division through Egypt to Italy and on to St Tropez, Paris, and Strasbourg as the Allies advanced – a path similar to Krull's. I am grateful to Brenda Danilowitz for sharing her extensive knowledge of Larrabee with me.

14 See Bernard Lefebvre ("Ellebé"), *Album de mes photographies avec De Gaulle en Afrique* (Luneray: Editions Bertout, 1990).

15 Ibid.: 124.
16 Ibid.: 198.
17 "Le Nouveau poste de Radio-Brazzaville," *Les Cahiers Français* 47 (August 1943): 46–50.
18 Félix Eboué to Germaine Krull, "Ordre de Mission," Brazzaville, September 27, 1943, Germaine Krull Nachlass.
19 "Autour de Brazzaville," *Index de la cinématographie française* (Paris: La Cinématographie Française, 1954), 586. This film is housed at the Centre National Cinématographique, Bois d'Arcy, France.
20 Félix Eboué to Germaine Krull, "Ordre de Mission," July 6, 1943. Krull's official travel documents from Afrique Equatoriale Française and the Service de l'Information de la France combattante en Afrique Française Libre, Germaine Krull Nachlass.
21 She was sent to Ubangi-Chari and to Chad.
22 The rubber industry was one of the major war efforts of French Equatorial Africa. It was expected to produce four thousand tons of rubber for sale to British Rubber Control from 1943 to 1945, although it often fell short of the quota (Jean Suret-Canale, *French Colonialism in Tropical Africa 1900–1945* (New York: Pica Press, 1971), 481). Krull recorded the Sanaga rubber plantation at Dizangue, in Cameroon, in June 1943.
23 For example, one caption (figure 12.8) reads "Exploitation minière de Mr. Vigoureux, travail à une table."
24 "Vie":182.
25 Ibid.
26 Ibid.
27 Christraud M. Geary, *Images from Bamum: German Colonial Photography at the Court of King Njoya, Cameroon, West Africa, 1902–1915* (Washington: Smithsonian Institution Press, 1988), 11. Also see Christraud M. Geary, "'On the Savannah': Mary Pauline Thorbecke's Images from Cameroon, West Africa (1911–1912)," *Art Journal* 49, 2 (Summer 1990): 140–8.
28 Malek Alloula has explored these fantasies in *The Colonial Harem*, translated by Myrna Godzich and Wlad Godzich (Minneapolis: University of Minnesota Press, 1986), and others have followed his lead.
29 Germaine Krull, "La Vie mène la danse," unpublished manuscript, Germaine Krull Nachlass, 184.
30 This photograph, in the archives of the Information Service, bears the label "Point Noire, Une Tchikombi déjà promise."
31 See Elizabeth Edwards, "Introduction," in *Anthropology and Photography, 1860–1920* (New Haven: Yale University Press 1992), 11.
32 Annie Coombes, *Reinventing Africa: Museums, Material Culture and Popular Imagination in Late Victorian and Edwardian England* (New Haven: Yale University Press, 1994), 85–7.
33 The film's presence at the Museum of Modern Art archive in New York is probably due to Kossoff, according to Conant's recollections.
34 When I first presented a paper on this subject at the College Art Association Annual Meeting in Toronto in February 1998, a filmmaker named Theodore Conant approached me after the talk to tell me of the huge impact that *L'Amitié noire* had on other filmmakers. Conant had been a documentary filmmaker, one of many assigned to film propaganda footage on the Korean War for the United Nations. Then, and in a conversation on July 18, 1998, he recounted the complex mix of propaganda, artistic effect, and historical circumstance that followed this film. I am grateful to him for sharing with me his recollections from those years and his memories of discussions about *L'Amitié noire* with men ranging from the renowned documentary filmmaker John Grierson to ethnographic filmmaker Robert Gardner.
35 Conant had shown *L'Amitié noire* at a film society showing at Swarthmore College in 1949 or 1950 and recalls that it was also shown at more mainstream New York theaters such as the Paris Cinema near the Plaza Hotel.

13

"A BETTER PLACE TO LIVE"

Government agency photography and the transformations of the Puerto Rican *Jíbaro*

Oscar E. Vázquez

Edwin Rosskam's *Shack in Puerto Rico* (figure 13.1), taken for the Puerto Rico Office of Information between 1944 and 1946, shows a *bohío* (rural cabin) with one set of the twin wooden doors shut, another open; the latter implies a gesture of invitation perhaps, but to what? Shadows and vague definitions; such are the spaces of beginnings and speculation. In the distance, barely visible at the photograph's left edge, is a deep valley with vegetation, and at the right, a partial view of another, perhaps better-maintained

Figure 13.1 Edwin Rosskam, *Shack in Puerto Rico*, c. 1944–46.

281

bohío. There is a poster in the center of the main *bohío*'s exterior that presents the straw-hatted profile of a *jíbaro*, the rural laborer of Puerto Rico, which became the symbol of the Partido Popular Democrático (Popular Democratic Party, or PPD). The other poster announces the candidacy for senate of one of that party's members, Ernesto Juan Fonfrías, who was to write much on the life of the *jíbaro*.[1] The elections of 1944 would be a prelude and key to those of 1948 when the island elected its first Puerto Rican governor. Before that date, and since 1900, two years after the Spanish American War when Puerto Rico became a possession of the United States, and its inhabitants "subject peoples"[2] of yet another government in that Caribbean island's lengthy colonial history, all governors (save one interim) had been North American appointees of the US President. The *jíbaro* symbol and the *bohío* in Rosskam's photograph, therefore, point not only to important cultural and political icons, but also to a watershed moment in the history of Puerto Rico.

Even given the importance of the historical moment suggested by Rosskam's photograph of a poster-covered *bohío*, we might decide to hesitate before entering that site. After all, Rosskam's photograph was probably never published (I have found no examples to prove otherwise), and it is an unremarkable photograph if one considers the hundreds of similar subjects taken for the Farm Securities Administration (FSA), Office of Information, and other government agencies in Puerto Rico beginning in the mid-1930s.[3] Indeed, US government agency photographs of shacks, and, more typically, of their quite often poverty-stricken and marginalized inhabitants, have become a leitmotif of the era and we are reminded of numerous other FSA photographic missions.

Yet, we immediately encounter problems through this clustering of diverse images. The wide array of significant geographic, political, and cultural differences among the subjects in Dorothea Lange's images of Western migrations, Russell Lee's visions of the Oklahoma dust bowls, and Walker Evans's commentaries of the southern United States, have taken on a uniformity by dint of their classification as FSA images and the choice of photographs to be studied. According to this model (a structural problem that reduces groups of images to a singular iconographic type), Russell Lee's photograph of a Mexican day-laborer's hut (figure 13.2) would function in nearly identical ways as Rosskam's Shack in Puerto Rico because of the common denominator of representations of labor and housing within the FSA files under categories such as "land," "transportation," "work," and so forth. In other words, a thematic structuring that, although often grouped by states, or regions, nonetheless frequently ignored the particulars of the where, who and how of the photographs' origins, function, and circulation. According to Trachtenberg, one result of this problem concerning the files' organization is that it constructed FSA photography as a category in and of itself.[4]

This iconographic structuring has also led to a second problem: an ideological reduction whereby FSA photographs have been consistently compressed in scholarship, so that they are understood solely as reflections of the ideological underpinnings of New Dealism, or as indices of the personality clashes between directors and individual photographers, such as that between Roy Stryker, Dorothea Lange, or Walker Evans. Such thematic generalizations serve well interpretations of FSA photography as merely an arm of Roosevelt's New Deal politics,[5] but they do little to help explain how the specific conditions of the photographed region, site, or events played a role in the production of often complex meanings.

Figure 13.2 Russell Lee, *Mexican Day Laborer's Hut. Santa Maria, Texas (vicinity)*, February 1939.

Much is at stake in ignoring the relations of building type to geography and of photograph to archive or discursive arena in both Lee's *Mexican Hut* and Rosskam's *Shack*. However, such disregard would be crucial in the formation of US governmental discourses and representations regarding Puerto Rico, and historically significant for the political course of the island. For one, such a move helped to reinscribe the "smooth space of hegemonic, metropolitan enunciation," by ignoring the articulations of difference in each of the representations, already thoroughly inscribed through previous practices.[6]

The photographs of Puerto Rico taken by Edwin Rosskam, Jack Delano, Francisco Delgado, and others are especially poignant cases because of the significance of the representation of site and geography in terms of national and cultural identities whose formations were explosive during this crucial period of the first gubernatorial elections. In a majority of their photographs, the site is the principal subject. Many of the images of Puerto Rico would lend themselves to a facile reading of political propaganda at a time of extreme violent labor disputes and independence movements which were crushed with the aide of US corporations.

I will argue that by the time of Rosskam's photograph the *bohío* had become a controversial site over the status of a large sector of the island, and consequentially, of the status of the island itself. The development of *bohío* and *jíbaro* photographic images depended as much on the representation of the spaces of land and home (for example,

the rural *bohío* and the small-farm home compound, or *batey*) as they did on the representation of labor summarized by the *jíbaro*. In short, the definition of a rural, farming class as an electoral constituency was among the elements at stake in the island's new status question. It is true that FSA images of mainland laborers formed part of a New Deal nationalist discourse against the specter of fascism and communism. Yet, the national sovereignty of the land photographed was never under question. Certainly one of the elements which begins to differentiate Rosskam's photographs of *jíbaros* and *bohíos* from other images within these iconographically organized files is the particular discursive contexts of which they formed a part: the construction, rehabilitation, and "improvement" of a colony.

Thus, to invoke the questions of regional political and cultural differences among the discursive arenas in which circulated government agency photographs, such as Rosskam's *Shack in Puerto Rico*, is to call forth immediately a complex network of meanings ranging from the administrative and bureaucratic to those of national identities and colonialism. The latter have remained largely outside the frame of reference of publications on other FSA photographs of peoples of the continental United States. To enter into Rosskam's shack, and ignore the particular geographic, cultural, and political conditions that this dwelling and site might have connoted then, would be to contribute unknowingly to a discourse of incorporation, homogenization, and proprietorship. This, as we shall see, was one of the rhetorical strategies of US government agencies employing photography. The colonial predicament engendered by a variety of power elite and colonizers will always be presented as ignorant of itself, and hence of the producers. In this way the question of intention is neutralized and the focus remains on the constructed beneficiary – the colonized.

A link, then, exists between the power structures that helped to direct Rosskam's attention towards this type of *bohío* imagery, and those that caused the image of the *jíbaros* and their *bohíos* to undergo dramatic and rapid transformations in both the material and discursive sense. Rosskam's and other photographers' images did not simply document material changes in a passive manner. They also engaged in the construction of a relatively new electorate and their residences at a time of massive industrial transformation and changes in the island's political status. Yet, the aim here is not to enter into the darkness of Rosskam's shack to discover the true identities of its dwellers; that is, I do not wish to use elite documents such as government-agency photographs as a means of giving "news of the consciousness of the subaltern".[7]

This chapter will therefore explore the geographic and discursive contexts of government agency photographs – particularly with reference to the rhetoric of the *jíbaro* and *bohío* – which purported to identify objectively the problems and merits of a populace of an island in economic crisis, while at the same time defining a voting public. It examines particular government agency photographs and their circulation within an arena of competing domestic and foreign policies concerning the status of Puerto Rico on the eve of the first gubernatorial elections, which set the island on the course towards commonwealth status (still in effect). Further, it links an otherwise forgotten fragment of the FSA and other agency files to Puerto Rican colonial history. In so doing it attempts to destabilize conventional readings of these images in light of FSA and documentary photography scholarship. In other words, it examines the circulation of "documentary" photographs within the conditions of

this particular colonial system. It also asks what aims and benefits arise from a reading of FSA and government agency photography through the lens of the post-colonial.[8]

In 1938, Edwin Rosskam had taken up the post of writer, editor, and layout specialist for the Historical Section of the Farm Securities Administration. A few months earlier, in December of 1937, he and his wife Louise were in Puerto Rico working on a private commercial commission to shoot the trial and events following the massacre of Puerto Rican Nationalists in the city of Ponce in 1937 (figure 13.3).[9] Because the photographs were never published, they were given a short time thereafter to Roy

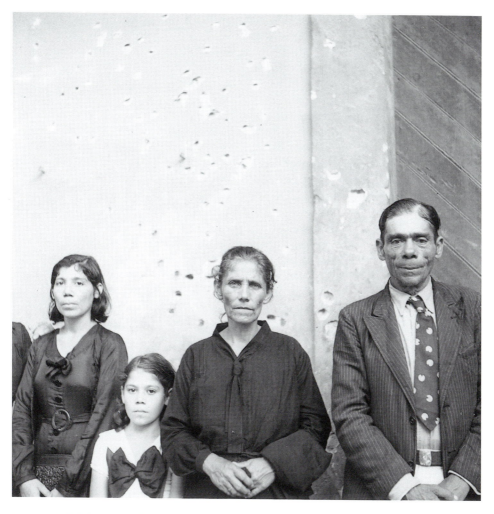

Figure 13.3 Edwin Rosskam, *Families of Nationalists*, December 1937. Caption reads: "Families of Nationalist demonstrators who were killed in the Ponce massacre, standing in front of the Nationalist headquarters. Note the machine gun bullet holes in the wall."

Stryker, head of the Historical Section, for inclusion in the FSA files. Within two years, FSA photographers would be sent to Puerto Rico to shoot the various social and agricultural conditions.

Rosskam's early work in Puerto Rico has largely been ignored or overshadowed by other important FSA photographers working on the island. Among the most notable were Jack and Irene Delano, whose photographic chapters and memoirs of Puerto Rico during the period have become among the most popular photographic records of twentieth-century Puerto Rico.[10] Yet, Rosskam's photographs of Puerto Rico pre-dated the Delanos and were among the earliest to become part of the permanent FSA files. (Even earlier government agency photographs were those by others working for the Puerto Rico Reconstruction Administration, one of the island's New Deal relief programs, more of which will be said later.) Further, Rosskam was editor for Stryker at the FSA Historical Section, and it was partly owing to the recommendation of Rosskam that Delano began his post at the FSA in May 1940.[11] Moreover, Rosskam continued to work on the island through the mid-1940s, even after the dismantling of the FSA, as head of the Puerto Rico Office of Information. Thus, his work on structuring photographic agencies on the island is significant and extends beyond the visual documentation of the island's condition.

A number of regional government agencies employing photographers and photographic files sprang up in Puerto Rico during this period. In 1941 Rexford Tugwell, previously a principal member of Roosevelt's "Brain Trust," an undersecretary of Agriculture, and the person who had hired Stryker to head the Historical Section of the FSA, became Governor of Puerto Rico (until 1946). He wanted there an office similar to the FSA's Historical Section, and therefore he established the Puerto Rico Office of Information. On Stryker's recommendations Rosskam was appointed director. The photographic laboratory was headed by Charles Rotkin, who had taken numerous photographs while stationed on the island as an army sergeant during the war. Through this office, the Rosskams introduced the Delanos to the future governor, Luis Muñoz Marín. In 1947–48 Jack Delano set up a documentary film department for the Division of Cinema in the Commission of Parks and Recreation, while Irene Delano began her silkscreen workshops for the Division of Community Education.[12] Photographs that were commissioned for some of these organizations found their way to the National Archives and the Library of Congress, and are now placed alongside of FSA images.

Thus, some of the earliest government agency photographs of Puerto Rico that form part of the FSA files were not directly commissioned by the Department of Agriculture or the FSA, but were made for island relief programs and other outside commissions. A striking example can be found in Rosskam's photographs of the trial of Nationalists and other images in the winter of 1937–38, which were given over to Stryker and lumped together with other works in the FSA files in Washington, DC (there were no regional FSA administrative offices in Puerto Rico). These files were augmented by photographs made by Delano on his visit to Puerto Rico in 1941 as part of the FSA project, and also by Rosskam's photographs of 1944–46 that included *Shack in Puerto Rico*, made for the Puerto Rico Office of Information. Although the card catalog of the Library of Congress clearly makes note of the original commissions, the organization of the files does not suggest the numerous types of disruptions and discontinuities that emerge from the juxtapositions within the files.

Even today one finds Edwin Rosskam's c. 1944 *Shack in Puerto Rico* alongside his and Jack Delano's FSA photographs of other Caribbean islands regardless of the place, the time, and the differences of their commissions. The storage and housing of photographs such as those by Rosskam were transferred from department agency to department agency, according to the needs of state administrations.[13] While the function of the files may have remained fairly constant, the changes of dependency and residency are significant because they parallel the types of constructions of the very constituency represented in the photographs. Just as the peoples were a file source for the US government, similarly the files of photographs were a resource for individual government agencies. This is not simply a metaphoric reading: many of the same departments that were charged with the transfer and displacement of Puerto Ricans also handled the planning and writing of photographic and textual records. (As an alternative, one could envision a completely independent department of Arts and Information services – as was constructed in Puerto Rico at a later date – that handled requests from all other government and civil agencies.)

There is another type of movement here as well. In his discussion of the "currency of the photograph," John Tagg has analyzed the problems of previous scholars constituting internal and external relations of the photograph, as one of locating "an unresolved stage in the methods of art history."[14] By this he means the act of moving from interpretation based on a descriptive, iconographic method that locates signs "in" the photographs, to one that searches for significance of the photographs as objects themselves.[15] Thus, on the one hand we would be addressing the tensions produced by a search for significance of the *bohío*, *jíbaro*, labor, and so on, represented in the images, and on the other the significance of the photographs as objects that are shifted from agency to agency, and from government publication to publication.

The question is not one of finding the true location or original context for the signs either "in" the work or of the photograph as object. Simply put, photographs such as Rosskam's can neither be accepted as "proof" of the Puerto Rican "condition" of the 1940s, nor serve as a document of an unproblematic New Deal policy applied to Puerto Rico by FSA or other government agencies.[16] Neither the style of the photographs nor their designation of a specific place and theme – let alone their being housed in files concerning the island – can constitute Rosskam's images as "Puerto Rican." After all there was no essential Puerto Rico or Puerto Rican identity against which such images could be measured. In other words, the construction of identity, be it *jíbaro* or Puerto Rico as a national, cultural, or political entity, did not take place apart from or outside of discourses. Rather it was precisely through the documents forming part of varied discourses that such identities were constituted and contested. The images immediately invoke the question of the circulation of these works by various government agencies using photography.

Most of these photographs of Puerto Rico, including Rosskam's *Shack in Puerto Rico*, were never published, nor did they circulate outside of the administrative bureaux. The issue is not one of government censorship, even if editorial-screening processes largely determined which would be allowed public view. (Recall Roy Stryker's punching holes in thousands of negatives, or of his requests for more photographs emphasizing the "ideas of abundance – the 'horn of plenty' and put maple syrup over it."[17]) More important are the tensions and the silences that occur among the sites of circulation. For example, the focus upon the *bohío* and *jíbaro* as indices of

poverty and labor in many government publications silenced the literary and cultural aspects of these symbols – not to mention their social contestations. Colonialism continues to operate unchallenged precisely when such differences are ignored, and it is here that the counter-readings can begin.

Regardless of the fact that many of these photographs ultimately found their way into the same files, their sources varied and the conditions under which they were made also differ one from the other. That similarities of subject do appear across the files is not so much a reflection of the reality of an essential Puerto Rico as it is a function of the files with administrative agencies. Thus, there is a link between the administrative agencies that constructed the files and the representations of *bohío* and *jíbaro* imagery. The *jíbaro* was not invented by the government files – *bohío* and *jíbaro* imagery had a lengthy history when Rosskam arrived on the island – but the files did help circumscribe the meanings of these for varied groups at this time.

The *jíbaro* was (and continues to be) a powerful, popular, and politically charged cultural symbol that represented everything from national pride and moral character to more recent connotations of colonial oppression, class elitism, and racism. While the bibliography on the *jíbaro* is extensive,[18] few scholars have interested themselves in its pictorial language. Although *jíbaro* and *bohío* imagery was already well established through literature and painting by the beginning of the twentieth century, in the 1930s and 1940s these two were fused and transformed into their most enduring and controversial manifestations. This occurred through a variety of cultural productions that included United States photographs such as those by Edwin Rosskam (figure 13.4) and Jack Delano, who worked for the FSA and other agencies, as well as those by Puerto Rican photographers such as Francisco Delgado and A. Moscioni, who worked for other US agencies on the island (figure 13.5).

The *jíbaro* emerged from nineteenth-century picturesque imagery as the defiant, poor but honorable signifier of a past yet uncomplicated by the pressures of urban capitalism. This vision of the *jíbaro* is evident in numerous popular illustrated lithographs (figure 13.6) and photographs on postcards, as well as in many turn-of-the-century paintings by artists such as Francisco Oller and Ramón Frade.[19] Their paintings manifest dramatic changes in the *jíbaro*'s representation, which are related to the socio-economic structure of Puerto Rico and are integral to the transformation of the photographic image of the *jíbaro* in the 1930s and 1940s.[20] For example, Ramón Frade, who produced many paintings of *jíbaro*s, was involved with the surveying of land under the New Deal's Puerto Rico Reconstruction Administration (PRRA) in 1937. A link thus exists between the development of an iconography of the *jíbaro* and that imagery's reformulation and solidification through New Deal programs that also sought to redevelop the very lands upon which the *campesino* was dependent, and which became the focus of much of the FSA and other government agency photographs.

However, the differences among the media and circulation of *jíbaro* imagery were significant. One important difference that distinguished a government agency photograph from a lithograph in a popular journal or an academic painting, for example, was the authority given it both as a government product and as a "truthful" document. Even in recent decades the work of varied theorists has revealed the extent to which FSA photography (and photography in general) was never completely objective, never a purely

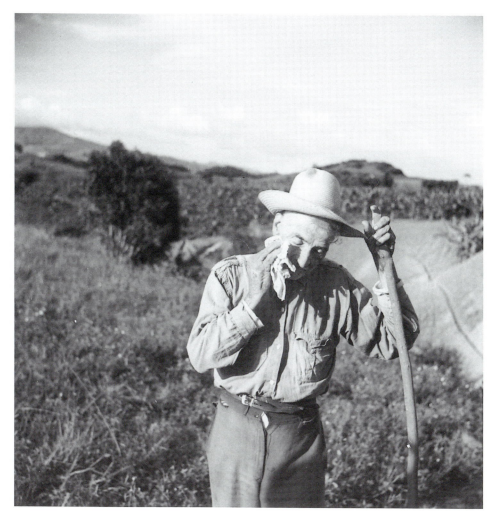

Figure 13.4 Edwin Rosskam, *Old Jíbaro, Patriarch of a Clan of 21 Tobacco Hill Farmers*, January 1938.

factual documentation of a reality organized by a disinterested photographer.[21] Still, the belief that the camera is neutral and reproduces "a" truthful reality persists.[22]

Nonetheless, the earlier art works had helped attach the image of the machete-wielding and straw-hatted weary *campesino* to the issues of land cultivation and laborers' displacement. Undoubtedly paintings and lithographs such as these also had much to do with the entrenchment of a discourse that segregated Afro-Puerto Rican laborers along the coast from the "true" *jíbaro* – in the words of the later Puerto Rican painter Miguel Pou, "the white inhabitant of our mountains, the direct descendant of the colonizers with all their virtues and vice."[23] This mythologized racial division between a white Creole of the island's interior and a coastal, labor class of African descent was part of a process that Lilian Guerra has termed a "discursive

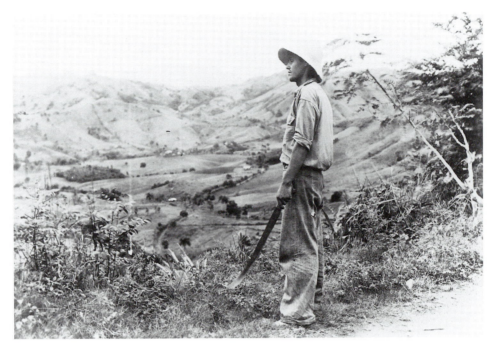

Figure 13.5 Photographer unknown (A. Moscioni or Francisco Delgado?), *Typical Jíbaro*, May 1936. From *Efemerides de la PRRA*, vol. III, photograph no. 2153, unpublished album of photos and typewritten commentaries. Caption reads: "Work is begun on the rural rehabilitation of the island after the purchase of American Supplies. The photo shows a typical *jíbaro* looking at the Valle of La Plata."

whitening" of the *jíbaro*.[24] The strategic racialized representation that constructed the *jíbaro* as a white male from the interior mountain regions of the island would be continued in government agency publications and photography of the 1940s, such as in figure 13.4 by Rosskam or in figure 13.5, probably by A. Moscioni, showing "typical" *jíbaro*s.

Like other appropriated images within colonial constructs, such as the image of the Native American, the racialized and gendered image of the *jíbaro* signified for Puerto Rican intellectuals and political elite both an independent, free-spirited people and one enslaved by capitalist colonial forces. Meanwhile, for US officials in Washington the rhetoric of the poverty-stricken *jíbaro*s in their *bohíos* helped construct a discourse of an Other.[25] There is clearly here much in common with the rhetoric of Orientalism. However, unlike European Orientalist images of the previous century, or those of Native Americans, from a very early period *jíbaro* narratives were already being produced by various political entities within Puerto Rico as part of a nationalist and cultural discourse among an elite for class distinction, as well as difference from their former colonizer Spain. The same mythologies of the *jíbaro* came to serve United States political interests during the period in question.

The questions of both the possible differences between the formal languages and strategies of self-representation of the colonized and their representations by the

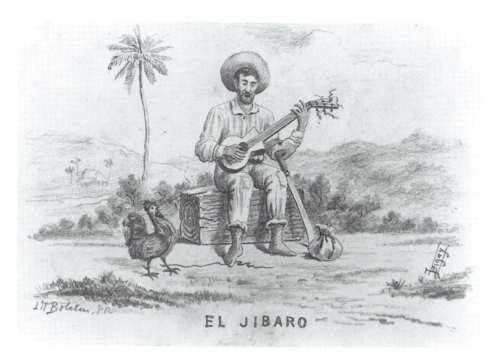

EL JIBARO

Figure 13.6 J. Bigay, *El Jíbaro*, lithograph. *La Ilustración Puertorriqueña* 1, 7 (July 10, 1892): 8.

colonizer need to be addressed briefly. After all, photographs of *jíbaros* and *bohíos* were taken by both US American photographers of the FSA and other agencies, and Puerto Rican photographers working for island administrations (albeit under the jurisdiction of the US government). This should not lead us to the assumption of two differing pictorial languages; between, for example, the work of Delano for the FSA and Delgado and Moscioni for the Puerto Rico Reconstruction Administration.

Certain formal differences do exist between the productions of these agencies. For example, the photos taken for the Puerto Rican Relief Administration (such as figures 13.5 and 13.7) tended on the whole to be unfocused, less concerned with light, and concentrated on larger fields of vision, and were more often scratched. This perhaps has as much to do with later storage methods as it does with the PRRA's photography unit not being as well funded and its photographs being used for internal reports to a much greater extent that those of the FSA. The FSA file photographs on the other hand (for example, figures 13.1 and 13.4) show more tightly focused, close-cropped portraits often with a narrative caption. Yet the problem of attempting to differentiate between a US mainland photograph and those by Puerto Ricans is complicated by realizing that the island administrations were under the mandates of the US government, and as such no clear division between that government's administration and a separate Puerto Rican government photographic unit can be found during this period. (Further, it will be remembered that Delano and Rosskam also worked for island administrations such as the Office of Information well after their missions with FSA.) A search for an independent language of Puerto Rican photography, therefore, would have to be

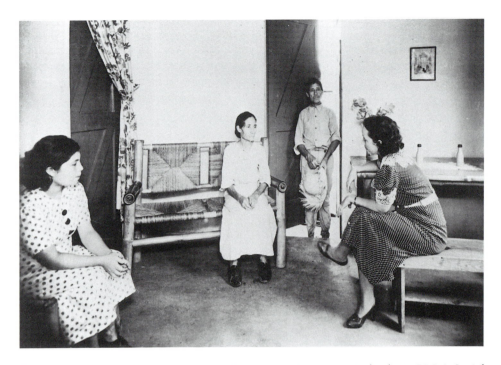

Figure 13.7 Photographer unknown (A. Moscioni or Francisco Delgado?), *PRRA Social Worker*, June 1936. From *Efemerides de la PRRA*, vol. III, photograph no. 1698, unpublished album of photos and typewritten commentaries. Caption reads: "Social Work is begun throughout the island in cooperation with established rural medical centers. A Social Worker visits the house of a PRRA farmer."

located in other areas (such as independent newspapers or periodicals) and in any event would pose numerous dilemmas. If political parties and agencies on both the mainland and the island used on occasion similar-themed works as part of discourses that recast the image of a relatively new citizenry, they did so not only because of the political and administrative links between the island and US mainland, but also by invoking the contradictions and dilemmas of the colonial project.

The problem of seeking formal differences between the productions of the colonized and the colonizer has been criticized by others elsewhere: the problem has been presented as a choice between recovering a true language or form of self-identity of the colonized, on the one hand, and seeing those formal languages of the colonized as necessarily imitative of the colonizers (and hence, the impossibility of a "true" subjectivity of the oppressed), on the other.[26] Such dichotomies are unproductive since they present the question as an either/or choice in the search for a model of nationalism as agency.[27] Resistance that effects political or social change must necessarily take place on a material level. However, the question of mimicry of forms does not necessarily lead us to an investigation of agency on the part of a colonized people because there is no intrinsic or fixed correlation between signification and the specific forms of representation. Acts of colonial resistance may also use mimicry and may happen outside the level of nationalist discourse. (The case of contemporary Puerto Rico is a prime example in

which an anticolonial practice dubbed *jaibería* is seen by many to employ postmodernist parody and mimicry.[28]) We should not, therefore, have to construct the problem here as one of desire over the (re)-discovery of a "true" voice of resistance or remorse over the impossibility of its existence. Rather, we might analyze the photographs of *jíbaros* and *bohíos* as a site for theorizing the strategies of government agencies with both Puerto Rican and US photographers with differing political commitments, and of the photographs' potential for counter-readings.

In the early to mid-1930s, a number of often highly racist sociological, anthropological, and ethnographic treatments of the *jíbaro* appeared in the US market as well as in Puerto Rico. Most of these emphasized what was perceived as the backward, "primitive" lots of the *jíbaros*, these modern-day natives. For example, by 1934, a watershed year in Puerto Rican history, Victor S. Clark published for the Brookings Institute the often-cited statistical report *Porto Rico and Its Problems* in which the *jíbaros* in the houses are described as fostering illness and accepting suffering with helpless fatalism.[29] Significantly, Clark, who served in 1935 as Chief of the Health Division on the planning board of the Puerto Rico Reconstruction Administration (PRRA), in 1955 also donated to the Library of Congress photographs division over 105 photographs of various PRRA projects from the late 1930s.[30]

The increasing concern over the *jíbaro*'s plight was manifest in the increased number of publications. By 1935, José Colomban Rosario's published Master's thesis for the University of Chicago, *The Development of the Puerto Rican Jíbaro and His Present Attitude Towards Society*, explained in its preface that "The recent extraordinary interest in the *jíbaro*" was reason enough for the publication. Through his inclusive identification of all non-urban barefoot workers as *jíbaros*, Colomban Rosario – later a university professor and adviser to the PRRA – believed that the rural laborer comprised almost three-fourths of Puerto Rico's population and thus constituted "the island's greatest social problem." Rosario defined THE *jíbaro* – for there was an essence to be found – as follows:

> the name given to the native Puerto Rican living in the open country. While the city inhabitants of the island have a civilization that may be compared favorably with that of Western Europe, their country brethren, coming mainly from the same Spanish stock, if anything purer than that of the town inhabitants, have lagged sadly behind. The *jíbaro* goes barefoot, is ignorant and sickly, superstitious, and as a producer, he is dreadfully inefficient.[31]

That same year, in his *La actualidad del jíbaro* (The Current Importance of the *Jíbaro*), Antonio Pedreira believed that, while the *jíbaro* may not have made up nearly three-quarters of the population, he certainly did still exist and was being transformed by socio-economic conditions.[32] Pedreira continued to be one of the principal sources of inspiration for Puerto Rican cultural writings through much of the second half of the twentieth century.[33]

Pablo Morales Otero in his 1947 *Nuestros problemas* concentrated much of his attention on the problems of the living conditions of the *jíbaro americano*, and described the *bohío*, "in spite of its humility and poor aspect," as representing "a tenacious effort of the *jíbaro*, making his home part of the native soil and adapting his

poverty to the conditions of the environment."[34] Thus, the *jíbaro*'s identity was firmly rooted to the earth s/he labored and more than likely did not own, but upon which the *bohío* stood. Here the latter itself becomes the very symbol of the *jíbaro*'s stubbornness and defiance. (Hence it offers, as will be demonstrated, room for a reading of resistance.)

It is clear that for Pedreira, as for Colomban Rosario and Morales Otero, a true and authentic *jíbaro* was to be found (a *jíbaro-jíbaro*, as he put it). Indeed, an extremely important practice of this "second generation of *jibaristas*" (writers on the *jíbaro*) in the 1920s through the 1940s is their construction and use of the *jíbaro* in the debates over the construction of a national identity. This search for an essential and "true" *jíbaro* is further significant in light of the circulation of photographs and statistical reports of the era. While the works of Pedreira and other *jibaristas* did not contain photographs of what they purportedly examined with the greatest of empirical observation, their language of locating essential national characters and problems through observation parallels numerous other contemporary reports which did employ photographic materials.

Coinciding with the organization of government relief agencies and the search for the "true" *jíbaro*, there developed a rhetoric of the veracity of FSA and government agency photographs. In spite of the controversies in the media regarding the fakes and manipulations of FSA photography, such as those by Arthur Rothstein,[35] contemporary PRRA and FSA photographs offered to almost all documentary "proof" of the "backward" living conditions and plight of *jíbaro*s. The rhetoric of "proof" would be largely constructed on the model of juxtaposition and contrasts of chosen examples.

Already in 1935, the cover page of a typewritten planning review document submitted to the Puerto Rican Emergency Relief Administration (PRERA, created in 1933) included a passage from the English poet Robert Browning: "Men must pass from old to new, from vain to real, from mistake to fact, From what once seemed good, to what now proves best."[36] In this way the report suggested the tenor of the language that would dominate the publications of the relief organizations: one of progress, modernization, and transformation. Thus, the reading of the poem in the context of the report signaled the necessary dying of the old culture to make way for a new, better society based on a reality of facts. Likewise, the privately published 1939 bilingual *Album de oro de Puerto Rico* made use of PRRA and other agency photographs as the factual basis for their program. The preface stated that "descriptions and explanations have been made without any tendency towards social, political or historical analysis . . . The fact, the object, just exactly as the camera caught with its undeniable scientific veracity and the honest pen of the journalist reported it from authorized sources only: these are the sole contents of this work."[37] The Album was very much in keeping with contemporary attitudes concerning "documentary"; Rosskam himself believed that the "amazingly homogeneous and purposeful" character of the FSA file he managed as picture editor was "an inclusive attitude which makes photographer, eye, and camera into an instrument of social science," while Walker Evans claimed that "the value and . . . even the propaganda value" of the photographs for government lay in "the record itself."[38]

Thus, it was undoubtedly in reaction to the works of Puerto Rican writers such as Pedreira and Morales Otero that US government agencies and others who desired at least stronger economic ties with the US (such as the editors of the Gold Album above) moved to recast the nationalist descriptions of a gloomy economic situation, and used

photography to strengthen their arguments. There was, then, a twofold move through many of these publications employing PRRA photographs: photography was employed to show the transformations of the economically depressed, "inefficient" *jíbaro*, and it tended to reroute the second-generation *jibarista* arguments that concentrated on the search for a national character and identity, to one focused purely on labor and land transformation. One can thus begin to understand how photography played a part in this "extraordinary interest" in the *jíbaro*.

Among the principal agencies to employ photographs in this move was the Puerto Rico Reconstruction Administration, or PRRA. For example, the preface to the 1940 *PRRA Guide to Puerto Rico*, which reproduced numerous photographs from its own and other agencies' files, contested the gloomy description of the island's conditions reported in many previous sociological studies by stating:

> This book written by Puerto Rican residents for their fellow-Americans in Puerto Rico and on the mainland, is not designed to add another to the volumes discussing the "problem of Puerto Rico". It is intended merely as a guide for the visitor or stay-at-home voyager, indicating points of interest . . . sketching the general background of Puerto Rico's history and tradition, tracing the great stream of Puerto Rican culture to the point where it mingles with that of the mainland, and describing some of the energetic efforts of the Insular and Federal governments, especially during the last few years, to make Puerto Rico a better place for Puerto Ricans to live in.[39]

The inclusionary description of Puerto Ricans as "fellow Americans" is in keeping with the shift in rhetoric towards the reconstruction of not just the island, but its inhabitants. One example, a 1936 article in *Scientific Monthly*, argued in words and photographs for a reconsideration of the *jíbaro*, significantly now as an "American Citizen" – a label manifesting the continued Americanization of Puerto Rican culture and an awareness of the availability of this still relatively new labor pool (and the need for its transformation as the author testified with photographs that the individual "*Jíbaro* as a workman is inefficient").[40] Thus, the varieties of official reports and sociological tracts, many liberally illustrated with photographs, established a narrative of progress and modernization especially under the PRRA.

Founded in 1935 within the Department of the Interior, the PRRA was set up principally to provide relief and employment with an emphasis on the rehabilitation of the rural and agricultural sectors of Puerto Rico.[41] Among its many projects was the construction of a new campus for the University of Puerto Rico, hydroelectric power plants, agricultural work camps, and educational programs, as well as the construction of hurricane-proof rural and suburban housing units. In short, it was a combination of early New Deal immediate-relief programs with second New Deal administration concerns over education and long-term structuring programs.

The initial plans of the PRRA contained no mention of or allocation for photographs as part of its statistical or information-gathering section, although in the early stages of the hiring there was already a staff photographer in Puerto Rico, Francisco Delgado. He was one of the founders of the Asociación de Fotógrafos de Puerto Rico (1924). Other PRRA photographers were Cruz Figueroa Castro, José Negrón Ferrer,

and A. Moscioni.[42] By 1940, the agency had enough photographs that it could be drawn upon to supply other sources, as it too drew from various other government-agency photograph sources such as the Federal Emergency Relief Administration (FERA).

The Puerto Rico Reconstruction Administration had compiled numerous photographs that sought to document that agency's efforts in transforming the *jíbaro's bohío* into a modern, albeit modest, worker's habitat that would withstand hurricanes (figure 13.8) (the devastation of the 1928 San Felipe and 1932 San Cipriano hurricanes that destroyed much of the island's sugar cane and remaining coffee crops was still fresh in the memories of most). The low-angle perspective employed in figure 13.8 parallels the types of heroizing compositions of work that have become stereotypical of FSA-era "documentary" photography. In this case, the house through such a composition becomes both eager home and modernist fortress. The PRRA constructed across the Island hundreds of these types of hurricane-proof houses in small tracts, or *urbanizaciones*. The houses in the country generally cost $850 to build, while the land cost another $100, and they could be rented at rates from $3.00 to $8.50 monthly with the right to purchase.[43]

The PRRA photographs file apparently was not as large or systematically organized as those of the Historical Section of the FSA, given the difference in the size of their

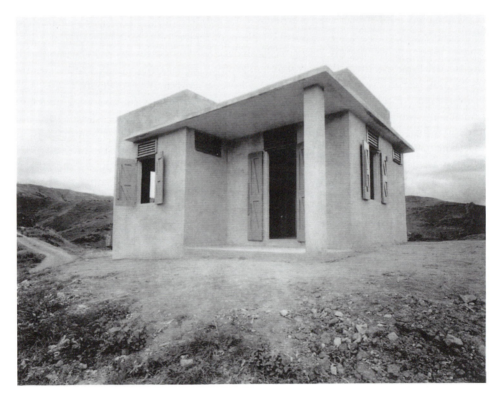

Figure 13.8 Photographer unknown, *Worker's Concrete House Built by PRRA Resettlement Program*. September 1936.

budgets and staffs (although I have found no news of the specifics of how the PRRA files were kept). While the photographs were made available to public and government agencies, they were used primarily for annual reports and publications produced by administrations to show, as stated in the 1940 Guide, the "energetic efforts" of the government at making Puerto Rico "a better place to live in." The photographs, like the written texts, employed a language in which the process of change and modernization was emphasized. A narrative of transformation was achieved by photographs showing existing housing or living conditions, which were then contrasted with photographs of conditions after the administration's interventions (constructions of housing, instructions for hygiene, etc.). In the 1939 PRRA publication *Rehabilitation in Puerto Rico*, for example, a narrative of transformation is revealed through the placement of one photograph of a *jíbaro* hut in the upper left with the caption "From this . . .", which is then contrasted by the lower-right photograph with the caption "To this . . ." (figure 13.9). The emphasis upon the old versus the new, the before and after, promoted a notion of change and transformation, but the implication was one of progress, modernization,[44] and betterment. This emphasis further advanced the construction of a new citizenry "of fellow Americans" as the PRRA attempted not only land reform but also education.

One problematic reading of these narratives of modernization is that of an evolutionary process informing us of colonialist government discourses that involve photography. Such narratives seek to demonstrate the transformation of a "backward" or "infantile" society into a more mature, hence, more capitalistic colonial system ("a better place to live"). Simultaneously, they offer an evolutionist depiction of developing nationalism: from the colonial subjection of peasants to the creation of a politicized bourgeoisie.[45] We can readily see how such narratives of transformation would have served an island elite with pro-US ties, as well as US officials.

The narrative of transformation as a strategy of proof was also in keeping with certain general views of documentary photography of the era[46] and its use within archives and files. For example, in a 1946 review article of the work of Edwin and Louise Rosskam for the Office of Information during the 1940s – the notions of the photographic archive having been well solidified and expanded by this time – the author explained that, in theory, a government agency or sociopolitical entity's existence depends largely on documentation as an expression of the needs of the people. Just as important, he emphasized the importance of contrasting differences:

> In this respect, the expediter [photographer] does not pretend to photograph the sum total of a society . . . Rather, the secret of the technique lays in the contrast – the nuances in the difference of conditions between yesterday and today; for example: between those conditions that prevailed in a community before reforms were initiated, and those that the reforms, once underway, have made clear.
>
> The gelatin plate that sensitizes the government's program of action does not tell us anything [alone], from a documentary point of view, if it is not accompanied by other plates which help reflect the problems which give life to the program . . . If one keeps this in mind, it will be readily understood that a documentary photographic archive can never be finished and that no one particular person begins one.[47]

RURAL REHABILITATION

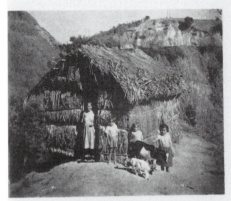

From this...

Puerto Rico is one of the most densely populated areas in the world.

About a hundred miles long and thirty-five miles wide, it must support more than five hundred persons per square mile on the produce of its soil. Lacking most of the raw materials generally associated with densely populated industrial countries, the economic life of the Island rests upon a basic foundation of agriculture.

But agriculture in Puerto Rico has not been properly developed to make a happy contented agrarian life. On the contrary, facts show that the great mass of people living in the Island are not only landless, but lack sufficient opportunity for employment. Consequently, they do not have income sufficient to maintain even the lowest acceptable standard of living.

Agriculture began in Puerto Rico under a feudal system back in Spanish days and the "hacienda" under the paternalistic "hacendado" helped to shape the country life of the early colonial period. In the mountainous interior, where coffee

and tobacco have been the main crops, the smaller farmer has predominated. However, during the past decade, two disastrous hurricanes, loss of world markets and associated events, have driven many a small farmer and his family from the hills into the slum areas of the towns.

Along the rich alluvial coastal plains and interior valleys, the growth of the sugar industry has been even more contributory to bringing about landlessness among the small farmers.

Despite a provision in the Organic Act of 1900, creating civil rule in Puerto Rico, prohibiting the ownership or control by corporations of more than five hundred acres of land, the development of the sugar corporations has led to the concentration of the best lands into fewer and fewer hands, a monopoly so comprehensive as to drastically reduce the number of farm owners, as shown conclusively by statistics.

Yet, because of quota restrictions, thousands of acres of these lands are not being adequately cultivated today and consequently not carrying

To this...

Figure 13.9 Photographers of insets unknown, *Rural Rehabilitation.* Puerto Rico Reconstruction Administration, *Rehabilitation in Puerto Rico, being an outline of the origins, of the functions and the accomplishments of the Puerto Rico Reconstruction Administration* (San Juan: Imprenta Venezuela, 1939), unpaginated.

In representing the different "conditions between yesterday and today" (in the case of our discussion, the old and new *jíbaro*s and their residences), there was more at stake than simply clearing away slums. For unlike the squalor at which cameras were aimed in the name of sanitation laws and land renovation in the late nineteenth century,[48] the cameras of PRRA and FSA photographers did not focus exclusively on particular geographic locales deemed more poverty-stricken than others, as were the areas outside of San Juan known as "El Fanguito" (the little swamp) and Porta de Tierra, or "El Machuelito" outside of Ponce – although these were certainly among their earliest subjects. (Governor Rexford Tugwell was to dub the entire island The Stricken Land.[49]) Rather, the rhetoric also turned to the Puerto Ricans themselves even outside of those areas, and especially to those cast as *jíbaro*s, who were seen as simultaneous cause and manifestation of the condition of the island. Moreover, the focus was repeatedly on the construction of a subject whose poverty remained unbound by class and gender, but extended to race and national identity. Certainly the rhetoric of many slum clearance projects in Europe and North America was also racially or ethnically coded.[50] However, here in the case of Puerto Rico, there were elements common to a colonial practice whereby the colonizer's rhetoric of paternalism and "helping" the colonized justifies the economic or politically oppressive conditions initiated or at the very least exacerbated by the very colonizer.

Indeed, such a view might be extended as explanations for the economic "success stories" of Puerto Rico that continued well into the 1950s and that employed contrasting photographs as factual testimony of the accomplishments of "Operation Bootstrap" ("Operación Manos a la Obra"). In this US government program industrial tax exemptions and the expansion of public debt to finance welfare programs ignited a minor boom period, while actually doing little to establish the long-term economic stability of the island.[51] These success stories can be "measured" for example by the differences in the photo-chapters *Life* magazine published between 1943 and 1953, in which the Island was pictured as being transformed from "unsolvable problem" to a "New Puerto Rico" with a "new spirit of energy and pride."[52] The question here isn't whether such measures helped improve the health and living conditions of individuals, but how photography facilitated a rhetoric of "improvement" and "transformation" which served nationalist and colonial concerns alike. Many of the photographic reports and guides by government agencies of the 1930s and 1940s, such as the PRRA and FSA, had clearly already laid the groundwork and facilitated these later "success stories."

Precisely how did the PRRA and FSA rhetoric of betterment facilitate a social program of rural rehabilitation aimed at transforming the lives of subjects cast as *jíbaro*s? While qualifying for FSA benefits meant having to show agricultural experience, as well as documents of ownership, rent, or residency on the land, it was easier to qualify for assistance from the PRRA.[53] Yet, in order to qualify for land subsidies one had to demonstrate a proficiency of sorts which generally meant submitting to one of the PRRA training programs that had been set up in the approximately nineteen work camps across the interior of the island to train and retrain farmers. The workers trained for six months, during which time they earned $1.00 per eight-hour day (minus 25 cents which went for a payment of a balanced diet).[54]

A report of 1938 defended the work camps of the PRRA by describing how these differed from Civilian Conservation Corps, and how they had transformed the lives of

the *jíbaro* into *la nueva jibarada* (the new *jíbaro* movement). The report's defense constructed an entirely new picture of the *jíbaro* by describing his contentment at being moved away from his hilltop *bohíos* to the new work camps or hurricane-proof homes. (Here the gender specific is appropriate, as will be shown). The report manifests very well the construction of a new definition of the *jíbaro* and his home through a PRRA political rhetoric of land tenure and development. The report's segment dealing with the *jíbaro*'s home merits reproduction almost in full:

> It is touching to see how our *jíbaro*, whom many wish to know but pass their entire lives without ever really knowing, understands how to respond with a deep sense of discipline and duty to the regimentation of work and cultivation which was imposed on him in the work camps. As with all *campesinos* everywhere, the Puerto Rican *jíbaro* knows how to assume and fulfill his responsibilities when he is not abandoned but rather when he is given proper attention. The work camps have demonstrated this much and in this way the intelligent observer can adduce upon seeing the desire for self-improvement by those of the *nueva jibarada* who have abandoned their *bohíos*, and moved away from their wives and families to the constructed seclusion of the work camps for six months; and he has moved again, carrying with him his dreams and ambitions conceived [in the camps], to his new small house of concrete, brick or wood, where his families waited, and was there advised by a Social Worker . . .
>
> The *jíbaros* in the work camps, removed temporarily from their mothers, wives and children, felt happy because they knew that there they incubated a better future; a home for the family; lands for their children to inherit, and the knowledge of the best ways of cultivating it; medical services for their health; and social services for moral strength.[55]

Thus, the language of the transformation of the geography and housing was extended to describe the personal outlook, health, and moral character of the *jíbaro* as all too happy to accept this new way of life. The photographs of the workers in the PRRA camps and new housing constructions more frequently show individuals at labor, or the crops that were the products of their labor. Fewer are the images showing camp workers at rest or in leisure activities (as in, for example, Arthur Rosthstein's photographs of Migration Labor camps of 1940).

The PRRA, with its social workers and overseers, also continued to direct a project of home education and hygiene even after the workers had left the work camp or mountain *bohío* for one of the new hurricane-proof homes. PRRA also had a hand in the regimentation of new divisions of labor whereby numerous female members of families receiving PRRA benefits were employed in needle and artisan workshops within the home, such as in figure 13.10 showing a woman at needle work in a PRRA constructed house, with PRRA-funded workshop furniture. There is much here in regards to the representation and construction of gendered hierarchization of labor, as demonstrated by the earlier figure 13.7, in which a *jíbaro* timidly stands at the door while a visiting social worker confers with women in the interior of one of the new PRRA homes. However, it is clear that photographs such as these served to bring representations of female labor roles into the fold of US-led policies of rural reform, while

simultaneously reinforcing a traditional, male-defined idealization of domesticity, and its part in the formation of national identities.[56]

Left out of this picture of contented order, hygiene, and betterment are any indications of the numerous agrarian groups and syndicates that were opposed to the PRRA initiatives from the start, or the drastic cultural breaks and discontinuities that are rendered invisible by the optimistic language of change. Understandably, a language openly suggesting a complete rupture with the past, and hence of denying the cultural continuity of a people (instead of a transitional language of modernization and betterment), would have been problematic. In either case, it would be difficult to imagine

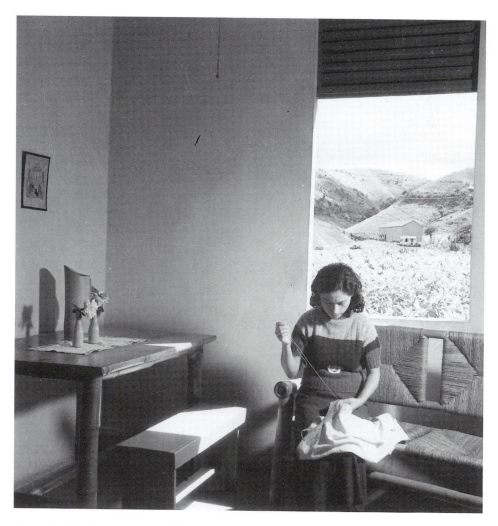

Figure 13.10 Edwin Rosskam, *Wife of PRRA Resettler*, January 1938. Caption reads: "Wife of resettler in her hurricane-proof house, doing needlework (homework for cash income). The furniture was locally built on local materials under P.R.R.A. (Puerto Rico Resettlement [*sic*] Administration) guidance. Outside the window a tobacco field and a tobacco barn. La Plata project, Puerto Rico."

how such a move could have been made without risking aggressive, if not violent protests. For this reason, the circulation of photographs and the language of change were no doubt largely aimed at island administrators, and in turn, through the circulation of internal reports and drafts, at corporate heads with an interest in the island's industrialization. In other words, these photographs and their accompanying literature were in no way intended for those "three-quarter" of the island's "problemed" population, namely the agrarian, rural workers, or *jíbaros*. Yet even Governor Tugwell recognized the negative aspects of (US intervening) industrialization on the lives of Puerto Ricans. In a double move of sympathy and condescension, he praised the *jíbaros* for knowing what the supposedly more sophisticated moderns could not: "Hence the tragedy – a people lost to both cultures, the old and the new. The slum dwellers scarcely had the ingenuity to make a chair out of a packing case; yet they were descendants of a people who, with a few primitive tools, had had the wit to exploit nature in the Puerto Rican hills for four centuries."[57]

We have thus far examined the historical significance of the representation of particular forms of labor and housing in Puerto Rico during the 1930s and 1940s. However, those forms of representation cannot be understood without a closer examination of some of the political and economic conditions which brought Puerto Rican and US mainland government agencies to photograph the work camps and the rapidly growing slums which were quickly becoming, as Tugwell described, the new homes of the *jíbaros*.

The depression of the late 1920s and early 1930s had exposed and made tenuous US domination over the island.[58] By 1928, importation of vegetables to Puerto Rico had increased by almost 1200 per cent, and there had been a 300 per cent increase in utilization of land for sugar production[59] (at the expense of coffee production in the interior). This had set in motion internal migrations of small coffee and vegetable growers of the mountain regions (that is, those populations considered as *jíbaros*) to seek urban employment or work in the sugar industry located principally along the coastal savannas. There was a minor boom period for sugar production during these years. First, tariff protections enjoyed by Puerto Rican sugar manufacturers allowed them to pick up much of the profits within non-protected markets, namely those in Cuba. Second, the Puerto Rican sugar industry had withstood the 1928 and 1932 hurricanes that had devastated most other crop productions such as coffee, tobacco, and fruit. Yet, as the island's sugar market was increasing, the working conditions and wages of sugar laborers had worsened in order to offset trade effects of the Depression which exacerbated the already grim situation. Food prices had risen dramatically while wages were decreased by almost half, even though the average number of working hours in the mills had increased during high season to twelve-hour shifts seven days a week.

During the 1930s, the large absentee US corporations dominating the sugar industry in Puerto Rico had been backed by the coalition of the Republican Union Party and the Socialist Party. The coalition of the two parties desired eventual statehood for the island. Nonetheless, much of that coalition was hostile to New Deal programs in Washington, as well as to the Liberal Party in Puerto Rico that sought increased political autonomy.[60] Added to these political party tensions was increased union activism by the American Federation of Labor (AFL), and the Free Federation of Workers (FLT). This latter union was a leading organization of resistance for artisans and

sugar workers on the island in the 1930s until the organization of the General Confederation of Workers (Confederación General de Trabajadores, or CGT) in 1940 (later demonstrations of the CGT were photographed by Delano while on FSA assignment, as in the clearly posed group in figure 13.11).

Meanwhile, threats of land reforms were increasingly heard. Among the principal builders of Puerto Rico's economic reform plans was the liberal Carlos E. Chardón, whose plan, now known as the Chardón plan, was announced in March of 1934 and struck a deep and terrifying chord within the halls of the sugar corporation offices. Among the most significant threats to these sugar corporations was the menace of enforcement of the 500-Acre Law, previously easily circumvented. Chardón's plan allowed for eminent domain of the insular government to take over and redistribute to individual farmers land plots of over 500 acres.

Thus, by 1934, on the heels of the Great Depression, the threatened stability of US-owned absentee sugar corporations and the increased hours and poor working conditions and wages for plantation laborers had created a climate rife with frustration and dissatisfaction on all sides. Early that year, aggravated by taxes on agricultural products, a wave of sugar cane workers' strikes rolled across the island.[61] Workers protested the 50 cents for the daily twelve-hour shifts without breaks. Attempts at resolutions by various sugar cane and agricultural groups under the umbrella union of the Free Federation of Workers (FLT) failed and within a period of several days in mid-January of 1934 all the major *centrales* (sugar refinery mills) were brought nearly to a halt because of laborers' strikes.

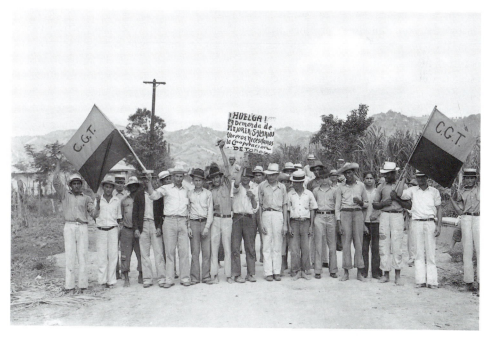

Figure 13.11 Jack Delano, *Sugar Strikers Picketing a Sugar Plantation* (Yabucoa, Puerto Rico), December 1941.

The Liberal Party, meanwhile, was divided on the question of participation or boy-cott of the upcoming 1936 elections and over the question of statehood or territory status. Luís Muñoz Marín formed a faction group within the Liberal party in 1936 called the Pure, Authentic and Complete Liberal Party that by 1938 had emerged as the Partido Popular Democrático (Popular Democratic Party), or PPD (the same party whose posters appear in Rosskam's later *Shack in Puerto Rico*). The more radical polit-ical party of the Nationalists, founded 1922 and led by the later imprisoned Albizu Campos, never acquired large popular appeal owing to its more openly militant strate-gies for independence and, more importantly, because of the government's suppression. Indeed riots and Nationalist uprisings had occurred in 1934, and that party's peaceful demonstration of 1937 in Ponce turned into a bloodbath when the insular police gave orders to fire upon unarmed marchers. What followed was the highly politicized trial photographed by Rosskam (figure 13.3), which resulted in the imprisonment of the Nationalist Party's leadership.

It is in the vacuum of the failed coalition of parties and the repression of the Nationalists that the PPD emerged. The PPD platform was constructed during a period of intense economic transformation – one that sought to resolve the problems of a fail-ing colonial project shifting from agrarian-based production to industrial commercial labor. Although at first a staunch advocate of independence, by the 1940 election cam-paign Muñoz Marín and the PPD felt that economic rehabilitation and industrialization developed by US-owned corporations should be dealt with first before considering the question of the island's sovereignty. Muñoz Marín argued that, for independence to become a reality, the island had to settle its economic situation first. Thus, the status question became a secondary issue for Muñoz Marín and the PPD, and he chose instead to focus on the problem of alleviating the economic structure within the colonial situation. Industrialization (namely a restructuring of US-owned capital) was presented by the PPD as having the greatest possibilities for jobs and future economic stability.[62] For the most part this tended to please US administrations since it no longer put to public test the island's status or the question of colonial hege-mony. Moreover, the PPD's platforms reflected and indeed promoted the strategic interests of those groups within the US that were linked to Puerto Rico's economies. Yet the PPD's political strategies on the island were reformist and populist-based.[63]

Muñoz Marín in his electoral campaigns lashed out at the foreign-owned sugar plan-tations, while he focused his attention on the most visible signs of the lack of the needs of the *campesinos* and rural workers, that is *jíbaros*. He adopted the straw-hatted ("Pava") *jíbaro* as his principal image and ran with the slogan "Pan, tierra y libertad" (Bread, Land, and Liberty), which followed the Mexican revolution's "land and lib-erty" and Russia's "peace and land." The PPD's adoption of the straw-hatted *jíbaro* symbol – seen in Rosskam's 1944 *Shack* photograph discussed earlier (figure 13.1) – thus was intended to articulate a discourse which suggested the *partido*'s social agenda of affiliation with the poor barefoot mountain region *campesino* and the coastal sugar cane worker. Simultaneously, this iconic image maintained the party's wish for greater US industrial investments at a time when the US's long-term military and economic interests of maintaining stability in the colony had been threatened by strikes and Nationalist demonstrations. These conflicting agendas came to focus on the image of the *jíbaro* as laborer and national symbol, and which was shaped by some of the key texts by Puerto Rican intellectual writers of the 1930s discussed above. As argued by

Lillian Guerra, the *jíbaro* concept came to be employed as "a refuge of the elite's own invention" during the Americanization process of this period, as the Puerto Rican elite attempted simultaneously to distinguish and distance themselves from North American hegemony while disavowing their involvement in class oppression.[64]

Unlike many political slogans of the PPD's populist, pro-labor counterparts in Mexico, Cuba, or Russia, the machete – the principal pre-mechanization tool of the sugar cane cutter photographed often by both Delano and Rosskam (figures 13.12 and 13.13) – is significantly absent in the PPD imagery. The tool had been adopted as title and symbol in 1924 Mexico by the Syndicate of Workers, Painters, and Sculptors for their magazine *El Machete*, had played a role in the Puerto Rican communist party iconography, while the term *Macheteros* in Puerto Rico identified the group of insurgents (often identified as *jíbaros*) in the years immediately following

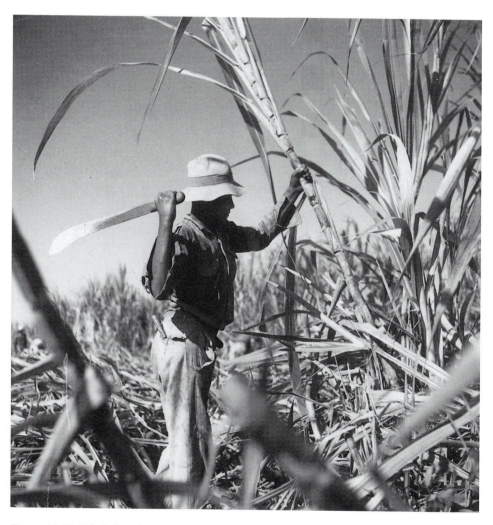

Figure 13.12 Edwin Rosskam, *Cutting Cane on a Sugar Plantation* (vicinity of Ponce), January 1938.

305

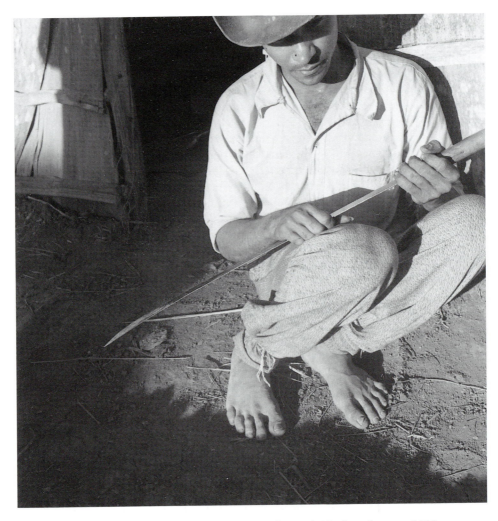

Figure 13.13 Edwin Rosskam, *Jíbaro Tobacco Worker with Machete*, January 1938.

the American occupation of 1898. Like the hammer and sickle that became indexes to the peasant worker bound to industrialized labor and agrarian land production, so too was the machete and straw-hat iconography purposefully linked to the social- ist and populist labor movements of these countries. Muñoz Marín rejected aspects of this iconography in favor of one that suggested the imagery of the earth, home, and hearth. In this way, *El Batey*, a term denoting the *jíbaro*'s small-farm, home compound, came to be the name of the PPD paper. Muñoz Marín's adoption of the *jíbaro* and *batey/bohío* imagery suggests not only a distancing from the potential connotations of violence emerging from other pro-independence groups (or at least from the Marxist or socialist connotations of the slogan and machete as Governor Tugwell himself recognized[65]), but also a strengthening of the US-linked policy with which he ran his campaign.

306

The PPD's uses of *batey* imagery, and of a "kinder, gentler" *jíbaro* now without the machete, suggests more than the domestication of the laborer; more importantly, they tie the *jíbaro* imagery to a lengthy rhetoric and highly problematic debate over the pacification (Americanization) of Puerto Ricans as docile (hence the perception of Puerto Rico's inability to form a sustainable independence movement or even to decide a political status beyond commonwealth).[66] We can understand how government administration photographs of the era could easily have been incorporated into this rhetoric of "docility."

Given the PPD's populist platform, the magnitude of the PRRA building program of hurricane-proof housing and work camps; and given the significant migrations which brought displaced Puerto Ricans "from the hills" to these new work camps, new *urbanizaciones* (tracts of homes), and urban slums, there seems little doubt that Rosskam would not have understood the significance and many of the rich connotations of the imagery of the PPD political poster on the "shack" which attracted his attention about 1944 while working for Governor Tugwell's Office of Information. (Although, we should be careful to add, he may have been ignorant of the image's historical significance, and his attention might have been drawn initially by something as simple as the lighting.)

Nonetheless, then, as now, the photographs of *bohíos*, *bateys*, or individuals at work acquired meanings through relations facilitated by discursive arenas. In other words, the images were already partially circumscribed by labels such as "photograph," "labor," or "documentary," not to mention *jíbaro* or *puertorriqueño*. These labels function not only in relation to one another, but also to the photographs' arenas of circulation such as "government agency file," or "annual report," and which had their own specific forms of practices (as opposed to, for instance, "painting," "salon," etc.).[67] Administrators in Puerto Rico or Washington, DC may have been able to control the physical limitations of the publication layouts, design, and files of the photographs in developing a rhetorical strategy of transformation, modernization, and of the constitution of a new electoral territory. Yet, they could not totally manage the circulation of photographs once out of their office and lent out to other agencies or individuals. Neither could they prevent the possibilities for unwanted relational meanings that arose from other juxtapositions and contrasts (the strategy upon which their own rhetoric depended.) Hence, the *jíbaros* and their related *bohío/batey* home-compounds had the potential for being read not only as significant cultural symbols, or the bases of a new labor force and electorate for a populist party with economic ties to US corporate policies, but also as the foundations of a violent, striking labor class, or even possibly a renewed *machetero* insurgency.

That so few publications of union activities or dissent were ever used in publications, and that the emphasis in many government articles was upon the *jíbaro* who was all too content to move to "a better place to live" (through compositions contrasting the "before" and "after"), suggests at least some of the strategies on the part of government agencies such as PRRA at the containment of meanings.

The question isn't, therefore, of the validity or greater truthfulness of the images' formal languages or critical languages; of whether, for example, Rosskam's 1938 photograph of a *jíbaro* tobacco worker with machete (figure 13.13) is a sympathetic imaging of a despondent, poor laborer at rest in front of his shack. This reading is enhanced by the downward, closely cropped and carefully composed composition of a figure in a tightly curled position and pushed to the right edge of the picture frame,

and whose machete attribute follows the diagonal of the shadows that divide the photograph into two dramatically lit, contrasting halves. Neither is the question whether this image represents the truthfulness of the island's economic conditions at the time. Rather, the question is how the languages of the photograph played a role in the stakes of varied social, cultural, or political positions. These positions, then, as places of power or resistance, of negation or forgetfulness, of loss or recuperation, were tied to the languages of both that photograph's imaged space – the dirt floor and shack the *jíbaro* sits upon and inhabits – and the discursive spaces in which the image circulated. Both of these were unstable spaces of migrations and transformations: Of the migrations that brought him to be constructed as a white male, of the mountainous interior region of the island, while the female laborers were moved inside the new homes or needle factories; of the migrations of the Afro-Puerto-Ricans from these discursive spaces; and of the migrations of (now white) Puerto Ricans to the foreground of a debate concerning the island's status as a territory in light of the massive industrialization of US corporation, that would by the late 1940s begin yet another major migration of Puerto Ricans to the mainland; and finally of a critical language of contrasting and comparing photographs – a language of before/after and of betterment – and which spoke of a real migration as well as migration of photographs across agency and files. Thus the definition and importance of the locale (of the local), as a physical as well as discursive site, is critical here. But it is also becoming aware, in the words of James Clifford, of the differences of "various inscriptions, 'places', 'histories' that both empower and inhibit the construction of theoretical categories." Location, as he stated, "is not a matter of finding a stable 'home'."[68]

The open door of the *bohío* in Rosskam's photograph invites us into a traditional, cultural space, as well as a problematic, colonized site that may serve also as a site of resistance. We need not problematize here the uses of pictorial space as metaphor for discourses of 1930s and 1940s government agency photographs; in the case of Rosskam's photograph, the choice of the metaphor of the house and home-plot is appropriate since it was precisely the strategy of certain US government administrations and Puerto Rican intellectuals of the 1940s (a "better place to live" as both home and as a new Puerto Rico). The difference in reading the same space either as colonial, or as a site of resistance is not entirely dependent on the historical conditions of the discursive frame, nor are they mutually exclusively of one another (although acts of transgression recorded in historical texts must be clearly distinguished from acts of resistance by present methods or counter-readings).

The *bohío* and *batey* were the traditional home places of the *jíbaro*. Bell hooks has defined the notion of homeplace as one that, "however fragile and tenuous (the slave hut, the wooden shack)" and in spite of oppression and domination, has a "radical political dimension."[69] If, as has often been said, one can never return home, it must be because there is no fixed home to which one may return; rather, that home is only the desire of the unimaginable real; or possibly memory as constructed by the desire for the recuperation of a felt loss.

In the encounter with Rosskam's photograph, there is both a return and a displacement. Return here has at least two meanings with which we might close our discussion. It refers, on the one hand, to the recuperation and reconsideration of texts from a specific historical archive. On the other, it refers to the desires and conditions that are

involved in revisiting this photograph's themes and properties here and now. As I write this chapter, almost two years after the island's latest plebiscite over its political position as a "Commonwealth" territory, the long-term status of the US Navy's bombing and maneuvers on Vieques (the island off Puerto Rico) and its permanent residency on the island are still in question. Further, it is written almost two decades into an active "casitas" movement in New York city where Puerto Rican residents there began in the 1980s to appropriate abandoned plots and construct "little houses" – reconstructions on a smaller scale of the *bohío* structure pictured in Rosskam's photographs – as a mnemonic sign, an articulation of cultural solidarity, and resistance against their own displacement within the metropolis.

Thus I find myself in front of Rosskam's photograph wavering over the choices (perhaps in parody of that older characterization of "docility"). Of course, I could choose not to enter, to remain outside, on the surface of the photograph as it were and risk homogenization with numerous other types of government agency photographs. The open and shut doors both distance and invite me to step into the *bohío's* interior. If I choose to enter it will not be to find a true *jíbaro*, but neither will I find a totally emptied space. The shack's emptiness may even signal to some a certain melancholy, as if in the owner's or inhabitants' absence there is signaled the displacement of *jíbaros* and other workers that had already begun to occur by this date on and off the island. (By 1947, a separate office of the Puerto Rican Department of Labor was created in New York to begin to deal with issues of employment for increasing numbers of émigrés.) To enter this shack is to reoccupy that space and begin to understand the tensions between locally constructed cultural representations and those of dominant, international languages. To enter is also to create tensions among relational meanings extant in the historical texts subsumed within the archives. But it is also to bring to this site other images, other histories of displaced inhabitants who have appropriated similar forms and which will create their own relational meanings and tensions (even at the risk of subsuming and appropriating the regional into languages of globalization). To step inside this space is purposely to provoke such tensions. In this move, the authority and legitimacy of the photograph and its archive may be put into question, even resisted, and used to disclose colonial sites of production.

Notes

1 Ernesto Juan Fonfrías was a lawyer, poet/writer, one of the founders of the Partido Popular Democratic (1938), and served as senator from 1948 to 1960. He was one of the more prolific writers on the theme of the *jíbaro*, having published *Conversao en el Batey: Historia de un Jíbaro Bragao* (1956) and *Presencia Jíbara desde Manuel Alonso hasta Don Florito* (1957).

2 On the construction of the island's inhabitants by an array of colonial instruments during and after the Spanish-Cuban American War, see Kelvin A. Santiago-Valles, *"Subject Peoples" and Colonial Discourses: Economic Transformation and Social Disorder in Puerto Rico, 1898-1947* (Albany: State University of New York Press, 1994).

3 The majority of these are now filed in the photographs division of the Library of Congress, the National Archives (College Park, MD), the General Archives of the Instituto de Cultura Puertorriqueña (San Juan), and the Colección Puertorriqueña of the Library of the University of Puerto Rico, Rio Piedras.

4 Alan Trachtenberg, "From Image to Story: Reading the File," in Carl Fleischhauer and Beverly W. Brannan, eds, *Documenting America, 1935–1943* (Berkeley: University of California Press, 1988), 50.

5 For a critique of this reductionism of New Deal "documentary" photographs, see John Tagg, "The Currency of the Photograph: New Deal Reformism and Documentary Rhetoric," in his *The Burden of Representation: Essays on Photographies and Histories* (Minneapolis: University of Minnesota Press, 1988), 153–83.

6 The phrase "smooth space of hegemonic, metropolitan enunciation" is that of Alberto Moreiras in his questioning the role of post-colonial Latinamericanism as "a form of antiglobal epistemic practice geared toward the articulation and/or production of difference through expression of an always irreducible if shifting distance from the global." "Global Fragments: A Second Latinamericanism", in Fredric Jameson and Masao Miyoshi, *The Cultures of Globalization* (Durham and London: Duke University Press, 1998), 84.

7 Gayatri Chakravorty Spivak, "Subaltern Studies: Deconstructing Historiography," in *In Other Worlds: Essays in Cultural Politics* (New York and London: Routledge, 1988), 203.

8 "Post-colonial" refers here to a post-world war period and a theoretical practice, rather than suggesting that Puerto Rico ever emerged from its political status as a colony.

9 According to one source, Rosskam was sent to Puerto Rico to record the events and trial following the Ponce massacre of 1937 for a United States magazine. For reasons unknown, the magazine never published these – perhaps for fear of political backlash. J. M. Toro Nazario, "Una exposición fotográfica documental se inaugura mañana lunes en la Universidad de Puerto Rico," *El Mundo* 28, 10487 (February 3, 1946): 5, 10.

10 Jack Delano's nostalgic publication *Puerto Rico Mío* recreated with a historical twist the photo-textual documentary publications of the 1930s by contrasting the FSA and Office of Information photographs he took during the 1940s with those he recorded in the 1980s. Jack and Irene Delano were additionally important for their setting up various cinema and printing workshops on the island. Jack Delano, *Puerto Rico Mío* (Washington, DC: Smithsonian Institution Press, 1990). For one record of the impact of Jack and Irene Delano in Puerto Rico see Nelson Rivera's *Visual Artists and the Puerto Rican Performing Arts, 1950–1990* (New York: Peter Lang, 1997). For their workshops in context see also Marimar Benítez, "El caso especial de Puerto Rico," in Museo de Artes del Bronx, *El espíritu latinoamericano: arte y artistas en los Estados Unidos, 1920–1970* (New York: Harry N. Abrams, 1988), 79–80; and Shifra Goldman, "Under the Sign of the Pavas: Puerto Rican Art and Populism in International Context" (1988), republished in her *Dimensions of the Americas: Art and Social Change in Latin America and the United States* (Chicago: University of Chicago Press, 1994), 416–32.

11 Jack Delano, *Photographic Memories* (Washington, DC: Smithsonian Institution Press, 1997), 29–31.

12 J. M. Toro Nazario, "Una exposición fotográfica documental": 5 and 10; Also, Delano, *Photographic Memories*, 112–43ff.

13 Although the catalogue *Official Images* looked at numerous government agencies outside of the FSA that employed photographers, it did not analyze the effects and significance of this in terms of the circulation of photographs. Pete Daniel, Merry A. Foresta, Maren Stange, and Sally Stein, *Official Images: New Deal Photography* (Washington, DC: Smithsonian Institution Press, 1987).

14 John Tagg, rather, has argued for the "absolute continuity of the photographs' ideological existence with their existence as material objects whose 'currency' and 'value' arise in certain distinct and historically specific social practices and are ultimately a function of the state." "Currency of the Photograph" in Tagg, *The Burden of Representation*, 165.

15 Fleishhauer and Brannan have suggested the importance of the differing geographic and cultural regions photographed by FSA employees; however, they never analyzed this element. "Introduction" in Carl Fleischhauer and Beverly W. Brannan, eds, *Documenting America, 1935–1943*, 10.

16 Alan Trachtenberg has questioned the use and meaning of "documentary" as a way of capturing some essential, fictional Americaness, such as in Walker Evans's *American Photographs*. Alan Trachtenberg, "Walker Evans's America: A Documentary Invention", in David Featherstone, ed., *Observations: Essays on Documentary Photography* (Carmel, CA: Friends of Photography, 1984), 56–66. Elsewhere, he has stated that "unity of time and place gives us no particular assurance of the truths of time and unity." Trachtenberg, "From Image to Story," in Fleischhauer and Brannan, ed., *Documenting America, 1935–1943*, 70.

17 Delano, *Photographic Memories*: 58–9.

18 The Puerto Rican *jíbaro* is not associated with the indigenous Jíbaros of South America; however, historically the terms are linked by confusion. Some of the more important and helpful sources are: Enrique A. Laguerre and Esther M. Melón, eds, *El jíbaro de Puerto Rico: símbolo y figura* (Sharon, CT: Troutman Press, 1968); Ana M. Ortiz Salichs and María Hernández Rodríguez, *El jíbaro puertorriqueño: bibliografía mínima* (Ponce: Centro de Estudios Puertorriqueños, Colegio Universitario Tecnológico de Ponce, 1989). The most detailed study is the recent work of Lillian Guerra, *Popular Expression and National Identity in Puerto Rico: The Struggle for Self, Community, and Nation* (Gainesville: University Press of Florida, 1998).

19 For example, Ramón Frade's work *Nuestro pan* (1905; Ponce, Museo de Arte) extends the theme of the rural laborer, whose machete and green plantains suggest his dependence upon the fruits of the land, in this case, the banana plantations probably owned by absentee land-lords. The title's use of the first person plural "our" suggests not only references to Christian prayer but also implies solidarity, or empathy, with those of the same class and situation. In contrast to Frade's work, which to a greater extent focuses on the banana-producing plantations and its laborer, the works of Francisco Oller (1833–1917) concentrate on the wealthier haciendas and *centrales* (sugar refineries). For these two artists see Osiris Delgado Mercado, *Ramón Frade León, pintor puertorriqueño (1875–1954)* (Santo Domingo: Editora Corripio, 1988); and Museo de Arte de Ponce, *Francisco Oller: un realista del impressionismo* (San Juan and New York, 1983).

20 The last decades of the nineteenth century were a critical period for the transformation of the rural proletariat, a process that Quintero Rivera described as transition "from artisan to proletariat" but which Guerra has argued to be more of a "pauperization." Angel Quintero Rivera, "Socialista y tabaquero: la proletarización de los artesanos," *Sin Nombre* 8 (1978): 100–37; Guerra, *Popular Expression and National Identity*, 26.

21 Among these theorists are included: Alan Sekula, "On the Invention of Photographic Meaning" and Victor Burgin, "Looking at Photographs", in *Thinking Photography,* ed. Victor Burgin (London: Macmillan, 1982), 84–109 and 142–53; Victor Burgin, "Re-reading *Camera Lucida,*" (1982) in his *The End of Art Theory: Criticism and Postmodernity* (1986; reprint Atlantic Highlands, NJ: Humanities Press International, Inc., 1992), 71– 92; John Tagg, "The Proof of the Picture" (1988) and "Totalled Machines" (1989) in his *Grounds of Dispute: Art History, Cultural Politics and the Discursive Field* (Minneapolis: University of Minnesota Press, 1992), 97–115 and 115–33; and Tagg, *The Burden of Representation.*

22 Not uncommon are statements regarding FSA photography such as those on Delano's photography of Puerto Rico, which continue the myth of the photograph and layout as self-explanatory and transparent of a "true" essence of the Puerto Rican people: "Viewed in this new arrangement [in *Puerto Rico Mío*] the photographs speak without the need for external text." Alan Fern, "The Project," in Delano, *Puerto Rico Mío*: 15. See Delano's interesting views in opposition to this in his *Photographic Memories*, 55. Elsewhere, photographs for Lawrence Levine (in spite of his recognition of their manipulation) are not so much sites of contested power as much as an index to occluded or missing realities of the human condition: "Photographic images, like statistics, do not lie, but like statistics the truths they communicate are elusive and incomplete." "It is precisely the details which these photographs help us recover." Lawrence W. Levine, "The Historian and the Icon: Photography and the History of the American People in the 1930s and 1940s," in Fleischhauer and Brannan, *Documenting America*, 17, 23.

23 Miguel Pou, from Ana Valdejulli de Pou, *Miguel de Pou: su vida y su obra* (Barcelona, 1968, p. 167); quoted in Benítez, "El caso especial de Puerto Rico," in *El espíritu latinoamericano,* 79. Benítez has noted this racial separation in the work of Miguel Pou; however, is it is already evident much earlier in the works of artists such as Frade. The 1940 *Guide to Puerto Rico* published by the PRRA continued to affirm this racialization of the *jíbaro* by repeating the vision of Pedreira and Morales, who argued that the Afro-Puerto Ricans lived mostly on the coast and that "few have migrated to mountains." Puerto Rico Reconstruction Administration, Puerto Rico, *A Guide to the Island of Boriquén* (New York: The University Society, Inc., 1940), 112.

24 Guerra, *Popular Expression and National Identity*, 41–2; 83ff.

25 As indicated by the title of the self-congratulatory, photographic album *Our Islands and their Peoples*, published a year after the 1898 Spanish–American War, the island's inhabitants were viewed as property like the islands on which they resided. William S. Bryan, ed., *Our Islands and Their Peoples As Seen with Camera and Pencil* (New York and Chicago: Thompson Publishing Co., 1899).

26 Gayatri Chakravorty Spivak has seen the problem of the radical intellectual in the West as being caught between "a deliberate choice of subalternity, granting to the oppressed either that very expressive subjectivity which s/he criticizes, or instead a total unrepresentability." "Subaltern Studies: Deconstruction Historiography", in *In Other Worlds*, 209; see also her "Can the Subaltern Speak?" (1988), reprinted in Bill Ashcroft, Gareth Griffiths, and Helen Tiffin, ed, in the *Post-colonial Studies Reader* (London and New York: Routledge, 1995): 24–8.

27 The "logical negation" to this either/or situation is the response produced by "the discourse of postmodernism" which, Spivak feels, "leads to an emptying of the subject position." Spivak, "Subaltern Studies: Deconstruction Historiography": 209. For further criticisms of this dichotomy see the introductory discussion by Ashcroft, Griffiths, and Tiffin, *The Post-colonial Studies Reader*: especially 8–9.

28 The term *jaibería*, from the word *jaiba*, or mountain crab, suggests the sideways movement of the crab to connote a politics of non-confrontation and even evasion. Ramón Grosfoguel, Frances Negrón-Muntaner, and Chloé Georas, "Beyond Nationalist and Colonialist Discourses: The *Jaiba* Politics of the Puerto Rican Ethno-Nation," in *Puerto Rican Jam: Essays on Culture and Politics*, eds Frances Negrón-Muntaner and Ramón Grosfoguel (Minneapolis: University of Minnesota Press, 1997): 26ff.

29 Victor S. Clark, ed., *Porto Rico and its Problems* (Washington, DC: Brookings Institute, 1930), quoted in Manuel Maldonado-Denis, *Puerto Rico: A Socio-historic Interpretation* (NY: Vintage Books, 1972), 74.

30 Lot 6982, Photographs Division: Library of Congress. It is unclear whether the photographs were taken by Clark, or others.

31 José C.[olomban] Rosario, *The Development of the Puerto Rican Jíbaro and his Present Attitude towards Society* (San Juan: University of Puerto Rico, 1935), 5.

32 Pedreira saw two critical moments in the development of the literature on the *jíbaro*: the first was a period of developing nationalism and a search for the defining characteristics of Puerto Ricans in the last decade of the nineteenth century; the second period began in the 1920s, a time of necessary reevaluation, and was tied to what he saw as the *jíbaro*'s disappearance. Antonio S. Pedreira, 'La Actualidad del Jíbaro', *Boletín de la Universidad de Puerto Rico* 6 (September 1935): 12, 16.

33 Antonio Flores, *Insularismo e ideología burguesa en Antonio Pedreira* (La Habana, Cuba: Casa de las Américas, 1979), 12ff.

34 Pablo Morales Otero, *Nuestros problemas* (San Juan: Biblioteca de Autores Puertorriqueños, 1947, 2nd ed.), 125.

35 Aspects of the Rothstein photographs controversy are discussed in James Curtis, *Mind's Eye, Mind's Truth: FSA Photography Reconsidered* (Philadelphia: Temple University Press, 1989): chapter four.

36 Bureau of Agricultural and Industrial Research, *Avenues of Approach: An introductory review of plans and projects which have been submitted to the P.R.E.R.A. in order to establish industries and to diversify farming in Puerto Rico on a balanced economic basis.* Typewritten manuscript, 1935. Library of Congress, Washington, DC.

37 Antonio M. Monteagudo and Antonio M. Escámez, eds, *Album de oro de Puerto Rico: obra de divulgación en pro de la fraternidad americana* (La Habana, Cuba: Talleres de Artes Gráficas, S.A., 1939).

38 Rosskam, quoted by Sherwood Anderson, "Hometown," in Edwin Rosskam, ed., *Face of America* Series (NY: Alliance Book Corp., 1940): 143. This work is discussed by Joanne Leigh George in *Imposed Integration: Identity and Layout in* 12 Million Black Voices (M.A. Thesis, Binghamton University, New York, 1996), who has examined the layout and design of Rosskam's publication. Walker Evans's quote is from *Walker Evans at Work* (New York,

1982) cited by Maren Stange, "'The Record Itself': Farm Security Administration Photography and the Transformation of Rural Life," in Pete Daniel et al., *Official Images: New Deal Photography* (Washington, D.C.: Smithsonian Institute Press, 1987), 1.

39 Produced in cooperation with the Writers Program of the WPA. PRRA, *A Guide to the Island*, vii.

40 The description is typical of the double move of constituting an "American" who is now a citizen but inferior: "The Jíbaro is an American citizen of whom relatively few Americans are aware and in whom they may take little pride. Although an American citizen, he knows not the meaning thereof and may not even be aware of the high honor thrust upon him by official decree. In his own circumscribed and prescribed thinking he is the same Jíbaro no matter what the citizenship, no matter what the form of government or by whom it is administered. He doesn't bother about citizenship; it is food that he wants." William H. Haas, "The Jíbaro, an American Citizen," *Scientific Monthly* 43 (July 1936): 33–46.

41 On the structure and workings of the PRRA, and other New Deal programs in Puerto Rico, one of the most helpful sources continues to be Thomas Mathews, *Puerto Rican Politics and the New Deal* (Gainesville: University of Florida Press, 1960), chapters 4–6; also useful is James L. Dietz, *Economic History of Puerto Rico: Institutional Change and Capitalist Development* (Princeton: Princeton University Press, 1986), chapter 3.

42 Puerto Rico Reconstruction Administration, *Interim Report on the Organization and Activities of the Planning Division*, ed. Earl Hanson (San Juan, Puerto Rico, 1936; Unpublished typewritten manuscript, Library of Congress); and "Personal Directivo al Iniciarse la PRRA. Epoca 1935–1936," in vol. 2 (1936) of *La PRRA según la prensa puertorriqueña: efemérides de la PRRA, 1935–1940*, a six-volume set of photographs, unpublished typewritten manuscripts, typed copies of newspaper daily reports, and other briefs concerning PRRA activities and progress between 1935 and 1940 (in the Colección Puertorriqueña, Library of the University of Puerto Rico, Río Piedras). This scrapbook collection of photographs and news briefs is clearly related to the two-volume photographic album in the National Archives (Record group 126-PRA). On the Asociación de Fotógrafos and its members, of which little has been written, see Osvaldo García, *Fotografía para la historia de Puerto Rico, 1844–1952* (Río Piedras: Editorial de la Universidad de Puerto Rico, 1989): 246, 280.

43 For example, one track of homes near the mountain town of Cayey comprised 78 houses of three to five rooms, while another near Ponce comprised 150. Yet, another near the town of Hato Rey was made up of some two thousand hurricane-proof houses which were to be rented for $8.50 monthly. Jaime Bagué, "Genesis, funciones y logros de la Administración de Reconstrucción de Puerto Rico" (p. 14), in *Efemérides de la PRRA* 2 (1936). This "Genesis, funciones y logros" manuscript appears to have been the basis for much of the US Puerto Rico Reconstruction Administration's *Rehabilitation in Puerto Rico, being an outline of the origins, of the functions and the accomplishments of the Puerto Rico Reconstruction Administration* (San Juan, Puerto Rico: Imprenta Venezuela, 1939).

44 Miriam del Carmen Lugo Colón, in an unpublished M.A. thesis in sociology, *Puerto Rico a traves del Lente: el discurso fotográfico durante la década de 1940* (Río Piedras: Universidad de Puerto Rico, 1992), analyzed the question of modernization and the social context of photography of the era, but did little with the "discourse of photography."

45 A criticism of this view is Gayatri Spivak's starting point in "Subaltern Studies: Deconstruction Historiography", 197; also Grosfoguel, Negrón-Muntaner and Georas, "Beyond Nationalist and Colonialist Discourses" in *Puerto Rican Jam*, 10.

46 For example, that of William Stott, *Documentary Expression and Thirties America* (New York and Oxford: Oxford University Press, 1973).

47 Toro Nazario, "Una exposición fotográfica documental," 5, 10.

48 Tagg, "God's Sanitary Law: Slum Clearance and Photography," in *The Burden of Representation*, 117–52.

49 Rexford Guy Tugwell, *The Stricken Land: The Story of Puerto Rico* (Garden City, NY: Doubleday & Company, 1947).

50 Tagg, "God's Sanitary Law", 133.

51 Dietz, *Economic History of Puerto Rico*, 309.

52 For a very brief discussion of the use of photo-essays on Puerto Rico during this later period of the years of "Operation Bootstrap" see James Guimond, *American Photography and the American Dream* (Chapel Hill and London: University of North Carolina Press, 1991), 182–4.

53 Francisco Ortíz, "Que es la FSA?", *El Mundo* (July 7, 1949, p. 9). Cited by Lugo Colón, *Puerto Rico a traves del Lente*: 24.

54 Regarding the work camps, Antonio Cruz y Nieves, "¿Que eran y que se han hecho los Campamentos de la Reconstrucción? Diferencia entre los CCC y Campamentos de la PRRA. Entrenamiento y selección . . . La nueva jíbarada. ¿Para que sirven ahora los campamentos?" Article from *El Mundo* (San Juan), September 11, 1938. Reproduced in *Efemérides de la PRRA 5* (1938): 3–4.

55 Cruz y Nieves, "¿Que eran y que se han hecho los Campamentos": 3.

56 How these programs may have been resisted, or implemented to promote a greater political or social presence for women is an interesting question that still needs to be addressed. For two insightful studies on the corresponding question of gender and sexuality in relation to early-nineteenth-century labor organizations and suffrage see: Eileen J. Findlay, "Free Love and Domesticity: Sexuality and the Shaping of Working-class Feminism in Puerto Rico, 1900–1917," in Aviva Chomksy and Aldo Lauria-Santiago, eds, *Identity and Struggle at the Margins of the Nation-State: The Laboring Peoples of Central America and the Hispanic Caribbean* (Durham and London: Duke University Press, 1998), 259; and Gladys M. Jiménez-Muñoz, "'So We Decided to Come and Ask You Ourselves': The 1928 US Congressional Hearings on Women's Suffrage in Puerto Rico," in Negrón-Muntaner and Grosfoguel, eds, *Puerto Rican Jam*, 140–65.

57 Tugwell, *The Stricken Land*: 120.

58 James Dietz (*Economic History of Puerto Rico*: 136) has written that workers', nationalists', and students' struggles arose when they did because of the severe crisis of the colonial model of development; in other words, he states, "The coming of the Great Depression simply made manifest the severity of the conditions that debilitated the island economy; it did not create or invent them."

59 Frank Tannebaum, "Los ultimos treinta años, 1898–1930: un manuscrito inédito de Frank Tannebaum sobre Puerto Rico," *Boletín del Centro de Investigaciones Históricas* 7 (1992): 165–207; cited by Guerra, *Popular Expression and National Identity*, 31–2.

60 Dietz, *Economic History of Puerto Rico*, 148–50.

61 It has been estimated that between 1931 and 1934 the number of workers per year involved in strikes increased from less than three thousand to over fifty thousand. A. D. Gayer, Paul T. Homan, and Earl K. Jones, *The Sugar Economy of Puerto Rico* (New York, 1938), 223, and other reports, cited by Dietz, *Economic History of Puerto Rico*: 164. Kelvin A. Santiago-Valles (*"Subject Peoples" and Colonial Discourses*, especially 150ff and chapter 7) has also calculated and analyzed the dramatic increase in, and the rhetoric of, violent crimes after 1934 and their relation to the construction of colonial subjects.

62 Emilio Pantojas García, "Puerto Rican Populism Revisited: The PPD during the 1940s," *Latin American Studies* 21 (October 1989): 551.

63 The PPD gained a broad alliance with a popular base by "presenting its reformist project as the alternative to the crisis of the sugar economy in which everyone gained something." After the colonial government's suppression of radical nationalists, and the failure of the PS–PR coalition to find a solution, the PPD "became the most appealing alternative both for the dominant and for the subordinate classes." Pantojas García, "Puerto Rican Populism Revisited": 554.

64 Guerra, *Popular Expression and National Identity*, 42, 75.

65 Tugwell, *Stricken Land*, 7.

66 This "literature of docility" was largely termed after the essay by René Marqués, "El puertorriqueño dócil" (The Docile Puerto Rican"), in *Ensayos* (Río Piedras: Editorial Antillana, 1972); for two early critics of this see Juan Angel Silén, *Hacía una visión positiva del Puertorriqueño* (Río Piedras: Editorial Edil, Inc., 1972), 199ff: and Flores, *Insularismo e ideología burguesa*.

67 "[T]he sites and the discursive practices they support are never isolated. Their interrelations

and hierarchies – 'Art', 'craft', 'mass communication', 'popular culture', 'folk art' 'subcultural styles' – also constitute levels of intervention demanding their own specific forms of practice." Tagg, "Introduction," in *Burden of Representation*, 31.

68 James Clifford, "Notes on Travel Theory," in James Clifford and Vivek Dhareshwar, eds, *Travelling Theories, Travelling Theorists*, vol. 5 of *Inscriptions* (Santa Cruz: University of California, Santa Cruz, 1989, p. 182). Cited by Tagg, *Grounds of Dispute*: 28.

69 Bell hooks, "Homeplace: A Site of Resistance," in *Yearning: Race, Gender and Cultural Politics* (Boston: South End Press, 1990), 41–9, quotations from 42, 43.

SELECT BIBLIOGRAPHY

Included here are recent works relevant to the overall theme of the anthology. Primary sources and additional books and articles on specific topics can be found in the endnotes for the essays.

Alloula, Malek. *The Colonial Harem*. Trans. Myrna and Wlad Godzich. Minneapolis: University of Minnesota Press, 1986.

The Art Gallery of New South Wales, Sydney. *Portraits of Oceania*. Exhibition catalogue with contributions by Judy Annear, Brenda L. Croft, Carol Cooper and Alana Harris, Paul Fox, and Michael Hayes. Sydney: The Art Gallery of New South Wales, 1997.

Ballhatchet, Kenneth. *Race, Sex, and Class under the Raj: Imperial Attitudes and Policies and Their Critics, 1795–1905*. London: Weidenfield and Nicolson, 1980.

Banta, Melissa and Curtis M. Hinsley. *From Site to Sight: Anthropology, Photography, and the Power of Imagery*. Cambridge, MA: Peabody Museum Press, 1986.

Banta, Melissa and Susan Taylor, eds. *A Timely Encounter: Nineteenth-century Photographs of Japan*. Exhibition catalogue with essays by Banta, Ellen Handy, Haruko Iwasaki, and Bonnell D. Robinson. Cambridge, MA: Peabody Museum Press, 1988.

Barringer, Tim and Tom Flynn, eds. *Colonialism and the Object: Empire, Material Culture and the Museum*. London and New York: Routledge, 1998.

Barthes, Roland. "Le Message photographique." *Communications* 1 (1961): 127–38.

Barthes, Roland. "Rhétorique de l'image," *Communications* 4 (1964): 40–51.

Barthes, Roland. *La Chambre claire: note sur photographie*. Paris: Gallimard Seuil, 1980. *Camera Lucida: Reflections on Photography*. Trans. Richard Howard. New York: Hill and Wang, 1981.

Bhabha, Homi K. "The Other Question: The Stereotype and Colonial Discourse." *Screen* 2, 6 (1983): 18–36.

Bhabha, Homi K. "Interrogating Identity: Frantz Fanon and the Postcolonial Prerogative." In *The Location of Culture* (London: Routledge, 1994).

Bhabha, Homi K. *The Location of Culture*. London and New York: Routledge, 1994.

Billeter, Erika. *Fotografie Lateinamerika von 1860 bis Heute*. Exhibition catalogue. Bern: Benteli, 1981.

Bourgeois, Claude and Michel Melot. *Les Cartes postales*. Paris: Éditions Atlas, 1983.

Brace, C. Loring. *Evolution in an Anthropological View: Collected Essays*. Lanham, MD: AltaMira Press, 2000.

Brantlinger, Patrick. *Rule of Darkness: British Literature and Imperialism, 1830–1914*. Ithaca, NY: Cornell University Press, 1988.

Çelik, Zeynep. *Displaying the Orient*. Berkeley: University of California Press, 1992.

Çelik, Zeynep and Leila Kinney. "Ethnography and Exhibitionism at the *Expositions Universelles*." *Assemblage* 13 (1990): 34–59.

Clifford, James. *The Predicament of Culture: Twentieth-century Ethnography, Literature, and Art*. Cambridge, MA, and London: Harvard University Press, 1988.

Clifford, James and George Marcus, eds. *Writing Culture: The Poetics and Politics of Ethnography*. Berkeley: University of California Press, 1986.

Cohn, Bernard S. *Colonialism and its Forms of Knowledge*. Princeton: Princeton University Press, 1996.

Coombes, Annie E. and Steve Edwards. "Site Unseen: Photography in the Colonial Empire: Images of a Subconscious Eroticism." *Art History* 12 (December 1989): 510–16.

Commonwealth in Focus: 130 Years of Photographic History. Festival '82, Australia. Victoria, Sydney, and Melbourne: Australia Council, arranged by the International Cultural Corporation of Australia Ltd, with assistance from the Royal Commonwealth Society, London; the Australia High Commission, London, the Department of Foreign Affairs; Department of Home Affairs and Environment and the Queensland Art Gallery, 1982.

Copely, Stephen and Peter Garside, eds. *The Politics of the Picturesque: Literature, Landscape and Aesthetics since 1770*. Cambridge: Cambridge University Press, 1994.

David, Deirdre. *Rule Britannica: Women, Empire, and Victorian Writing*. Ithaca and London: Cornell University Press, 1995.

Delacroix, Catherine. *Espoirs et réalités de la femme arabe*. Paris: L'Harmattan, 1986.

Dennis, Kelly. "Ethno-pornography: Veiling the Dark Continent." *History of Photography* (Spring 1994): 22–8.

Di Maria, Yves. *Guide practique de la carte postale*. Paris: Les Impressions CEPI, 1981.

Edney, Matthew H. *Mapping an Empire: The Geographical Construction of British India, 1765–1843*. Chicago and London: The University of Chicago Press, 1997.

Edwards, Elizabeth. "'Photographic Types': The Pursuit of Method." *Visual Anthropology* 3 (1990): 235–7.

Edwards, Elizabeth, ed. *Anthropology and Photography, 1860–1920*. New Haven and London: Yale University Press, 1992.

Fabian, Johannes. *Time and the Other: How Anthropology Makes Its Object*. New York: Columbia University Press, 1983.

Foucault, Michel. *L'Archéologie du savoir*. Paris: Gallimard, 1969. *Archaeology of Knowledge*. Trans. A. M. Sheridan Smith. New York: Harper & Row, 1976.

Foucault, Michel. "The Subject and Power," *Critical Inquiry* 8 (Summer 1982): 777–95.

Gates, Jr, Henry Louis, ed. *"Race," Writing, and Difference*. Chicago: University of Chicago Press, 1985.

Graham-Brown, Sarah. *Images of Women: The Portrayal of Women in Photography of the Middle East 1860–1950*. London: Quartet Books and New York: Columbia University Press, 1988.

Green-Lewis, Jennifer. *Framing the Victorians: Photography and the Culture of Realism*. Ithaca: Cornell University Press, 1996.

Guha, Ranajit, ed. *Subaltern Studies: Writings on South Asian History and Society*. New Delhi: Oxford University Press, 1982.

Guha, Ranajit and Gayatri Chakravorty Spivak, eds. *Selected Subaltern Studies*. New York: Oxford University Press, 1988.

Gutman, Judith Mara. *Through Indian Eyes*. New York: Oxford University Press, 1982.

hooks, bell. *Yearning: Race, Gender, and Cultural Politics*. Boston, MA: South End Press, 1989.

hooks, bell. *Art on My Mind: Visual Politics*. New York: The New Press and The International Center of Photography, 1995.

Jammes, Isabelle. *Blanquart-Evrard et les origines de l'édition photographique française: catalogue raisonné des albums photographiques édités, 1851–1855*. Geneva: Librarie Droz, 1981.

Krauss, Rosalind. "Photography's Discursive Spaces, Landscape/View." *Art Journal* 42 (1982): 311–20.

Krauss, Rosalind. "Notes on the Index," Parts 1 and 2. In Krauss, *The Originality of the Avant-Garde and other Modernist Myths*. (London: MIT Press, 1985), 191–219. Originally published in *October* 3,4 (Spring and Fall, 1977).

Levine, Robert M. *Windows on Latin America: Understanding Society Through Photographs.* Coral Gables, FL: North–South Center, University of Miami, 1987.

Lopez Mondejar, Publio. *Las fuentes de memoria: fotografia y cociedad en la España del siglo XXIX.* 2 vols. Barcelona: Lunwerg Editores, 1989.

Lorimer, Douglas A. "Race, Science, and Culture: Historical Continuities and Discontinuities, 1850–1914." In *The Victorians and Race*, ed. Shearer West (Aldershot: Scolar Press, 1966): 12–33.

Low, Gail Ching-Liang. *White Skins/Black, Masks: Representation, Colonialism and Cultural Cross-dressing*, London and New York: Routledge, 1996.

Lutz, Catherine and Jane Collins. *Reading National Geographic.* Chicago: University of Chicago Press, 1993.

McClintock, Anne. *Imperial Leather: Race, Gender and Sexuality in the Colonial Contest.* New York and London: Routledge, 1995.

MacKenzie, John M. *Orientalism: History, Theory, and the Arts.* Manchester and New York: Manchester University Press, 1995.

Marcus, George E. and Fred R. Meyers, eds. *The Traffic in Culture: Refiguring Art and Anthropology.* Berkeley: University of California Press, 1995.

Massin, Benoit. "From Virchow to Fischer: Physical Anthropology and Modern Race Theories in Wilhelmine Germany." In *Volksgeist as Method and Ethic: Essays on Boasian Ethnography and the German Anthropological Tradition*, ed. George W. Stocking, Jr. Madison: University of Wisconsin Press, 1996.

Metcalf, Thomas R. *An Imperial Vision: Indian Architecture and Britain's Raj.* Berkeley and Los Angeles: University of California Press, 1986.

Metcalf, Thomas R. *Ideologies of the Raj. The New Cambridge History of India.* Part 3. Vol. 4. Cambridge: Cambridge University Press, 1994.

Mitchell, Timothy. "Orientalism and the Exhibitionary Order." In *The Art of Art History: A Critical Anthology*, ed. Donald Preziosi. Oxford and London: Oxford University Press, 1998: 456–57.

Mitchell, W. J. T. *Landscape and Power.* Chicago and London: University of Chicago Press, 1994.

Mitchell, W. J. T, ed. "The Photographic Essay: Four Case Studies." In *Picture Theory* (Chicago: University of Chicago Press, 1994): 281–322.

Mongia, Padmini, ed. *Contemporary Postcolonial Theory: A Reader.* London and New York: Arnold, 1996.

Monti, Nicolas. *Africa Then: Photographs 1840–1918.* London: Thames and Hudson, 1987.

Nochlin, Linda. "The Imaginary Orient." *Art in America* 71, 5 (May 1983): 118–31, 187–91. Reprinted in *The Politics of Vision: Essays on Nineteenth-century Art and Society* (New York: Harper and Row, 1989): 33–59.

Oles, James. *Mexico en la imaginacion Norteamericana, 1914–1947.* Trans. Marta Ferragut. *South of the Border: Mexico in the American Imagination, 1914–1947.* Washington, DC: Smithsonian Institution Press, 1993.

Pinney, Christopher. "The Parallel Histories of Anthropology and Photography." In Elizabeth Edwards, ed., *Anthropology and Photography, 1860–1920* (New Haven and London: Yale University Press, 1992): 74–95.

Pinney, Christopher. *Camera Indica: The Social Life of Indian Photographs.* London: Reaktion Books and Chicago: University of Chicago Press, 1997.

Pohl, Klaus, ed. *Ansichten der Ferne: Reisephotographie, 1850–Heute.* Exhibition catalogue. Berlin: Deutscher Werkbund und Anabas-Verlag, 1983.

Porter, Dennis. *Haunted Journeys: Desire and Transgression in European Travel Writing.* Princeton: Princeton University Press, 1991.

Pratt, Mary Louise. *Imperial Eyes: Travel Writing and Transculturation.* London and New York: Routledge, 1992.

Richards, Thomas. *The Imperial Archive*. London: Verso, 1993.

Ripert, Aline and Claude Frère. *La Carte postale: son histoire, sa fonction sociale*. Paris: Presses Universitaires de Lyon, 1983.

Rony, Fatimah Tobing. *The Third Eye: Race, Cinema, and Ethnographic Spectacle*. Durham and London: Duke University Press, 1996.

Rosenthal, Donald A. *Orientalism: The Near East in French Painting, 1800–1880*. Rochester, NY: Memorial Art Galley, University of Rochester, and the Neuberger Museum, State University of New York, 1982.

Ryan, James R. *Picturing Empire: Photography and the Visualization of the British Empire*. Chicago: University of Chicago Press, 1997 and London: Reaktion Books, 1997.

Said, Edward W. *Orientalism*. New York: Random House, 1978, Vintage Books edition, 1979.

Schwartz, Joan M. "The Geography Lesson: Photographs and the Construction of Imaginative Geographies." *Journal of Historical Geography* 22 (1996): 16–45.

Sekula, Allan. "The Body and the Archive." *October* 39 (Winter 1986): 3–64.

Smith, Bernard. *European Vision and the South Pacific, 1788–1860: A Study in the History of Art and Ideas*. 2nd ed. New Haven: Yale University Press, 1985.

Solomon-Godeau, Abigail. "Going Native: Paul Gauguin and the Invention of Primitivist Modernism." *Art in America* 77 (July 1989): 118–29.

Spencer, Frank. "Some Notes on the Attempt to Apply Photography to Anthropometry during the Second Half of the Nineteenth Century." In *Anthropology and Photography, 1860–1920* ed. Elizabeth Edwards, (New Haven and London: Yale University Press, 1992): 99–107.

Spivak, Gayatri Chakravorty. "Subaltern Studies: Deconstructing Historiography." In *In Other Worlds: Essays in Cultural Politics* (New York and London: Routledge, 1988).

Stafford, Barbara Maria. *Voyage into Substance: Art, Science, Nature, and the Illustrated Travel Account, 1760–1840*. Cambridge, MA: The MIT Press, 1984.

Stewart, Susan. *On Longing: Narratives of the Miniature, the Gigantic, the Souvenir, the Collection*. Durham: Duke University Press, 1984.

Stocking, George W. *Race, Culture, and Evolution: Essays in the History of Anthropology*. New York: Free Press, 1968.

Stocking, George W., ed. *Bones, Bodies, Behavior: Essays on Biological Anthropology*. Madison: University of Wisconsin Press, 1997.

Suleri, Sara. *The Rhetoric of English India*. Chicago: University of Chicago Press, 1992.

Tagg, John. *The Burden of Representation: Essays on Photographies and Histories*. Minneapolis: University of Minnesota Press, 1993. Originally published 1988.

Thomas, Nicholas. *Colonialism's Culture: Anthropology, Travel and Government*. Princeton: Princeton University Press, 1994.

Thomas, Nicholas and Diane Losche, eds. *Double Vision: Art Histories and Colonial Histories in the Pacific*. Cambridge: Cambridge University Press, 1999.

Wallis, Brian. "Black Bodies, White Science: Louis Agassiz's Slave Daguerreotypes." *American Art* 9 (Summer 1995): 39–61.

Wells, Liz, ed. *Photography: A Critical Introduction*. 2nd ed. London: Routledge, 2000.

West, Shearer, ed. *The Victorians and Race*. Aldershot: Scolar Press, 1996.

Young, Robert J. C. *White Mythologies: Writing, History and the West*. London and New York: Routledge, 1990.

Young, Robert J. C. *Colonial Desire: Hybridity in Theory, Culture and Race*. London and New York: Routledge, 1995.

FIGURE CREDITS

The contributors, editors and publishers gratefully acknowledge permission to reproduce illustrations as follows.

Fig. 2.1: Collection Brenda L. Croft, courtesy John P. McD. Smith and Brenda L. Croft. Fig. 2.2: Art Gallery of New South Wales, Sydney. Figs 2.3–4: National Gallery of Victoria, Melbourne.

Figs 3.1–8: From Maxime Du Camp, *Egypte, Nubie, Palestine et Syrie*, 1852, plates 27, 87, 28, 65, 47, 17, 48. Courtesy Photography Collection, Miriam and Ira D. Wallach Division of Art, Prints and Photographs, The New York Public Library, Astor, Lenox and Tilden Foundations.

Figs 4.1–10: Oriental and India Office Collections, British Library, London.

Figs 5.1–3, 5, 7: Oriental and India Office Collections, British Library, London. Fig 5.4: Boston Public Library, Print Department. Fig. 5.6: Cambridge University Library. Bourne and Shepherd catalogue nos 1745, 1746, 1747, 1748, 1749, 1750, 120.

Figs 6.1–7: Deutsches Archäologisches Institut, Istanbul.

Figs 7.1, 12: Société de Géographie, Paris. Figs 7.2, 5: Peabody Essex Museum, Salem, Massachusetts. Fig. 7.4: Japan Society of Northern California. Figs 7.7–8, 11: Photography Collection, Miriam and Ira D. Wallach Division of Art, Prints and Photographs, The New York Public Library, Astor, Lenox and Tilden Foundations. Figs 7.9–10, 13–14, 16–17: Peabody Museum of Archaeology and Ethnology, Harvard University, Cambridge, Massachusetts. Fig. 7.15: Worcester Art Museum, Worcester, Massachusetts.

Fig. 8.1: Editions Milan, Toulouse. Fig. 8.2: Bibliothèque Nationale, Paris. Fig. 8.3: Baschet Editions, Paris. Fig. 8.4: University of Minnesota Press, Minneapolis. Figs 8.5–6: Collection Rebecca J. DeRoo.

Figs 9.1–3: Burton Brothers Collection, Museum of New Zealand, Te Papa Tongarewa, Wellington.

Fig. 10.3: British Library, London. Fig. 10.4: National Library of Australia, Canberra. Figs 10.5–7, 10, 11: Peabody Museum of Archaeology and Ethnology, Harvard University, Cambridge, Massachusetts. Fig. 10.9: Peabody Essex Museum, Salem, Massachusetts. Fig. 10.12: Hedemann Collection, Bishop Museum, Honolulu, Oahu, Hawai'i. Fig. 10.13: Metropolitan Museum of Art, New York, Gift of William Church Osburn, 1949.

Figs 11.1, 7, 9–10, 13: from *Unter fremden Völkern*, ed. Wilhelm Doegen (Berlin: Otto Stohlberg, Verlag für Politik and Wirtschaft, 1925). Figs 11.2, 4–6, 8: Berlin, Staatsbibliothek zu Berlin, Preussischer Kulturbesitz, Handschriftenabteilung.

Figs 12.1–2, 4–11: Germaine Krull Nachlass, Fotografische Sammlung im Museum Folkwang, Essen. Fig. 12.3: Jean Suret-Canale, *French Colonialism in Tropical Africa, 1900–1945* (London, C. Hurst and Company, 1971).

Fig. 13.1: Prints and Photographs Division, Library of Congress, Washington, DC, file CA 21, lot number 7554(J). Figs 13.2–4, 10–13: Prints and Photographs Division, Library of

Congress, Washington, DC, USF 34, negative numbers 32081-D, 12558-E, 12557-E, 12365-E, 48686-D, 12511-E, 12512-E. Figs 12.5, 7: from Volume III of *Efernérides de la PRRA*, photograph numbers 2153 and 1698 Colección Puertorriqueña, Sistema de Bibliotecas, Universidad de Puerto Rico, Recinto de Río Piedras. Fig. 13.8: United States National Archives and Records Administration, photograph no. RG 126-PRA, no. 116 in album II of "Albums of the Puerto Rico Reconstruction Administration, 1935–1937." Fig. 13.9: PRRA, Rehabilitation in Puerto Rico (San Juan, PR: Imprenta Venezuala, 1939), Library of Congress, Washington, DC.

INDEX

Page numbers in italics refer to illustrations.